Natural History

Photography

Natural History

Photography

Edited by

D. M. TURNER ETTLINGER

1974

ACADEMIC PRESS

London · New York · San Francisco

A Subsidiary of Harcourt Brace Jovanovich, Publishers

ACADEMIC PRESS INC. (LONDON) LTD.
24/28 Oval Road, London NW1

United States Edition published by
ACADEMIC PRESS INC.
111 Fifth Avenue, New York, New York 10003

Library of Congress Catalog Card Number: 73–19024
ISBN: 0–12–703950–3

Printed in Great Britain by
W & J Mackay Limited, Chatham

Contributors

H. Angel

M.Sc., F.R.P.S. Professional biological photographer and author. Extramural biology tutor, Universities of London, Bristol and Southampton. Member, Fellowship and Associateship (Nature) Panel and Licentiateship Panel, Royal Photographic Society.

S. Beaufoy

M.B.E., B.Sc. (Eng), C. Eng, F.I.E.E., F.R.P.S., F.R.E.S. Council member, Suffolk Trust for Nature Conservation. Past-President, Zoological Photographic Club. Member, Fellowship and Associateship (Nature) Panel, Royal Photographic Society.

S. C. Bisserôt

F.R.P.S. Professional photographer specializing in Natural History. Member, Fellowship and Associateship (Nature) Panel, Royal Photographic Society.

F. V. Blackburn

Freelance Nature photographer.

J. B. and S. Bottomley

Amateur Nature photographers, specializing in waders and other birds away from the nest.

D. A. P. Cooke

M.B., Ch.B., M.R.C.G.P., F.R.P.S., M.B.O.U. Past-Secretary Zoological Photographic Club. Member, Nature Conservancy Council's Advisory Panel on the Protection of Birds Acts.

A. Gilpin

Hon. M.Sc. Council member, Royal Society for the Protection of Birds, and Yorkshire Naturalists' Trust. Secretary and Past-President, Zoological Photographic Club. Executive member, Association of Natural History Photographic Societies. Former Chairman, Fellowship and Associateship (Nature) Panel, Royal Photographic Society.

H. A. Hems

Dip. Ed., F.R.P.S. Senior master, Cromer County Secondary School. Member, Fellowship and Associateship (Nature) Panel, Royal Photographic Society.

J. N. Lythgoe

M.A., Ph.D. Member, Medical Research Council's Vision Unit, University of Sussex.

G. Lythgoe

Dip. Ed. Founder member, British Society of Underwater Photographers, and Director of its library 'Seaphot'.

M. C. F. Proctor

M.A., Ph.D., F.R.P.S. Senior Lecturer in Biological Sciences, University of Exeter. Member, Fellowship and Associateship (Nature) Panel, Royal Photography Society. Former editor of the Botanical Society of the British Isles' journal 'Watsonia'.

J. F. Reynolds

M.A., M.B.O.U. Biology teacher, Jamhuri High School, Kenya. Former District Representative, East African Wildlife Society. Former Hon. Game Warden, Tanzania.

D. M. Turner Ettlinger

F.R.P.S. Chairman, Fellowship and Associateship (Nature) Panel, Royal Photographic Society. Secretary, Association of Natural History Photographic Societies. Member, Nature Conservancy Council's Advisory Panel on the Protection of Birds Act.

D. L. Urry

B.Sc., Ph.D., F.R.P.S. Former senior lecturer in Ecology, Hatfield Polytechnic. Freelance Nature photographer and author.

K. J. Urry

B.Sc., F.R.P.S. Freelance Nature photographer and author.

M. P. Whitehouse

M.A., Ph.D., F.R.P.S. Council member, Hood Medallist, Member of the Fellowship and Associateship (Slide-sound Sequence) Panel and Past-Chairman of the Colour Group, Royal Photographic Society. Vice-President, The Stereoscopic Society.

J. M. Woolley

B.Sc., Ph.D., F.R.P.S. Research photographic chemist. Photographer to the British 1964 Gouffre Berger expedition.

Acknowledgements

One tribute we should like to pay—to John Cruise, of Academic Press, whose idea this book was. A considerable photographer himself, with a most sympathetic interest in Natural History, he died while the book was still in its very early stages. We hope he would have been proud of his brain-child.

Contents

1

Introduction

DEREK TURNER ETTLINGER

2

Big Game

JOHN REYNOLDS

3

Small Vertebrates

HAROLD HEMS

4

Bats

SDEUARD C. BISSERÔT

5

Birds at the Nest

ARTHUR GILPIN

6

Birds away from the Nest

BRIAN and SHEILA BOTTOMLEY

7

The Uses of Play-back Tape

FRANK BLACKBURN

8

Birds in Flight

DAVID and KATIE URRY

9

Flight Photography with Electronic Flash

DAVID A. P. COOKE

10

Insects and Other Vertebrates

SAM BEAUFOY

11

Aquaria and Vivaria

HEATHER ANGEL

12

Plant Photography

MICHAEL PROCTOR

13

Underwater Photography

JOHN and GILLIAN LYTHGOE

14

Photography in Caves

JOHN WOOLLEY

15

Stereo Photography

PAT WHITEHOUSE

16

Tropical Conditions

JOHN REYNOLDS

17

Some Technical Points

DEREK TURNER ETTLINGER

List of Plates

4 Bats: Sdeuard C. Bisserôt

5 Birds at the Nest: Arthur Gilpin

6 Birds Away from the Nest: Brian and Sheila Bottomley

7 The Uses of Play-back Tape : Frank Blackburn

8 Birds in Flight : David and Katie Urry

9 Flight Photography with Electronic Flash : David A. P. Cooke

10 Insects and other Invertebrates : Sam Beaufoy

11 Aquaria and Vivaria: Heather Angel

12 Plant Photography: Michael Proctor

13 Underwater Photography: John and Gillian Lythgoe

14 Photography in Caves: John Woolley

15 Stereo Photography: Pat Whitehouse

16 Tropical Conditions: John Reynolds

17 Some Technical Points: Derek Turner Ettlinger

1

Introduction

Derek Turner Ettlinger

Natural History Photography

There are two extreme approaches to the photography of wild animals and plants. One is concerned simply with making good-looking pictorial photographs without serious regard for the subjects themselves. On the other hand, strictly *ad hoc* biological illustration will show exactly the features to be studied to the exclusion of all other considerations. In this book we are concerned with a middle path (and with converting the extremes to our view). We want to show the subject as accurately as possible, but in such a way that the photograph also arouses a more general interest: and we have one major additional requirement—concern for the welfare of the subject.

We write for the Naturalist with a camera. A Naturalist is curiously hard to define; Nature, or Natural History, is often taken these days as mere popularized biology. There is something in this, since it usually has an element of amateurism—either because the study is unpaid and in the Naturalist's own choice of time and field, or because it is a general rather than a specialized interest, with a consequently less exactly-informed approach. But any Naturalist (as opposed to a 'Nature-lover' or a pictorial photographer) does study his subjects in the field; he learns at least something of their habits and characteristics, and brings that experience to bear on conservational and photographic problems. The terms 'Nature' and 'Natural History', one might observe, have a certain musty air for most biologists nowadays, and they are rarely seen in journals with any pretensions to technicality: even amateur researchers

on a small scale are described as 'scientists'. But Charles Darwin called himself a Naturalist and so, in a less specialized field, did W. H. Hudson. We can be proud to do likewise.

A Natural History photographer, then, is a Naturalist who uses his camera to record observations, take 'specimens' for study, or just obtain momentoes of his subjects, while at the same time trying to make the results interesting to others and keeping a constant watch on the welfare of his subjects.

The biologist can of course include himself in this category without losing any professional rigour. We would also include the 'civilized hunter'—in whom the urge to pursue and capture is strong, but who prefers to get his trophies without damaging the quarry: John Reynolds enlarges on this category in Chapter 2. Photography offers the additional challenge that, by and large, it is much more difficult to obtain a good photograph than a physical trophy. One wonders how many deerstalkers, 'braves chasseurs', or butterfly-collectors would be capable of taking even moderate photographs of their stags, song thrushes, or swallowtails. Of course, the civilized hunter must know a good deal about his quarry if he is not to damage it indirectly or accidentally: he must be, or speedily become, a Naturalist too. All prospective Nature photographers should study their subjects first and their photography second.

Treatment

There are so many Natural History subjects, and the photographic techniques vary so much, that we think the only way to deal with them comprehensively is through chapters by a number of authors, each with an established reputation in the field his chapter covers.

But subject-types do not have clear-cut boundaries, and from a photographic point of view they certainly do not follow biological classification. No chapter-series could look entirely logical. Some biologically-related topics (e.g. birds in flight and birds in other away-from-the-nest activities) need such different techniques that different chapters are inevitable. Even birds in flight need different treatment according to whether the lighting is natural or artificial.

Some duplication is unavoidable. 'Big Game' and 'Small Vertebrates',

for instance, both include animals of the size of a fox. Home-rearing butterflies in 'Insects and Other Invertebrates' is similar in treatment to part of 'Aquaria and Vivaria'. In the course of 'Operations in the Tropics' there are observations on 'Birds at the Nest'. 'Photography in Caves', while a highly specialized affair photographically, has some subjects which in fact are 'Insects and Other Invertebrates' and others which are 'Plants'.

So even a reader with a single Natural History interest should find useful points in other chapters (the Index and cross-references in the text will show him where to look). There are a few interests without chapters of their own at all. Zoo photography, for example, has been divided up, according to animal size, between 'Big Game', 'Small Vertebrates' and 'Aquaria and Vivaria'.

The one major omission from the book is cine-photography. The techniques for setting-up the photographic situation are, of course, the same as for still photography and are to that extent covered. But the considerations governing the use of moving film—noise, choice of shot, camera tracking and zooming, and above all editing and continuity— these are so different that they would have required a lengthy chapter for which we simply do not have the space. Space has also dictated a few minor omissions; we should have liked to include a chapter on 'Operations in the Arctic' and to have had more on photographic technicalities, for instance.

But, in general, we think we cover all the Natural History still-photography subjects which have a widespread appeal; we hope to produce a standard work, up-to-date and of world-wide relevance.

Of our eighteen contributors, five can be described as professional biologists, the others being amateur Naturalists (though some are pro-fessional or semi-professional photographers); five are women—a welcome proportion and a fair one, we think, for a field where male chauvinism has virtually disappeared. All are British, but with experience in other countries—some of it extensive; John Reynolds has been four-teen years in Africa, for example.

Each author, of course, has his own style and may choose to emphasize aspects which another would pass over. If two mention a type of appar-atus, or a technique, they may have differing views on its value. We have not tried editorially to extract compromises in such things—one must

remember that committee of angelic experts who, delegated by the Creator with the design for His specification 'racehorse', compromised so successfully that the result was a camel. Nor have we tried to impress any common pattern of chapter (except as to layout); we hope there is an overall sense of unity, though we think small-scale diversity a gain.

Assumptions

From our definition of a Natural History photographer as primarily a Naturalist, it is clearly unnecessary to make more than passing references to Natural History *per se*. We also assume a certain knowledge of photographic processes and optics, and modern camera types: the first are covered by numerous books (a selection is in the Bibliography to Chapter 17) and the last by a large number of periodicals. Any Naturalist who is a newcomer to photography is advised to master these.

Broadly, and with a few exceptions, we are limiting our considerations to maximum reproduction ratios of about 1:1—i.e .to 'close-up' photography, as opposed to macrophotography (1:1 to 10:1) or photomicrography (over 10:1): again, the Bibliography gives references. This is an arbitrary decision, chiefly because the higher reproduction ratios demand more specialized techniques, for which we do not have the space.

This is intended to be a practical book, and we do not think that a strict treatment of technical matters is always necessary. For some chapters, technicality is inevitable ('Flight Photography with Electronic Flash' and 'Stereo Photography'), but for most we think that unvarnished common sense backed by practical experience is the most useful approach.

To save space, we have transferred to an Index the scientific names of most species which have vernacular English names.

Ethics

Any true Naturalist will have the well-being of his subjects at heart, and will not knowingly do anything to harm either individuals or the species' population status. Regrettably, some ruthless wielders of cameras do exist, and there are depressing examples in the 'Big Game' chapter; these

are largely responsible for the adverse opinion of photography held (vehemently at times) by some sections of the Conservation movement. It is fair to add that the facts are often exaggerated by rumour: any desertion of a bird's nest, or trampling of a rare plant, is only too readily ascribed to the man known to have been present with a camera, regardless of other visitors or considerations. This is particularly unfortunate since the Conservation movement is heavily indebted to photography for much of its propaganda material: such a debt does not excuse real carelessness, of course, but one does sometimes wish that critics of photography knew a little more about the difficulties of what they criticize.

We must admit that errors in technique can and do cause conservational damage at times, even with well-meaning and well-informed photographers, and we must minimize them. We must always operate on the principle that the welfare of the subject is more important than the photograph and stay our hand, or find another subject, if the risk is excessive. This is an article of faith among all genuine Nature photographers.

All chapters in the book contain warnings and advice on this topic. We also reprint, as an Appendix to this chapter, the (British) Association of Natural History Photographic Societies' *Nature Photographers' Code of Practice* (with acknowledgment to the Association's Executive). This, produced with the help of many purely conservational bodies is, we think, the first of its kind produced anywhere and is much more detailed than other conservational codes. While some of it needs extrapolation for use outside the UK, we strongly recommend that Natural History photographers everywhere take it as giving the principles to follow. It contains few absolute 'musts' and 'must nots', since many of the precepts can, at times and by experienced operators in individual circumstances, be overridden; but the advice in general cannot be lightly disregarded by any responsible person.

Photographic Standards

Any serious Nature photographer, whether his medium is colour print, black-and-white print, or colour transparency, will want results of the highest quality consistent with his finances. Apart from studying the

advice on techniques in this book, the beginner may find some difficulty in progressing. Experienced Nature photographers are relatively thin on the ground, even in Britain, and it may not be easy to get criticism of results from someone competent to give it. A beginner will get worthwhile advice from local photographic societies on such things as composition, exposure and print-quality (which alone makes them worth joining, of course) but on little else of relevance. Nor will he be able to deduce much from exhibition acceptances, unless there are specialist Natural Historians on the judging panels and this rare in international exhibitions. Amateur photography in general is dominated by the pictorialists who, quite properly, are concerned with such things as design or composition, colour-harmony, human interest and social message. Accuracy of detail, colour or tone, and general significance to the Naturalist (which are our chief concern) are of little account to them, and their knowledge of the ethical points, to which we attach so much importance, is negligible. Whether favourable or adverse, their judgments must be taken with reserve by the Nature photographer.

But we should not damn pictorialists out of hand. When their virtues are added to ours, the result may become one of the real masterpieces of our craft. Few of the more way-out techniques currently fashionable in pictorial photography have much place in Natural History; solarization, posterization, montage, deliberate subject movement, excessive grain, accent on the out-of-focus image, cannot possibly help our prime requirements. But careful composition (including its more liberated modern styles), dramatic use of colour, selection of unusual formats and variation of subject scale within the picture to accentuate some aspect of it, these can be grafted on to our needs.

For a masterpiece, it is not enough to portray accurately, say, a sparrow: we must capture also the essence of sparrowishness, and this is not easy within the confines of a narrow traditionalism. We suggest that a *selective* adoption of pictorial standards (while not losing sight of our own special requirements) is one of the more important advances in Nature photography likely in the next few years.

Postal Societies

Reverting to the beginner, as soon as he has reached a modest standard of competence in general club photography (exposure, print quality, etc), we recommend that he join one of the postal photographic clubs devoted to Natural History, or one of the Natural History Circles in more general postal clubs. These, we think, are peculiar to Britain, and we would suggest that energetic Nature photographers in other countries might seek out fellows within reasonable postal range and form similar societies. They operate as follows. When a folio (as it is called) arrives by post, one inserts a print (or transparency) of one's own, well documented as to the Natural History and photographic details: one studies and makes considered comments on other members' entries on a sheet provided for the purpose, and removes one's previous entry, noting the remarks other members have made on its comment sheet during its round. The folio is then posted on to the next member. In this way, one not only sees and can criticize other work in the same general sphere, but has the enormous help of established experts' observations on one's own work. In addition, most folios have a Notebook, in which members write about operational hints and tips, gadgets, special techniques, new apparatus, etc.—all of them valuable to the beginner. And most postal societies hold periodic conventions, at which one can meet and chat with the people whose work has become familiar in this way.

Appendix
The Nature Photographers' Code of Practice

Introduction

This Code has been produced by the Association of Natural History Photographic Societies, with grateful acknowledgments for help received from the Royal Society for the Protection of Birds, the British Trust for

Ornithology, the Botanical Society of the British Isles, the Mammal Society, the Joint Committee for the Conservation of British Insects, and the Society for the Promotion of Nature Reserves. Such things are always compromises, and the Code should not be construed as committing these bodies to all its recommendations as matters of policy.

General

The Law as it affects Nature photography must be observed. In the UK the chief legislation is the Protection of Birds Acts, 1954–67, though by-laws may govern activities also in some circumstances. In other countries, one should find out what restrictions apply (and it should be noted that these may include plants).

There is only one other hard-and-fast rule, whose spirit must be observed *at all times*—'the welfare of the subject is more important than the photograph'.

This is not to say that photography should not be undertaken because of slight risk to a common species. But the amount of risk acceptable decreases with the scarceness of the species, and the photographer should always do his utmost to minimize it.

Risk, in this context, means risk of physical damage, suffering, consequential predation, or lessened reproductive success.

The photographer should be familiar with the Natural History of his subject: the more complex the life-form and the rarer the species, the greater his knowledge ought to be. He should also be sufficiently familiar with other Natural History specialities to be able to avoid damaging their interests accidentally. Photography of scarce animals and plants by people who know nothing of the risks involved is to be deplored.

For many subjects, 'gardening' (i.e. interference with surrounding vegetation) is necessary. This should be to the minimum extent, not exposing the subject to predators, people, or adverse weather conditions. It should be carried out by pinning- or tying-back, rather than cutting-off, and it should be restored to as natural a condition as possible after each photographic session.

If the photograph of a rarity is to be published or exhibited, care should be taken that the site location is not accidentally given away.

It is important for the good name of Nature Photography that its practitioners observe normal social courtesies. Permission should be obtained before operations on land to which there is not customary free access, and other naturalists should not be incommoded. Work at sites and colonies which are the subjects of special study should be coordinated with the people concerned.

Photographs of dead, stuffed, home-bred, captive, cultivated, or otherwise controlled specimens may be of genuine value, but should *never* be 'passed off' as wild and free. Users of such photographs (for exhibition or publication) should always be informed, however unlikely it may seem that they care.

Birds at the Nest

It is particularly important that photography of birds at the nest should only be undertaken by people with a good knowledge of birds' *breeding* behaviour. There are many otherwise competent photographers (and bird-watchers) who lack this qualification.

It is highly desirable that a scarce species should be worked only in an area where it is relatively frequent. Many British rarities should, for preference, be worked in countries overseas where they are commoner. Photographers working abroad should, of course, act with the same care they would use at home.

A hide should always be used when there is reasonable doubt that the birds would continue normal breeding behaviour otherwise. No part of the occupant (e.g. hands adjusting lens-settings, or a silhouette through inadequate material) should be visible from outside the hide.

Hides should not be positioned on regularly-used approach-lines to the nest, and (unless erected gradually *in situ*) should be moved up on a roughly constant bearing. They should not be allowed to flap in the wind.

A hide should not be erected at a nest where the attention of the public or any predator is likely to be attracted. If there is a *slight* risk of this, an assistant should be in the vicinity to shepherd away potential intruders. No hide should be left unattended in daylight in a place with common public access.

Tracks to and from any nest should be devious and inconspicuous. As

far as possible they (like the gardening) should be restored to naturalness between sessions.

Though nest failures attributable to photography are few, a high proportion of them is the result of undue haste. The maximum possible time should elapse between the consecutive stages of hide movement (or erection), introduction of lens and flash-gear, gardening and occupation. There are many species which need at least a week's preparation.

Each stage should be fully accepted by the bird (or both birds, where feeding or incubation is shared) before the next is initiated. If a stage is refused by the birds (which should be evident from their behaviour to any properly-qualified photographer), the procedure should be reversed by at least one stage; if refusal is repeated, the attempt at photography should be abandoned.

In difficult country, acceptance can be checked indirectly, by disturbed marker-twigs, moved eggs, etc. provided the disturbance in inspecting the markers is minimal.

The period of disturbance caused by each stage should be kept to the minimum. It is undesirable to initiate a stage in late evening, when diurnal birds' activities are becoming less frequent.

Remote-control work where acceptance cannot be checked is rarely satisfactory. Where it involves resetting a shutter, or moving film on manually between exposures, it is even less likely to be acceptable because of the frequency of disturbance.

While the best photographs are often obtained at about the time of the hatch, this is no time to start erecting a hide—nor when eggs are fresh. It is better to wait till parents' reactions to the situation are firmly established.

There are few species for which a 'putter-in' (and 'getter-out') is not necessary. Two may be needed for some wary species.

The birds' first visits to the nest after the hide is occupied are best used for checking routes and behaviour rather than for exposures. The quieter the shutter, the less the chance of the birds objecting to it. The longer the focal length of lens used, the more distant the hide can be and the less the risk of the birds not accepting it.

Changes of photographer in the hide (or any other disturbance) should be kept to the minimum, and should not take place during bad weather (rain or exceptionally hot sun).

Nestlings should never be removed from a nest for posed photography; when they are photographed *in situ* care should be taken not to cause an 'explosion'. It is never permissible to prevent artificially the free movement of young.

The trapping of breeding birds for studio-type photography is totally unacceptable in any circumstance.

The use of play-back tape (to stimulate territorial reactions) and the use of stuffed predators (to stimulate alarm reactions) need caution in the breeding season, and should not be undertaken near a known nest.

Mammals and Birds Away from the Nest

It is not always true that, if techniques are at fault, the subject will either not appear or it will move elsewhere and no harm will be done.

Predators should not be baited from a hide in an area where hides may later be used for photography of birds at the nest.

Wait-and-see photography should not be undertaken in an area where a hide may show irresponsible shooters and trappers that targets exist; this is particularly important overseas.

The capture of even non-breeding birds just for photography under controlled conditions is not an acceptable practice. Incidental photography of birds taken for some valid scientific purpose is acceptable, provided it causes minimal delay in the bird's release, but in the UK this must be within the terms of the licence issued by the Nature Conservancy Council under the Protection of Birds Acts.

Taking small mammals for photographic purposes is acceptable, provided they are not breeding and that they are released with minimum delay in their original habitats, but the practice is not recommended. Particular care is needed with shrews, which may starve to death in three hours.

Bats need special care. Disturbance at or near a breeding colony may cause desertion of an otherwise safe site; several UK species are very rare and the loss of even one site could be critical. Unnecessary disturbance of roosting sites should also be avoided, and photographic visits should be coordinated with those by people studying the colonies.

Awakening hibernators for photography is not recommended. If there

is a strong case for doing so, choose a mild spell near the end of a mild winter. Bats are especially vulnerable, since their fat reserves may only be adequate for four or five awakenings in an entire winter. An awakened hibernator should be offered food, but refusal to feed should not be a reason for taking an alternative specimen; it should be returned to hibernation as soon as possible.

Other Animals

For cold-blooded animals and invertebrates, temporary removal from the wild to a studio or vivarium (or aquarium) for photography is a well-accepted practice, but subsequent release should be in the original habitat and as soon as practicable.

Chilling or light anaesthesia for quietening invertebrates is not recommended. If it is undertaken, subjects should only be released when the effects have completely worn off.

When microhabitats (e.g. tree-bark, beach rocks, etc.) have been disturbed, they should be restored after the photography.

Insect photographers should be familiar with the Joint Committee for the Conservation of British Insects' *Code of Insect Collecting* and *British Macro-lepidoptera; Rare and Endangered Species*. While these allow moderate rarities to be collected, photographers should take a more restrictive view of what ought even to be put at risk by their activities.

Plants

The comments in the General section about gardening are particularly important for rare plants within reach of the public.

Trampling of habitats can cause serious damage in vulnerable areas, especially marshes. It is essential that preparations to photograph one specimen of a rarity do not involve treading on other specimens, including non-flowering ones. Tracks to and from a rarity should be devious and inconspicuous, and should be restored to naturalness afterwards.

Plant photographers should be familiar with the Botanical Society of the British Isles' *Code of Conduct* and *List of Rare Plants*. While these allow the picking of moderate rarities, photographers should take a more restrictive view. No rarity should be picked (still less dug up) for studio photography, or to facilitate the *in situ* photography of another specimen. Nor should part of one be removed to facilitate the photography of another part.

2

Big Game

John Reynolds

Introduction

Palaeontology, archaeology and anthropology clearly show that Man is a predatory primate who, in terms of the biological time-scale, has only very recently stopped living as a hunter and scavenger. With the development of 'civilization' and urbanization, hunting became a favourite leisure activity of the rich. In some parts of the world, particularly after the invention of fire-arms, hunting degenerated into wholesale slaughter; but in others, the killing became tempered by respect and sympathy for the quarry, which led to a strict code of sporting ethics in which fair play figured largely and the chase was considered more important than the trophy. Nowhere was this attitude more evident than in Britain, where a considerable number of the 'landed gentry' became hunter-naturalists, making important contributions to our knowledge of Natural History.

It is not surprising that, with the development of the portable camera, many of these hunter-naturalists gave up the gun in favour of the camera, bringing to the new field sport of wildlife photography concepts of fair play similar to those evolved for hunting. These concepts, although applied in practice by the majority of photographic Naturalists in Britain and elsewhere, have only recently been committed to writing in *The Nature Photographer's Code of Practice*. It is a disturbing feature of modern Nature photography that some newcomers to the sport are ignorant of these concepts; this is particularly prevalent among tourists photographing big game in East Africa, and is discussed at some length in the next section.

The term 'big game' is used by hunters for the larger carnivores (e.g., lions, tigers and bears), large, potentially dangerous herbivores (e.g.,

elephants, rhinos and buffaloes) and those species, large or fairly large, of deer, antelope, sheep and goat whose males possess handsome horns. From the photographic point of view, 'big game' is a larger and more heterogeneous collection of animals, linked by the fact that their photography involves methods rather different from those developed (and discussed in other chapters) for the successful portrayal of small animals. The techniques considered in this chapter are mainly applicable to mammals ranging upwards in size from that of a fox, large birds such as bustards, cranes, eagles and vultures (when not nesting), and large reptiles such as crocodiles and turtles. The subject matter of Chapter 6 partly overlaps that of this one, but is approached by the Bottomleys mainly with regard to conditions in the north temperate zone.

Wildlife and Tourism

In certain parts of the world, notably East Africa, large populations of spectacular animals living in wild, unspoilt country, combined with pleasant predictable climates, have provided the basis for thriving tourist industries which could not have developed before the advent of the modern jet aircraft and the package tour.

That East Africa retains a greater variety and quantity of big game than any other part of the world owes little to the former Colonial Governments; their most favoured wildlife policy was one of extermination, to make way for subsistence agriculture or scrub cattle which, thanks to the vaccines introduced by the veterinarians, soon increased to numbers beyond the carrying capacity of the land. Only in areas patently unsuitable for any agricultural development was game tolerated. Rather grudgingly some of these were designated as National Parks, mainly in the years following the end of the Second World War. As the 'wind of change' swept through Africa, conservationists realized that the only way to ensure the survival of these priceless samples of virtually pristine eco-

Plate 1. Lioness yawning. An example of how close some animals can be stalked from a car. Range 4 m. Mamiyaflex C.220, 180 mm Sekors, 1/500 at f8 on FP4 roll-film developed in Microphen 1:3.

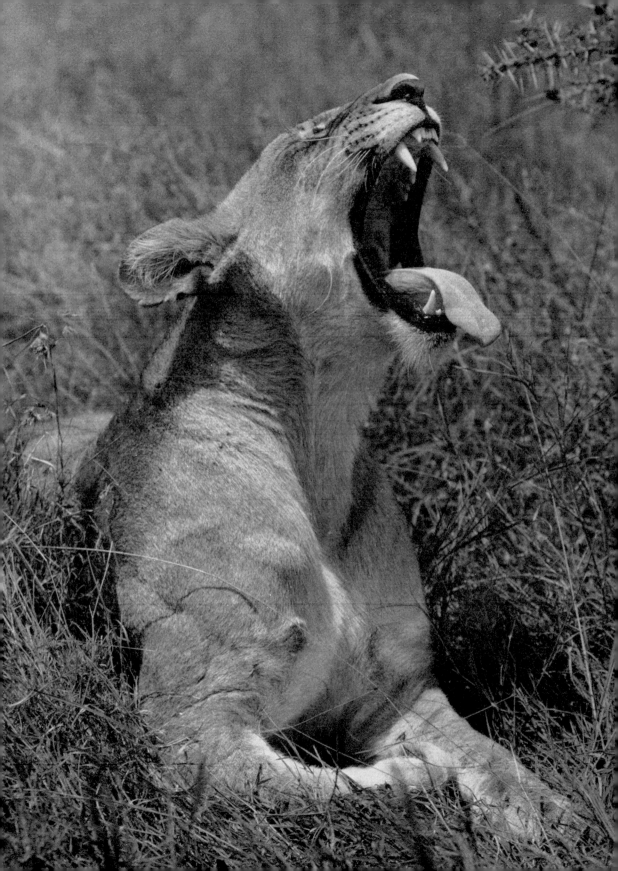

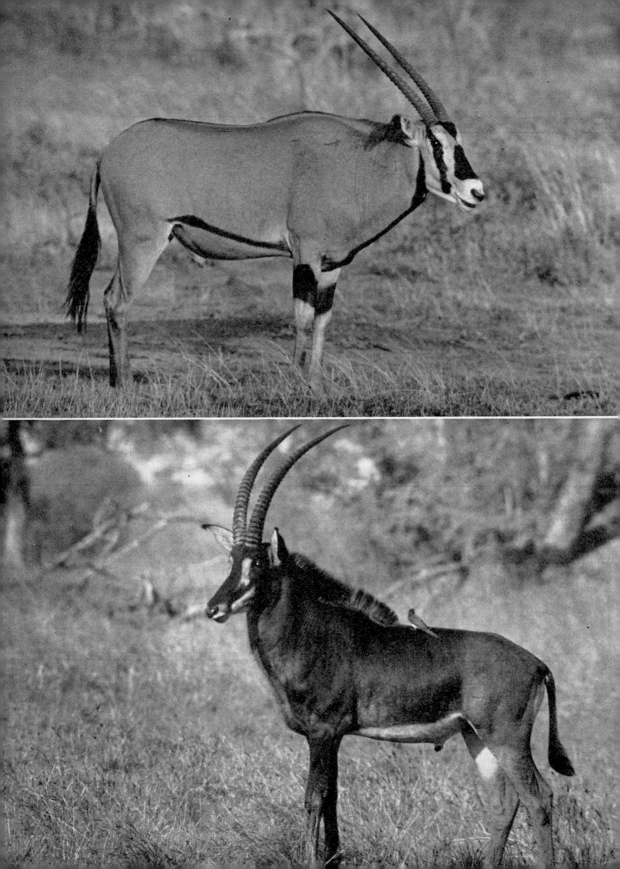

systems was to convince the future African governments that game was an asset to be cherished. To preserve game habitats from human encroachment it had to be shown that maintaining these in their natural state could be more profitable than using them for, say, ranching. The main economic argument was that tourists from, mainly, Europe and North America would visit East African countries to enjoy the spectacle of their wildlife. The argument was valid: tourists come in ever-increasing numbers, so that, in East Africa, the tourist industry is rapidly becoming the largest single earner of foreign exchange. With the example of African countries before them, it is only a matter of time before countries in other continents still possessing spectacular wildlife start to exploit it in a similar way.

A result of this great surge in tourism is that a high proportion of game viewers in Africa are non-Naturalists, regarding animals purely as a form of entertainment to be photographically recorded. Because of their largely urban upbringing, few have much personal experience of animals, and seem to be unaware when their activities cause distress, endangering the well-being of the animals they photograph. Most tourists approach game in vehicles whose drivers, because of their culture and standard of living, have little respect and sympathy for wildlife. These men have learnt that tourists wish to be taken close to certain species, notably lion and cheetah (a basically nervous and temperamental species), especially when these have young. To achieve this they frequently chase shy individuals until they collapse from exhaustion and can be approached close enough for photography without the tele-lenses normally essential for game photography. Letters published in *Animals* magazine and in *Africana* (the publication of the East African Wildlife Society) describe inexcusable harrying of pregnant and nursing cheetahs, and Somali wild asses being chased until they dropped dead. The only conclusion that can be drawn from such cases is that many tourists see nothing wrong in animals being chased and seriously disturbed so that they may obtain photographs. There is no excuse for harrying shy individuals as, quite apart from ethical

Plate 2. Less confiding animals stalked in a car. (Upper) Fringe-eared oryx. Pentax S.3, 500 mm Takumar; 1/250 at f8 on FP3 film developed in Unitol.
(Lower) Sable antelope in *miombo* woodland (with oxpecker on its back). Details as above.

considerations, it is usually possible to find others indifferent to a vehicle's close approach: in both the Serengeti and Nairobi National Parks some cheetahs jump on to the roofs of cars to get a better view of potential prey scattered over the plains.

If it is true that much of this tourist behaviour is due to ignorance and thoughtlessness, one of the big conservation organizations should co-operate with National Parks Authorities in producing educational leaflets for issue to all tourists. These could be based on the relevant parts of our Code of Practice, amplified and modified to cover the conditions obtaining in the Parks concerned. The purpose of these leaflets would be to make the visitor more aware of the good manners he owes the wildlife and his fellow visitors. Improving the behaviour of drivers could be achieved by giving courses in the proper way to approach wildlife, followed by an examination that must be passed in order to obtain a licence for taking visitors around the Parks. If the Parks Authorities then banned any company whose drivers broke the Code, there would be an immediate improvement—financial penalties having much more effect than mere exhortations.

As tourism increases, another problem that is starting to worry Parks Authorities will steadily worsen. This is ecological damage resulting from cars being driven across country in large numbers. The time will un-doubtedly come in the not-so-distant future when all game viewing in well-frequented Parks will have to be carried out from fixed roads and tracks, to avoid damage to the soil and vegetation. There is also a photographic aspect to this: pictures of game are badly marred if tyre marks are showing. A driver who takes his vehicle across a salt-lick or dust bath renders that site unphotogenic for subsequent photographers until his tracks have been eliminated by the animals' trampling.

This is, perhaps, also the appropriate place to castigate litter-bugs. Litter and pollution are the hall-marks of the affluent society in its own urban habitat. It is baffling to find that members of that society who are

Plate 3. (Upper) Grevy's zebra: suspicious, but the car has not yet reached its flight distance. Pentax S.3, 300 mm Takumar, 1/250 at f11 on FP4 film developed in Unitol. (Lower) Oribi; buck and doe fawn sniffing each other. Sexual preoccupation has tempo-rarily reduced the flight distance. Details as above, except that a 500 mm lens was used.

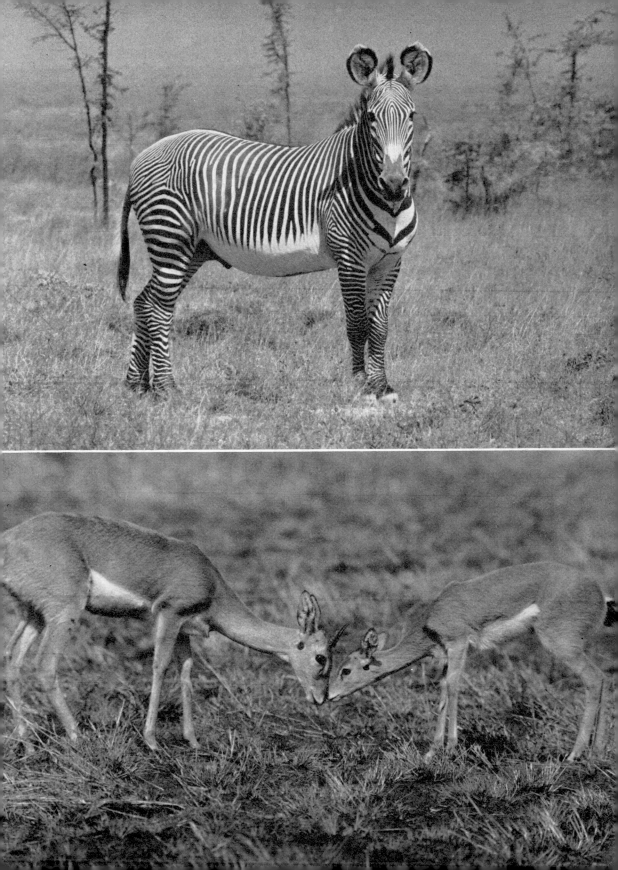

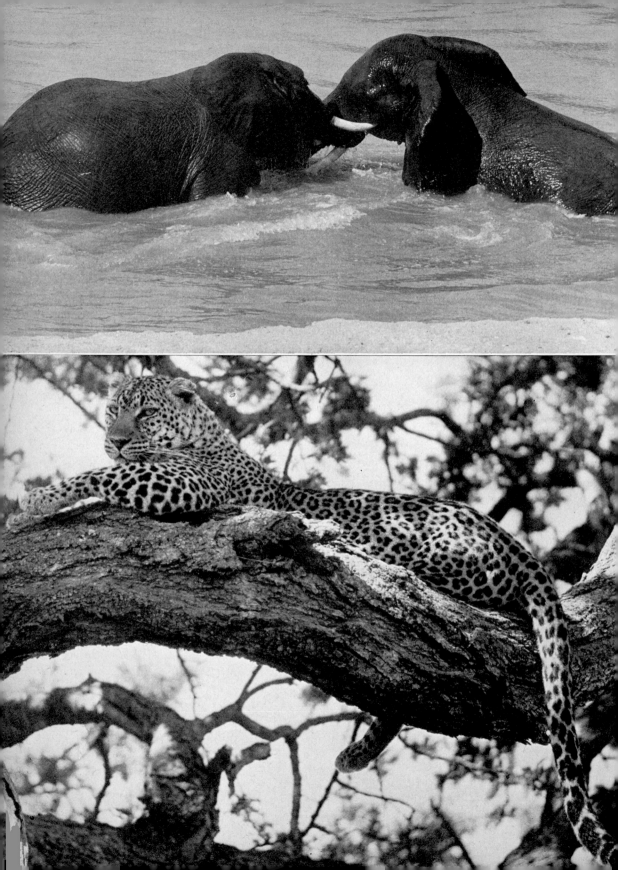

prepared to pay considerable amounts of money to view spectacular wild animals in equally wild surroundings can be so insensitive to these sights that they desecrate them with empty cigarette cases, film cartons, sandwich boxes and other debris.

Tourism has undoubtedly been a major factor in slowing down the probably inevitable destruction of Africa's wildlife wonders: it is sad that so many visitors do not truly appreciate what they see, and, by irresponsible behaviour, endanger some of the rarer species.

Equipment

The earliest big-game photographers were among the first Nature photographers to realize the advantages of the reflex camera and the then 'miniature' size of quarter-plate ($3\frac{1}{4} \times 4\frac{1}{4}$ in.; $8\cdot3 \times 10\cdot8$ cm). A favourite model was the Soho reflex fitted with a 17 in. (432 mm) Dallon telephoto, a combination capable, in expert hands, of giving results little inferior to those produced with modern equipment fifty years later. A reflex is still the most suitable camera for this branch of Nature photography. We will now consider the pros and cons of the various types available, first listing the ideal characteristics of a camera for big game photography.

(a) Availability of long-focus lenses (up to at least $6\times$ the focal length of the standard lens), with fully automatic diaphragms (FAD). Unless the lenses chosen can be focused down to about 3 m, the camera/lens combination should be such that extension tubes can be used if necessary.

(b) A simple, accurate, rapid-focusing mechanism, using eye level viewing, that retains its efficiency with long lenses.

(c) Through-the-lens metering.

(d) Rapid film-transport coupled to the shutter-cocking mechanism.

(e) A minimum (true) shutter speed of 1/500 sec, 1/1000 sec being preferable.

(f) Robustness.

Plate 4. (Upper) African elephants, playing in the Ruaha River after mating. Stalked. Pentax S.3, 135 mm Takumar; 1/250 at f8 on FP3 film developed in Unitol.
(Lower) Leopard, stalked in a car in the Serengeti National Park—the only place in Africa, probably, where the species can be approached in this manner. Details as above.

(g) Light weight.

(h) Availability of efficient and rapid servicing.

(i) Interchangeable backs (in 35 mm SLRs only the very expensive Contarex has this feature at present).

(j) Reasonable price. Since good Nature photography is only possible with high-quality optics, one must be prepared for a considerable financial outlay. How much will depend in part on the tax structure of the country where one lives. Actual prices are best obtained from careful study of photographic magazines, or from reputable dealers. Suitable 35 mm equipment costs approximately half that of most large-format equipment (with the exception of the Pentacon-6 which is in the same price bracket as 35 mm equipment).

The above characteristics mean that the twin-lens reflex (TLR) is unsuitable specifically for game photography, as only one model has interchangeable lenses, 250 mm being the longest focal length available.

This leaves the single-lens reflex (SLR), and here the initial decision has to be between 35 mm and larger format (usually 6 × 6 cm or 6 × 7 cm) models taking 120 and/or 220 roll-film, or even larger sizes of flat film. Many photographers think that 'the 35 mm SLR can do almost everything that is asked of it; if it doesn't, it is your technique that is to blame, not the camera.' The main advantages of the 35 mm format are relative cheapness, light weight, availability of many interchangeable lenses, and generally faster handling. The only advantage that larger format SLRs have is their larger image size. There is no doubt that a large print from most of a 6 × 6 cm negative will be of better quality than the same sized print from most of a 35 mm negative, provided both have been correctly processed, but this differential quality is only maintained when the larger negative area is fully utilized. In Nature photography this means either using a lens of longer focal length (at once introducing problems of reduced depth of field) or moving closer to one's

Plate 5. Work at waterholes. (Upper) Lioness drinking. This illustrates the difficulty of combining bird and game photography at the same site. A 300 mm lens had been in use on birds, and when the lioness appeared the shortest lens available was 135 mm—too long to include the whole animal. Pentax SV, 1/250 at f8 on FP4 film, developed in Perceptol 1:3.

(Lower) Ostrich, a group of juveniles coming to drink. Mamiyaflex, 180 mm Sekors, 1/250 at f11 on FP4 roll-film developed in Microphen 1:1.

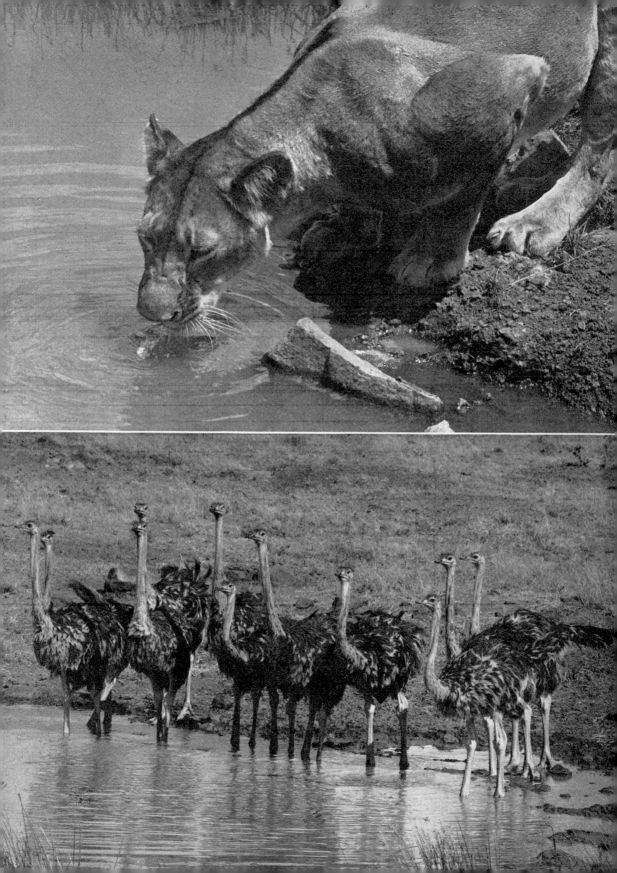

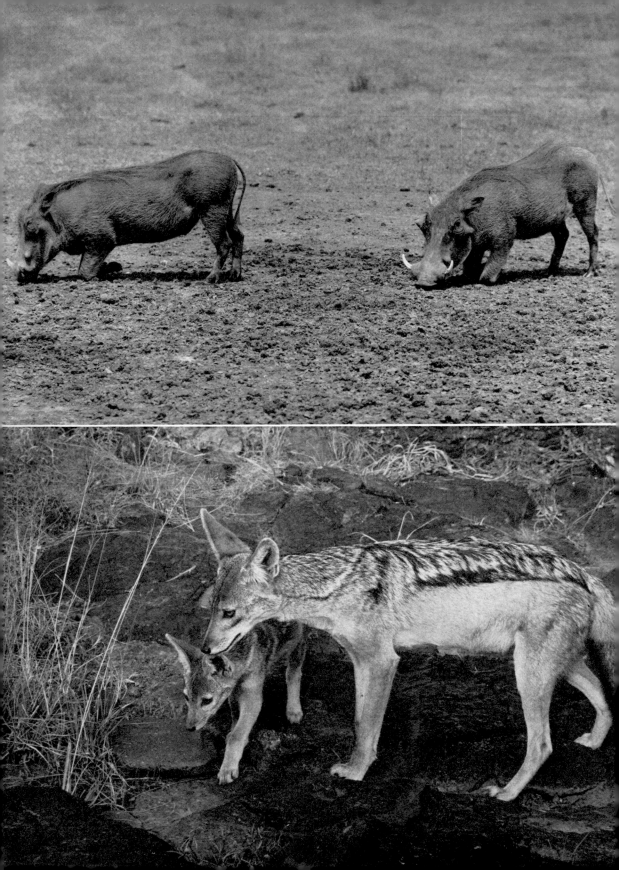

subject—which, in game photography (and much bird photography), is often not possible. Two further advantages of the larger negative are that faster film can be used (providing that most of the negative is utilized) without incurring problems of grain, and composition does not have to be quite so critical: it is all too easy with 35 mm to find that one has not left quite enough space below the feet, above the head, behind the tail, or in front of the face.

Each photographer has to make his own final choice. Not all workers have the same photographic objectives: some want 35 mm transparencies for projection, others want to produce prints for illustrating scientific papers, while others want transparencies for reproduction and negatives from which really large prints can be made for exhibition or framing. In the latter cases the photographer should, if he can afford it, select a 6 × 6 cm or larger format camera. Otherwise, especially with meticulous negative technique, he will find the 35 mm format adequate. There is little to choose between 20 × 25 cm (8 × 10 in.) prints from 6 × 6 cm and 35 mm negatives, and the latter can produce good, if seldom superlative, exhibition prints in the 30 × 40 cm and 41 × 51 cm sizes.

Having chosen the format, one still has to select a suitable battery of lenses, as very little except habitat shots can be taken with the standard lens. Again the choice is personal, but for 35 mm work, 135 mm and 300 mm lenses will generally be the most useful; for shyer species, and birds generally, a 500 mm is often desirable. For larger format work a 250/300 mm and a 500/600 mm will be needed. For both formats FAD lenses should be bought if possible, as this feature greatly increases operational speed. If only one tele-lens can be afforded, it should be the longer one. Mirror-lenses are much more compact than orthodox lenses of the same focal length but suffer from the great disadvantage of a fixed aperture, usually between f8 and f11. The writer has no personal experience of zoom lenses, which are most useful for a photographer concentrating on transparencies for projection, where critical resolution is not as important as in printing.

Plate 6. (Upper) Wart-hogs at a salt-lick. Mamiyaflex, 180 mm Sekors, 1/500 at f11 on FP4 roll-film developed in Microdol 1:3.
(Lower) Silver-backed jackal and cub (c. two months old) near their lair. Pentax SV, 135 mm Super-Takumar; 1/125 at f8 on FP4 film developed in Promicrol 1:3.

As in all Nature photography, a really steady tripod is highly desirable and should be used wherever possible. When this is not feasible, a very useful degree of support can be obtained from one of the shoulder-pods based on the idea of a gun-stock.

Game Areas and The Photographer

Although foxes have been found living as quite successful scavengers in the suburbs of cities in western Europe, and monkeys are common in Indian cities, it is generally true that large animals are only found in any numbers far away from the amenities of civilization. A notable, and unique, exception is the wide spectrum of wildlife (including between 3,000 and 15,000 large herbivores, depending on the season) in the 11,400 hectares (44 square miles) of Nairobi National Park, one of whose entrances is only 8 km from the city centre. However, this is because the Park has permanent water, and is the dry season concentration area ('shop window') for a much more extensive ecological unit which is being threatened with development for ranching. Game can only survive in wilderness areas which for one reason or another (in the Tropics, commonly lack of water or the presence of disease-carrying insects, such as tsetse flies) cannot be used for farming or ranching. Since such areas have not been 'opened up' for large-scale human settlement, they are inevitably rather inaccessible unless they have been developed as tourist attractions, as in the African National Parks.

Travelling in the Wilderness

Although expeditions to some wilderness areas, such as the Canadian Arctic, Amazonia, New Guinea and the Himalaya, may require intricate

Plate 7. Work at a carcase. (Upper) White-backed vultures, at wildebeest carcase. Pentax S.3, 135 mm Super-Takumar; 1/250 at f11 on FP4 film developed in Promicrol 1:3. (Lower) Spotted hyaena, with wildebeest leg. Details as above, but 300 mm Takumar.

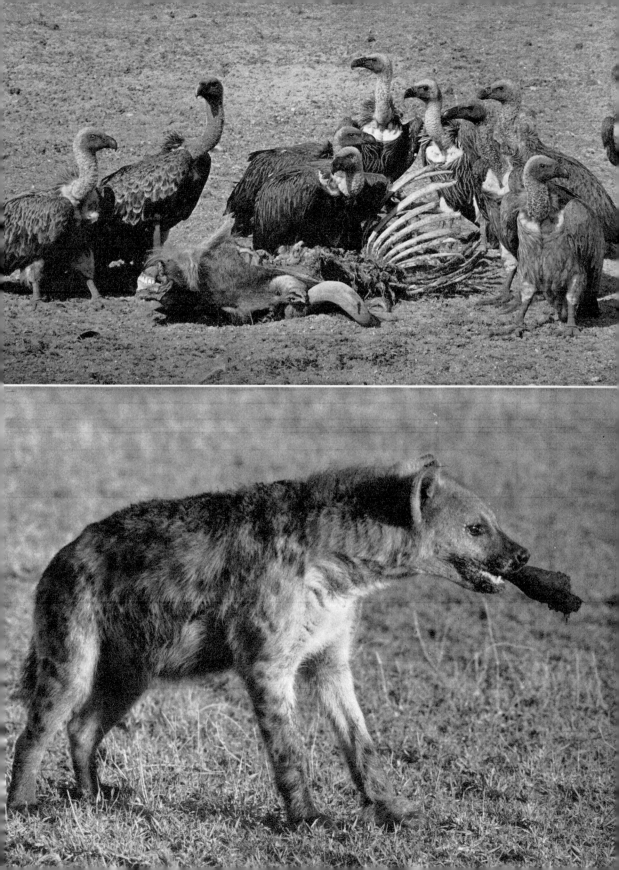

planning (possibly involving air-lifts, boats, porters, and pack animals) on account of their remoteness and the physical difficulties of their terrain, there are now remarkably few game habitats that cannot be reached by modern four-wheel-drive vehicles such as the Land Rover. Even so, trips into the wilderness should not be lightly undertaken by the inexperienced visitor. A good idea of the planning that may be involved can be obtained from Laurens Van Der Post's *Lost World of the Kalahari* (see Bibliography).

Some newcomers to Africa and other 'big countries' drive out into the wilds not even knowing how to mend a puncture, not appearing to realize that the spare tyre can also be punctured on even a short trip. Tyro tourists also tend to forget that fuel tanks are mostly designed for use in countries where filling stations are seldom more than 10 km apart. The 73 litre (16 gallons) tank of a LWB (109 in.; 277 cm) Land Rover gives a range of about 385 km, provided that four-wheel drive and low-ratio gears are not in frequent use. Since the 'promised land' may well be 160 km or more from the nearest fuel supply, plenty of extra fuel must be carried to allow game searching trips around one's camp as well as the return journey. By fitting an extra fuel tank (usually 45·5 litres) one's range can be increased to about 640 km without carrying jerry cans. However, for some safaris in Africa and Australia it is necessary to carry 340–370 litres (75–82 gallons) of fuel. Ideally, two vehicles should travel together, and at least one member of the party should be a good mechanic able to fix (or improvise) spare parts. However, when the alternative is a walk of 100 km or more, it is surprising how even the mechanically ignorant can improvise repairs: I once snapped my steering track-rods on a concealed stump, but was able to limp home by lashing part of a hide pole and two tyre levers between the broken parts, while on another occasion a siphon from a jerry-can direct into the carburettor solved the problem of a broken petrol pump. Besides a selection of maker's spares (including distributor points and cap, sparking plugs, radiator hoses, fan belt and instruction book), the following items should be carried: a high-lift jack (most jacks provided by vehicle manufacturers are useless when the car is bogged to the axles in mud), not less than four stout planks about 1·5 m × 25 cm for supporting the jack's base and putting under the wheels after these have been raised, a shovel, an axe or machete (panga), a tow rope or wire, distilled water for the battery, and a tin of

clutch and brake fluid (at a pinch, water can be used for these systems!).

Camping in the Wilderness

Camping in a wilderness surrounded by large wild animals is a memorable and satisfying experience which does not pall with repetition.

Unless 'living off the country' by hunting (repugnant to many wildlife photographers), one has to take enough tinned and/or dehydrated food to last the duration of the safari, remembering that, particularly in parts of the Tropics (where most game photography is done), such foods may be in short supply and only available in large towns (see Chapter 16). Without first-hand knowledge of the area it is impossible to guess what can be obtained away from one's base: thus, shops in Norwegian and Finnish Lapland stock tinned peaches but not baked beans, while in Africa the smallest village *duka* sells sweetened condensed milk but seldom evaporated milk.

As surface water in many game habitats is too alkaline for man to drink, several jerry-cans of drinking water should always be carried. These can be topped up whenever reasonably clean water is found, but, at any rate in the Tropics, this should always be boiled before drinking.

The most desirable feature of a tropical camp site is a large tree to provide shade during the middle of the day. Camp sites near water can be extremely pleasant, but (in Africa) should be carefully selected to avoid tracks regularly used by hippos, which are rather prone to make unprovoked attacks when on land. It is often dangerous to bathe or wash in rivers or lakes, on account of crocodilians and the risk of contracting bilharzia. Tents should be insect-proof as mosquitoes can be troublesome in the Tropics, and in the tundra and taiga their numbers and voracity have to be experienced to be believed.

According to some Hollywood films, campers (especially beautiful women) are regularly attacked in their tents by an extraordinary variety of wild animals: in reality, this very seldom happens. On emerging at first light, I have frequently found elephant and lion tracks; these animals had passed within a few feet of my tent without awaking me. Visits by spotted hyaenas can be more annoying, as they will chew up any unwashed plates or cooking utensils left lying on the ground overnight.

Health Precautions

Ill-health in the wilderness is most likely to come from food or water contaminated with pathogens, allergic reactions to arthropod attacks, diseases carried by insects, excessive exposure to ultra-violet radiation, salt loss in sweat exceeding the normal dietary intake, and (most difficult of all to guard against) accidents.

When travelling between the temperate and tropical parts of the world one must have valid International Certificates of Vaccination against yellow fever, smallpox, and, for some places, cholera. Vaccination against typhoid, tetanus and polio is advisable for many areas. Malaria is endemic in most tropical and sub-tropical regions: sensible residents take an anti-malarial drug regularly, while visitors should start doing this a week before arrival and continue for about three weeks after leaving.

In the wilderness, boiling water is the most effective way of destroying water-borne parasites, but in towns where the water is of dubious quality water-sterilizing tablets are useful. Raw fruit should be peeled.

The first-aid kit should include anti-histamine creams and pills (many people react strongly to mosquito and tsetse fly bites, and few are immune to scorpion stings), insect repellents, insecticide (for clearing a tent or car cab of biting insects), and aspirin. Snake-bite serum is probably advisable in some areas (e.g., northern Australia), but can be dangerous if the snake is not accurately identified. Severe sun-burn is usually the result of care-lessness, but lips and nose often benefit from a protective cream, and the eyes need special protection when snow is reflecting ultra-violet rays.

Methods of Photographing Game

Most higher vertebrates have specific 'flight distances', at which they start to withdraw from real or potential danger. Flight distances depend both on the inherent wariness of the species concerned and on the actual experience the animals have had of the dangers to which they react. Thus wildebeest distinguish a resting lion from a moving one and adjust the flight distance accordingly, and European gamekeepers claim that carrion crows allow an unarmed man to approach them much more

closely than one carrying a gun. A man who suddenly appears within the flight distance induces instant flight (as opposed to the gradual withdrawal shown when his approach has been watched over a distance) unless he has come within the 'critical distance', at which a powerful animal is more likely to attack than to flee. In open country there is little danger of provoking attack by coming within the critical distance (though a lion whose flight distance is 30 m can be invisible at 20 m when asleep in not-very-long grass), but this can easily happen in dense cover, being most likely with a mother guarding young.

To take successful game photographs one has to get closer to the subject than its flight distance for an unconcealed man on foot, but not so close as to induce attack. None of the methods to be described for achieving this is infallible, and the photographer has to choose the one most appropriate for his particular assignment and the conditions under which he has to work. As in all Nature photography, success is most likely when the photographer is experienced in the general behaviour and ecology of his subject.

Stalking on Foot

This was the method favoured by the early hunter-naturalist-photographers who treated game photography as a field sport. Most Naturalists know the basic features—inconspicuous clothing, smooth and gradual movement when the quarry is busy feeding or otherwise distracted, making use of cover, and so on. Since many mammals rely on smell and hearing even more than on sight, they must be approached up-wind (i.e. wind from subject to stalker) which may be quite the wrong direction for lighting or composition. As stalking is inevitably a slow process the photographer must expect to find that, while he has been getting within photographic range, his subject may have moved out of photogenic surroundings. Viewpoints are often low, tending to produce unpleasantly out-of-focus foregrounds.

The habits and/or habitats of some species are such that stalking is the only feasible method of getting photographs. Mountain dwellers, whether on open slopes, like wild goats and chamois, or in dense cloud or rain forest, like gorillas, can only be approached on foot; the strenuous nature

of the stalk puts a high premium on the comparative lightness of the 35 mm SLR. Most large marine mammals and birds of the southern hemisphere (e.g. elephant seals and penguins) are utterly without fear of Man on their breeding grounds so no concealment is necessary when photographing them.

While it is very satisfying to approach a wary wild animal really close by the use of skilled field-craft, it must be admitted that one is less likely to get really good photographs than by other methods. Moreover, most game photographers, unless they are fortunate enough to live near game habitats, will gravitate towards National Parks and Game Reserves since with few exceptions, e.g. parts of the Arctic, these are often the only places where large animals can be found in good numbers; even in sparsely inhabited parts of Africa one can travel for hundreds of kilo-metres without seeing any game except the occasional dikdik. In National Parks established to preserve spectacular wildlife, visitors are not nor-mally allowed to wander about on foot, though, in some Parks, experi-enced people may be permitted to do so in parts not frequented by most visitors. Foot approach under armed escort is allowed in the Luangwa Valley Reserve (Zambia) and the Umfolozi White Rhino Reserve (Zulu-land).

Anyone considering stalking potentially dangerous animals must remember that too successful a stalk may bring him within the critical distance at which attack is likely. The greatest risk is from individuals not spotted when the stalk of the chosen subject was started. Elephants and buffaloes can be virtually invisible in dense cover, and can be very dangerous, especially if they have been hunted in the area (*The Shamba Raiders* should be read by anyone contemplating the photography of these species away from National Parks or Reserves). An unarmed man is easily killed by many mammals (and some birds: cassowaries are aggres-sive when breeding and have killed people in New Guinea and Queens-land) and will probably take sufficient care not to get into danger. For an armed man or his escort to shoot in self-defence can hardly be con-demned but it is poor technique to get into the position where this is necessary. For a photographer with an armed guard to deliberately pro-voke a charge in order to obtain a spectacular photograph at the cost of the subject's life is disgusting behaviour, completely at variance with the accepted ethics of wildlife photography.

Working from a Hide

For basic details of hides and their construction see Chapter 5.

Wherever the movements of game animals are predictable there is no doubt that the best results can be obtained from a hide in a strategic position. The siting of the hide will be determined mainly by considerations of range, lighting and composition, but its successful occupation will also be affected by the wind. For game work, hides should be well camouflaged, this being particularly important when the hide is not a permanent one to which resident animals can become accustomed. It is best not sited too near trails used regularly by elephants, rhinos, hippos or buffaloes; only English cows have actually damaged my hides but I can testify from personal experience that elephants some 3 metres from a conventional bird photographer's hide are not conducive to the occupant's peace of mind. Hide work is often not permitted in National Parks and should only be attempted if the Warden gives permission.

The five main ways of using a hide in game photography are now discussed separately.

Baiting

All large carnivores, except the cheetah, will eat carrion and scavenge on kills made by other predators. Leopards and spotted hyaenas can certainly be attracted within photographic range if suitable bait is regularly provided at the same place overlooked by a permanent hide. Whether the killing of wild or domestic herbivores to obtain photographs of carnivores is ethically acceptable is a point that must be squarely faced by the photographer. The problem has many facets; for instance, will the purchase of a domestic animal to be used as bait still further reduce the protein intake of a local human population whose children are already protein-starved?

While the killing of animals for bait is ethically dubious, there can be no justification for tethering a live animal to a post where its calls attract the photographer's quarry to make its kill within camera range. This method is commonly used for securing tiger pictures, many of which have the tethering post clearly visible. Apart from ethical considerations,

providing powerful predators with live domestic animals might well condition them to become persistent stock-killers whose destruction would then be demanded by the local villagers. In India and Pakistan, the use of a live goat is the traditional way of luring man-eating or stock-eating tigers and leopards within rifle range. The goat is tethered in a clearing that can be overlooked from a platform, partly screened by cut branches, built in a nearby tree. The usual *machan* for shooting is not really suitable for photography as it is too far from the bait for the effective use of flash.

Live prey can sometimes be used as natural bait without any management on the photographer's part. In parts of Alaska and Canada, salmon and other fishes on their way to their spawning grounds have to traverse shallow rapids where they are very vulnerable to predation. When a fish-run is in progress, such rapids attract brown bears and wolves to feast on the easily captured fish. The photographer lucky enough to be in the vicinity should make the most of his opportunities as the fish glut may only last for a short time. Similar chances for photographing Arctic foxes are sometimes offered when these regularly 'raid' colonies of Arctic terns. Success is most likely when a colony is on a narrow promontory, forcing the fox to approach by a fixed route which can be commanded by a suitably placed and camouflaged hide; the problem is to find such a colony in a fox's hunting range.

There are, of course, no ethical objections to the opportunist use of carcasses that have died of such natural causes as disease, old age, or predation. Since these are likely to be used more or less *in situ* some might cavil at calling this 'baiting', but it seems more logical to discuss the method here than elsewhere.

Carcasses that have been killed by large predators will, when found, almost certainly have these in attendance or, if they have satisfied their hunger and abandoned the remains, a seething mass of vultures that rapidly convert the carcass to a clean-picked skeleton—about 10 minutes in the case of a Thomson's gazelle and 40 minutes for an Indian water buffalo. Some predators consume their prey in a remarkably short time, not leaving anything for vultures or other scavengers. For example, Kruuk records that 45 minutes after a bull wildebeest had been killed by four spotted hyaenas only the head and spine remained after the whole 'clan' of 14 had feasted on the kill, while 10 minutes after a

zebra foal had been killed 'nothing remained on the spot but a dark patch on the grass and some stomach contents'. This rapid disposal of kills, together with the possibility of attack from powerful carnivores disturbed while eating, means that hide work is rarely feasible at kills. While lions normally run away when a man on foot approaches within about 30 m, it would be foolhardy to rely on this behaviour if setting up a hide near a kill on which lions were still gorging. However, at any rate in Africa, good pictures of predators and/or scavengers at a carcass can often be taken from a car (used as a mobile hide as described below), provided the kill was not made in long grass, which, unfortunately, is often the case.

Although animals that have died from disease in open country are commonly found by scavengers, particularly vultures, this by no means always happens. If a photographer finds an untouched carcass and hopefully settles down in a hide beside it he is likely to get nothing more exciting than nauseating whiffs from the putrefying corpse. Mammals may, of course, locate such carrion by smell but, like man, they more often do so by watching vultures converging on the spot from afar. Particularly in the Tropics, the skin of an untouched carcass soon becomes so hard that only the most powerful scavengers—hyaenas and lions—can rip it apart to get at the inside if found much more than twelve hours after death.

Two rather different forms of baiting are now described.

Both in the Tropics and the temperate zone the construction of small watering places in otherwise dry areas can yield a rich harvest of pictures. A polythene-lined tank 8 m wide by 11 m long by 1·8 m deep, constructed in an English Forestry Commission conifer plantation as an emergency water supply in case of fire, attracted fifteen species of regular bird visitors, including sparrowhawks and jays which are seldom photographed away from the nest. The tank is probably visited during the night by red foxes, badgers and roe deer; suitable adjustments to its edge could provide photogenic settings for these species. Bird baths in tropical gardens are visited at night by mongooses, genets and civets, and it would not be difficult to construct photogenic drinking places for such nocturnal species during the dry season when natural pools may be completely dried up. Needless to say my occupation of a house whose garden was regularly visited by mongooses (and, to a lesser extent, leopards)

coincided with a period when I was unable to obtain batteries for my flash equipment!

Fruit such as bananas and paw-paw can be used to attracted monkeys and hyrax, though it is not advisable to encourage monkeys to become regular garden visitors, as they become an unmitigated nuisance once they lose their fear of man. In Europe and North America pictures of deer have been obtained by putting out supplies of hay when natural fodder has been hidden by snow.

Natural Water Holes

Those parts of the Tropics that still have large game populations have the year divisible into dry and wet seasons. For example, many parts of southern and western Tanzania have much the same total of rainfall as the eastern half of England, but all of this, apart from a few scattered thunder-storms, falls between the end of November and late April; in the north of the country and Kenya, the regime is different with 'short rains' in October and November, and 'long rains' from March to May. Both patterns result in long, hot periods during which no rain falls for months at a time. During these, many rivers cease to flow, long stretches drying out completely leaving only the deeper reaches as isolated pools, while seasonal swamps variously known as *mbugas* (East Africa), *dambos* (Central Africa) and *jheels* (Indian sub-continent) become reduced to muddy water holes. It is the water supplies that persist (only just in many cases) from one wet season to the next that determine the total population of animals that can be supported by a given area. Where water is limited, the herbivores, followed by their predators, concentrate in the vicinity of the remaining pools, consuming most of the fodder that is available within easy reach of water. With the arrival of the rains, the animals spread out over a much larger area, giving the apparently devastated zone around the dry-season water holes ample opportunity to recover. Species differ widely in their dependence upon water: buffalo and impala have to drink every day, zebras every three days, oryx, eland and several gazelles hardly ever. In East Africa, all the following species regularly visit water holes, though, of course, not all occur together in the same habitat: baboons and monkeys, jackals, mongooses (mainly at night), spotted hyaenas, the three local big cats, elephants, zebras, rhinos, warthogs,

giraffes, kudus, bushbuck, roan antelope, sable antelope, waterbuck, bohor reedbuck, bubal hartebeest (kongoni), Lichtenstein's hartebeest, topi, wildebeest (gnu), impala, buffalo.

Isolated water holes in dry bush country are a focal point for animals other than mammals. Sometimes the muddy edges are white with myriads of pierid butterflies, while the fantastic numbers of birds that flock in to drink are among the most exciting of all wildlife spectacles. Waiting in a hide for the arrival of thousands of sandgrouse has an excitement very similar to that experienced when awaiting waders at a high-tide roost in northern Europe.

Since water is vital for so many different animals it is not surprising that water holes provide excellent opportunities for game and bird photography. The surrounding dry mud and sand provide a good setting as there are no bushes or clumps of grass to obscure the animals' legs and create unsightly out-of-focus foregrounds.

The ideal water hole for photographic purposes is large enough to attract reasonable numbers of animals but not so large that the drinking animals may be out of range. As the shape, size and surroundings of water holes vary so much only the most general advice can be given about the positioning and construction of the hide.

Tracks and droppings will reveal much about the favoured approach routes of the most common visitors, but, unless the photographer is exceptionally skilled in reading spoor, watching will be needed to find out when the different species come.

These observations enable one to decide on which size range of animals to concentrate. Generally, the requirements of bird and large mammal photographers are not compatible, though, given the right shape of pool and a battery of varied lenses, one might be able to take good pictures of, say, sandpipers and antelopes from the same hide. When the photographer lives within easy reach of the water hole it is worth erecting a more or less permanent structure, perhaps on a pylon to give the higher viewpoint that is helpful when photographing massed animals (see Chapter 16 for possible difficulties in connection with the hide's shadow). Such a hide, provided it is completely opaque and flap-proof, will be accepted as a regular feature of the landscape by resident animals, even if not camouflaged. When a more conventional hide is used over a short period it should, if at all possible, be sited among rushes or bushes so as to minimize the

change in appearance of the water hole's surroundings. Whatever the exact nature of the hide's construction it should allow photography through both sides as well as the front. Camouflage and growing vegetation should be tied well clear of the three fields of view, and fixed firmly enough not to be displaced by the miniature tornadoes, known as dust-devils, that are a regular feature of the dry-season landscape.

Game is always wary when approaching a drinking place so it is vital that the photographer does not enter or leave the hide when animals are in the vicinity of the water hole.

Salt-Licks

Many animals seem to have an instinctive awareness of their mineral requirements, and make regular visits to places where the soil contains greater than average quantities of various salts. Trampling by game in such restricted areas destroys all the grass so that, like water holes, salt-licks provide a setting in which the animals' legs are not obscured. Some species use parts of the bare earth as a latrine with the urine and faeces (deposited daily on the same spot) probably serving as some sort of dominance or territorial mark.

Once a natural salt-lick has been found, its attraction can be enhanced by sprinkling salt on the ground. This is done at the salt-lick overlooked by the world famous Tree Tops Hotel in Kenya. The hotel has all 'mod. cons.' and many tourists go to bed arranging to be called when the elephants arrive at the floodlit salt-lick! This sort of set-up is not congenial to the genuine Naturalist who gets much of his pleasure simply from being in natural and unspoilt surroundings. Tree Tops is, however, one of the few places where the elusive giant forest hog and the even more elusive bongo can be seen and sometimes photographed.

Lairs or Dens

Many mammals, especially carnivores, have regular lairs in which they sleep throughout the year. The lair may be natural (cave, recess among rocks, hollow tree, etc.), or excavated by the occupant or previous owner, not necessarily of the same species; it is frequently used as a nursery for the new-born cubs. For photographing comparatively small nocturnal mammals as described by Harold Hems in Chapter 3, a hide is

optional. It is, however, necessary north of the Arctic Circle (where the sun does not set during the summer) and for diurnal species elsewhere. Since photography at a lair often depends on the maternal instincts of the mother bringing her regularly to it, the photographer has to be particularly cautious not to do anything that jeopardizes the safety of the young. He must, therefore, observe much the same precautions when introducing a hide to the vicinity of a lair as when photographing birds at the nest, with the added complication that mammals use the sense of smell in addition to those of sight and hearing. This means that even simple 'gardening' (see Chapter 5) can be a critical operation. A further difficulty is that some species, e.g., jackals and hyaenas, shift young from one den to another even when they have not been alarmed by the sight or smell of Man.

As even timid species may attack when they think their young are being threatened, great caution should be exercised when photographing, with cubs, such powerful predators as bears, wolves, and hyaenas.

Display Grounds
During the breeding season, the males of certain birds, mammals, and cichlid fishes (e.g. *Haplochromis* spp.) gather together in 'arenas' or 'leks' where, by combat, mainly ritualized, they stake out small individual territories to which the females come for mating. 'Lek' species familiar to European workers are the black grouse and ruff (see Chapter 6); other avian examples are the cock-of-the-rock found in Central and South American tropical forest, Jackson's widow-bird of the East African highland grasslands, the Australian lyrebird, and the birds-of-paradise. Lek systems also operate in a number of mammals, of which the Ugandan race of the kob and its near relative, the puku, have been studied in detail. Many lek species become largely oblivious to stimuli unconnected with their territory-holding so that a hide is often accepted very readily, especially if placed somewhere on the periphery of the lek. Nonetheless, unless the lek is completely deserted when the hide is entered the photographer should have a companion to see him in and walk away, as in nest photography.

Lek grounds offer exceptional opportunities for studying and photographing behaviour associated with threat and mating displays.

Working from Motor Vehicles

In spite of an almost complete lack of roads, in the modern sense of the word, the motor car penetrated deep into the wilds of the American West and Africa remarkably early in its history. Seronera, present head-quarters of the Serengeti National Park in Tanzania, was first reached by car in 1920.

The early motorists in the wilds found that most of the animals they encountered had much shorter flight distances for cars than for a man on foot. Probably a man in a car, although having his head and shoulders visible (and, therefore, in theory being recognizable) is not mentally associated with that dangerous predator, man on foot. The initial reaction of most species to this new factor in their environment was cautious curiosity, which experience soon modified either into fear or indifference, depending on the behaviour of the motorists. Wherever cars were used for chasing and shooting game, flight distances rapidly became even greater than for a man on foot, but, where abuses had not occurred, photographers soon discovered that a car could be used as a mobile hide which could approach feeding game, or be parked beside water holes, salt-licks or carcasses. Since the photographer is at all times able to observe the reactions of his subjects to his vehicle, he is able to withdraw at once if he sees that his presence is causing any sort of distress or abnormal behaviour in his subjects. Unfortunately, as already described, a considerable number of game viewers do not behave in this considerate way.

The most suitable vehicle for game photography is one with four-wheel drive and low-ratio gears, such as the Land Rover, Jeep, and Toyota Land Cruiser. All these are much more robust than ordinary cars, have greater ground clearance, and are easier to extricate from mud or soft sand. Photography can be done through the side windows or through a specially constructed roof hatch. The latter gives the best overall view-point and allows greater flexibility in positioning the vehicle, but is diffi-cult to use unless someone else is driving. For mainly selfish reasons, I favour solo operations and, therefore, normally work from the driver's window. Although many species appear to take no notice of the face at the window and the hand movements involved in operating the camera

it is good policy to carry a piece of cloth which can be hung from the top of the door so that only the lens is visible as in a conventional hide. This is often necessary when photographing birds as these have to be approached much more closely than most game mammals.

Good photos seldom result unless the camera is firmly supported. Supports range from a bag of sand or rice slung over the window edge to a loop of rope suspended from the top of the door, but it is best to use a fitment that clamps, temporarily or permanently, to the car door (or roof when a hatch is used), and to which the pan-and-tilt head of one's tripod can be attached. Suitable fitments are made commercially, e.g. by Rollei, or they can be made up by a handyman. Mine consist of two thin steel plates, 12×5 cm, joined by a cross-piece slightly longer than the thickness of the car door; a bolt with the same thread as his tripod is passed through the cross-piece and welded to its under side. Rubber, bonded to the inner surfaces of the two arms, gives a firm grip when the 'clothes' peg' is jammed over the window edge. In game country, this fitment with the pan-and-tilt head attached is kept permanently in position (it only takes a moment to detach the complete assembly if the window needs to be closed).

It is essential that the camera can be rapidly fixed to, and removed from, the pan-and-tilt head, and that these operations can be done while driving. If a slot is cut in the top of the pan-and-tilt head, the camera-retaining bolt can be left partly screwed into its bush. Fixing the camera then consists of slipping the bolt into the slot and tightening up. With lenses of more than 200 mm the lens bush is used in preference to that of the camera body, allowing the lens to be left in position when black-and-white and colour bodies are exchanged. Naturally the camera should only be fixed in position immediately prior to its use, so that vibrational shocks and exposure to dust are reduced to a minimum. In really dusty conditions it is advisable to put the camera and lens in a polythene bag when not in use.

All the methods of game photography so far described, with the obvious exception of stalking on foot, can be done from a car, though not always as successfully as from a hide. In particular, animals are often reluctant to drink at a water hole by which a car is parked, even though, away from the water hole, they may, in well frequented Parks like Nairobi, hardly move out of the way of a slowly moving vehicle. When it is

obvious that one's vehicle is not accepted one just has to drive away without delay.

It is only in National Parks visited by many people that, unless harassed by irresponsible viewers, animals are almost completely indifferent to cars. Game photographers who have only visited the more popular Parks have no idea how much more difficult (and exciting) game photography is in places off the 'tourist milk run', where animals are a good deal more cautious. As regards African species, ostrich, eland, the two kudus, and oryx are normally very difficult to approach; the first two in Ngorongoro Crater, and the first three in Nairobi Park, have become conditioned to cars but elsewhere all remain shy.

Let us now consider the sequence of operations. In grassland or lightly wooded country most potential subjects will be spotted from a considerable distance. Stop the car and carefully assess the situation. Are the animals in photogenic surroundings? Do they offer chances for group, or individual portrayal, or both? Can they be approached by a route free from obvious vehicle hazards—rocks, stumps, boggy patches, soft sand? Having decided on an attempt, fit the appropriate lens and make sure that the retaining bolt is in its correct bush. Check the lighting, set the shutter speed and lens aperture (*never* assume that these were previously set at this combination), cock the shutter, and place the assembly on the seat beside you. Change into four-wheel drive (this allows a smoother approach at low speed even when the nature of the ground does not require its use), and start moving slowly towards the subject in an oblique direction—a direct approach is much more likely to induce flight and ends up with the car at the wrong angle to the subject (unless a roof hatch is in use). If the subject shows no alarm continue until nearly within range when, without stopping, the camera should be put on the pan-and-tilt head; when you think you have reached the right place for starting photography, stop but do not turn off the engine. Quickly check through the view-finder that the position is right for optimum image size and composition, checking particularly if any out-of-focus objects, e.g., stumps or clumps of long grass, could be lost by a small change in position of the 'hide'. If everything is right, *turn off* the engine, focus critically, and start exposing. If, during the approach, the animals seem uneasy it is advisable to pause frequently, without turning off the engine, and, when one has reached the furthest distance at which photography is

worth-while, take some long range shots since these are better than nothing of rare or shy species. Once these 'record' shots have been exposed one can attempt a closer approach for more satisfying photos. A common experience is that an animal holds a perfect pose while the car is moving but edges away as soon as one stops. Animals may tolerate one driving close and stopping but be startled when the engine is restarted to change one's position. One can usually forecast from the general behaviour whether this is likely to happen and if it is, it is best to allow the animals to wander well away before starting up and getting into position again. As already stressed a 'reluctant' subject should never be chased or harassed.

Game photography from a car is sometimes so easy that one tends to forget that the reason the animals allow a close approach is either because they have not had cause to learn that cars are dangerous or because they have learnt to regard them as harmless. In either case getting out of the car within sight of animals will almost certainly destroy their confidence and make future approaches much more difficult (cf. hides incorrectly vacated at birds' nests).

When approaching dangerous species (which in a car means elephants, sometimes rhinos, occasionally buffaloes and black bears annoyed at not being fed) one should first make sure that the terrain allows a rapid getaway (elephants can accelerate much faster than cars on rough ground) and, of course, that one's starter is working properly. Particularly when photographing elephants, keep a careful watch for individuals that are not being photographed and may be closer to the car than the subject(s). Where elephants encounter many cars they are usually very tolerant but, in other places, they may be either very timid or very aggressive. They should always be treated with caution and respect whether on foot or in a car: tuskless females and ones with small calves are the most dangerous.

Most game photographers concentrate on the larger mammals, but much successful bird photography can be done from a car. Such birds of prey as eagles, buzzards, and chanting-goshawks spend long periods perched on dead branches or other vantage points. Where these magnificent birds have not been senselessly persecuted they are often remarkably indifferent to the approach of a vehicle, or even, sometimes, a man on foot. Many perches are too high to be commanded satisfactorily from a car but where these birds are common one finds a reasonable number of

of photogenic perches occupied by obliging subjects. Herons, storks, and waders will often pass within range of a car parked near the edge of a water hole and occasionally one finds individuals that will tolerate the careful approach of a moving vehicle—and for small sandpipers this represents a very close approach. Generally, however, species of the genus *Tringa* are not 'well behaved'; several of them are much more confiding on their arctic breeding grounds than in their tropical winter quarters. Ground-dwelling savannah groups such as bustards and thick-nees can also be tackled by the slow, oblique approach but the number of co-operative individuals who are also in photogenic surroundings is very small indeed. This is probably the only way in which birds with nidifugous young can be photographed with them after the nest has been vacated. Although the method is obviously most applicable to large species, it can be used for small passerines like larks and pipits, though, if these are within range and on the ground, the viewpoint is rather higher than is desirable.

When driving across country one must be careful not to drive over the nests of ground-nesting birds. Fortunately most of these sit tight, and an observant driver can spot the sitting bird in time. In fact, this is by far the easiest way of finding nests on open plains where there is no cover from which an observer on foot can mark back a bird to its nest. It is often possible to drive within photographic range of incubating birds. If nest photography has to be done from a car (as, for example, when the photographer has no companion to see him into a hide) it is important not to get out of the car near the nest. When 'gardening' is needed, the car should be reversed for at least 100 m. One gets out from the side away from the bird, follows the tracks back to the nest, does the gardening as quickly as possible, and returns to the car to watch the bird back through binoculars (see Chapter 16 regarding the incubatory behaviour of some tropical birds). After the bird has had time to settle down comfortably a new approach is made. If one is prepared to wait long enough there are good chances of getting shots of a 'stander' in addition to those of the bird incubating. It should be emphasized that only bird-watchers with considerable experience of birds' breeding behaviour will correctly interpret responses made by birds to a car's approach. Even when not using a car irresponsibly, the inexperienced may unwittingly do damage to nesting birds.

The above examples show that, in a wilderness with suitable terrain, the opportunities for satisfying wildlife photography from a car are almost limitless for the observant driver who is quick off the mark. However, most of these chances will not even be seen unless one drives at not more than 20 km/hour, with constant scrutiny of the surrounding country. Finally, it must again be stressed that exploitation of such chances depends entirely on the subject's reactions to the car's approach being favourable; when they are not the conscientious photographer must withdraw and leave it in peace.

Miscellaneous Other Methods

Using Elephants

Game photography from motor vehicles is best suited to fairly open savannah and, as described, is the main method used for game photography in African National Parks. Habitats that are swampy or contain very tall grass are difficult, often impossible, to work from a car, even one with four-wheel drive and low-ratio gears. In several of the game sanctuaries of India and Pakistan, game-viewing is done from a howdah strapped to the back of an elephant whose movements are controlled by his mahout sitting astride the neck. An elephant is able to travel in terrain quite impenetrable by vehicles and its approach is unlikely to cause alarm to wild animals familiar with elephants. In the howdah the photographer is able to see over the top of tall grass but his scent is less effectively masked than in a vehicle. The main drawback to this method is that, because of the elephant's breathing, there is never an absolutely rigid support for the camera. This means using a faster shutter speed and wider aperture (or faster film) than one might have selected otherwise.

Photographing Amphibious Game

A boat, preferably with some sort of concealment for the occupant(s), can be used to approach animals of aquatic habitats when they are at the surface, at the water's edge, or resting on aquatic vegetation. Skin-divers can leave their boat to pursue their quarry underwater (see Chapter 13), but most freshwater habitats are too turbid for this. In the crystal-clear water of Mzima Springs (Kenya) an exceptional film showing the

underwater activities of hippos, crocodiles, otters, and darters was taken under very risky conditions.

Much game-viewing is done from boats in Uganda's Ruwenzori (formerly Queen Elizabeth) and Kabalega (formerly Murchison Falls) National Parks where their use is accompanied by abuse of the sort already described for cars. This is particularly serious in Kabalega where boats are deliberately driven close to sand-bars where breeding Nile crocodiles congregate, so that tourists can take pictures as the huge reptiles dive spectacularly into the water. Because of this constant disturbance, the breeding beaches are deserted often enough for monitor lizards and Marabou storks to take a heavy toll of the unprotected crocodile eggs. It is ironic that the greatest concentration of big Nile crocodiles in the whole of Africa should be endangered not only by illegal hunting to supply skins for handbags but by the visits of tourists, many of whom would claim to be 'Nature lovers'.

A preferable, because less disturbing, method of photographing crocodiles, alligators, and muggers is a well concealed hide near a favourite basking place. These reptiles are extremely wary and, unless one can enter the hide unseen or before they have started basking, it will be several hours before they emerge once more.

Various species of fresh-water turtles and monitor lizards are likely to be encountered in the same habitats as crocodilians. Their photography involves the same principles but either a closer approach or the use of a more powerful lens as they are considerably smaller. Marine turtles at their breeding grounds, e.g., in Malaysia, can usually be stalked.

Game Photography From The Air

Photography of wild animals from aeroplanes, gliders, and balloons is nearly always concerned with obtaining accurate data for population studies, and is really outside the scope of the present work. Aeroplanes flown low enough for picture-making as opposed to record-making frighten animals a great deal, often causing stampedes in which injuries and deaths may result.

Photography under Controlled Conditions

So far this chapter has been solely concerned with the photography of animals whose movements are not restricted in any physical way by the photographer. Perhaps there is a certain amount of mental coercion when animals are 'tempted' by bait or 'drawn' by their maternal instincts, though, if the preparatory work has been done properly, the animal should be unaware of the photographer and indifferent to his hiding place. For many wildlife photographers real satisfaction is obtained only when their subjects are completely uncontrolled, and they have no interest in photographing captive animals.

However, an animal photograph may not be only a civilized form of hunting trophy; it may be an expression of one's aesthetic feelings, or a scientific record, or a combination of all these. Photographing captive animals will never satisfy the sublimated hunter, but the other aims may well be achieved with subjects under captive conditions. Incidentally, this refers to the permanent captivity of a zoo, and not the time immediately after capture when the subject is often in a state of considerable stress.

Photographs of captive animals, particularly when taken in surroundings resembling the natural habitat, should never be circulated without a statement that the picture was taken in captivity.

The concluding two sections give examples of the sort of work that can be done in zoos and similar institutions, including so-called safari parks in England.

Zoo Portraiture

Several workers have specialized in producing what can only be described as character studies of the larger and more impressive inmates of zoos. By concentrating on the head outlined against an out-of-focus unobtrusive and neutral background, the often aesthetically unpleasant surroundings of zoo animals can be effectively avoided. This approach, developed to a fine art by T. H. Middleton and Eric Kirkland in the 1950s, demands great patience and considerable technical skill. It produces results that cannot possibly be mistaken for pictures of wild animals, and are often

preferable to pictures that look 'natural' but are actually only spurious imitations of the real thing.

Scientific Records from Zoos

Some species are so rare or so inaccessible, because of their habits or distribution, that the only way of photographing them is to portray one of the few captive specimens. For example, it is doubtful that the giant panda has ever been photographed satisfactorily in the wild, but photos of Ming and Chi-Chi have made this rare mammal familiar to everyone with the slightest interest in animals. It is, however, surprising that some quite well-known systematic works have been illustrated with zoo photos when far better pictures of the same species in their natural habitats were available.

Examples of events of biological interest which could only be obtained with the greatest difficulty, if at all, in the wild, are sequences showing mating behaviour of nocturnal species, births (that showing the birth of a kangaroo marked a distinct advance in our knowledge of marsupial reproduction), maternal behaviour with very young offspring which, in the wild, would be hidden in a den, and the egg-breaking technique of mongooses. The analysis of movement in fishes, snakes, birds, and mammals has been largely dependent on still- and cine-photography carried out under controlled conditions.

Bibliography

Africa; A Natural History, Brown, L. (H. Hamilton) London, 1965.
Living Mammals of the World, Sanderson, I. T. (H. Hamilton) London, 1955.
The Lost World of the Kalahari, van der Post, L. (Hogarth) London, 1961; also (Penguin) London, 1964.
The Shamba Raiders, Kinloch, B. (Collins) London, 1972.
The Wild Life of India, Gee, E. P. (Collins) London, 1964; also (Fontana) London, 1969.

3

Small Vertebrates

Harold Hems

Small Mammals

Many small mammals are nocturnal or crepuscular and spend much of their periods of activity wandering at random in search of food. The daylight hours may be spent entirely in permanent homes, subterranean holes or holes in trees or rocks, from which they emerge at dusk, perhaps not returning until dawn unless they are engaged in such activities as storing food, carrying bedding or visiting young, or if danger threatens. If they have young, they may stay close to home, which they revisit frequently; when large enough, the young may play for long periods around the mouth of the den. The carnivorous species are the greatest wanderers and a watcher close to the entrance of the den may see them, as they emerge, for no more than a few seconds. At this moment they are often very cautious and may return below ground if alarmed or suspicious; their well-developed senses help them to detect danger readily, and they apparently dislike rain, wind or extreme cold, all of which render them less active. Some may hibernate fully, others become torpid in winter and rely on food stored in their dens.

The problems raised by these habits must be considered with care when approach techniques are being evolved. Much of the apparatus used in bird photography is quite suitable for this also, but for nocturnal work an adequate source of illumination must be available, and a second lamp to provide weak but continuous light is also often desirable so one can see what is happening.

Stalking

The first method, demanding least preparation, is a slow stalk in day-light. The first exposure should be made as soon as the animal is close enough to give the smallest useful image on the film, and subsequent exposures as one gets closer. It is most disappointing if a long slow approach yields no result because the animal leaves just as the stalker approaches the optimum working distance. The main problem, once one is close enough, is that of keeping the camera still during the exposure. The fur of most mammals is extremely fine, and even slight shake would utterly spoil the definition. A tripod is seldom of much use, being difficult to control, but unipods and gun-pods present fewer difficulties. Some small mammals, such as squirrels and chipmunks which frequent public gardens or parks, may be quite tame and are excellent subjects on which the beginner can try his skill. In general, however, stalking is not likely to produce much work of quality nor to allow one to collect photographs of a variety of species.

Wait-and-See

The wait-and-see approach, so often successful with birds, is of little value for small mammals because they are more secretive and seldom active in full daylight. However, if it can be established that a nocturnal animal regularly visits certain places, a camera set up close by can be successful. The most obvious place is close to the entrance to the living quarters; another is a well-used drinking place. Some carnivores, such as the badger, make well-defined paths around their territories, but may not use all during one night's wanderings; efforts to obtain photographs along such paths are best left until a satisfactory series has been obtained close to the den. The first rule, obviously, is to keep downwind; one might assume that a stiff breeze helps in this respect, but I have seldom had much success under such conditions, partly perhaps because of the animals' natural dislike of windy weather, and perhaps because in some places the wind can eddy back, carrying scent with it. On still, windless

nights, the scent is carried upwards by convection and such nights often give the best results. The moment of emergence is often the most rewarding, and photographs showing the animal with its den have an added interest. Even species which are usually continuously active may pause briefly when they first come above ground, reassuring themselves that all is well. If the photographer is careless, their suspicions may be aroused, and they will often remain below ground until they are sure that he has left the area. Sometimes there are several exits from a series of linked passageways in old, well-established dens, though one is often more favoured than the others. In this case it is best to carry out exploratory watches for several evenings before attempting photography, choosing a point from which the maximum number of holes can be seen. A tree overlooking the area is a particularly good vantage point. If one cannot find time for this, an alternative is to prop thin twigs across the mouth of each hole, inspecting them daily to see which has been dislodged. The method has limitations; the occupant may emerge from one hole but re-enter, perhaps several times, by others—or several species may occupy the same network of passageways—so there is little certainty in the information provided.

With some knowledge of the behaviour of the animal at the mouth of the den, photography can begin, sometimes without further preparation. The use of hides for animals of the size of foxes or badgers can create rather than solve difficulties. The sudden appearance of so alien an object may prove unacceptable and the animal may move elsewhere. Vixens with cubs will not hesitate to move them if unduly alarmed. Species with poor sight, such as badgers may be worked without any cover, provided that the direction of the wind is right and that no precipitate movements are made. If the species has good sight, as with foxes, it may help to place oneself and the camera close to a bush; branches may be brought from elsewhere to improve the camouflage, but care must be taken to arrange them so that in failing light they cannot slip unnoticed in front of the camera or flash heads. Fixing the camera well above ground level is a good idea, since animals of this size seldom expect or look for danger from above. I have had considerable success with a camera placed on a bracket fastened permanently on the trunk of a tree about 3 m above ground level and 5 m from a fox earth: I have also used successfully a three-legged tower of tubular steel, erected close to an earth.

Whatever preliminaries are carried out, it will be necessary to set up and check the photographic apparatus about an hour before the expected arrival of the quarry. This will allow time for the photographer to settle and for the animal to recover from any alarm which the preparations may have caused. Adjustments to the aim, focus, working distance and area to be covered cannot be carried out when the light begins to fade, nor can faults in the flash be rectified. During the preparation, all movements should be slow but deliberate, to avoid causing vibrations in the ground. The entrance to the den should not be too closely approached; objects which may spoil the photographs, such as light-coloured stones or tall stems of vegetation between camera and hole, should have been removed several days before.

In removing the camera and other gear when a session is over, care must be exercised. The operation can be carried out in almost total darkness and it is best to avoid the use of a hand-torch, which may cause severe disturbance; one should plan in daylight the route by which one will leave, making sure it is free from obstacles. If the camera, flash and tripod can be carried as a single unit to a point some distance away, it may be dismantled and packed at leisure. However, small attachments such as shutter releases and synchro-leads should be removed on the spot, as they easily fall off unnoticed or may catch on snags and be damaged. One should practise dismantling the camera by touch alone in a dark room, or with closed eyes, so that it becomes second nature not to rely on sight alone. Sometimes it is possible to use a light of low intensity to see what is happening at the den, but to introduce a light and a camera together might have an adverse effect, and is not usually worth the risk. It is better if the light is switched on nightly for many nights before photography begins, so that it becomes part of the environment, and it should at first be well masked. It has been suggested that a red light is the most

Plate 8. (Upper) Red fox, returning to earth after hunting. It may be well worth waiting a while after the subject has left its den (especially when cubs are present) in case a return visit is made. The beaten appearance of the soil is a good indicator of the presence of well-grown cubs. Range *c.* 4·5 m. 9 × 12 cm Field camera, 21 cm Tessar; sited *c.* 3 m above ground level; one medium-sized expendable flash-bulb.
(Lower) Badgers. Female collecting bedding, attended by a well-grown cub. A tripod was used but no hide. Camera and lighting as above.

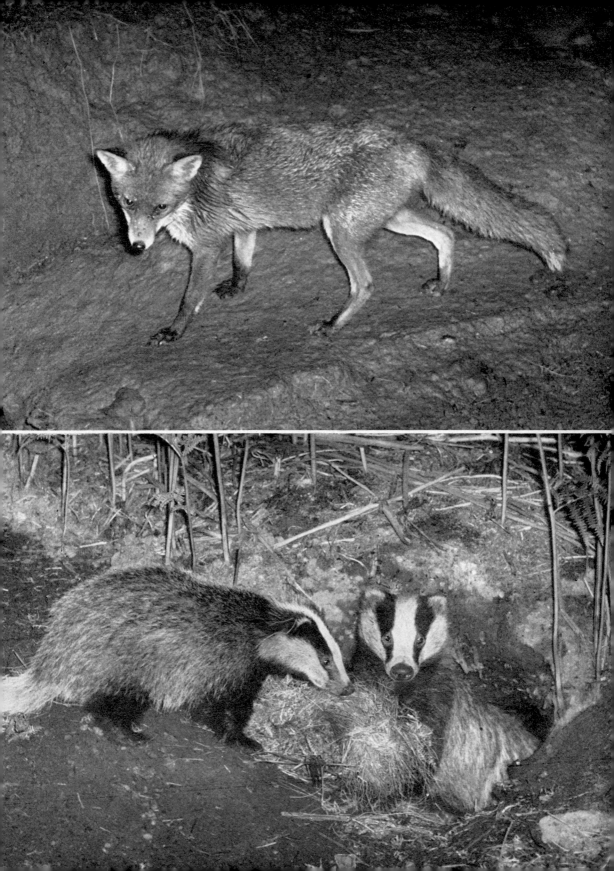

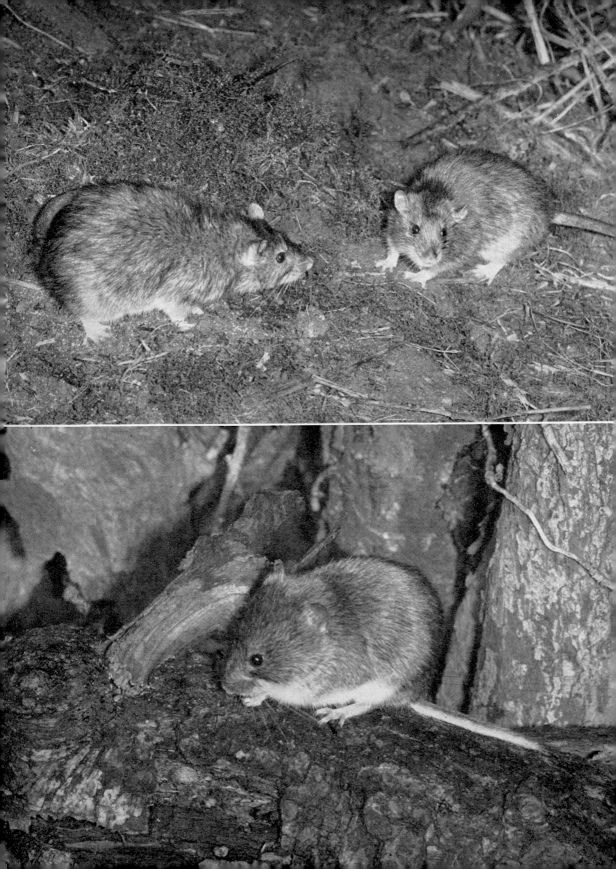

effective, but since most mammals are colour-blind, intensity is the most important consideration. The lamp holder should be well above ground level, and should not be able to swing in a high wind. No ray should fall on the cameraman or his apparatus.

Bait

The use of bait is by far the best way of attracting rodents. It may be used throughout the year, and, once a site has been prepared, one may experiment and adapt it so photographs with differing backgrounds may be obtained. It obviates the need to locate the entrances to underground passageways—often small and well hidden—and it can be used for those species which have no permanent home. It allows the photographer to choose his own site and background. If the site is at ground level, it should slope down towards the camera, in order to eliminate as far as possible the out-of-focus foreground which can spoil an otherwise excellent photograph. Vegetation in front should be very low, or the ground should be bare. Bait can be mixed with soil, from which the animals will readily remove it, and this will render it inconspicuous in the finished work. Many small rodents are excellent climbers and often seek food in the lower branches of small bushes, or the stems of grasses and cereals, a baited site above ground looks natural and reduces many of the technical difficulties encountered at ground level. When using bait, I usually work from a hide, or sometimes behind a simple canvas screen, though this offers no protection from cool night breezes, showers of rain, or from the attacks of biting insects (which can be quite maddening). It is best to put up with these attacks, rather than use smelly repellants, which may repel both mosquitoes and the expected rodent.

Plate 9. (Upper) Brown rats. The one on the left raised its fur in challenge as the second approached, making it look larger; the second responded with a submissive sideways head position. Taken at bait, which was mixed with soil along a line parallel with the film plane, so focus did not have to be changed whatever position the animals chose. Quarter-plate camera, 2 × HSF lamps, f16 on P.1200 plate.
(Lower) Bank vole. Baited at a natural outdoor site. This is a diurnal species, but flash was used because of the poor daylight. Exposure as above.

To prepare a baited site, first place a flat stone on the ground, at or directly below the chosen site, and on it place small bird-seeds for small rodents, cake crumbs and chopped fruit or vegetables for larger ones. The stone will prevent the food from being lost in undergrowth, and make it easier to check when and how the food is being taken. It is not usually necessary to check for the presence of small mammals in the area before baiting begins, as they are to be found in most open places, even in towns. A large leaf, placed like an umbrella a few inches above the bait, will hide it from seed-eating birds until dusk, and give shelter from predators so that visiting rodents will eat with more confidence. If the first baiting is carried out about an hour before dusk, and the results checked as soon as possible the following morning, it is usually found that at least a part of the food has been eaten, though it may have been carried away from the stone. Within a day or two, one or more animals may be visiting the stone as a matter of routine, eating the bait where it lies, and leaving seed husks or nibbled vegetables as clear evidence of their activities. If an elevated perch is to be used, it may now be placed in position above the stone. Branches should not be thick, or they will dominate the picture, and allow the animal using them too much freedom in the choice of the attitude it adopts when feeding (it will almost invariably sit facing the camera, with its tail hidden behind the perch). Ideally, the perch should be from 25 to 30 cm above the ground, and a branch with a small natural hole, into which food can be placed, should be chosen. This will confine the food to one place, difficult for the feeding animal to scatter, and keeping it out of the picture. It is best to use small quantities of bait, and replenish when all is eaten. It is surprising how confiding these small creatures become when they begin to associate human activity with the arrival of food; but should domestic cats become aware of what is happening, and wait at the site for live food to arrive, another site must be found.

Plate 10. (Upper) Grass snake. Wild, photographed where found but coaxed into position. Field camera, 8½ in. Aviar lens, 1/40 at f16 on P.1200 plate, developed in ID.11.
(Lower) African house gecko. Captive specimen under control. Field camera, 8½ in. Cooke Aviar lens, f22 on P.1200 plate, developed in D.76. Electronic flash.

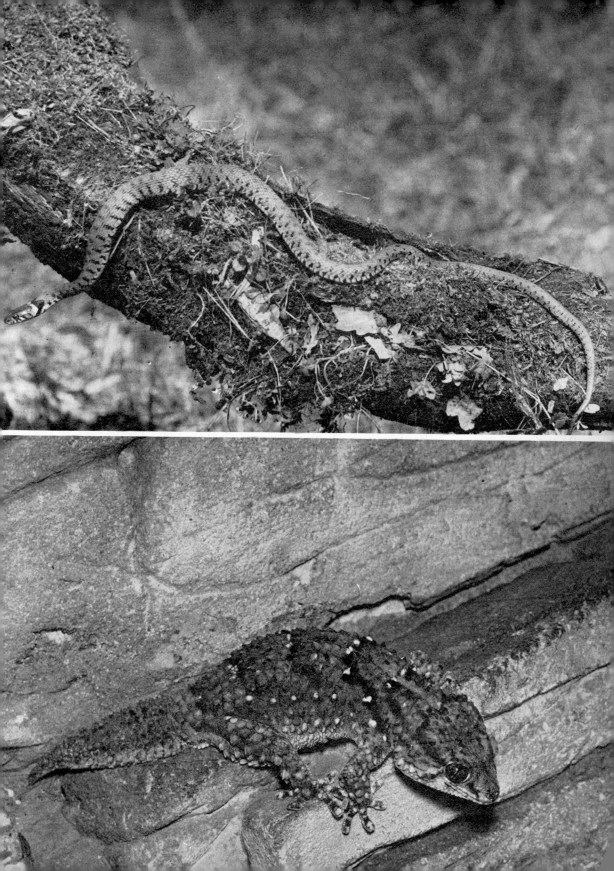

When the perch is in position, food is placed at the same time on both perch and stone, or, if no perch is required, the stone is removed and bait placed on the ground. Food on perches is quickly located and as soon as it is being eaten, a hide is erected at a suitable working distance, and photography can be attempted on the following evening.

If the subject is truly nocturnal, a lamp of low intensity is essential to illuminate the site. If one is close to a source of mains power (I have done much work of this type in my own garden), a cable can be run to the hide for a lamp of low wattage such as a child's nightlight. A lamp holder is easily constructed from a 1-kilo fruit can, over the open end of which may be fastened initially a sheet of red plastic film to reduce further the intensity; this can be removed in time. The best position for the lamp is on the ground between the hide and the site; lamps fixed to the hide may move in a wind, and may illuminate both hide and site. If light is provided from an hour before till an hour after sunset each night it will soon be readily accepted and may even come to be regarded as a sign that baiting has taken place and bring the visitors quickly to feed. With luck, several individuals, perhaps of more than one species, will come regularly and it should be possible to obtain a good series in a short time.

Bait for small carnivores may be tried, though the ratio of success to effort is likely to be much smaller. Bait left too close to a den is often

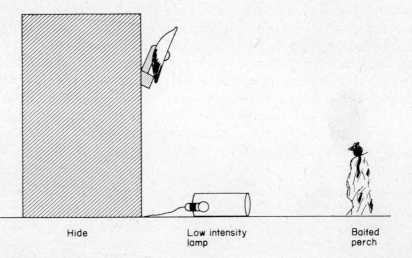

Hide Low intensity Baited
 lamp perch

Figure 1. Typical set-up for small mammals at bait.

regarded with extreme suspicion, especially if in the form of whole carcases. I have watched a fox circle a dead chicken left near its earth for several minutes, only to retire leaving it untouched. It was not taken for four days, though a second dead chicken, intended for future use and placed several feet up in the branches of a small tree at some distance from the first, was somehow removed and eaten on the first night. Less obvious baits may be successfully used; cooked meats, chocolates and other candies, smoked fish, and other prepared foods are certainly attractive to badgers; they can be cut or broken into pieces small enough to pass undetected in a photograph. Experiments carried out before work begins may determine which foods are suitable.

Remote Control

For those to whom long and perhaps fruitless waits do not appeal, trip wires or other forms of automatic releases may be tried. Even then the operator must be near to change the film or reset the shutter, visiting the camera when the flash is seen to fire; otherwise one must be satisfied with a single shot per session, returning only to remove the gear. Trip wires activate the shutter mechanically when the animal presses against a wire or other strong filament stretched across its path. The trip must be as unobtrusive as possible in order both that the subject should not be upset, and that it does not appear in the photograph. It should be as short as possible, or it may operate when the animal is out of focus or off centre. A better form of auto-release consists of two metal plates, kept apart by a weak spring, operating a battery solenoid when the contact is completed as the animal treads on the plates; these are covered thinly with soil. Since low voltages are used there is no danger to the animal but, since the plate is rather small, the chances of success are not great. A modified form of the infra-red beam described in Chapter 9 can also be used.

Controlled Conditions

Much good work has been done with animals either in permanent captivity or caught in live traps and kept under suitable conditions until photography is finished (when they should be immediately released into

their natural habitat). The welfare of the captive animal should be of prime importance, and no act which might cause harm or distress should be contemplated. There is less danger in catching small mammals for photography than in catching small birds, since the former usually go into hiding places (which can be provided in the trap—grass or moss is best) whilst the latter may batter themselves in attempts to escape. To set up an outdoor studio, dig a pit about 30 cm in depth and of the same size as the cage to be made, spreading wire net of not more than 1 cm mesh over the bottom and filling in to ground level; the captive cannot escape prematurely by digging but may construct tunnels if it does so in nature. The sides, made of plate glass, may be obtained cheaply when shops are being demolished, and are sunk to the level of the wire base. The plate glass lid should allow for the free entry of air, and the occupants should be introduced and left to acclimatize. If the camera is placed close to the plate glass, distortion should be slight, but for best results a simple hinged door at one end will allow the unimpeded use of the apparatus when photography is in progress. A series of suitable backgrounds can be set up at the opposite end.

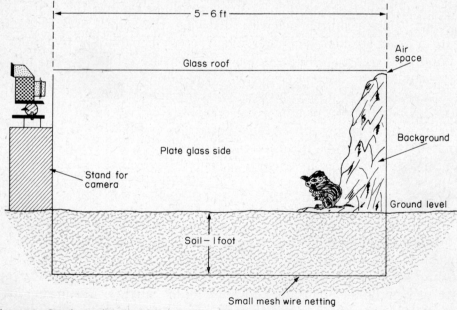

Figure 2. Outdoor glass cage for captive small mammals.

Zoos

Some small mammals which are rare, difficult to trap, or to maintain in captivity are seldom seen outside zoos, where their natural habitats are often closely simulated; they may be photographed in these conditions provided the zoo is willing to make special facilities available. If the photographs must be taken through wire mesh or bars, then the closer the camera is to them the less obtrusive they will be; but care should be taken, as even small animals can sometimes be dangerous if too close an approach is made, and one should not attempt this uninvited. It is unethical when offering work done with captive or controlled subjects for publication to give the impression that it is of free, wild creatures.

Light Sources at Night

Little success could be expected if a photoflood lamp were suddenly to be used on a timid wild animal. Continuous lighting of this sort is only of use if its intensity can be built up to a peak over many days or even weeks of patient work, checking at each stage to make sure it has been accepted. If an animal can be induced to behave normally in such lighting there are considerable advantages; there is no violent 'explosion' of light such as accompanies a flash exposure, and direct meter readings can be taken to determine precise exposures; furthermore, the light could be used for cine work. Exposures must be fast enough to stop movement and, because some illumination of the hide is inevitable, great care must be taken that movement within the hide is not detected.

Expendable flash bulbs are available in a range of sizes with a wide choice of light output; they are light in weight and several sizes can be carried at once for use with various types of films. The largest will provide sufficient light for work at long range and with long-focus lenses, improving the chances of success with timid subjects. The initial cost of a flash gun with a small supply of bulbs is low, but for large-scale work, running costs could be prohibitive. There are several disadvantages in their use, the main one being that the flash duration is comparatively long, so that any movement of the animal at the moment of exposure will

show in the photograph. This can be overcome if the shutter has a reliable 'M' setting, as the peak of the flash can be used in conjunction with a high shutter speed; but this wastes some of the bulb's full potential, and complicated adjustments must be made in the selection of the aperture to compensate for the loss. It is perhaps best when using expendables to stick to slow shutter speeds, and wait until the animal is still before exposing. Most bulbs have a coat of plastic film which prevents the glass envelope from shattering when the flash is fired, and these coatings are sometimes coloured to vary the colour temperature of the light output. The heat distorts and blisters the covering, sometimes burning right through it, and the smell of burning and the cracking noise of distortion last for several seconds after each exposure. This may frighten a timid animal more than the light itself. Bulbs must be changed after each exposure, and to do this one must either withdraw the flash head into the hide, or put out a hand. Either takes time and may cause detectable noises, with disastrous consequences; it is best to delay the action until one can be sure that the subject is not in sight, and care should be taken to ensure that the aim of the reflector is not changed whilst bulb-changing is in progress.

Electronic or high-speed flash is the most satisfactory type for use at night, especially for close-range work. Modern sets are compact and easy to carry, though as a general rule the more compact the set the smaller its output and the longer the duration of the flash. Some sets allow for division of the light between two or more heads, thus giving scope for modelling, but it must be remembered that this may destroy some of the nocturnal effect. As one may see by reference to Chapter 9 large, old-fashioned sets give a fairly high light output, and a flash of very short duration capable of portraying even small creatures in rapid motion; but they are heavy, and a vibrator is usually incorporated in the circuit, producing an audible buzz when switched on. The effect of this varies, but it is best avoided by incorporating a circuit of the type shown on p. 185; noise may inhibit normal behaviour more than the light itself, because it is difficult to simulate for the purpose of acclimatization during preparatory work. Modern transistorized low-voltage sets give only a thin whine, though this too may be audible to sensitive ears. A commercial set by Clive Courtenay of Dorking, England, works from a dry battery of 480 volts and is completely silent, but the battery has a life

of only about a year and is expensive to replace—as well as being potentially dangerous if mishandled when removed from the set. The very modern 'computer-type' sets also described in other chapters could be a valuable tool in the future.

Reptiles and Amphibians

These may mostly be photographed in daylight with fewer problems than one meets with small mammals. Many reptiles are both active and shy, readily seeking hiding-places when humans are near; this makes stalking difficult but by no means impossible. Most lizards habitually sun themselves on walls, logs or rocky outcrops, all of which are excellent photographic sites, and a good method is to set up camera and tripod at such a place whilst the reptile is in hiding, waiting for its reappearance. Snakes, other than those which live in desert areas, move in vegetation deep enough to mask them or produce out-of-focus and other problems; in such places it is common practice to coax the snake gently into a more suitable situation, using a stick for poisonous species, and the hand for harmless ones; it is best, of course, to know one's snakes well! Most published work in this field is, however, the result of the clever use of captive specimens in vivaria, for which see Chapter 11. Reptiles have, perhaps, not yet received the attention in the wild which they deserve from the photographer.

Amphibians and batrachians take so readily to life in the vivarium that specialists in this work do most of it under controlled conditions. However, some aspects of their lives cannot readily be shown in a naturalistic way in captivity; frogs and toads, for instance, congregate in clear, shallow water close inshore, where their movements, on or just below the surface, create patterns of great variety. If the photographs are taken from vertically above problems are few, but shots from oblique angles call for considerable technical skill. For the best results, one should choose a still, cloudless day, so that reflection does not cloud the surface, nor ripples distort it. Surface reflections may to some extent be reduced by the use of a polarizing filter.

Most fishes are photographed either in tanks or by underwater methods

(see Chapters 11 and 13) but small specimens in rock pools or shallow fresh water may be dealt with in the way described for spawning frogs.

Cameras and Equipment

The type of camera to be used is largely a matter of taste; the main problem is to decide on the size of negative to be employed. I have used all sizes from 35 mm up to 9×12 cm, the larger sizes being for the now obsolescent glass plates. Any apparatus used should allow for the free interchange of good-quality lenses of various focal lengths. The shutter should offer a range of speeds and be synchronized for flash, with both 'X' and 'M' settings, and the film transport mechanism should be easy to operate, even in darkness. Automatic or preset diaphragms and click-stopped shutter settings are invaluable when working at night. Other useful features of many modern cameras are double-exposure prevention and combined lever-wind frame-counting and shutter-cocking devices. Roll-film holders (whether fixed or detachable) with windows through which the frame number is read are difficult to use in a hide even in daylight, and quite impossible at night without a torch. Plate, or cut-film holders are difficult to change, and slow down operations, but they do allow quick processing after sessions during which a few exposures have been made: it is worth-while to see one's results before attempting more work, as mistakes can be considered and rectified, but it is wasteful to develop a full roll of film on which only two or three frames have been exposed. Large negatives cover a wider area, making the position of the subject less critical; alternatively, they allow a larger subject image, with potentially better quality in the final print.

No camera can be said to be ideal for Nature photography, since no modern camera is designed for this type of work alone. I prefer a Mamiya-flex TLR with interchangeable paired lenses and shutters, giving 12 frames of 6×6 cm; a version taking 24 frames on 220 film is available. The lens chiefly used is of 180 mm focal length, and others of 105 and 65 mm provide considerable versatility. Cameras with focal-plane shutters tend to be noisy and are difficult with flash, especially HSF, since synchronization can only be achieved at relatively slow shutter settings,

but compur-type shutters are synchronized for all types of flash through-
out their range.

A strong tripod is essential, lack of a good one often being the cause of
poor work by a beginner. A cable release should be used, long enough to
be held in comfort throughout lengthy sessions, especially at night since
vital seconds can be wasted groping in the dark if the release is not con-
tinuously held. In cold weather, fingers may stiffen into uselessness when
holding the plunger of a conventional wire cable; an air line with bulb
release can be held in the hand in a warm pocket. Such air lines often
include a long extension which will effectively operate the camera up to
10 m from the camera, though one should remember that at night it may
be difficult to see what is happening at such a range.

SPECIES	WORKING DISTANCE
FOX/BADGER	4 —5 m
RABBIT	2·5—4 m
SQUIRREL	2·5—3 m
RAT	1·5—2 m
MOUSE (LONG TAIL)	1·3—2 m
VOLE (SHORT TAIL)	1 —1·5 m

Figure 3. Ranges for small animals. The range chosen should be governed by the desired
image size and the ratio of that size to the surroundings in the finished picture.

Assumptions

100 mm lens on 35 mm material
180 mm lens on 6 × 6 cm material
250 mm lens on 9 × 12 cm material

4

Bats

Sdeuard C. Bisserôt

Introduction

It is sometimes said that the most difficult aspect of bat photography is finding the bats; this is true to a certain extent, as they are the most elusive of all the mammals, seldom flying in daylight and leaving very little evidence of their presence. The only way to find them is by patient searching, talking to local inhabitants, and concentrated observation during periods of possible emergence or return to the roost, which varies with the species.

Bat distribution is virtually world-wide, except in the Arctic and sub-Arctic, though only fifteen species are found in the British Isles, mostly in the southern counties. As in other branches of Natural History, photography can be roughly divided into two methods, namely 'wild and free' and 'controlled'. The former presents many problems, some of which are virtually impossible to solve without a considerable amount of time and money being spent and ingenuity brought to bear.

Choice of Camera

The choice of camera is a matter for individuals, but a single-lens reflex (SLR) is undoubtedly the best for field work, allowing last-minute checks to be made on focus and composition, and avoiding parallax error. The final selection will depend on the amount of money available, the size of

format required, and whether both black-and-white and colour are undertaken.

Photography 'Wild and Free'

Photography in hibernation or at a roost usually involves going into caves or quarries, and the owner's permission should be obtained first. Bat-hunting should *never* be undertaken unaccompanied; this is a precaution in case of accidents (see also John Woolley's comments in Chapter 14 on cave safety).

Most bats are relatively easy to photograph in hibernation, though difficulties may be caused by the site itself and the position of the bats within the site. Seldom are they located at easy camera level; more often they are well above the head, or tucked into a tight crevice or cavity that is too small for the photographer's body and camera. As the work has to be done in darkness, it is best to make one's preparations before entering the site. The temperature is normally higher in the site than outside, and humidity is often high; one needs to guard against condensation not only on lenses but on electronic leads and switches. I usually put my standard lens and a 200 mm lens either in my pocket or inside my jacket, so that they remain relatively warm. All electronic power-packs, leads, and flash heads are carried in cases or bags, which not only helps to prevent condensation but guards against damage while climbing in and out of caves.

On entering the site, cameras and electronics should be assembled and connected before making any contact with the bats, ensuring that the minimum of disturbance is caused; this helps in getting better pictures, also it is better for the bats, whose welfare is an important consideration.

Comfort and ease of operating are essential; focusing in complete darkness is difficult, footholds are often unstable, and conditions often wet. To help in this respect I had a lightweight rod made, with a camera mounting-point in the centre, and electronic flash heads at each end (see Plate 13, lower); this enables me to concentrate on focusing and composition without having to worry about the position of the lights. This system is basically for colour, where a flattish lighting is best; for mono-

chrome it is better to damp down one head, or bounce it off a reflecting surface.

Whereas most hibernating bats will not react very obviously to a short photographic session, they do sometimes eventually wake up and move. Some species, particularly the European greater horseshoe bat are very sensitive to the approach of people, and will react by drawing up the knees—not very good for photography unless this particular reaction is required. The problem can be overcome by setting up the camera on a tripod, focusing up, and then going to another part of the cave for about half an hour and returning quietly to get the shot. It is sometimes possible to get several exposures this way. During summer when the bats are roosting, the same difficulties occur, but they are more alert and react very quickly to the approach of human beings.

Photography in flight, *in situ*, is extremely difficult; the only way to get satisfactory pictures is to locate the exit point of a colony and set up a photo-electric beam circuit, and a high-speed electronic flash (as discussed later) so that the bats photograph themselves on leaving or returning to the roost.

In countries where hibernation does not take place, there is more scope but there are greater problems. To be confronted with a vast cave containing several million bats, as in Borneo or South America, presents difficulties very different from those of Europe and which can only be solved on the spot. The use of wide-angle lenses and multiple flash (either several outfits operated by slave units, or one outfit fired several times) are sure to be involved; scaffolding or ladders may be necessary.

Controlled Conditions

Controlled portraiture and flight shots require different techniques (and a great deal of patience) but both are best done in a small room with the minimum of furniture and equipment.

Portraits can be obtained by pre-focusing on a selected spot and firing the shutter when the bat crawls past, though there is a high percentage of failures with this method.

It is advisable to keep the bats for two or three days before attempting

to take any photographs. This will give them time to become used to handling, also to commence feeding. However I have found that some species, e.g. the greater and lesser horseshoe bats, are very reluctant to feed in captivity. Should this happen, the specimens should be returned to hibernation immediately, or released, whichever is applicable. When a bat is feeding, select a suitable object for it to cling to, such as a piece of wood (a natural piece, not a bit that has been recently chopped for the fire or cut for building), against a black background. The black background should be stressed, because bats are creatures of the dark and a light background looks unreal. Foliage and bark can be used, but must be carefully placed to avoid confusing the outline of the bat.

Initially the bat should be held in the warmth of the hand or against the body until the increased breathing rate indicates that it is waking up. It is then placed in a suitable position and the camera focused to include as much of the bat as is required. A critical stage has now been reached, as the bat will continue to increase its breathing rate and to open its eyes, but this is not the time to expose. Eventually it will open its eyes fully and look up; this is the time for photographs, but it will be short as the bat will fly or move as soon as it is fully awake. It may even move before this, so a quick change of focus must be expected.

Bats that feed readily may also be photographed while feeding, but great care must be taken to ensure that morsels of food are not adhering to the lips or fur—particularly if it is not natural food, e.g., meal-worms. Urination frequently occurs when bats are woken up by hand; this can spoil the fur, which should be carefully cleaned.

Flight shots are fascinating and exciting, and can be obtained with relatively unsophisticated equipment. Mine consists of a photoelectric cell and beam outfit built cheaply by a colleague about eighteen years ago; a similar commercial circuit is available these days, and, by the use of transistors, is more efficient and compact, though undoubtedly more expensive. An electronic flash unit with a flash duration of 1/3,000 sec or less, will, properly controlled, produce first-class results. With modern

Plate 11. Leisler's bat, on point of take-off. Composition and focusing were done while the bat was becoming fully alert. Bronica, 75 mm Nikkor; HSF was used as shown in Plate 13 (Upper); at f22 on Verichrome Pan film.

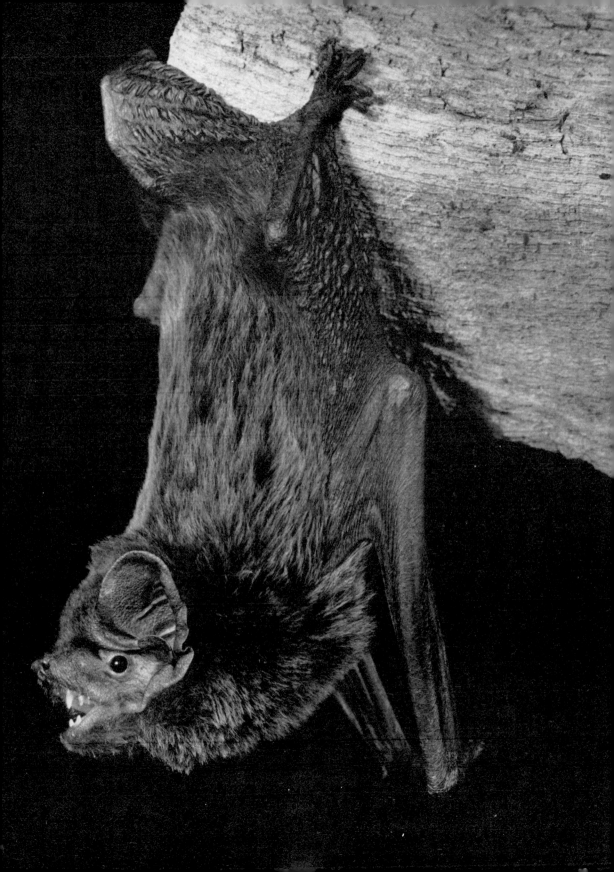

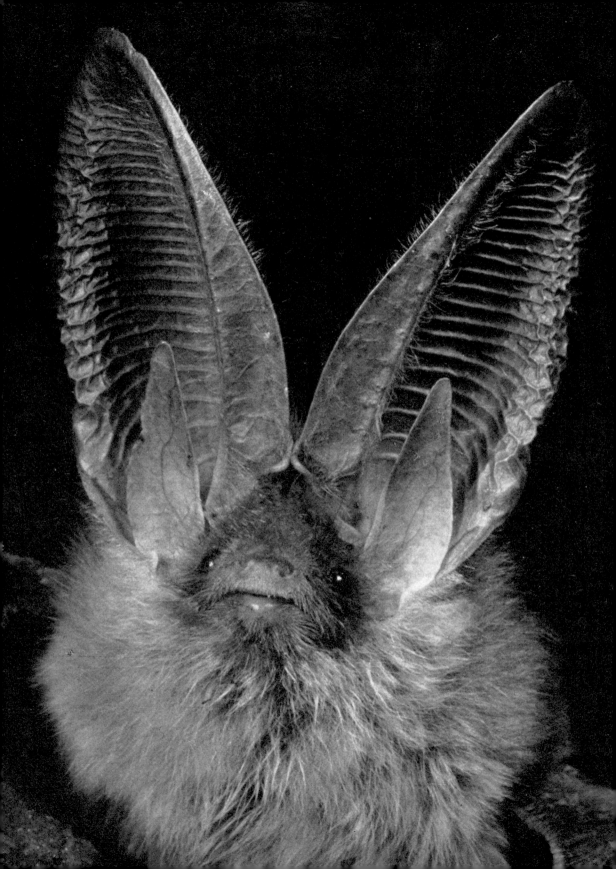

low-voltage (and consequently low-speed) units it is difficult to obtain a short enough flash duration to stop movement and yet enough light to enable a small stop to be used for maximum depth of field. David Cooke's Chapter 9 goes into more detail on these technical problems.

Procedure for flight shots with the equipment mentioned is simple and fairly elementary.

It will vary with different individuals and operating methods, but basically it consists of an electric torch focused on a photoelectric cell, which in turn is linked to a battery-powered electrical circuit. The cutting of the beam by the bat in flight actuates the relay and operates a solenoid attached to the camera shutter.

As shown in Chapter 9 the delay between the cutting of the beam and the firing of the shutter is best determined by test shots, and it will vary considerably according to the electrical characteristics of the relays and shutters in use; once these are established, the camera can be pre-focused at the appropriate distance in front of the beam to compensate. With a simple system like this there is bound to be a considerable number of failures, usually caused by the bat making a sudden change in direction and cutting the beam with one wing-tip while on the turn, leaving the rest of the body and the other wing outside the depth-of-field. Other shots will be lost because the bat is in a bad position, perhaps with one wing obscuring the head and body. One acceptable photograph in twelve is a good average.

The distance between the torch and the cell varies in relation to the species being photographed, as the wing-span can range from 200 mm (8 in.) to 400 mm (18 in.).

Treatment of Bats in Captivity

Bats tire quickly, and this becomes evident in the look of their fur; it loses its glossy, well-groomed look, and this is noticeable to people who know bats well.

Plate 12. Long-eared bat. Focusing was carried out on a preselected spot and the shutter fired when the crawling bat reached that spot. Details as for Plate 11.

The larger species, e.g. noctule, serotine and mouse-eared, are very reluctant to fly when there are objects close to the take-off point. In other words they need 'air space', and this is sometimes limited when there are cameras, tripods, electronic flash heads, and other equipment near.

One should work in a place where there are no nooks and crannies that the bats can crawl into, where they might pick up dust and cobwebs on their fur and claws, and from which it might be difficult to extract them; or they might get lost altogether, since they can disappear into very small spaces indeed.

They should be handled carefully and slowly, kept in a draught-free but ventilated box; tree bark should be fastened on to the sides for them to hang on to and the roof roughened up to provide a foothold. If provided with water and food (such as moths and flies when available in the summer, and meal-worms in winter), they will usually become tame in a very short-time—seldom biting unless frightened. Do not keep them longer than is absolutely necessary to complete photography, and return them to hibernation or release them as soon as possible.

Conclusion

In conclusion, the importance of causing the least amount of disturbance possible must be stressed. The numbers of all bat species in developed countries are decreasing—through the destruction of habitats, loss of food by insecticides, collecting, and disturbance. If specimens are removed from hibernation for photography, this should only be done near the end of the hibernating period, and it is very important to get them to feed before attempting photography. They can then be kept and fed and in good health until natural food is available, and they can then be

Plate 13. (Upper) Greater horseshoe bat in flight. Quarter-plate-field camera, 150 mm Heliar lens: HSF at f18 on HP3 plate; Langham Press 200 flash set, linked to a photo-electric cell and triggering device.

(Lower) The author photographing a greater horseshoe bat in hibernation, using the apparatus described on p. 70. (Photo by James R. Grinn.)

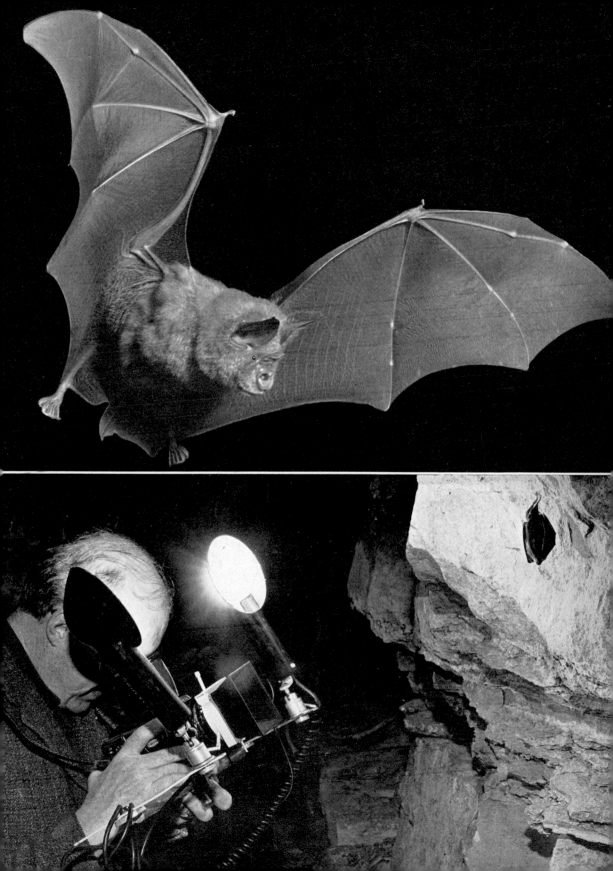

released; or, if they are returned into hibernation, they will have enough fat stored to keep them alive. If a bat refuses to eat it should be released or returned to the roost as soon as possible if it is to have a chance to survive.

Bibliography

Bats of America, Barbour, R. W. and Davies, W. H. (U.P. of Kentucky) Lexington (USA.), 1969.
Field Guide to the Mammals of Britain and Europe, van den Brink, F. H. (Collins) London, 1967.
Handbook of British Mammals, Southern, H. N. (Blackwell) London, 1965.

5

Birds at the Nest

Arthur Gilpin

Introduction

The final decade of the last century saw the beginning of bird photography and by 1910 it was an established hobby and profession. Even in the early days some, like R. B. Lodge who in 1907 photographed eagles and vultures gorging on the carcase of a dead horse in the Balkans, took pictures of birds away from the nest. However, by far the greater number of pioneers portrayed them at the breeding place. In fact, until about 1950 only a small minority of photographers looked for their pictures away from the nest.

The advent of long-focus lenses for 35 mm cameras made it easier to take pictures of birds away from their breeding place. Of recent years, with the improvement in resolution of lenses and of films, the results have had quality comparable to those taken on larger negatives. But even now, in spite of the comparative ease of long shots, many workers prefer birds at the nest. The breeding cycle is one of the most interesting periods of the subject's life, and the photographer, instead of taking pot-luck with bird and background, can choose what and, within limits, where he will work.

Sitting close to a bird unaware of your presence is part of the special appeal of photography at the nest. Considering how many of the most satisfying bird portraits are taken in such an attractive situation, its continued popularity seems certain. What follows is written in the hope that the reader will be helped to gain the utmost pleasure from this field work without harming the birds and to produce good results—in what is often referred to as the Classical style of bird photography.

My experience has been in temperate and sub-arctic climatic zones and the chapter is written on that basis. Conditions in tropical countries give rise to many differences, and these are covered in John Reynold's Chapter 16—'Tropical Conditions', his last section being in effect a supplement to this chapter.

The Nest

Before one can take a photograph of the bird at the nest, there is an essential preliminary; first find your nest. Sometimes it is possible to rely on others to do this, but there are disadvantages in doing so. In this branch of Nature photography more than any other, it is important to know something about the habits of the subjects; and the fewer other people that know of a nest you intend to photograph the better. Your aim, in your own interests and that of the birds, should be to keep any disturbance at the nest to the minimum. Anyone beginning bird photography should be familiar with the contents of *The Nature Photographers' Code of Practice*, appended to Chapter 1.

As a result of the increased usage of the countryside and the interest in birds, it is now rarely possible to erect a hide in a public place without attracting unwelcome attention. To avoid this you will require permission to work on private land. Having obtained it, take care to observe any limitations laid down by the owners.

The day when it was enough just to get the bird in the picture has gone, and the choice of nest is important. This should be typical of the species and have pleasing surroundings. Far too much time and material is wasted on sites that are ugly and it is always worth while searching for one that will make a picture. For example, where a species like the short-eared owl breeds on the ground in either grass or heather, the massed effect of the latter will set the bird off better than the straight streakiness of grasses. Obviously if the photographs are for purely scientific purposes, the surroundings are not as important. A minor thing, but one that can affect the attractiveness of pictures of waders or game birds is the clutch size. It is as well to choose a nest with the normal complement of eggs. Apart from the aesthetic effect, pictures of birds settling on clutches small for the species can leave the viewer wondering what happened to

the other eggs and whether the photographer was in any way to blame for their absence.

I include in this chapter the portrayal of birds on perches near the nest. Some nests, e.g. of chats, are often so deeply buried in vegetation that to open them up satisfactorily is impossible. Birds that nest in holes in banks—kingfishers and bee-eaters—or in trees—flycatchers and tits—often enter them very quickly and give the photographer little chance, but they may pause upon a perch. Where the birds are using some natural perch regularly the normal thing is to focus on it. If it is badly lit or too far from the hide, it is often possible to introduce a perch. This should not only bear a natural relationship to the surroundings, but also one to the birds. Nothing shows lack of taste more than a picture of, say, a whinchat perched on a branch that has obviously been cut from the nearest hedgerow, had the side twigs removed, and been stuck in the ground, possibly the wrong way for its growth. Normally there are plenty of tall, dead, but strong, weed stems near a whinchat's nest and it is not difficult to transplant one of them. If, for a tree-nesting bird, it is necessary to fix a perch so that it appears to grow from the tree, it is as well to make sure that the branch and tree are of the same species. For some ground-nesting birds a rock in the right place will lift them clear of the tangle of grasses. Many of the boulders that dippers alight upon, when going to and from the nest, are fairly large and create depth of field problems. It is usually possible to introduce a stone that will satisfy both bird and photographer (see Plate 20).

Some of the foregoing may seem obvious and perhaps trivial, but it is written on the assumption that the reader is interested in producing first-class pictures of birds at or near the nest. It is surprising how often trivialities spoil pictures and how often the obvious is overlooked. Perhaps it is a little extreme, but when thinking of working a nest, I find it worth while considering whether the site will prevent me taking a best-ever photograph of the species.

If you are a beginner, do make your early attempts at the nests of common birds. There is no point in going long distances to photograph rarities until you have developed an adequate technique. In Britain, it is necessary to have a permit from the Nature Conservancy Council before any of the birds on the First Schedule of the Protection of Birds Acts (1954–1967) may legally be photographed at or near the nest. This

schedule lists the rare birds and one is unlikely to be granted permission unless evidence of previous field experience can be produced. Many of the species on the list are common in other parts of Europe and it is often better to photograph them there. Because of the larger numbers, interference matters less and there are more nests to choose from.

On most occasions it is necessary to have someone to see the photographer into and out of the hide. As most of a bird photographer's work is away from centres of population it is often difficult to find someone to do this, and many photographers work in pairs. This arrangement has many advantages, for both are aware of the need for care, and each, when acting as assistant, knows what to do. It is important that both have apparatus that will give them satisfying pictures at the same range. Many years ago I met two bird photographers holidaying together; they had similar cameras, but one used a 6-in. lens, the other a 12-in. The compromise hide positions meant that the results from the shorter-focus lens had a large depth of field and a small image of the bird, while from the other there was inadequate depth and too large a bird.

The Hide

For ease of carriage most bird photographers use hides that are collapsible, usually in the form of a jointed frame over which a cloth cover can be stretched. As it may be necessary to carry the hide long distances over rough terrain, weight is an important factor, but lightness should not be achieved at the expense of stability and strength. Designs vary; my choice is for a frame with telescopic legs of light alloy and, for obvious reasons, a waterproof cover. Adjustable supports are vital for use on hillsides (see p. 90). If hide making is too much trouble, at least one commercially-made hide is available in Britain.

The cover must fit the frame and not be of a material that stretches easily. Nothing is more likely to keep a bird off the nest than a flapping

Plate 14. Kittiwakes and auks on a cliff-face. A general shot of a sea-bird colony, one of the few occasions in bird photography when a wide-angle lens is necessary. Mamiyaflex, 60 mm Sekors; 1/500 at f8 on Tri-X roll-film developed in Azol.

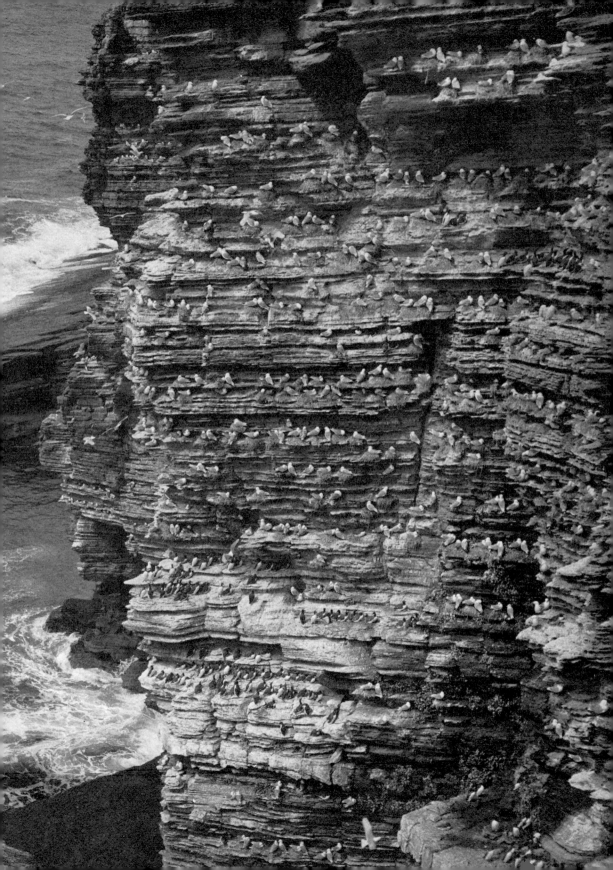

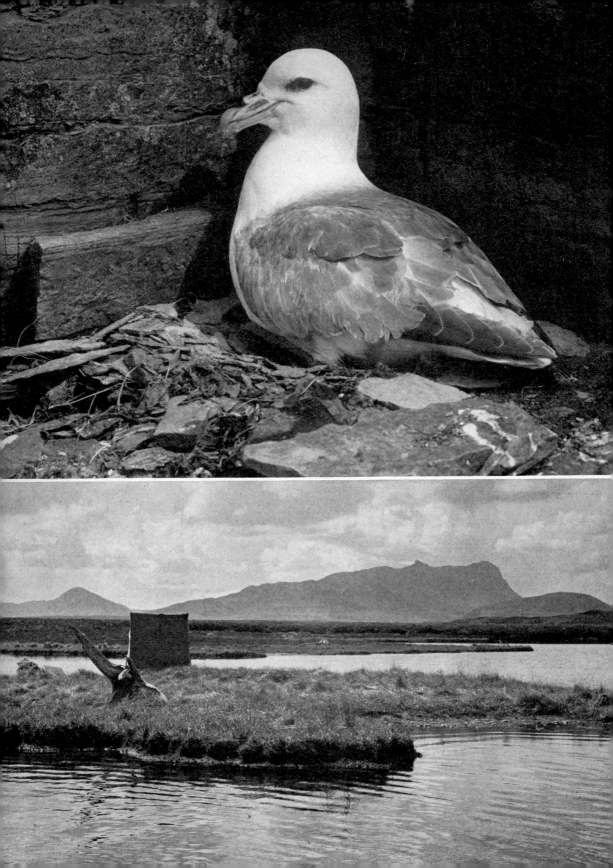

tent close to it. It is always as well to carry a good number of large safety pins to take up any slack, but the tighter the cover is, the fewer of these you will require. The material should be dense enough to prevent even the strongest of sunlight casting a shadow of the occupant on any part of the hide. Sometimes it is suggested that where thin cloth is used, the front should be of double thickness, but this is not enough. When the hide is in an open situation a bird may approach the nest from any angle. On the sun-baked mud of Provence, a shadow on the side of the hide would keep a pratincole away from the nest as effectively as one on the front.

The place of concealment should be big enough to allow the photographer—with camera in position on the tripod—to sit in reasonable comfort without touching the sides. A compromise between weight to carry, space in use and wind-catching area, in a size acceptable to most birds, is a structure approximately 1 m × 1 m and at the most 2 m high.

The colour of the cover does not seem to be of great importance for, although birds are thought to have colour vision, there is little doubt that it varies from species to species and is different from ours, so it is difficult to know how the colour of hide affects them. I have used with success green covers in sandy areas and brown amid bushes. The late Jasper Atkinson, one of the pioneers of bird photography, told me of what must be an exceptional occurrence. With others, he was going abroad on a photographic trip and, being short of hides, he ordered from a London firm a tent that he thought would suit his purpose. This was addressed to his hotel in Holland and it was only when he opened it that he realized that he had not specified a colour; it had alternate broad black and white stripes! In desperation the tent was tried and, to everyone's surprise, accepted by the birds. Nevertheless there is nothing to be gained by using brightly coloured covers and most are of a green, brown or grey tint. My own experience is that camouflage, painted or dyed, is unnecessary.

Plate 15. (Upper) Fulmar. An example of a species which can be stalked on the nest. Field camera, 210 mm Goerz lens: c. 1/15 (Luc shutter) at f22 on P.1200 plate developed in Azol.
(Lower) Nest-site of black-throated diver, with a typical ground hide *in situ*. Retina III 35 mm SLR, 50 mm Xenon lens: 1/250 at f16 on Tri-X film developed in Microdol-X.

To have, in the front of the hide, only one aperture for the lens is very limiting, particularly when the height cannot be adjusted. Far too often one sees almost plan views of ground-nesting birds because the only place for the lens was near the top of the hide. Ways of presenting the lens to the bird vary. Some workers make a round hole in the material and push the lens, usually with hood, through. This method suffers from having a barrel projecting from the hide and pointing rather ominously at the nest. As the lens is stationary, any movement of the front of the hide alters the amount protruding and the variation in the length projecting makes the movement very obvious. Plovers and curlews, for example, often walk around the hide and are very conscious of this sort of thing, and it may delay or prevent them returning to their eggs: a sleeve sewn to the front of the hide suffers from the same disadvantage and makes even minor adjustments of camera position difficult. My hides have two rectangular openings one above the other, each with a flap that can be pinned over the space when it is not required, and my lens-hoods are each fastened with their front edge flush with the centre of a piece of matching cloth that is considerably bigger than the openings (see p. 90). When the hide is in position the opening to be used can be chosen, the camera set up and, after all adjustments have been made, the cloth attached to the hood can be pinned to the cover. In this way no projection can be seen and it is possible to alter the camera controls without touching the hide front.

Peepholes in the cover are necessary and they can vary from small holes, cut as required, to slits with two flaps that can either be fixed shut with safety pins, or allowed to remain partly open. It is useful to have pieces of cloth sewn on both sides of the interior of the hide to form pockets for pieces of gear and spare films, while a broad hem with open top around the lower edge of the cover forms a useful receptacle for stones or sand to weight it down. A strip of material or a broad tape placed horizontally

Plate 16. (Upper) Kentish plover. The photograph was taken while the hen paused to expose her brood-patch before settling on to the eggs; range 2·2 m. Field camera, 210 mm Goerz lens; *c.* 1/15 (Luc shutter) at f22 on P.1200 plate developed in Azol.
(Lower) Short-eared owl with young, showing the advantage of selecting this type of site (see p. 80). Range 2·3 m. Details as above.

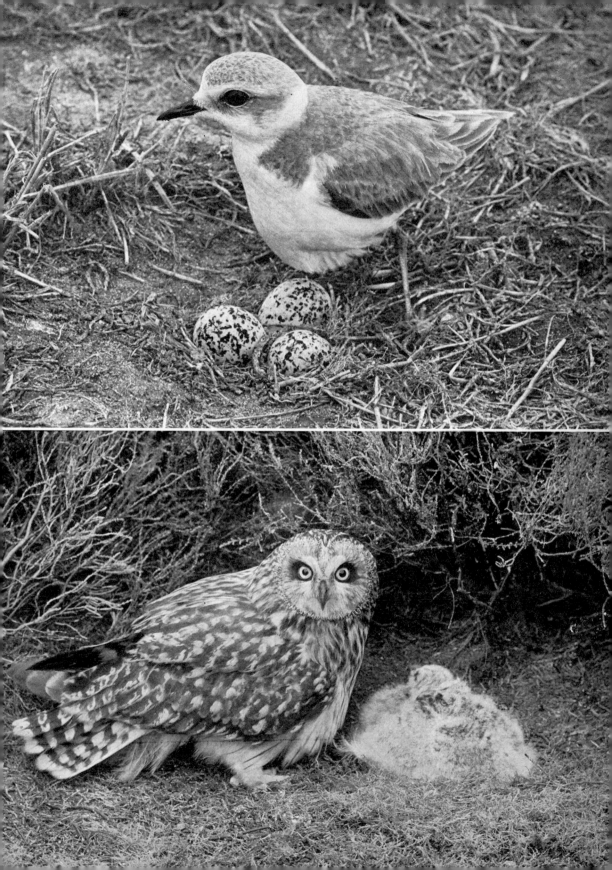

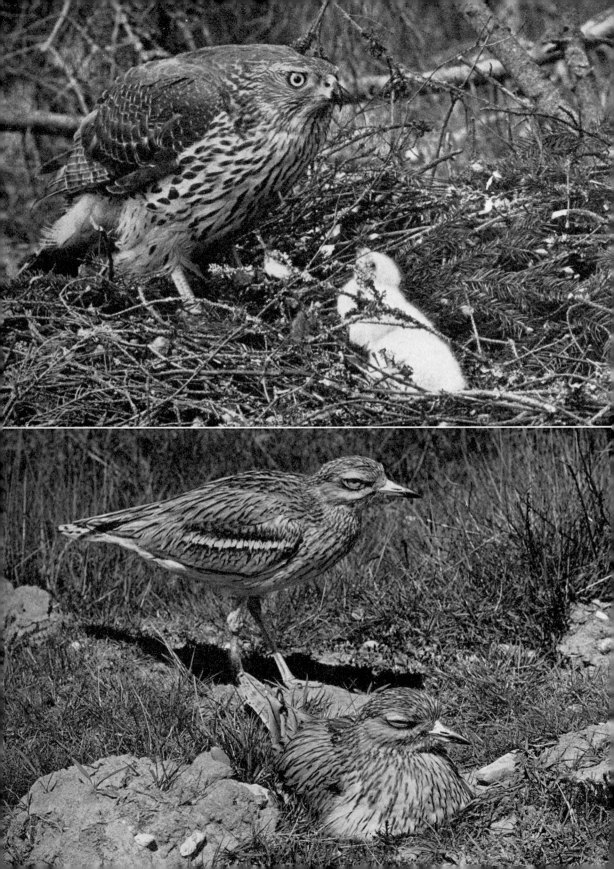

around the cover at half its height and sewn to it at 20 cm intervals, provides loops into which natural camouflage can be inserted and held in position.

Normally, pushing the legs a short distance into the ground will give the hide enough stability, but when this is not possible, or in open sites where the wind may be strong, guys are required: they should be fastened to the frame of the hide rather than to the cover.

Introducing the Hide

All introductions require care and that of a hide into the breeding territory of a bird is no exception. The method used depends to a great extent on the type of habitat and the species of bird. Warblers can usually be treated in a very different way from harriers.

However, certain basic requirements are common to all situations. It is best to introduce the hide when the nest contains fairly well incubated eggs or small young. Work should not be started when the eggs are chipping or the nestlings are less than three days old. This is a critical period and in cold or very hot weather the absence of the adults for a comparatively short time can mean disaster. Conversely it is seldom worth while starting to introduce a hide to a nest containing well grown young. The disturbance may adversely affect their chances of survival by causing them to leave prematurely or, in the cases of ground-nesting herons and owls, they will wander into the vegetation around the nest and their parents will feed them there. When young birds of prey can tear up food for themselves, their parents often stock the nest with bodies and only visit it at long intervals. In those circumstances it is far more difficult for the photographer to check the adults' reaction to his preparations than it is at an earlier stage of the breeding cycle.

Plate 17. (Upper) Goshawk, hen. An example of particular ornithological interest, since it shows a bird breeding successfully in immature plumage. Range 2·8 m. Details as for Plate 16.

(Lower) Stone curlews. Pictorial interest is enhanced if the pair can be photographed together at the nest. Range 2·5 m. Details as for Plate 16.

A hide should not be erected where it will attract undue public attention, or be insecure (i.e. likely to fall over or flap) or be unprotected in the

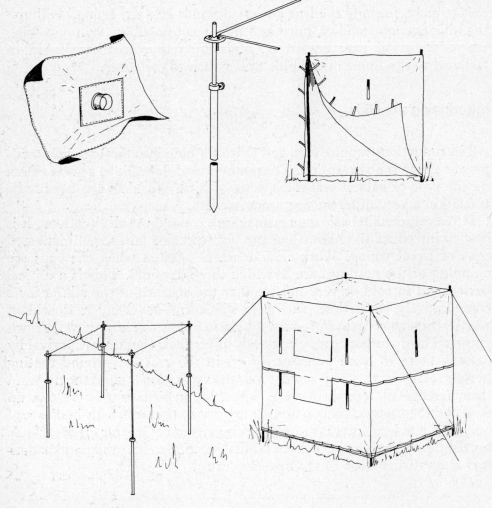

Figure 1. Hide details.

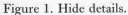

Plate 18. Little owl. A straightforward example of flash photography of a nocturnal species. Range 1·4 m. Field camera, 210 mm Goerz lens; one flash head, above and to the left of the camera; f22 on Tri-X roll-film (6 × 9 cm) developed in Microdol-X.

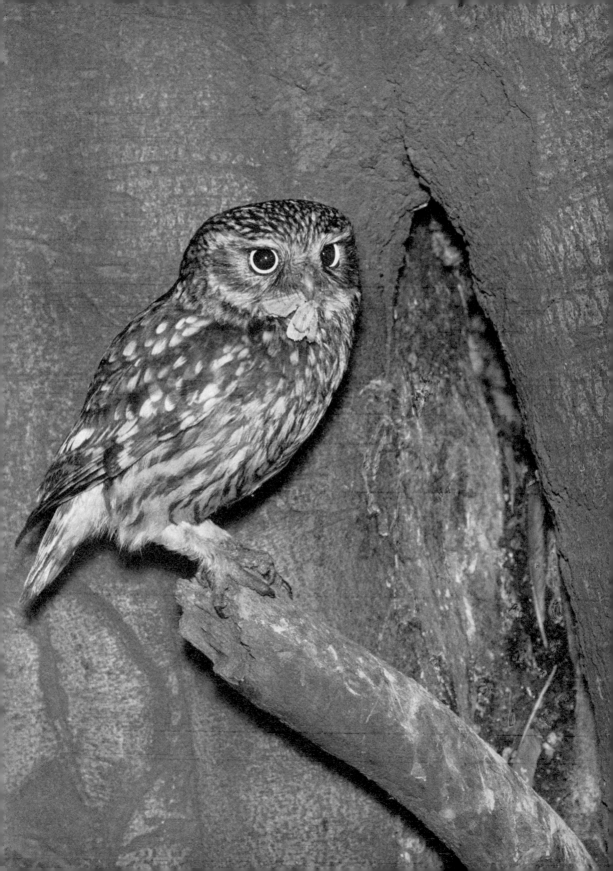

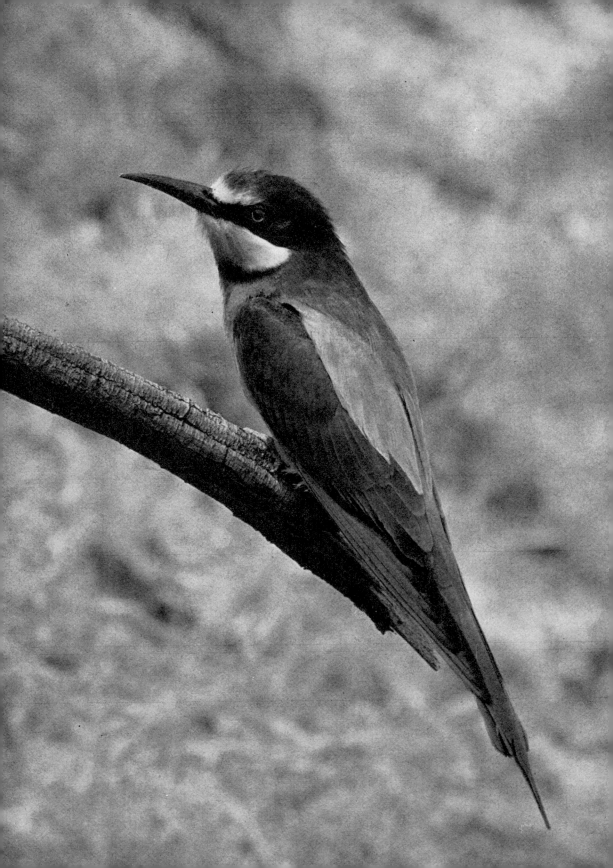

presence of goats, horses or cattle. In the last case not only will it be knocked down and torn, but any ground nest in its vicinity is likely to be trampled upon.

In open country it is a good thing to let the birds have a good view of the hide while it is some distance from the nest. With waders it is as well to start some forty metres away, erecting the hide on the southerly side if possible (in the northern hemisphere). Here the hide can be set up at operational height, and tall weeds, heather or bracken can be fixed to it to break the outlines. Once all is secure one should withdraw to a distance and, from cover, watch one of the birds back to and settled upon the nest. With most species, if this has not happened in less than half an hour, there is something wrong. It may be that the bird is aware of the observer and a more distant viewpoint should be tried, but if at the end of an hour—in warm, dry weather a little longer can be allowed—the bird has not returned, the hide should come down. A fresh and more distant start can be made another day.

If all goes well, on each of the next three days the distance between the hide and the nest can be halved, the moves being made as quickly as possible and the bird watched back each time. From about 5 m, using a long-focus lens on a 35 mm camera, it is possible to get reasonable photographs of a bird like a curlew. Most bird photographers consider that lenses of about 180 mm focus on the 6 × 6 cm format and 13·5 cm on 35 mm give the best results and 3 m is about the right distance (see the table on p. 107). The last move of the hide is the trickiest of the lot, and great care is necessary. My hide being adjustable, I lower it to about two-thirds working height at this stage, and when starting work the following day raise it to normal.

It will be realized that all these recommendations are only guides and they possibly err on the side of caution. One is governed by local conditions and the behaviour of the birds. If the latter ignore the hide in its first position, it may be possible to increase the distances the hide is moved each time and save a day in the process. Any such saving should

Plate 19. Bee-eater, on a natural perch near the nest. The advantages of taking photographs on the birds' way to or from the nest are discussed on p. 81. Range 2·5 m. Details as for Plate 16.

be on the intermediate moves, not at the first or the last position. As one will visit the ground many times during the preparatory period and when photographs are being taken, a different line of approach should be used each time to avoid an obvious track developing.

A hide that is not being seen by the sitting bird, or the parents of young as they approach the nest, is doing little if anything to further your purpose, so different tactics are required in some habitats. Among bushes or small conifers it is as well to find the greatest distance one can get from the nest on its most open side, without the hide being obscured completely from the birds, and erect the hide there. If your subject is a gamebird, say a partridge, nesting at the foot of a tree or bush, and other bushes hide everything beyond 20 m, the only thing to do is put the hide at that distance. It should be kept low, if possible, beneath overhanging branches and nearly buried in vegetation.

One of the great problems with gamebirds in such situations is watching them back to the nest. Once disturbed the bird may well stay away for an hour or more and eventually return walking through thick cover. When the hide is up it is as well to get right away from the area and return in about two and a half hours. If the bird is then seen to leave the nest, or the temperature of the eggs indicates they have just been left, beat a hasty retreat. Should the eggs be cold, take no risks; remove all signs of the hide. Game birds are kittle-cattle, and whereas one will sit until nearly touched another will flush at ten yards range and never return.

Should the hide be accepted, it can be raised to near working height next day without moving its position. Then, if all goes well, it can be moved forward gradually, over a period of about three days, to working distance. Checking that the birds return will still require care, and all disturbance must be kept to a minimum. A further visit shortly after the bird has been flushed by the photographer can create enough disturbance to cause a bird to desert.

In reed beds, where bitterns, rails, some warblers and ground nesting herons breed, the question of tracks is particularly important. One cannot

Plate 20. Dipper, on an introduced perch near the nest. Range 1·3 m. Details as for Plate 16 but exposure *c.* 1/30.

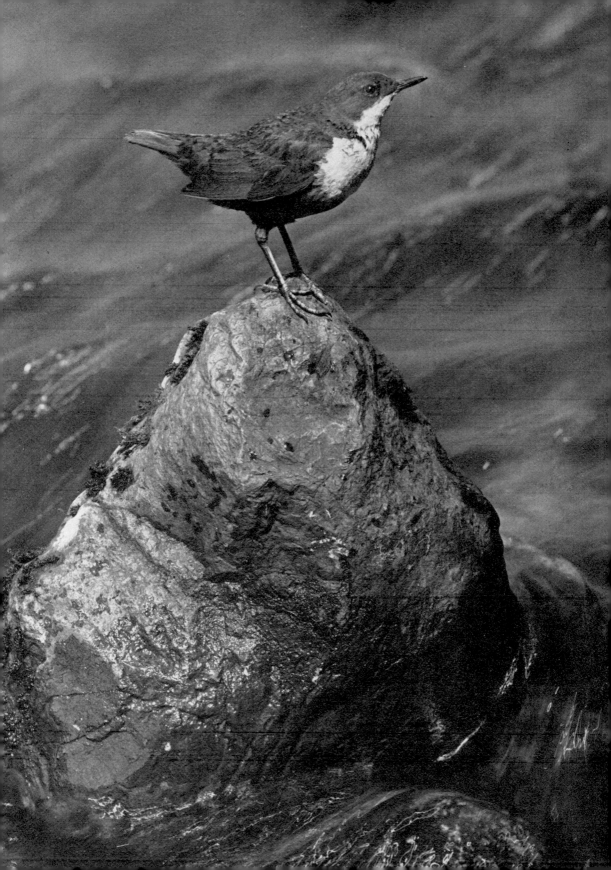

move through close-growing *phragmites* stems without leaving a track
reminiscent of an elephant through a cane brake. Firstly, the area should
be too remote or closely guarded to allow much risk of human inter-
ference. Once the nest is found and the hide in position—contrary to what
one would do in other types of country—only one track should be used.
The approach along this should always be noisy enough to warn the bird
at the nest and allow it to leave before one gets too close. Sneaking along
quietly and suddenly appearing close to the nest is likely to make a
nervous bird desert.

As the reeds are often two or more metres high and the birds that breed
in them frequently travel through the mass of stems rather than fly back
to the nest, there is little point in starting the hide far from the working
position. In any case, the more moves made the greater the area of tram-
pled reeds. Having decided where the hide should be in relation to the
nest (in a deep reed bed, where one's vision is limited to a metre or so in
any direction, a compass can help), put it there; any reeds removed to
make room for the hide can be placed on top of it. At this stage, because
of the intervening screen of stems, nothing will be visible from the nest
and very little from above.

The next stage is to open up a space between the hide and the nest.
There are two ways of starting this: some workers argue that the opening
should be from the nest outward, and others the reverse. I know that both
ways have been successful; for the first the benefit claimed is that, as the
opening is extended day by day, the bird begins to see the hide through
the reeds and becomes used to the space between. I do not favour this
method as it increases the amount of walking about near the nest whereas,
working from the hide, only the track to it is used. Lifting the cover,
one can gain access to the nest by going through the hide and fastening
back the nearest reeds to leave a space before it. As each day this is
extended towards the nest the bird sees more and more of the hide
through the thinning screen of reeds and becomes accustomed to it
gradually.

With nests on the ground, or in low vegetation in woodlands, there is a
risk of treading down plants over a wide area; this can often be best
dealt with by introducing the hide at a low height a little further away
than photographic distance. Camouflage in the form of trailing branches
of bramble or similar plants can be used to break up the outline. Then

the hide can in stages be increased in height and moved forward.

Nests in shallow water can be worked in a similar way to those in open situations on land. The hide can be started some distance away on the shore, or in the water, and brought forward in stages. When the water is too deep to allow this, a boat or punt may have a hide erected upon it and then be secured some distance from the nest, before being moved towards it in stages. My main objection to the boat method is the lack of stability. Although secured to poles driven into the mud, anything afloat is subject to changing water levels and wave action.

Alternatively one can build the hide at working distance. If built from the bottom, the back two poles driven into the mud, leaving enough above water to form part of the hide frame, will be enough for the first day. On subsequent visits the frame can be completed and the cover added bit by bit. I do not put a floor in such a hide. If the water rises it can be awash and I have known the weight of a photographer on such a platform force the poles further into the mud: by the time his relief came he was almost sitting in water. A seat built from the bottom can suffer from this defect and should be left higher than required and well weighted for several days before use. A long wooden crate—one end loaded with stones—is ideal. The flat end prevents it sinking to the same extent as poles.

In a hide without a floor, setting up requires care. Cases can be hung on the hide frame, and other items stowed in the pockets in the cover. A waterproof cover is a great boon when working over water. It is almost impossible to prevent the cover getting wet and if the material is absorbent it is possible for rising damp to make the hide pockets unusable. A hot sun shining on the wet cloth can cause condensation on lenses, mirrors and focusing screens.

For photographing birds at their nests in tall bushes or small trees the usual method is to erect a pylon hide, but a friend of mine has done very well with a commercially produced portable deer-seat. Pylons can be built of timber or tubular scaffolding, although many workers are now using slotted metal angle for the purpose. With this material it is possible to use the same pieces time after time, retaining the same platform and cover size. When erecting a pylon it is advisable to cross brace it to ensure rigidity, and to put out struts or guys to keep it upright.

The photography of birds nesting in tall trees or on cliff ledges is particularly challenging. If one has the money, professionals can be hired

to erect scaffolding, but it is assumed that most of the readers of this book will wish to do their own preparation.

In broad-leaved trees it is often possible to build a framework of poles or slotted angle and boards on the branches of the tree containing the nest, or an adjacent one, and this is the most often used method. When the nest is in a tall conifer a method I have used is to place two strong poles with one end of each on branches below it and the other ends in nearby tree forks at about the same level. These then form a 'V' with the nest near the point; the other end can be boarded over and a hide erected there (see p. 99). On cliffs, hides can be on ledges or structures erected to support them, but erection should always be done in stages and the reaction of the birds checked at each stage.

Before leaving the problems of introducing of the hide, I would repeat the basic principles, which are in the birds' and photographer's interests (after all, if the bird deserts you have wasted your time).

All work on hides should be carried out as quickly as safety allows and the bird kept away from the nest for as short a time as possible. When hides are being built on cliffs or in trees, the work should be programmed, and a firm time limit be set on each day's work: I suggest half-an-hour, and all work (whatever its stage) should be stopped at the end of that period. Once, caught by a sudden storm when trying to raise a hide on a ledge near a golden eagle's nest, a colleague and I pushed the hide over the edge because we knew we could not secure it in time. Starting again the following day we eventually photographed the birds. Hides should not be introduced at late evening. When the weather is bad, and it is essential that the adults cover the eggs or young, hides should neither be started nor moved. Any camouflage should be firmly attached to the hide and nothing should be left in such a way that it can blow onto the nest. Hides should be left with the cover tightly fastened and the whole secure; in open places guys may be required to ensure this. When you have finished work and removed the hide, leave the site as tidy as possible.

Gardening

The word 'gardening' is a euphemism, used in nature photography to describe the practice of opening up the surroundings so that nothing

obstructs the camera's view of the subject. The aim in nest photography should be to ensure that the bird can be clearly seen, yet the whole site retains its naturalness. The process is a subtractive one and some purists insist that it is wrong to introduce anything, as this essentially changes

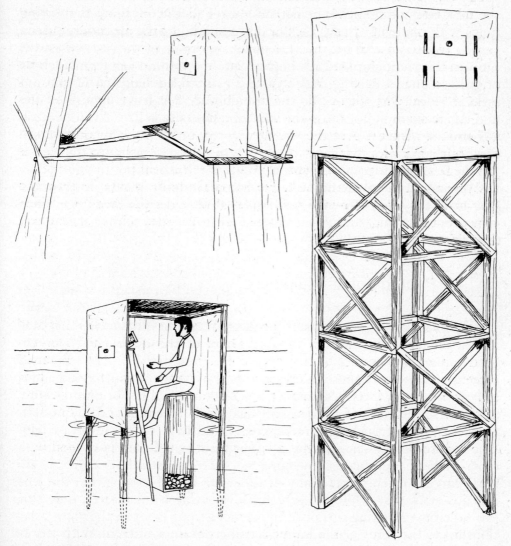

Figure 2. Hides, pylon and tree in water.

the natural characteristics. My opinion is that it is far better to get the right site than to try and alter one to your own taste.

Assuming a photographer has the basic techniques of his craft, there is nothing that will affect the results as much as his choice of sites and ability to 'garden' them aesthetically. Only in extreme circumstances should stems and branches be cut, and never should anything supporting the nest be removed. Tying back or down should be the procedure; green garden twine is useful for this. Do make sure none of the fastenings will show in the photographs. Pegs pushed into the ground can form anchors or, where one is dealing with grasses, giant-sized hairpins of the old style are ideal. Do not overdo the opening-up, but leave enough of the immediate surroundings to show what the nest site is like. Avoid leaving any broken plants, leaves the wrong way up, or cut ends in the picture area, but make sure that what is left is typical and pleasing to the eye.

Whenever photography is not in progress release all the ties and allow the vegetation to cover the nest. Do not place loose plants or branches over it, as they may slip into positions that obstruct the birds' approach or prevent incubation. Another risk is that leaves may wither and attract attention.

Photographic Equipment

Until about 1950 the equipment for photographing birds at the nest was almost standard; more than three-quarters of the established workers used a quarter-plate (8.2×10.8 cm) or 4×5 in. (10.2×12.7 cm) field camera of mahogany and brass, with a 'Luc' type silent shutter and a lens of between $7\frac{1}{2}$ in. (180 mm) and $8\frac{1}{2}$ in. (220 mm) focus. For photography at the nest this sort of camera still has much to commend it (modern metal cameras of this type are expensive and have no great advantage). The square-bellows camera has a larger front panel than is normal on a taper-bellows type taking the same size picture, and it is easier to fix fairly large shutters to it. Many of them are back-focusing, i.e. the lens remains stationary while the screen moves away from it. In a hide this can save time in fixing up; once the camera front is set in the right relationship to the front of the hide, focusing does not alter it. With front-focusing it is difficult to assess the final position of the front until focusing

is completed; then it may be necessary to move the tripod, because the lens is either too far back or projecting too much. Another great advantage of this type of camera is that a swing-back is a standard fitting. Used with discretion this adjustment is invaluable when photographing birds at nests on the ground. (See also Chapter 17, p. 360.) Where a bird is to be photographed at, say, a nesting hole in a bank running at an angle to the camera, or on the side of a tree with the trunk projecting towards the lens, side swing can similarly be used to bring more of the foreground into focus.

Few plates are now made and roll-films have improved, so most people now using this type of camera have changed over to a roll-film back. These are usually for the 9×6 cm size and, in addition to allowing the photographer to make many more exposures at a sitting, they have reduced his load by cutting out the need for heavy plate holders.

Weight is important, as there are often long trips over rough country to and from the sites being worked, and one of the criticisms of the field camera is that it is heavy. However, upon weighing the cameras I use (in their cases with all necessary accessories) I find there is little difference, the field camera turning the scale at 5 kg, while the twin-lens 6×6 cm reflex and 35 mm single-lens reflex each at 0·6 kg less. Two lenses are carried with each of the larger cameras and three with the miniature.

From time to time one misses golden opportunities because moving and refocusing the field camera is a slow procedure, but these occasions are comparatively rare. For the classical photograph of the adult at the nest the field camera is ideal, especially for the beginner. He will learn a great deal about basic photography by using one; perhaps the greatest advantage is that (with the aid of a focusing magnifier) he can check exactly what is in focus at any lens aperture. When the back is swung, the depth-of-field is moved to a more or less shallow angle to the ground and there is a possible danger that a tall bird by the nest will have its head through it. A knitting needle pushed into the ground at the place where the bird is expected to stand with a card fixed to it at the bird's height, enables this to be checked on the focusing screen.

At close quarters the 'Luc' type shutter is a great advantage, being silent in operation until it closes, making only a slight click *after* the exposure. As this type of shutter requires no setting one can vary the exposures as the light changes, without touching the camera.

However, it is difficult to judge exposure accurately enough for colour reversal material.

Of recent years the Mamiya twin-lens 6 × 6 cm reflex has become very popular with bird photographers, largely because of its adaptability and the high resolution of the Sekor lenses. The lens most often used for photographing the bird at the nest is the 180 mm. In the hide it can be difficult to get above the camera to focus, but with a Porroflex finder in place of the hood one can see the picture easily and focus from behind. One can make large prints from 6 × 6 cm negatives without serious loss of definition and the films do not demand the high standard of processing technique needed for 35 mm material. Unfortunately, the viewing lens is of fixed aperture and there is no way of accurately checking the effects of stopping down. The shutter has set speeds and when open to its full extent makes a small noise before closing. On slow speeds, particularly with small birds, the chances of movement during exposure are thus increased. Where electronic flash is used this does not apply, but if one is restricted to one camera and does not wish to use EF at every nest, it is important.

When used from a hide the major advantage of the reflex is, that if the birds offer opportunities a little distance from the nest, it is possible to move the camera and focus quickly. I have also found my twin-lens camera ideal for stalking birds nesting on the ground or on cliff ledges. With the camera fixed to a tripod's adjustable top, it is possible to approach many species, ranging from woodcock to gannet, and photograph them without any cover. Where pictures of nesting colonies are required the larger format has distinct advantages.

Although the 35 mm miniature camera has been used for bird photography since it was first introduced, it is only comparatively recently, with the introduction of advanced reflex models and the improvement of lenses and materials, that it has fully justified its use on birds at the nest. For those wishing to take colour transparencies, for their own enjoyment or to illustrate lectures, it is the obvious choice. Where negative-print photography is concerned, greater demands are made, and there is always the temptation—knowing quite large numbers of negatives can be exposed in quick succession—to fire away and hope that some will be satisfactory, rather than concentrating on each exposure.

The 35 mm, because of the smaller reproduction ratio required to fill

the picture area, has a distinct advantage over larger formats where depth-of-field is concerned. At a given distance, the 13·5 cm lens required to fill the 35 mm frame will give an adequate depth of crisp definition at about one stop larger than that of the lens needed to cover the same area of ground on 6 × 6 cm format. Although both cameras lack swing backs, it is the larger camera that is most affected. Naturally the small area of film limits image size; for good enlargements, the image of the main object must be large enough to contain all the necessary feather detail but should also allow adequate surroundings. In practice I find it imperative to carry more lenses for the small camera. For birds at the nest, I think 80 mm 13·5 cm and 300 mm lenses about the right combination; very long-focus lenses (500–1000 mm) sometimes enable one to tackle sites that are outside the scope of any other still photographic equipment.

Within a hide, through-the-lens-metering (TTL), available on most of the latest 35 mm SLR cameras, is a great boon, particularly for colour material, with its more critical requirements. Automatic resetting of the shutter with film-wind is welcome to anyone who has at some time taken two first-class portraits on one plate, and its speed of use is also an advantage. Ease of setting up and the small space required by the miniature camera are also points in its favour. In addition it shares with the larger reflexes the advantages of quick change of viewpoint and focusing.

Although there are some 35 mm SLR cameras with provision for viewing the image on the screen after the lens has been stopped down, it is extremely difficult to judge the field of adequate definition because of the small image size; as with the 6 × 6 cm twin-lens reflex, it is impossible to know with any degree of accuracy what is in focus. With practice one can learn the characteristics of cameras and lenses and gather some idea of where to focus at full aperture to ensure the required amount of sharply defined foreground. However, this takes time and leaves an element of doubt. I have never found a miniature camera with a shutter as quiet as the 'Luc', and many are noisy. This is a disadvantage for the daylight portraiture of birds at close quarters; as has already been said, the less noise the better. The care necessary in the processing 35 mm film has been mentioned, but it should be emphasized that the utmost caution is required to prevent damage to the negatives *every* time they are used.

Flash

My own view of electronic or high-speed flash is that HSF is often used for taking photographs when a better result could be obtained with the available daylight. At night, in dark situations or with fast moving birds, it enables the photographer to take otherwise unobtainable pictures. As long as the flash heads are correctly sited there seems to be no disadvantage in its use with colour material, but when I have been able to compare black-and-white photographs of the same subject, taken by flash and soft daylight, the former has had a curtailed tonal range. The short exposure will 'stop' the jerky actions of such birds as the Wagtails, and obtaining photographs without movement is easy. However, unless one's results are going to look 'flashy' or appear to have everything in the same plane—wallpaper pattern style—skill and care are required in positioning the lights. One way in which the HSF has proved to be of great assistance, particularly in the sunnier parts of the world, is as a fill-in light. Until its advent it was almost impossible to obtain a satisfactory photograph of a bird amid sunlit foliage, but now, with flash heads set to illuminate the shadows, the photographer has a very good chance of doing so.

The positioning of the lights is all-important and the site influences this to a great degree. However, if one follows the studio technique of having one lamp close to the camera, with one or more lamps further away to give modelling (normal studio practice is to use 1:4 in light output) one can vary the settings as required. As natural light is from above and casts single shadows *below* objects, the aim should be to emulate it.

The inspired use of electronic flash, combined with a system whereby the bird flying through an infra-red beam triggers off the flash, has resulted in the taking of some of the finest photographs of nocturnal birds ever produced. Owls at the nest have also been lit in such a way that a convincing impression of moonlight has been created, and a new era of photography at night has been entered. This type of work is covered in detail by David Cooke in Chapter 9.

Other Gear

I use the camera on a tripod when photographing birds at the nest, even when they are on cliff ledges; although I know that—in the past—the

sight of me working along a narrow shelf, feeling for the edge with a tripod leg while my head was under the focusing cloth, has caused my colleagues no little concern. In a hide a tripod is essential. There is no point in having a lens and film capable of producing high resolution if the camera does not remain stationary during the exposure. As the exposures in daylight are likely to be between 1/10 sec and 1/125 sec, the tripod should be rigid. Another important point is that one cannot hold a camera in the hand and keep it in the same place for long periods. A lens that appears and disappears is likely to disturb the birds being photographed and put the young or eggs at risk.

With the larger cameras a separate exposure meter is required and, as the light is likely to vary after the hide has been occupied, one that will take incident light readings is an advantage. With it one can then check the light from the back of the hide and minimize the risk of disturbance. A soft, clean cloth and brush should be carried; the former to mop rain spots or condensation from the lens surface, the brush to remove dust. A shutter release is also needed and as conditions in a hide are cramped, this should be long enough to allow it to be reached without undue strain. Lens hoods, a focusing magnifier, and a clearly printed card to focus on, are also essentials.

Films

In the larger sizes, where grain is not such an important factor, most of the established bird-at-the-nest photographers use a black-and-white film of about 400 ASA. When high speed is necessary, this type of film can also be used in the 35 mm size, and if correctly exposed and developed, will yield practically grain-free prints up to 30 × 25 cm. Films of between 100 and 200 ASA can give finer grain and slightly better definition. For colour transparencies there is not a wide choice of roll-film in the 9 × 6 cm or 6 × 6 cm sizes, and I use one of 50 ASA. For 35 mm size there is a considerable range; the one I choose is rated at 100 ASA. Colour is a very personal thing and opinions as to what is good colour rendering vary considerably. 'A' contends that 'Z' film has a blue cast and is not good on greens, while 'B' insists that 'Y' film is good on greens, but poor with reds, yet at a show of transparencies both will admire some which,

unknown to them, are on the film they dislike. After a few initial trials, choose the film that suits you best and stick to it. Constant changing from one to another will not allow you to make the best use of any. With every film there is a pamphlet giving developing details and as a start it is as well to follow the makers instructions. One point that cannot be over-emphasized is that the developer, rinse and fixer should all be the same temperature throughout the processing of a film. I am sure that many negative faults are due to temperature fluctuations in processing.

Camera-to-Subject Distance

Advice on this can only be given in the broadest terms. We do not all like the same proportion of bird to surroundings, neither do we wish to produce the same formula every time. Where the surroundings are photogenic it is a good idea to get them in the picture, and this is more easily done on the larger sizes of film. Recently when using a 35 mm camera to photograph blackcock 'lekking', I took a few shots with the 6 × 6 cm camera, keeping the images of the birds the same size on both. The prints from the larger negatives were a valuable addition to the series, as I was able to show the hill and give a good idea of the country around the lek.

The chart on page 107 gives some guidance, but to a large extent the final position will be decided by the vegetation, the nest and the surroundings. On cliffs in trees and on small islands choice of camera position can be very limited, and then one must choose the lens to suit the site, rather than the range to suit the lens.

Present Trends

If used properly, all the cameras described, with or without electronic flash, can produce high-quality photographs of birds at the nest. Although

Figures 3 and 4 (facing page). Ranges with various lenses. For birds with short necks allow 10 per cent reduction on the text-book measurement to allow for the natural attitude.

Allow a further 10 per cent for long necked birds that normally carry the neck at about 90 degrees to the horizontal body, e.g. curlews and ibises.

With some long legged birds, e.g. stilts, storks and herons the relevant measurement is the height of the standing bird.

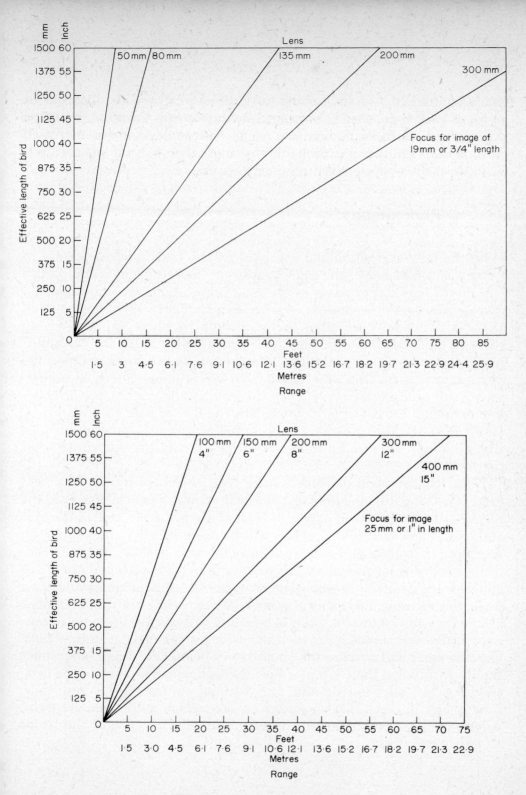

Best ranges with various lenses.

many established workers, hoping for the best of all worlds, have one or more of each type, there has been a definite swing towards 35 mm in recent years. In the same way, the use of flash in daylight has increased to such an extent that it is probable that more than half the photographs of birds at the nest are taken now with its use.

Photography

With the hide in position and accepted by the birds, and the choice of camera and film made, the photographer is ready to start work. At this stage quickness and neatness in the final preparations are important. As two people should be present, one to act as a decoy later, both should know what to do. Very often they will both be photographers, taking turns in the hide; while the one to occupy it first is fixing up his equipment, there are plenty of things the other can be preparing. Should the nest require 'gardening' this can be started, although the final adjustments will probably be made when the photographer views the arrangement through the camera. The assistant should see that no branches or leaves in the picture area have been pulled or twisted unnaturally. Also that nothing is left in a position from which it may later slip in front of the nest.

What happens then depends on the type of camera in use. If a field camera is being used the photographer will require the helper to hold the focusing device described on p. 101, just above the front edge of the nest and, with the lens at full aperture, will focus on it. Then, depending on the depth-of-field required, he will stop down the lens to f16 or f22 and, using a focusing magnifier, ask his partner to move the printed card back and forward while he checks what areas are in focus. This having been done the focusing mechanism is locked and, while the photographer makes himself comfortable, the helper can be securing the hide fastenings. If natural camouflage is used the assistant can make certain none is likely to move and obscure the lens. Before being left, the photographer should ensure that there is a peephole through which he can see the nest, and that he can wind on the film without unnecessary contortions. Finally he will check that all screws on the camera and tripod are tight. After all this has been done, the decoy, already having an agreed time for

his return, should leave the area as obtrusively as possible, making sure his departure is noticed by the birds. With either of the two other types of camera described, or when electronic flash is in use, there will be minor differences, but the basic principles are the same.

Once alone in the hide, one can sit quietly and wait. At this stage there is nothing to be gained and possibly something to lose, by looking out of various peepholes to see where the birds are. Two things are important— to avoid touching the hide cover and to be wearing clothes that do not rustle with the slightest movement. If your preparation has been well carried out you should not have a long wait; small birds are usually back at the nest with food quite quickly, although the seed-eaters, e.g. most European finches, feed their young at intervals of roughly half an hour.

It is always as well to allow the bird to settle on its eggs, or feed its young, on the first visit without taking photographs. It is likely to be wary at this stage and by watching it one can get a good idea of what to expect on subsequent visits, and when the best chances of photography will occur. If the bird is on eggs, let it sit for five minutes or so before making your first exposure. Note carefully what effect the shutter noise or the flash has, but do not attempt to wind on the film straight away. In the case of a bird feeding young the same procedure should be followed at the second visit. Should the exposure cause no reaction, wind on the film while the bird is present, and see whether this is accepted. If it is, one can then carry on taking photographs at intervals, making as little noise as possible.

Occasionally one will come across a pair of birds that, having accepted the hide, will jib at the lens, or at the inevitable small sounds made when photographs are taken. It is as well to be prepared for this by arranging for your helper to return when a handkerchief is shown at the back of the hide. Upon his arrival vacate the hide and, leaving it well secured, give the birds a little longer to become thoroughly used to its presence. If the birds are feeding young, the behaviour pattern of visiting the nest becomes more and more firmly established and hence harder to break. After a day or two, another attempt at photography can be made with every chance of success. If the birds still refuse to co-operate, it is as well to dismantle the hide, tidy the site and credit the time wasted to experience.

Although on holiday it may be difficult to do so, it is advisable to develop at once the first batch of pictures taken from a hide. One can then

see whether there is anything wrong with the set-up before taking more. The required adjustments can then be made. When the hide is no longer needed it should be removed and, even if the young have gone from the nest, the area left tidy.

Photography at the Nest without a Hide

There are many species of birds that it is possible to photograph without a hide, but of these a fair number show their awareness of the human presence so much that it is seldom worth while doing so. I remember one of the pioneers of bird photography saying: 'In my early days I photographed willow warbler and reed warblers at the nest without a hide, but it was never successful, they looked so strained in the finished result.' Dotterel and woodcock can be photographed without the use of extra cover, but I found with the former that, although in front of a hide it walked on to the nest with an upright stance, the bird crept on to the eggs when one was not used, its legs barely showing. When stalked the sitting woodcock takes up a crouching position quite unlike the head-up stance in which it normally incubates.

Seabirds offer the best opportunities for those who wish to take pictures of birds at the nest without using a hide. On massed colonial sites such as the Bass Rock and Ailsa Craig in Scotland, it is possible to approach gannets close enough to get pictures, without putting them off the nest. On some island groups, like the Farnes (North-east England), one can do the same with kittiwakes, guillemots, shags and Arctic terns. Because of the short time that elapses between focusing and being able to fire the shutter, reflex cameras, either 6 × 6 cm or 35 mm, are ideal. The light is normally so good that it is possible to use small stops and fast shutter speeds, but even so I still prefer having the camera on a tripod. I compose the picture, focus on the bird, stop down as required and expose, without fear of camera shake.

Remote Control

It is possible to operate a camera from a distance electrically, by radio or by pulling a string, and in certain circumstances the technique is a useful

one. For those who intend to use the method regularly an electric release is probably the best. These are easily made and not expensive. Radio equipment is costly and, in Britain, a Post Office Licence allocating a wave-length is required before one is allowed to operate the transmitter. Even stricter regulations governing their use are in operation in some other countries. Particularly over water, radio control has advantages, but only in exceptional circumstances does it justify the expense and licence problems. The danger with the string method is that the pull necessary to release the shutter can cause camera-shake. However I have used it with some success.

When using the remote control method one must be satisfied with very few photographs, or work on species that go away after each feed. After each exposure it is usually necessary to go to the camera to set the shutter and turn on the film, so this method should not be used where the birds remain close to the nest and are disturbed by every visit to the camera. Although most photographers prefer to work from a hide, choosing the poses to take, rather than use this somewhat chancy technique, there is no doubt that it can be very useful in situations where the presence of a hide could attract too much attention.

One of my own experiences will give an idea of the circumstances in which remote control can be used to advantage. I knew of a lesser spotted woodpecker's nest, about six metres up a tree that was well lit on the edge of a clearing in a small wood. Unfortunately, less than a hundred metres away, the village children had dammed a small stream and made a pool to which they came each day immediately school was over. As they ran about over a fair area, it was obvious a hide would attract unwelcome visitors. Taking with us a long length of sash cord, my colleague and I borrowed a ladder from a farm and tied the cord to it. This was done in such a way that it could be quickly set up vertical at the right distance from the nest tree and fastened there with stays to other trees. After that we arrived early each morning and, in little over half an hour, had the ladder in place with a camera clamped to a rung just above the nest entrance. A hide was erected across the clearing and the remote control led to it. About an hour before the children were due out of school we took care to remove everything. The nest suffered no interference and we obtained our pictures.

Completing the Series

Most of those who photograph birds at the nest wish to show as much of the breeding cycle as possible. A photograph of the nest and eggs is usually the first step towards this. It is as well to take pictures of these as opportunities occur, choosing the most typical examples you can find. For instance the 'basket handles' should show clearly in photographs of nests of warblers such as the blackcap and marsh warbler. Typical clutches of eggs, both in number and appearance, are the obvious choice, but unusual ones are also worth a picture. Among the photographs I value is one of a blackbird's nest containing white eggs with pinkish spots, and another of a lapwing's six egg clutch. Remembering how popular egg-collecting used to be, I am surprised that, since the advent of colour photography, more people have not taken up the portrayal of birds' nests and eggs as a hobby.

Although it is sometimes possible to look down from some vantage point into tree-top nests, this is rare; one usually has to climb, and there is little choice but to hold the camera in the hand. The miniature is the most suitable for this work. Where the nests are in bushes or under-growth some gardening is likely to be required and this should be done with care. As with photographs of birds, a plan view is not the most satisfying. With a cup nest containing five eggs, the angle should be such that the whole of three eggs and a small portion of the other two are showing. It is very difficult to photograph nests in holes effectively. To expose the eggs of woodpeckers and tits, pieces can be cut out of the trees, and digging will remove the cover from those of bank-nesting martins and bee-eaters; to do so is, in my opinion, quite unjustifiable, as the chances of causing desertion are great and the nests are put at unnecessary risk. However, photographs of the entrances in relation to the surroundings can be useful additions to series.

With shorter-focus lenses than used for the birds themselves, all the cameras described are suitable for nest-and-egg photography. Standard lenses, that is those supplied with the cameras, are adequate for this form of photography, allowing a closer approach, reducing the amount of necessary 'gardening' and enabling a higher viewpoint to be obtained if required. Because of the ease with which it can be carried, the speed with

which it can be used, and greater depth of field the combination of small picture and short-focus lens gives, the 35 mm camera is ideal for nest photography. A tripod is recommended and a pan-and-tilt head is essential. With the smaller camera one of the lighter alloy tripods is adequate and even when carried throughout a day's 'nesting' these do not become too great a burden.

The same apparatus is also very useful for the photography of the down-clad young of game-birds, waders and ducks. Often the groups of these, or individuals crouching to avoid detection, make attractive pictures. Young gulls have their favourite hiding places to which they retreat whenever there is any threat, and can often form a part of pleasing compositions of lichen covered rocks.

The End-product

The first essential of a Nature photograph is that the species of the subject is recognizable from the picture. Some workers who are neither interested in nor knowledgeable about birds, try to use them as a basis for 'mood' or 'pictorial' photography. The pictures cannot be considered as nature photography, and any resultant desertions are likely to be blamed on genuine nest photographers. This does not mean that photographs of birds at the nest cannot be both good portraits and aesthetically satisfying, though the difference between ordinary and outstanding bird portraiture is as much a matter of taste as of technique.

Ideally a nest photograph should have good definition from the bottom edge of the picture to the most distant part of the bird. With the more widespread use of the 35 mm camera one sees more out-of-focus foregrounds and these are less keenly criticized than they were. This, to me, seems to be a case of lowering the standard because it is not easily achieved, and I recommend the reader to aim at the ideal.

Obtrusive highlights—particularly if they are out of focus—can be an eyesore in either the foreground or background. If the final result is a print, something can usually be done about them at the enlarging stage; if it is a transparency they may be softened with transparent water colours, or photo-tints, though this requires considerable skill. This is one of those situations where prevention is better than cure. When

choosing nests to photograph, avoid those where patches of light show through foliage.

There are fashions in photography as in other things; what is generally accepted to be the right range of tone and contrast in a monochrome print varies from time to time. At present I think there is a slight reaction against the excessively contrasty print that has been popular. By all means produce bright prints, but remember that the tones should be in relation to the bird's colours. For instance, the golden plover is not a black-and-white bird and should not look like one in the print.

See as much original work as you can—published pictures have often been trimmed excessively to meet the editor's requirements—and this will help you to form ideas of standards and trends. Above all be self-critical; remember that those who see your final results will not know what difficulties you encountered and will judge them simply on their merits as photographs and pictures. The end-product must speak for itself.

The Future

Before considering technical advances it is as well to think of the future of the birds that are our subjects. There seems little reason to assume that, e.g. in Great Britain, the laws affecting the photography of birds at the nest will be any less stringent, and they may well become more so. In industrial countries, whether we like it or not, we who wish to photograph birds at the nest will—quite rightly in my opinion—only be allowed limited opportunities at most of the established reserves. These cannot be thrown open to all photographers without putting at risk some of the creatures the reserves have been created to protect. Remember that we photographers are only a small section of the vast numbers of people interested in nature, and favours granted to us are apt to create 'Why not me?' situations.

However, our woods, fields and moorlands are still the breeding places of many birds that are not particularly rare, and by obtaining the permission of landowners and farmers, it is possible—even near large cities—to find areas where one can work undisturbed. Many comparatively common species have been less well photographed than the rarities. There are far

more good European pictures of the red-throated diver than there are of the house sparrow.

The rarities of any country are often found more commonly in others. With the ease and comparative cheapness of holidays abroad, there is every reason for photographing a species where it is common. Furthermore, there are relatively few restrictions on photographing birds at the nest (other than in reserves) in countries other than Britain. However, before setting out on a trip it is always as well to make sure what rules there are. One of the great advantages of going to where a species is numerous is that one has a wider choice of nests and possibly of species. In a comparatively small area of beach backed by marshy fields in Denmark, I worked two pairs of avocets, two pairs of black-tailed godwits, one pair each of Kentish plover, little tern and reeve at their nests. Apart from the plovers, I had many sites of each to choose from. Alternate days I spent in a hide near a goshawk's nest in one of the forests. The photographer gains in another way where several pairs of species which nest singly in his area are nesting in a scattered colony; those that have nests some distance from the hide return to them quickly, thus encouraging those that have to approach it more closely. When people go abroad, it is of course expected that they will observe the precautions and courtesies they use at home.

On the technical side, the making of colour prints seems to have lagged behind, probably because of the cost and, if home processed, the time involved. The fact that publishers prefer colour transparencies may also have had some effect. One problem appears to be the retention of good definition, and very few colour prints enlarged from 35 mm transparencies have given complete satisfaction in this respect. There is no doubt that the negative/positive colour processes can yield magnificent results and I have seen some very fine prints in this medium. A cheaper, simpler process would give this branch of photography a tremendous fillip. In spite of forecasts to the contrary, I am sure black-and-white photography will continue for a long time, partly because of the costs of colour reproduction and also because it is satisfying in itself.

A 35 mm camera in the middle price range with interchangeable backs would be welcomed by many nature photographers, but this would have a minority market and it is unlikely to be a commercial proposition.

One thing is certain and that is that although damage done to breeding

birds by photographers is infinitesimal compared with natural losses, some sections of public opinion—often uninformed—are such that it behoves all photographers who work at the nest to use the utmost care, in order to avoid doing anything prejudicial to the future of this, the most interesting branch of bird photography.

Bibliography

Bird Photography, Yeates, G. K. (Faber and Faber) London, 1946.

Bird Photography as a Hobby, Hosking, E. J. and Newberry, C. W. (Stanley Paul) London, 1961.

Keartons' Nature Pictures, Kearton, R. (Cassell) London, 1910.

(These are examples of older-fashioned nest photography—some of them of quality at least equal to anything being produced today.)

6

Birds Away from the Nest

J. B. and S. Bottomley

The photography of birds other than at their nests relies on three basic techniques: stalking, 'wait-and-see' and the use of bait. The first and last of these methods explain themselves, but the second may require some clarification. Although it has been a well-understood term among bird photographers for over half a century, it now covers a somewhat wider field than it did when first applied to the photography of passage and wintering waders. Then, the photographer erected his hide at some likely spot such as a well-used feeding pool or resting place and 'waited to see' what would come within range of his camera; nowadays, although waders (and wildfowl) are still the main subjects, the description wait-and-see refers to any bird photography done from a hide other than that carried out at or near a nest, or at a baited place. In this connection it should be mentioned that photographs secured in what may be termed the general environs of a nest (but with the nest itself excluded from the final result) cannot properly be called photographs of birds away from the nest. This may seem patently obvious, but shots of this sort are published frequently as such if, for some not always very creditable reason, it has been thought undesirable to show a straightforward nest picture.

This chapter is concerned chiefly with temperate and sub-arctic climates. The rather specialized tropical countries are referred to in Chapters 2 and 16.

Stalking—General

The main advantage of this method is its great flexibility; photographs can often be obtained of a species that normally would be almost

impossible to approach using a hide, because its habits or behaviour are unpredictable, its normal food is such that baiting is impracticable or its breeding grounds are inaccessible for political or other reasons. This same flexibility enables the stalking photographer to concentrate on a particular individual bird, which is important for the recording of rarities. Further, the photographer is not restricted to a previously- and, quite likely, wrongly-chosen hide position, but can approach his subject in a manner and from a direction suitable to the circumstances, conditions and, most important, light direction prevailing at the moment the chance of photography occurs.

Methods

There are four so-called first principles to be borne in mind. Firstly, sombre clothing is essential and the wearing of a camouflaged jacket certainly would not be a fad. Secondly, advantage should be taken of any cover available, however insignificant; a clump of rushes, for example, or a shallow fold in the ground can be surprisingly useful. Thirdly, when it is necessary to approach a bird in full view (and this can worry some individuals far less than the sudden emergence of a suspicious-looking human head and shoulders at a gap in some foliage or over the top of an embankment), weaving from side to side should be avoided; a looming figure that only gets slowly larger would seem to be less threatening than one that dodges about as well. Fourthly, all movements, including those small ones needed to make adjustments to the camera and lens settings, or to wind on the film, should be careful and deliberate. If possible, such actions should be carried out while the bird is occupied itself; for example, when feeding, preening or, if it is a water bird, diving.

In stalking, light and weather have important applications additional to the normal photographic ones. From experience it would seem that for the sun to be at the stalker's back as he is approaching his bird in the open is a bad thing, probably because his bulk, thrown into stark relief, looks especially menacing from the bird's viewpoint; but as side or back lighting is seldom desirable in a stalked shot it is a situation that often cannot be avoided. Wind is important, too, because its bearing governs the direction of take-off of all but the smallest species; if the photographer

takes this into account and avoids any tendency to 'cut off' the bird in his approach he will not only worry it less but, if it is alarmed into departing suddenly, he will stand a far better chance of a successful flight shot.

A further consideration is the bird's, or group of birds', own behaviour, and this can vary from day to day and even from hour to hour. It will be found frequently that a shy and unapproachable subject can change overnight into one that can be stalked to close range with ease; but sometimes the reverse is the case. Hunger, degree of tiredness and, again, weather (particularly the amount of wind) all can have a marked effect on a bird's behaviour. In addition, some species have inherent traits; dotterels, for instance, are often ridiculously confiding, even on passage, while redshanks are notoriously wild.

While these remarks suggest that the stalker should not give up too easily, no bird, whether common or rare, should be harried persistently, especially if it is tired or trying to feed. An apparently tame individual really may be one that is too exhausted to care, and should be treated accordingly. Mention should be made here of the practice of stalking breeding birds in the area surrounding their nests, when the parental pull towards young (or eggs) can be so strong as to make them unwontedly bold. Because of the disturbance which this procedure so easily creates (usually far greater than that caused by the properly rapid erection of a hide), it is not to be encouraged. Quite commonly a photographer will announce that a shot of this sort was 'taken without a hide' in tones that invite some sort of commendation for his careful approach to bird photography, when, in fact, the opposite is the truth. Adult birds escorting family parties of young, well clear of the nesting site, are a somewhat different matter, but here again great care should be taken to avoid harming the young ones either by treading on them (sometimes they can be almost unbelievably difficult to see), by preventing the parents from brooding them in cold weather, or by dispersing them and thereby exposing them to predators.

Cameras

Although in theory a camera of almost any format could be used for stalking birds, the choice nowadays normally lies between those taking

120 roll-film with a negative 6 × 6 cm and those using 35 mm film; only these two sizes will be considered here.

The advantages of the larger negative are well known, but the photographer who wants to stalk birds must be able to use these advantages. Chiefly, he must be able to obtain an image of his main subject that is large enough to make full use of the picture area available on his film, and in practice it is only rarely possible to get close enough to a wild bird to do this. Occasionally, of course, extremely confiding individuals are encountered, but these are very much the exception and there seems little doubt that 35 mm cameras are, on the whole, the more useful type for stalking. Apart from being generally cheaper, these small-format cameras, including their lenses and attachments, are lighter, more compact and more versatile—all points that the bird photographer who needs to have his gear constantly with him (not a couple of kilometres away in his car) will find of major importance. However, where groups or flocks of birds are to be photographed the larger format is unquestionably more suitable.

Returning to 35 mm, the basic requirements of a camera suitable for stalking birds can be reduced to three. These are single-lens reflex design (the ability to track in the viewfinder an often very active subject right up to the moment of exposure is of supreme importance; a reflex housing on a rangefinder camera allows this also, but it is bulky, heavy and a big additional expense), the acceptance of interchangeable lenses, and the availability of shutter speeds up to 1/1000 sec.

Through-the-lens metering has obvious advantages, as has a motor-drive, but the former is not essential and the latter is somewhat of a luxury, even if a very useful one.

Lenses

The choice of a lens is more difficult and here it is impossible to ignore the price factor as, apart from optical qualities, this is affected so much by the features offered in any particular model.

Focal Length

The most useful focal length is probably 400 mm (it is certainly the most popular), although focal lengths up to 1000 mm can be used. The

photographer who is tempted to go for the longest available focal length should bear in mind that increased image size also means increased risk of camera-shake (whether or not a tripod is used).

Focusing Range

Apart from focal length, the most important feature is whether it will focus sufficiently close to be usable without extension-tubes or bellows— a point that is often forgotten. Accepting a 400 mm lens as being a useful all-round one for general wildlife photography, it will be found that the closest distance at which all the currently-available cheaper models will focus is between 6 and 9 m. If the bird to be photographed is small (for example, a tit or a bunting) such a range is too great for a good-sized image; it is no use being able to move close up to a subject if one cannot focus on it when one gets there. Extension-tubes or bellows solve this, but their fitting and removal in the field can present problems. Apart from the irritation of having to juggle with equipment in what can be trying circumstances (perhaps on a muddy estuary in half a gale), it is easy to be caught out by being unable to take an unexpected long-range chance, such as a flight shot, because an extension-tube is already in position for a close-up. If the stalking photographer wishes to include small bird species among his subjects he must employ a lens that allows him to focus as close as he can reasonably want, which in the case of a 400 mm lens would be in the region of 4·9 m. Regrettably, this requirement seems to be met only in the more expensive models.

Maximum Aperture

Apart from adding considerably to the cost of a lens, a large maximum aperture (which in the case of a long-focus lens would be one greater than f5·6) contributes a good deal to its weight and diameter; in practice, f5·6 or f6·3 (commonly available on 400 mm models) is generally sufficient.

Automatic Aperture Control

While highly desirable because of its aid to speed and steadiness, this facility adds a fair amount to the cost of a lens. Where the lens is of the pre-set type (the usual alternative nowadays to an automatic one), the position of the aperture closure ring can be important; the ability to

rotate it without the need to move the lens-supporting hand along the barrel after focusing (and just prior to the moment of exposure) notably increases the photographer's efficiency. Ideally, this rotation should be effected merely by the flick of a finger without a change of grip.

Before leaving the question of lenses mention should be made of two types which, although differing in design, are eminently useful for stalking birds. The first of these incorporates a precise 'follow-focus' system operated by squeezing a spring-loaded control on a pistol-grip fixed below the lens barrel. But in this arrangement the hand releasing the shutter also has to make any necessary adjustment to the aperture closure ring.

The second type is the mirror- or reflex-lens, a design discussed in more detail in Chapter 17, since it has applications in other fields of nature photography. It is of particular value in stalking because of its compactness and lightness, as well as its close-focusing facility. On the other hand, the fixed aperture limits exposure adjustment to changes in shutter speed. Further, the ring-shaped rendering of out-of-focus highlights can be embarrassing, particularly in colour where they cannot be retouched. But, on the whole, there is no doubt that mirror-lenses, because of their general handiness, can be extremely useful. A 500 mm example, attached to a camera, can be carried easily for hours in a case no bigger than that needed for a medium-sized binocular.

Avoiding Camera-shake

At first sight a tripod would seem to be an essential requirement when using a long-focus lens, but the stalker will soon find that it causes more failures than successes and that it will not even begin to compensate him

Plate 21. Examples of birds stalked, away from the nest. (Upper) Lesser yellowlegs; range 10 m. Notice the 'double' out-of-focus lines in the background, caused by the use of a mirror-lens: see p. 370. Nikon F, 500 mm Reflex-Nikkor: 1/500 at f11 on Tri-X film developed in Microdol-X.
(Lower) Grasshopper warbler, male 'reeling'; range c. 4·5 m. Details as above but 1/250 at f8.

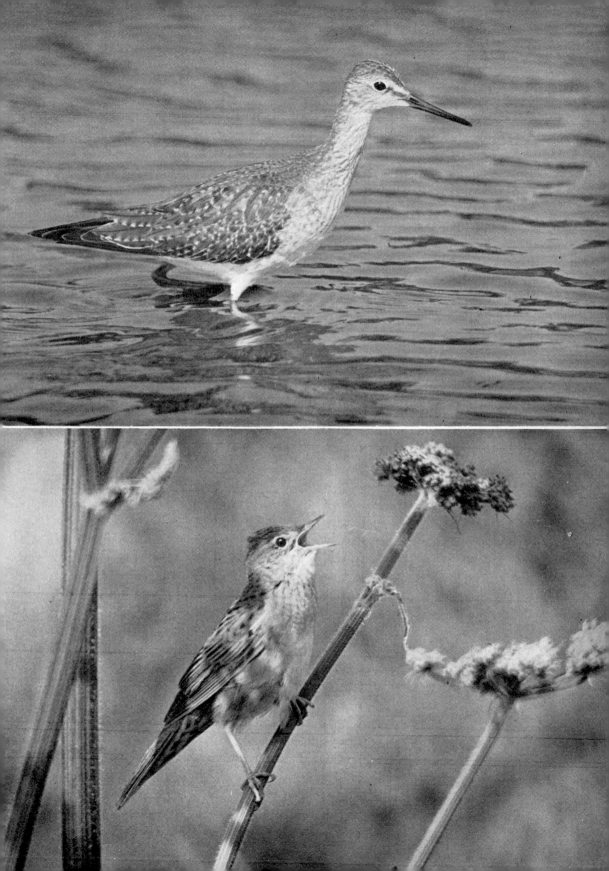

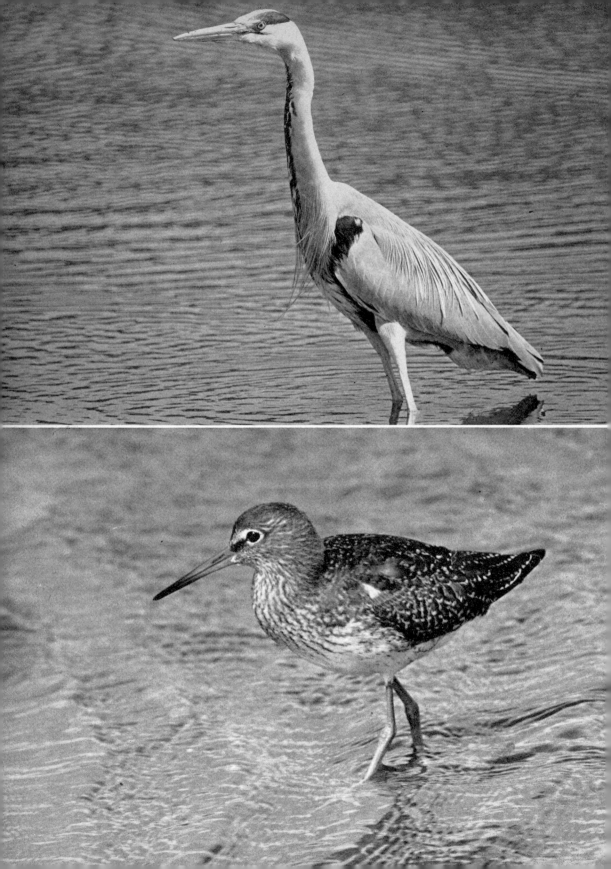

for the labour of humping it about. To be effective when used with lenses of long focal length, a tripod that is adequately rigid is unavoidably large and heavy. Even then, we recall an occasion when, using an ex-government surveyor's tripod of exceptional robustness with a 300 mm lens, the vibration caused by a moderate wind was clearly visible in the viewfinder. Unless a tripod can contribute real as opposed to illusory rigidity, quite literally it does more harm than good; the alternative of hand-holding the camera is more efficient and has a number of other advantages.

Firstly, the need to be able to track an often very mobile bird and to switch quickly from one subject to another is far and away more easily met by a camera held in the hand than by one clamped on a tripod. Secondly, although high shutter speeds (1/125 sec and faster) are needed to counteract camera-shake with a hand-held camera, these fast shutter speeds are usually needed anyway to control subject movement. Lastly, a camera operated in the hand is more often than not higher above ground level than one fixed to a tripod, and this is a factor which helps to reduce the amount of out-of-focus foreground in the resulting negative (see also p. 377).

Reference should be made here to a piece of equipment that is almost a *sine qua non* of stalking bird photography, the 'shoulder-pod'. This has a butt that fits into the shoulder and enables the camera to be aimed like a rifle; a pistol-grip and trigger may also be incorporated, the latter being cable-connected to the shutter release on the camera. The increase in steadiness achieved with this piece of equipment (provided that it, too, is of robust construction) is such that the shutter speed employed can be at least one setting slower. Alternatively, if maximum shutter speeds are used, it is possible, with a shoulder-pod, to take hand-held photographs with lenses of extreme focal length, even up to 1000 mm. This is particularly useful in the case of shy and unapproachable rarities.

Plate 22. (Upper) Heron. A wait-and-see shot, using a car as hide. Range *c*. 18 m. Details as for Plate 21 but 1/500 at f8. Notice again the effect of a mirror-lens on out-of-focus background lines.
(Lower) Redshank. Wait-and-see, using a conventional hide. Range 7·5 m. Nikon F, 300 mm Auto-Nikkor: 1/500 at f8 on FP4 film developed in Promicrol.

Wait-and-See—General

Although there is dissension as to which of the early British bird photographers pioneered this technique, the first regularly successful wader results were achieved by the late Guy Farrar before the last war. The equipment that he and other early enthusiasts used was big and unwieldy, not so much in their cameras which, although often large-format could be 6 × 6 cm, but in the only choice of lenses then available. These were generally 'straight' objectives with focal lengths of up to 750 mm, and needed extreme extensions on the cameras, as well as tripods (or specially-designed 'focusing tables') of appropriately solid proportions. If this, often home-adapted, gear was of somewhat gimcrack appearance the results obtained certainly were not; in fact, the resolution and quality in their photographs have rarely been equalled since. However, the number of successful shots was comparatively small, and they were limited to a fairly narrow selection of species whose habits lent themselves to what was basically a rather inflexible technique.

Nowadays the many small-format cameras on the market, taking a wide range of compact medium- and long-focus lenses, have not only widened the scope but made it much easier as well.

Methods

The basic requirement of this type of bird photography is the correct selection of hide position, and it is necessary here to enlarge on the opening paragraph of this chapter, where the term 'wait-and-see' was discussed briefly. In practice, wait-and-see is often a misnomer, as this is usually exactly what the photographer does not do. Generally, he is pursuing a particular species or group of birds or, sometimes, a special individual (if it is a rarity), and his choice of hide position is influenced by

Plate 23. More examples of wait-and-see work. (Upper) Curlew, with beak half buried in estuary mud. Range 10 m. Details as for Plate 22 (Lower).
(Lower) Pectoral sandpiper, walking briskly. Range 9 m. Details the same.

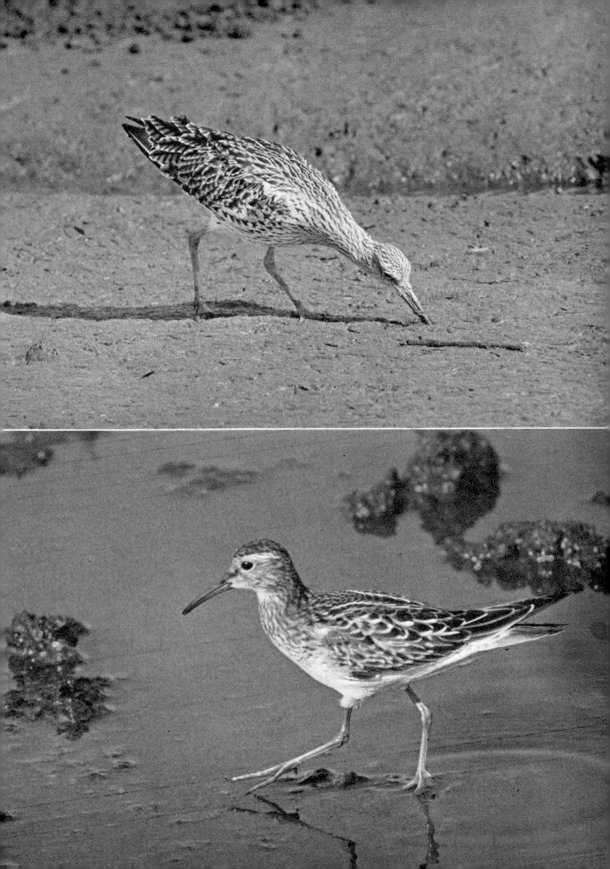

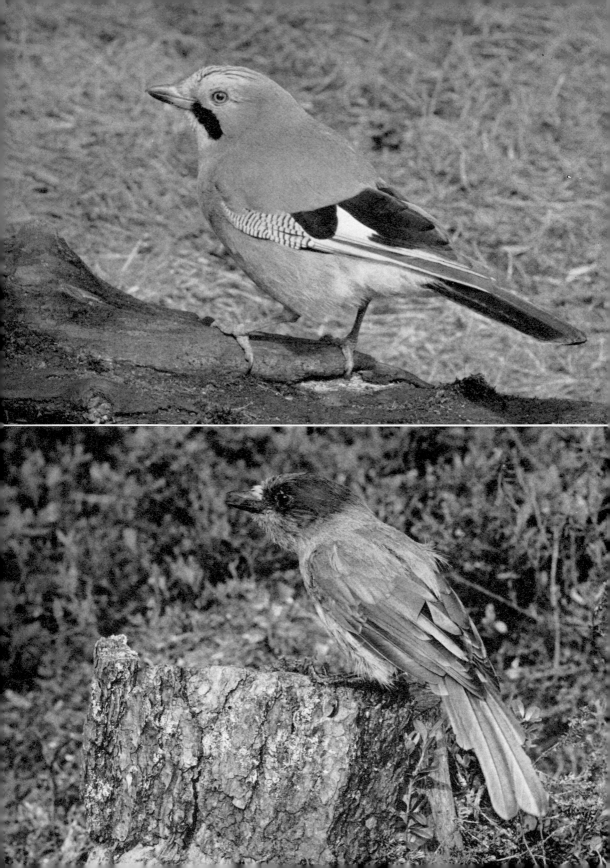

what he knows, or has been able to learn, about the habits and local behaviour of the birds concerned.

The places most suitable for wait-and-see photography will almost invariably be associated with birds' feeding, resting and, in certain special cases, display grounds, and there are several points to be borne in mind when erecting a hide.

Whenever possible it should be sited when the quarry is absent, and this should be done as long as is reasonably practicable before it is to be occupied—say, 48 hours. However, this is often not possible because of the risks of human interference, damage to the hide from tides or indicating likely targets for illegal shooting. On the other hand, a hide will often be quickly accepted by the birds and the photographer will be able to occupy it immediately after putting it in position, particularly if it is small, low and well camouflaged.

The design of the hide itself can be closely similar to that used for nest photography (see Chapter 5), with rigidity of major importance (a hide that moves even slightly in the wind is a disaster). It is worth bearing in mind that much wait-and-see photography is in extremely exposed situations, sometimes in the depth of winter, so that heavy-duty hide material not only helps stability but also provides a certain amount of insulation for the photographer. The only necessary modification to a nest-photography hide is the provision of additional lens- and observation-openings on both sides and at the back. Further, a sharp penknife is an important item of equipment for the wait-and-see photographer so that he can make an extra lens-opening rapidly should a subject appear at a tantalizingly awkward angle. As for size, a height of 120 cm should be treated as a maximum, with sides not more than 90 cm across. A good case can be made for a hide as low and as small as possible, especially on open mud-flats, but if it is too cramped the photographer's all-round efficiency will be much reduced.

Camouflage of a wait-and-see hide is important, to deceive not only the birds but also humans (an increasing source of interference in recent

Plate 24. Birds at bait. (Upper) Jay. Range 2·9 m. Gandolfi field camera, 25 cm lens: 1/30 at f16 on HP3 roll-film developed in Promicrol.
(Lower) Siberian jay. Range 3 m. As above but 1/40 at f22 on Tri-X film.

years). On more than one occasion we have been amazed by the effective-
ness of quite primitive camouflage, even against bird-watchers who have
sat within a few metres of a hide without noticing it, and have admitted
so later! The choice of camouflage is fairly straightforward. The material
used should be coloured with the well-known disruptive pattern of
greens and browns as used by the Services; but this can, indeed should,
be varied to suit a particular habitat. Whenever possible additional
natural cover, such as reeds, should be added (one or two cords tied
horizontally and tightly round the hide easily hold it in place), although it
can be tiresome if it interferes with the lens when tricky angled shots are
being attempted. An effective alternative is ex-Army vehicle camouflage
netting which can be thrown over the hide and which also allows the
'planting' of local vegetation in the mesh.

The actual position for a wait-and-see hide is largely a matter of
commonsense, and any photographer will know well enough how to set
it up in relation to the light, although it is perhaps worth mentioning that
the angle of the sun can change considerably between the time when a
hide is first occupied and when the first exposure is made, perhaps three
or four hours later.

Estuary work is still the most usual application of wait-and-see
photography and this can be tackled in two fundamental ways. A hide can
be erected either at a resting place for birds above high-tide mark, or it
can be put by a channel or creek left by the receding tide where they
feed. In the first case the birds (mostly waders) are required to congregate
slowly, perhaps over a period of hours, on dry ground as their feeding
areas are gradually submerged beneath the rising tide. Ideally these
collecting places should be free from all disturbance, and should be
limited in size and number if the photographer is not to be frustrated by
the birds having too many alternative sites to choose from. Traditionally,
the autumn wader passage period (from August to October) is the best
season for this sort of work, and on suitable estuaries and in the best
conditions, numbers can be spectacularly high, though the variety of
species (in the UK, oystercatchers, redshanks, knots, dunlins and so on)
may be fairly small. If the photographer chooses his pitch with care, and
ensures that he is in position well in advance, he may be rewarded by
these normally shy and elusive creatures packing right up to the foot of
his hide.

In the second method, although numbers will be less, the variety of species to photograph will almost certainly be greater. Here the need is to get the hide near the recently-exposed feeding ground as quickly as possible after the tide has receded. The use of thigh-boots (or even ordinary gumboots) enables the photographer to get settled in before the water has cleared from his chosen site (a 'putter-in', as recommended for nest photography, is also highly desirable). It almost goes without saying that careful reconnaissance and a proper knowledge of the behaviour of the local tides (with and without wind) are essential if minor, or indeed major, disasters are to be avoided.

Another source of wait-and-see photographs, although a much more specialized one, are the display grounds which certain birds use regularly in the breeding season (cf. comments on p. 41). Two species well known for indulging in these 'leks' are the black grouse and the ruff, although other birds (for example, the great snipe) also go in for a similar form of jousting. This is not the place to describe in detail the ritualized posturings that the males, attended by the females, perform at these traditional sites, but the opportunities for photography will be readily appreciated. In the case of the black grouse the most intensive lekking is at, or even before, dawn, although it often continues until the light is good enough for photography. Ruff leks go on throughout the day and are therefore less of a photographic problem.

Before leaving the subject of wait-and-see methods mention should be made of the use of a car (as described in Chapter 2) as a form of hide. There are many limitations but even in industrialized countries, if suitable access and hard-standing are available, a car can be extremely effective in providing cover for a photographer.

Equipment

On the whole the same cameras and lenses as used for stalking are right for wait-and-see photography, although the 6 × 6 cm format can be employed with much greater advantage; estuary work in particular (and at leks) often involves the recording of groups (large and small) of birds to which the small negative area of 35 mm film cannot do full justice. Further, birds photographed from a hide can often be very close to the

camera and the larger format can give the big images which most bird photographers find so desirable.

The only other major consideration is the use or otherwise of a tripod, and the answer here lies in the circumstances prevailing. If the photographer is in his hide at a high-tide roost, with the waders in front of him merely loafing about, perhaps on one leg and with shoulders hunched, the use of a tripod is strongly recommended; slower shutter speeds can be used and small apertures employed so as to give maximum depth of field. On the other hand, a single wader feeding actively in the shallows, perhaps close to the hide, is almost impossible to track through the viewfinder except with a hand-held camera, preferably using a shoulder-pod. Further, a hand-held camera can be switched much more quickly to any of the alternative lens-openings on the other sides of the hide.

Bait—General

Before going into the various ways of using bait for photographing birds (a method employed by C. W. Teager as long ago as the 1920s, to obtain remarkable shots of wintering fieldfares) it is worth making some general points.

The bait itself should be either invisible in the final result or it should be a natural, or at least unobtrusive part of it. The baited site, too, should be natural and should be chosen so as to give a satisfying picture, not only from a photographic but also from a biological aspect. With the general effect so much under the photographer's control there is no excuse for such things as obtrusive backgrounds or offensive highlights. Excessively careful arrangement of perches and surrounding vegetation, so as to include as much as possible in the depth of field of the lens, should be avoided, as this is liable to give an artificial or 'studio' effect.

Almost all bait photography is best done from a hide similar again to that used for nest photography, but careful and very thorough natural camouflaging is usually necessary for raptors and the crow family.

Methods

The group loosely known as 'garden birds', which in northern Europe includes such species as hedge sparrow, blackbird, chaffinch and the tits,

can be photographed easily at a bird-table stocked with the recommended foods and suitable kitchen scraps. Volumes have been written giving somewhat earnest instructions on how to feed birds in the garden, but we have never found anything to beat cheese as a bait, although fruit-eaters such as waxwings regularly attend for raisins in North America—a habit not yet recorded in Europe.

However, no matter how attractive in themselves, birds do not make much of a picture while standing on a rather squalid bird-table, so natural perches should be provided and positioned in such a way that the bird-table itself is outside the picture area. The whole set-up needs to be placed so that a suitable and unobtrusive background appears well out of focus in the resulting photograph. It is worth remembering that the twigs used as perches should be changed frequently; not only do they get soiled and polished with use (this soon shows on film, particularly colour), but too long an employment of the same prop becomes painfully obvious in a series of shots from the same site.

A species now seen regularly at bird-tables in Europe is the great spotted woodpecker, and its taste for cheese and fats can be exploited by inserting caches of these foods in small natural or artificially-made holes in suitable trees. Considerable care in the positioning of the hide and camera is necessary here so that the bait is hidden from the lens by the curvature of the stem. Again, for the reasons mentioned earlier, excessive use of the same baiting spot should be avoided.

In many parts of the world members of the crow family will come to bait, particularly carrion or something which shows prominently, such as white bread, and we have successfully photographed Siberian jays in Arctic Finland in this way. But it is usually necessary for the hide to be in place for about a week before photography is attempted. This form of baiting should not be employed during the breeding season if there is any danger at all of attracting predatory birds into the vicinity of the nests of other species, particularly ground-nesters.

Before and after the last war H. G. Wagstaff secured a remarkable series of buzzards photographed at bait and his results remain unequalled to this day. The lure was rabbit (which, incidentally, meant a perfectly natural photograph) and the semi-permanent hide was built of natural materials so well camouflaged as to look almost an integral part of the fell-side on which he was working. However, the time spent in preparation

could be measured in months (almost years) and the necessary constant replenishment of the rabbit bait was extremely time-consuming. All this was followed by long hours in an often very cold hide; but Wagstaff was among the most patient of what in those days was a very patient fraternity. His methods have been imitated for other species of raptor since, with varying degrees of success, and there is no reason why this field should not be explored further in the future.

Using a drinking pool as bait it is possible to obtain pictures of species that would otherwise not come within camera-range in this way, particularly the pigeon family (great drinkers), finches and sandgrouse (cf. p. 37). The method is normally only successful in dry weather (or in dryer areas) when the birds' choice is limited and the photographer can erect his hide at a well-favoured spot. An artificially-prepared pool (the flooding of a suitable hollow is the most natural) has the added advantage that the selected place can be one where lighting and other factors (lack of human disturbance is important) are the most favourable. It has been suggested that dripping water (which can be arranged fairly easily) adds to the attraction of a pool from the birds' point of view.

Baiting can be an opportunist method like stalking, and the photographer should be ready to take advantage of any fleeting chance. Fieldfares, again, have been successfully photographed while feeding on fallen apples in hard weather, and we have attracted a water rail (an exceptionally skulking species) within range by exploiting its carnivorous tendencies and offering it raw minced meat; on this occasion the bait was also taken by a grey wagtail. The provision of grain on or close to water used by wildfowl is worth trying, although the danger of facilitating unauthorized shooting is always a risk.

Choice of Film

It should be remembered that when stalking or wait-and-see photography is the method, not only are high shutter speeds nearly always the rule but lighting conditions are often not very good. Fast film (monochrome and colour) is therefore a regular choice, although a medium-speed fine-grain film can usually be used up to the end of the autumn.

The inherently more pronounced graininess of fast film may be

thought to be of little consequence where the main image is large, but where the film frame includes a number of small images (for example, a group of waders) this graininess can detract noticeably from the effective resolving power of a lens. In such a situation a slower, fine-grain, film should be used.

Most of the above remarks apply also to bait photography, except that in close-range work (with or without electronic flash) much slower films, with consequently higher definition, are more appropriate.

Conclusion

Having considered the various ways by which birds can be photographed away from the nest, it seems worth suggesting the sort of results which might be aimed at. Straightforward portraits, sharp and of high quality, are very satisfying, but much more can be achieved when fast shutter speeds are used. Display, in all its varying facets, is an obvious first example; feeding methods, preening and bathing, fighting and even resting and sleeping all offer opportunities for interesting shots. In addition, recording immature, winter and eclipse plumages (especially those of wildfowl) has so far received little attention from photographers.

Bibliography

British Waders in Their Haunts, Bayliss Smith, S. (Bell) London, 1950.
Masterpieces of Bird Photography, Hosking, E. J. and Lowes, H. (Collins) London, 1947.
The Feathered Folk of an Estuary, Farrar, G. B. (Country Life) London, 1938.

7

The Uses of Play-back Tape

Frank Blackburn

Introduction

The idea of attracting animals and birds close by simulating their calls or song is by no means modern. Prehistoric man must have used the technique as an aid to hunting, just as primitive man does today. Even in our present civilization artificial sound implements are manufactured specifically for the hunter, wildfowler and (in some less conservation-minded countries) bird-catcher. Few resemble the required call exactly, but they are nevertheless efficient enough for the intended task. Even the crude sound made by rubbing a stick over a notched bone was one widely used to call corncrakes out of cover. And the owl, an international symbol of wisdom, can be deceived by the simple hoots produced by blowing into cupped hands. As a boy, I witnessed a fox being called from afar to a few feet away by oral mimicking of the distress squeals of a rabbit. In America a similar squeal has been manufactured and is used to attract birds of prey.

The advent of magnetic tape has now made it possible to record complicated songs, dub them repeatedly, carry them out into the field, and amplify them without much effort. This technological age of electronics and printed circuits has even provided lightweight cassette players, so that hours of recorded sound can be easily carried in a jacket pocket. Despite the availability of these ideal facilities, relatively few wildlife photographers have so far taken advantage of their use. In part this is probably due to the reluctance to break away from established methods in order to explore an uncertain one; others lack the facilities and

know-how to record or dub the required song initially. In my own case, although I had noted the potential of call-back, and was very keen to exploit its possibilities, it was not until I met Victor Lewis in 1967 and could take advantage of his help and equipment, that I was able to do anything about it. For those who lack these facilities there are enterprising recordists who offer pre-dubbed tapes to order as a commercial service: this is an excellent idea, but few photographers seem to be taking up the challenge. Consequently, little has been written on the subject, and it is still not possible to write about the technique in comprehensive terms. My own experiments, compared with the world-wide potential, only scratch the surface, but they should serve as a useful guide to those wishing to extend the science. This last point is all important; it is better to think, not so much that the technique works with blackcap, chaffinch or woodlark, but that it will work on certain warblers, finches, larks and so on. Universally, these genera are more or less biologically the same and should give similar reactions throughout the world. The main purpose of this chapter is not so much an attempt to inform readers how the technique works as—by proving that it does work—to stimulate people into carrying out their own experiments.

Principles of Operation

Basically, the idea takes advantage of the behaviour of birds when they hear their own specific song or calls; the technique has obvious limitations, and should be considered as a supplementary rather than a general method of obtaining wildlife pictures. But it is no mere fly-by-night gimmick: it has enabled me to photograph species which would have been difficult and time-consuming by orthodox methods, and, as the birds are all pictured away from the nest (often in display postures) the results are not stereotyped—in keeping with modern trends in wildlife photography. Call-back is only another method of overcoming the main problem of photographing wild creatures—that of getting close to a wary subject. The idea is simply to call a bird over by playing back its song and photographing it as it perches near a controlled song-source. Success will depend on many things—equipment, weather conditions, the time of

day to some extent, and, most important, the physiological condition of the bird itself.

As we are so concerned with song, as much as possible should be learnt about its biological function in order to achieve maximum efficiency in the field. In some species song is replaced by other territorial sound signals (the resonant drumming on a dead branch by most woodpeckers, for example) and unless one is familiar with such facts, opportunities will be missed.

It has long been known that song replaces inter-specific fighting in defence of the territory and is used to advertise claim to that territory. Its use may be either to attract a female or intimidate a male of the same species. The response will depend on the physiological condition of the recipient. These factors will make the difference between good, bad or indifferent response to call-back, and are the reason for negative results being reported from some potentially responsive birds. To simplify this confusion, I have categorized the various responses into three main types: 'peak', 'secondary' and 'low' responses.

Peak response is usually from unmated males, especially at a time when they first arrive to stake claim to a territory. With some resident birds this can be unexpectedly early; in fine sunny periods it may be even as early as February in temperate latitudes. For some warblers and finches the response is very intense, resulting in the birds flying down and attacking the loudspeaker as soon as the song is played, though normally a short period is required to locate the source of sound. During peak response, the bird becomes so intent on seeking out the intruder that it seems oblivious of man, even landing on the loudspeaker when it is placed at the feet of the operator.

This intensive condition may last for only a short time, depending, apparently, on how soon a pair-bond is established. It took me several years to catch a grasshopper warbler just in this vital period between arrival on territory and the establishment of a pair-bond. All previous attempts with this species indicated a low response. I had a bird so responsive one day that it sang from my foot while I had the play-back machine in my hand, yet it refused to come within 3 metres the following day when a female had been attracted into the territory.

Generally speaking then, the typical peak response species will be a small one that naturally uses song as opposed to visual display to attract

a mate and maintain the territory. It will normally be located in the early part of the breeding season (unless unmated or, sometimes, between broods), and it will become so aggressive that the body movements will be quick and erratic. Within seconds of play-back it will use perches close to the loudspeaker, which it will attack as soon as the source of sound has been pin-pointed. And it will often become so 'tame' that it is possible to work within a few feet of it without concealment.

Secondary response can come from the decay of peak response, or it may be the only natural response of some species. While a bird in secondary response will not attack the loudspeaker, or sing from your foot, the possibilities of photography are often better than with a fiercely aggressive bird: there is little to be gained by having a bird displaying on a loudspeaker if it is not suitable to photograph it there. Its approach to the play-back song will be more cautious and less erratic, and it will tend to stay on a nearby perch rather than use it as a staging point. Though not as 'confiding' as a peak response bird, it will allow a much closer approach than normal and will sing from a perch long enough for a good series of pictures to be taken.

It would be foolhardy to quote any definite time for a peak response bird to change to secondary; indeed it may make both responses on the same day, though a definite change does take place once a mate has been attracted. It is sometimes thought that play-back may disturb an established pair-bond. My experience is exactly the opposite—as soon as a pair-bond is established, it overrides the attraction of play-back to an overwhelming degree. But this is a possible factor to be borne in mind when working overseas, or with a species previously unworked by this technique. Some species will only use secondary response even when unmated. These are generally the more colourful males (the stonechat is a good example) which use exposed perches and mainly sing only for a short period prior to breeding. Once breeding is under way they tend to ignore call-back completely, though they will respond to a visual stimulus such as the presence of another male of the species. This point is a little

Plate 25. Tape operations in the field. (Upper) F. V. Blackburn and V. C. Lewis attempting to call back whinchat, using very light-weight equipment. (Photograph Gwen Blackburn.) (Lower) Reed bunting. A 'low-response' bird photographed from a hide at a regular song-perch. Bronica, 400 mm Tele-Megor; 1/125 at f11 on HP4 roll-film developed in Unitol.

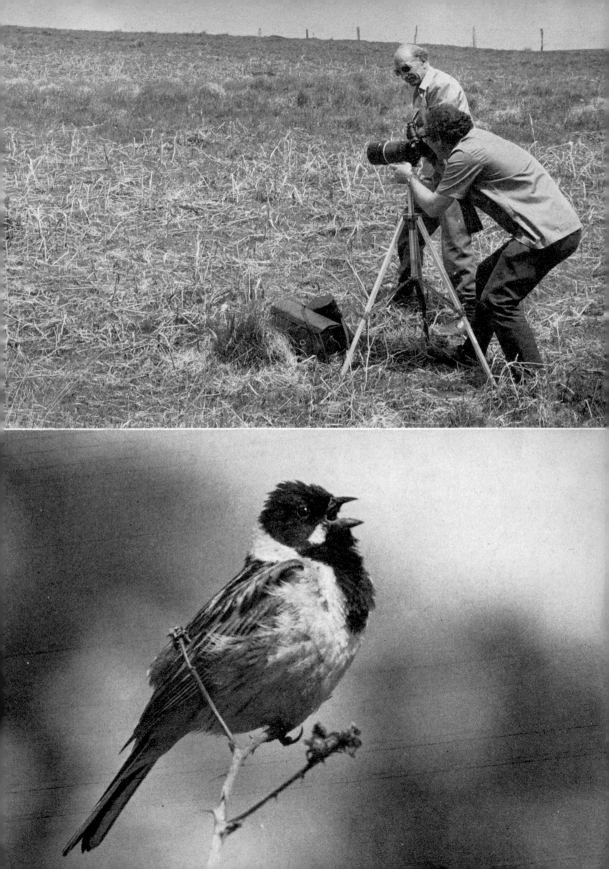

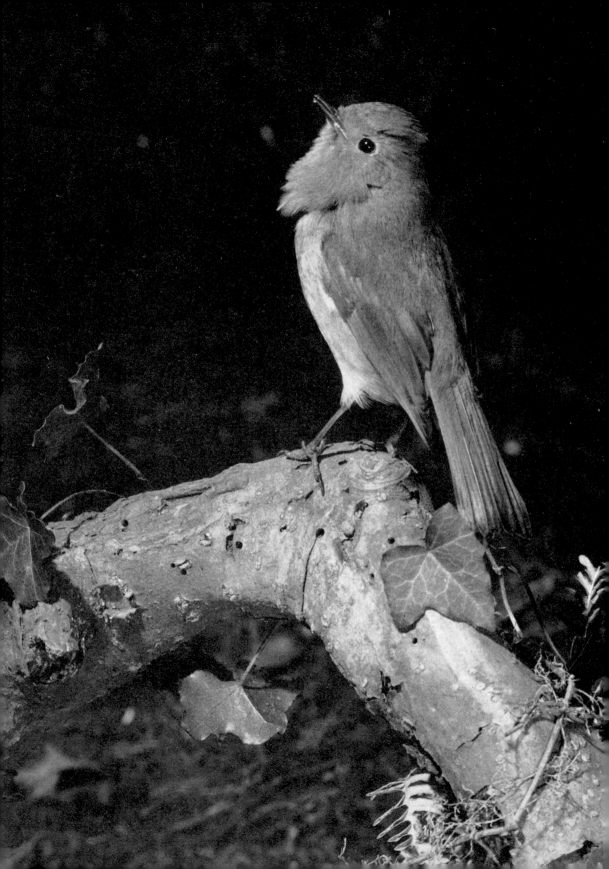

puzzling, but presumably is due to the greater relative importance of visual signals once breeding has commenced. If the picture is important then it is worthwhile introducing suitable colour animation to the set-up as an added stimulus if all else fails. I have tried this successfully in the garden to induce the territorial display of the (European) robin, using only the very tattered remains of a stuffed one. It is an interesting point that the stuffed bird would be ignored during the greater part of the day, and attacked only during peak advertising periods, such as early morning and late evening, but the resident bird could be induced to display close to the stuffed one at any time if robin song was played nearby (see Plate 26).

Low-response birds are those which defend a territory with song but have not been found sufficiently responsive at any stage during the breeding period to be photographed through call-back without the use of a hide. In this class are such genera as buntings and pipits, which will sing from regular perches throughout most of the breeding season, showing clearly that song plays an important part in the defence of the territory. Possibly a series of experiments at different times would place these birds into the secondary response category, but until now my tests have shown their reaction to be uniformly low. Even so, call-back can be used quite successfully; by noting the regular song perches used by these species, and playing back their song from a hide placed nearby, it is possible to call over immediately a bird which otherwise may only use the perch once every hour or so in the natural defence of its territory. Without play-back, the nearness of a hide is sufficient to stop a wary bird like a corn bunting using the perch altogether. Not only time will be saved; the photographer will be able to make the best use of the sun relative to available time.

For locating and establishing the degree of response I carry with me cassettes dubbed with at least five minutes of song of the species likely to be found in one habitat. With lightweight equipment and a small shoulder bag, the burden is hardly noticed; in fact I carry mine on most outings as a matter of course, irrespective of whether I am looking for subjects for photography.

Plate 26. Robin, reacting to play-back combined with the use of a stuffed robin in February (well before breeding starts). Bronica, 200 mm Auto-Nikkor; HSF at f22 on HP4 roll-film developed in Unitol.

Preparation of Tapes

Direct Recording

Direct recording is extremely time-consuming. My own experience is that it is not practical to record short snatches of song for playing back to the same bird as an aid to on-the-spot photography. Although this is possible with luck, it has always been found more efficient to plan the programme in advance. A detailed study of how to make high-quality recordings of bird sound would be too lengthy and is in any case unnecessary as high quality is not required, provided the volume is sufficient and the bird can recognize its specific call (my only responsive grasshopper warbler was called over when using a faulty machine which made the bird's reeling song sound more like a motor boat). Nevertheless, maximum quality should be the aim. The best results are obtainable from reel-to-reel recorders, preferably full-track at 38 cm/sec with standard thickness tape. Cassette recorders at 4·75 cm/sec can be quite adequate for our purpose, though they do have editing and splicing problems and a long period of song is invariably required for call-back. Parabolic reflectors—the audio equivalent of long-focus lenses—can be useful with both types of machine, particularly in enabling the recorder's own microphone to be used without lengthy extension. For fuller details on the subject, Richard Margoschis's booklet *Natural History Sound Recording* is very good value for money (see Bibliography).

Dubbing

Much the easiest way of producing a play-back tape is to dub it from an existing tape or from records of bird song. This has one serious drawback—the copyright laws, which in all Western countries are extremely

Plate 27. Dartford warbler, taken at long range without a hide, well before breeding was under way. The importance of this type of photography lies in its lack of disturbance to the breeding cycle; photography of this species is currently prohibited at or near the nest in Britain, under the Protection of Birds Acts. Bronica, 1000 mm Reflex-Nikkor: 1/60 at f11 on FP4 roll-film developed in Microdol.

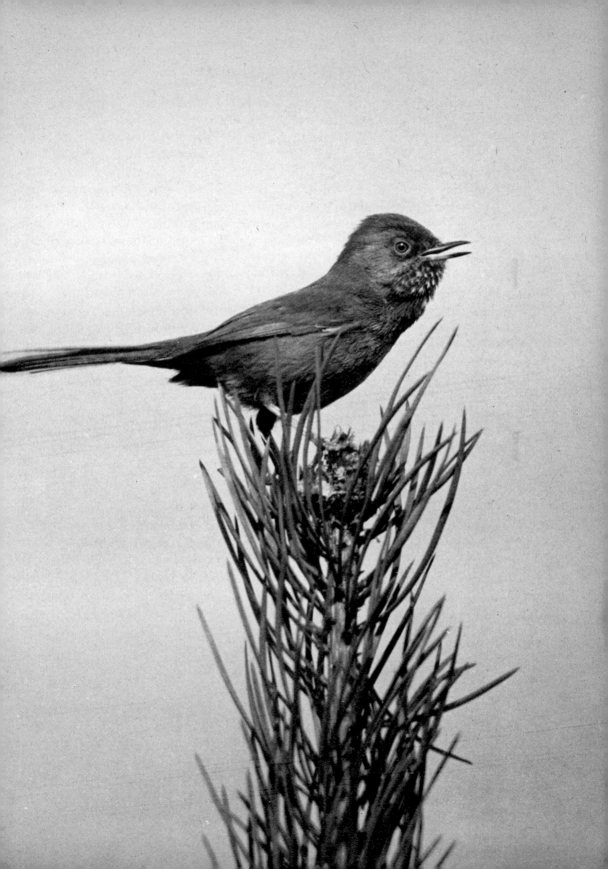

complicated and restrictive. It is, for example, an offence in Britain to use copyright material even for one's personal and private use without prior authority from the copyright owner or his agent. In Britain, the relevant Acts are the Copyright Act, 1956, and the Dramatic and Musical Performance Protection Act, 1925. Licences for various types of reproduction can be obtained from the British Phonographic Industry, the Mechanical Copyright Protection Society, and Phonographic Performance Ltd, but space is too short to give details, which in any case change from time to time. Prospective users should contact a local photographic or cine society for advice: much the same applies in all other Western countries. Of course, if one has a friend with original recordings, life will be much easier.

Actual transfer is easy—well covered by the machines' instruction manuals—though volume levels must be correctly adjusted to avoid distortion. It is a great help if the recorder has a digital counter, so that start and finish positions can be easily found: this also helps the repeat dubs which are needed for a sufficient length of play-back material.

Choice of Play-back Equipment

While reel-to-reel recorders may be better for recording—wild sound or dubbed—there is no doubt that a cassette recorder is entirely suitable for playing back in the field. Size, weight and operational ease are far superior. For play-back only, a simple cassette player—not intended for recording—is generally the least expensive and lightest. There is a lot to be gained in having a machine with a fast forward- and back-wind. An extension speaker or battery operated amplifier with about a 15 m lead will enable the operator to control the sound from the camera position, and make it unnecessary to dub very long periods of song.

Procedure in the Field

Through playing-back in suitable spots, the responsive birds will soon make themselves known and a few tests will establish how the bird is

likely to perch relative to the play-back machine. Only then is the question of photographic equipment considered. The distance that birds can be attracted depends on the size of territory it normally holds. By playing back the female cuckoo song while I cycled home, I managed to bring two male cuckoos home with me from a distance of 2 km. The woodlark will come over (or down) from several hundred metres, as long as the play-back volume is audible at that distance. But a warbler is not easily drawn far from the confined territory being defended.

When the responsive bird has been located, successful photography is still doubtful. Inducing the bird to perch just where it is required is the most difficult factor. People familiar with food-baiting in the garden will know how easy it is to picture a bird at the nut basket, yet how frustrating it can be trying to show it poised sharply on a nearby perch (especially if a remote release is being used). In this respect the techniques are similar, the only real difference being the method used to lure the bird onto the perch.

Success will depend too on having comprehensive photographic equipment available, particularly in relation to the lighting problems. And time of day may be vital if subjects such as, for example, nightjars are to be attempted: this species will not respond to call-back until sunset any more than a willow warbler will respond at night.

As the movements of a bird in peak response are mostly fast and erratic, some form of artificial lighting is advisable, and this is always necessary when working a woodland bird in the shade. Flash bulbs are lighter in weight but a powerful electronic flash is preferable.

In conjunction with the flash unit, a remote release can be used to operate the camera from a working distance of around 5 m. To prevent continuous use of the battery, my power unit has been modified to take a long extension lead and a switch to by-pass the normal on/off switch of the unit. Some sets now have this feature built in, but professional modification of older sets costs little. With very responsive birds it is possible to work from the camera position 1 or 2 m from the subject; but it is not often practicable because hand and body movements cause disturbance. A hide, or simple cover could, of course, be used, but would only add to the weight to be carried, and in practice it restricts both mobility and field of view. The main disadvantage of the remote release approach is the need to be able to pre-judge, and focus on, the exact position where the

bird will land. Also, unless the camera has motor-drive, only one shot can be taken at each visit of the bird to the perch. This is not such a disadvantage as it seems, for it will provide an opportunity to switch off the sound and give the bird a rest between shots.

There are two ways of establishing the position of focus, firstly, by noting the perches commonly used relative to the position of the loudspeaker and setting-up to the one most often used, alternatively, once the responsive bird is located, the camera can be focused on a spot which is convenient to the photographer and seemingly ideal for the bird to land on. Whichever method is chosen it is likely to require modification, for birds are often unpredictable. However, an intelligent choice of perch can save time and it should be considered carefully before setting-up initially. The one most likely to bring quick success will be an isolated branch or prominence which provides only one convenient landing position.

The importance of this point is best demonstrated by the tale of a completely wasted morning in 1967, when the British Broadcasting Corporation television programme *Animal Magic* team came to film the technique in operation. It was July, and the only responsive bird available so late in the season was an unmated willow warbler, whose territory included a lovely lily pond. The producer wanted to use this attractive setting as a background, and on the face of it, this seemed fine. In reality, the spot offered so many perches that the odds were very much against us being able to show a bird in the act of being photographed by the callback method. After wasting the best part of the day, the equipment was removed and focused on an isolated perch a short way off, where success was immediate.

The aural axis of the loudspeaker can, it seems, affect perching habits, even to the extent of controlling success or failure. On the first attempt with a willow warbler, the only suitable perch was about 2 m high and the loudspeaker was placed on the ground directly underneath it, with the sound travelling along the ground. With the equipment positioned this way, the flight line of the bird was from left to right and vice versa, using perches on either side of the speaker. By turning the loudspeaker on its back and allowing the sound to travel upwards, the bird changed its path to the top of the tree downwards, using the selected perch on the way down.

Another problem with peak-response birds is, oddly enough, *over-*

response. An example is the type of bird which, having once found the source of sound, will fly down to the speaker when play-back song is continued and refuse to perch anywhere on the way to it. To prevent this by covering it with vegetation will only result in the bird vanishing into the foliage in an even more determined effort. The first wood warbler I attempted did this and finally resorted to attacking the covering with such gusto that it rolled over on its back several times. While this behaviour may interest the scientist, it is of little use to the photographer. The problem was only solved by moving the equipment away and starting all over again, obtaining the pictures before the bird had pin-pointed the sound.

With secondary-response birds the problem is not as great, since the actions of the birds are slow enough to stop without the need for electronic flash. Even so, most of the focusing problems are still there, and the procedure for luring the birds down to a precise position is exactly the same.

Undoubtedly the best way to work the secondary-response bird is with a long telephoto; something in the region of 500–1000 mm gives a good 'bird-to-frame' ratio when working at a distance unlikely to disturb the bird from its perch. It will, of course, eliminate the need for a remote release and give the photographer freedom to focus on the bird as it sings from various positions in the area around the play-back machine. In woodland, where it is difficult to use a long telephoto because of the lack of light, it is possible to lure the bird to a sunny spot rather than compete with the focusing restrictions of electronic flash. One disadvantage with the secondary-response bird is that it will not return to a perch so readily after being chased off while re-setting the shutter. With the long telephoto there is no need for this disturbance. A long period of dubbed song will be necessary when not using a play-back machine with extension speaker.

Long lenses can also be used to an advantage with low-response birds from a hide. The greater working distance means less disturbance to the bird and more pictures of a natural quality. It will be found that once the bird has been lured over to its song-perch, play-back can be limited or stopped altogether. A relaxed bird will normally preen once it ceases to sing, providing additional pictures which would not be easily obtained working nearer to the subject with a shorter focal length lens.

Care must be taken to keep both perch and background consistent with

the species being photographed. This may seem rather an unnecessary statement, but is a point easily overlooked when excited by a displaying bird only a metre or two away. A series of pictures I took in a hurry of a goldcrest lured into a birch sapling were much improved after pine was added to the set-up for the later shots. Species such as woodlark look natural on a dead branch or a nicely arranged stone or clod of earth, but would look out of place singing from a gorse bush just because it happened to land there when subjected to play-back. A nightjar, too, would look more at home on a horizontal branch than trying to balance itself on top of a swaying sapling. The impression of height is also important to the correctness of the picture. It would not be a typical blackbird shown singing from the depths of a bramble bush. Nor would a grasshopper warbler look typical of the species singing against a blue sky unless the overall impression was of low vegetation.

Other Possible Uses

Apart from the small bird defending a limited territory, there are wider applications worthy of exploration both during and after the breeding period. Most are only a matter of putting casual observations into practice, or applying basic ornithological knowledge. For example, the quail could hardly be called a songster, but most of us are familiar with the call that they use in the vast fields where they breed. It is logical to assume that as the call is so frequent it must have a good biological function. Tests soon proved this to be so, and I had no difficulty in calling one over from a distance of half-a-mile to within a few feet of me in a matter of minutes. Being a naturally skulking bird (though not shy) it could not be lured out of concealment in the limited time available; but clearly the potential was there for working a bird rarely photographed in the wild. It should be possible to photograph other birds with similar breeding behaviour. We already know that it works with corncrake; then why not with partridge, pheasant, grouse, or even water rail and bittern? All experiments are worth trying, as was demonstrated by Eric Hosking's attempt with a cuckoo. Knowing it should work, he spent eight hours in a hide playing back non-stop the call of that species. Lesser men would

have given up after a much shorter period, proclaiming the technique useless. But he persisted and was rewarded finally with a series of pictures he had longed for a lifetime to get.

Outside the breeding season there are many approaches still to be explored, and at a time when Naturalists' cameras are least used. Some bird ringers (or banders) are now attracting migrating flocks into their nets with simple call or contact notes. The photographer should be able to call them down to a wait-and-see hide. Even waders on passage seem to be potential candidates; a reliable colleague informed me that he had no great difficulty in calling over a lesser yellowlegs by using the spring calls of that species, recorded in the USA and played back to a bird on passage in England.

The raucous 'spring assembly' calls of some crow species could be used for two purposes; one, to call these species into an area and, two, to induce other species there. I have on several occasions seen sparrowhawk fly in and perch close to a mob of screeching jays as they have invaded its intended nest area. Owl calls too, can be used to induce birds into an area for the purpose of mobbing, especially if used in conjunction with stuffed birds. Dr R. K. Murton discusses this point and other points relating to the use of pre-recorded tape as an aid to Wildlife Management on pp. 308–312 of *Man and Birds*. One colleague frequently uses a series of 'spooshing' sounds to bring over parties of foraging tits for the same purpose. Just what that sound represents is not easy to say but, apparently, it works extremely well in Switzerland and to a lesser degree in Britain; this technique is also used in the USA.

My pet tawny owl used to sit on the landing window-sill and call the resident owls over to a nearby pear tree. It was still too young to hoot, but contact notes did the trick very efficiently. Probably visual stimulation had something to do with it, again indicating the potential use of sound in conjunction with animation.

Distress calls have been used to chase birds away from airfields, buildings, etc., and they can be used to attract some species into an area. I once watched a hen harrier in pursuit of a green woodpecker; the distress calls of the unfortunate woodpecker immediately drew kestrel, carrion crow and magpie into the area to rob the harrier of its intended meal. Whether call-back could be extended to take photographic advantage of this fact is, for the moment, something to look forward to. Surely it is the pioneering

aspect, as much as anything, that makes it so exciting. In time, when the technique has been perfected, it may even be possible to talk most birds into position at any time of the year. It will take dedication and the will to exploit the opportunities to find out, but the rewards will be great. One thing is certain; it is no use giving up hope with any species because it does not work first time. It was in 1964 when my interest was first stimulated in call-back, by a chaffinch struggling to get inside a tape recorder placed at my feet. Yet even now, after ten years, I have not located another specimen of the species which was more than mildly interested. Some species can be moody for no apparent reason, and go 'hot and cold' over short periods; the nightjar and cuckoo especially so, particularly if the weather is not to their liking.

There is plenty of scope for call-back in the garden, too. As the birds found there are mostly resident species, an early start should be made. The robin will respond extremely well in January if weather conditions are good. Generally speaking a good time to start experimenting is as soon as the first true song is heard. In the field this is easily missed as activity there is usually restricted to the weekends, and garden observations can be used to indicate what to expect in wilder areas. A singing blackbird, for example, could be used as a reminder that it is time to attempt skylark. The skylark will respond in February by hovering low over the loudspeaker, giving a good opportunity for flight shots.

Call-back can also be used as an aid to nest-finding. With many species, once the females start incubating, the males are very secretive and are only seen easily while escorting their mates when feeding. Stonechat and red-backed shrike are classic examples of this vanishing-trick and their breeding territories are easily overlooked. Play-back during this secretive period may interest the males sufficiently to pop up and show themselves. When working new areas during bad weather, when song is repressed, call-back can be used to the same advantage. Again, where song is more evident at dusk or night, such species as nightingale or stone curlew can be induced to disclose their territories. The presence of long-eared owl can be detected by playing back their calls at night in late winter and early spring. In most of these instances nest-finding becomes a simple matter once the territory is known.

So far I have only discussed call-back as an aid to photographing birds; mainly because I have not personally tried it in any other field of Natural

History. But clearly the potential is there with both mammal and insect and, as with birds, it is only a matter of applying good basic knowledge to the test. The fox (as already pointed out) can be lured over by the distress squeals of a rabbit; why not other predatory mammals? And most mammals have calls which are used for the same purpose as birds in their breeding biology. In a collection of pictures my father obtained in Canada as long ago as 1925 was one of moose being called over with the aid of a hunting horn.

As for insects, bush-crickets and grasshoppers have highly specific songs and respond readily to the calls of their own species. The qualified lepidopterist could no doubt find many uses for the call-back technique. And what about frogs or geckos?

From a conservation point of view the call-back technique must, on balance, be considered a safe one if used with the care expected in any other form of wildlife photography. Most birds show little interest once breeding is under way; since it is not in the photographer's interest to play-back to an uninterested audience, there is a built-in safeguard to the breeding birds. (Naturally it is expected that the area will be checked carefully for other breeding species likely to be disturbed.) In any case, one should never extend play-back over too long a period; it is my experience that what you do not get over a short period, you will be less likely to get over a long one though there are exceptions, e.g. cuckoo.

Acknowledgements

I wish to thank Victor Lewis for the many hours he has spent dubbing song on to tape for me and for the use of his sound library generally. And, particularly, for the happy hours we have spent in the field together, often with him carrying heavy equipment for miles on my behalf. I wish to thank him too, for his kind advice on the recording aspect of this chapter. My thanks are due also to Derek Washington for supplying other songs on cassettes, and to Dr R. K. Murton for reading the first draft and making useful suggestions from the rigorously ornithological point of view.

Bibliography

Man and Birds, Murton, R. K. (Collins) London, 1971.
Natural History Sound Recording, Margoschis, R. (Print and Press Services Ltd)
 London.

8

Birds in Flight

David and Katie Urry

Introduction

Flight, an extremely demanding and specialized method of locomotion, has been mastered successfully by few groups of animals. Birds, however, have become intensively adapted, structurally and functionally, to the requirements of flight. Bird flight, a commonplace yet stimulating facet of the visual environment, has become deeply ingrained in the poetic imagery of our culture. These considerable zoological and aesthetic attractions make it surprising that so few photographs are of flying birds. It is to be hoped that an increasing number of photographers will take advantage of recent and continuing improvements in photographic apparatus and chemistry, and devote at least a part of their energies to this rewarding branch of photography.

The remarks in this chapter will relate exclusively to the photography of free, wild birds in flight, using natural lighting. Flight photography by electronic flash is dealt with in Chapter 9, and photography under laboratory or other captive conditions lies outside the scope of this treatment and the authors' experience. However, the type of photography under consideration has an important role to play in the study of bird flight. Comparatively simple and portable apparatus allows the photographer to record the flight of a great variety of species in a range of habitats, often remote and intractable.

A photograph of a flying bird allows the leisurely study of moments isolated from a rapidly occurring continuum of movement, normally too fast for the observer's eye.

Basic Requirements

The basic purpose of any photograph is to convey information. Broadly speaking, this may be objective, dealing with factual aspects, or subjective, dealing with the more emotional or aesthetic qualities of the subject. Nearly all photographs contain a varying proportion of both ingredients. In their proper desire for scientific accuracy, nature photographers have perhaps neglected to exploit the subjective aspects of their work. Flight photography provides opportunities for both approaches; there is a real need for factual information about bird flight but, mainly because of its emotive appeal, it is also an area peculiarly amenable to a carefully considered subjective approach.

Flight photography combines the usual problems of the bird photographer with those of recording fast action; there are no additional inherent difficulties, and success depends on finding compatible solutions to these demands. The basic requirements are to record a reasonably large, sharply focused image of the flying bird, and to reduce movement blur to an acceptable level.

Bird Flight

It is essential that the flight photographer should be a reasonably competent Naturalist, and have an understanding of basic aerodynamics. A comprehensive literature deals with these subjects, and ornithological considerations will only be dealt with here in so far as they relate directly to photographic procedure.

Bird flight has been refined and diversified by evolutionary change, adapting to the different modes of life adopted by a variety of birds; these differences find expression in the many types of flight, and in idiosyncrasies of wing shape and flying behaviour.

Photographs of the slow, measured flight of a swan will be very different from those showing an auk coming to land, controlling its descent with relatively small, rapidly beating wings. Similarly, the low aspect-ratio wings of a soaring buzzard, with deeply slotted wing-tips, contrast

strikingly with the slender, pointed, high aspect-ratio wings of a speeding gannet.

Even more fascinating to the photographer are the variations in wing shape displayed by individual birds during the various manoeuvres of flight. These changes are brought about mainly by feather movements, and can considerably alter the appearance of the bird (see Plate 31).

Most larger birds, as well as the relatively simple flapping of level flight, have a much more complex wing movement used during landing, take-off, or hovering. These moments of intense activity are rich in photographic opportunities. Only at these times are both upstroke and downstroke of the wing powerful muscular actions, causing considerable bending of the feathers, and producing surprising and elegant alterations of wing shape. In addition, wing-tips can become deeply slotted by the fanning of emarginated primaries, leading edges become interrupted by the erection of the bastard wing, the angle of attack is altered, the tail feathers spread and the feet lowered.

Many species add interest to flight photography by their habit of flying in co-ordinated flocks; there is a dramatic geometry to be found in a formation of flying geese, or a wheeling mass of waders.

The locomotory patterns of flight are often incorporated into display behaviour of a reproductive or social significance. This interesting and challenging aspect of flight photography offers further opportunities for original work.

Prediction of Flight Paths

To obtain a reasonably large image, even when using long focal-length lenses, the distance between the photographer and the flying bird has to be surprisingly small. Since a wild bird is largely unpredictable in its movements and, if disturbed, will fly away from the photographer, a close approach is one of the main problems. It is often better to tackle this from the opposite point of view, and contrive the approach of the bird to the photographer; this ensures that the bird is not alarmed, and is therefore flying and behaving normally, but it does require a fairly accurate prediction of flight paths.

Some localities, of fundamental significance in the life of the bird, become focal points of flight activity, with regular flight paths radiating from them. During the breeding season the nesting area is an obvious centre of activity. Nesting areas themselves must not be disturbed, but since interest is in the approach and departure of the birds, this is not difficult.

Other situations providing foci for flight activity are roost-sites, favoured feeding places, and their connecting flight routes.

Flight lines should always be thoroughly studied before commencing photography; successful prediction of flight paths is then more likely, and disturbance of the birds' normal routine can be avoided.

Fluctuating conditions will quickly modify flight lines, and must be constantly noted during photography. For instance, a slight veering of the wind can within a few moments completely alter the flight direction of sea birds as they approach a cliff-face.

Concealment

Normal flight behaviour must not be disrupted and some concealment is often necessary. This will vary with the species, the activity in which the birds are engaged, and the locality. Elaborate precautions must be taken with shy birds, but some, such as gulls in city parks used to food from passers-by, will be attracted rather than dispersed by the photographer's presence.

The hide, the commonest form of concealment used by bird photographers, is of limited value in flight photography. In most cases it places an unacceptable restriction on the angles through which the camera can be moved, and requires an accuracy in predicting flight paths that is impossible in practice. Some situations, however, make its use necessary, such as at the high-tide resting places of waders; these are easily predetermined, and are commonly in terrain devoid of natural cover.

Plate 28. Arctic tern. The wing action during hovering is vigorous and produces considerable bending of the feathers. A hovering bird will always face into wind; for frontal lighting the relationship between wind direction and sun position is important. Leica M.3, 280 mm Telyt: 1/1000 at f11 on Tri-X film, developed in Microdol-X 1:3.

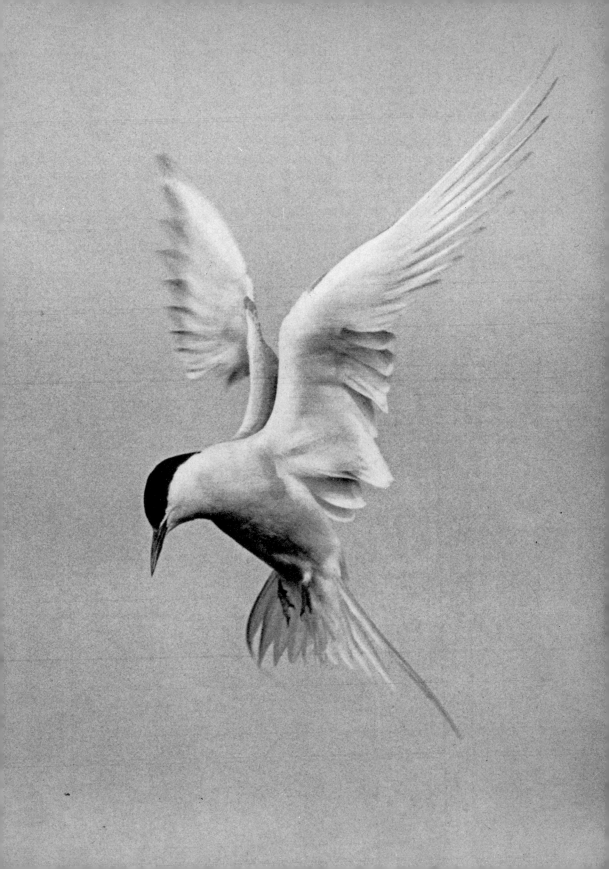

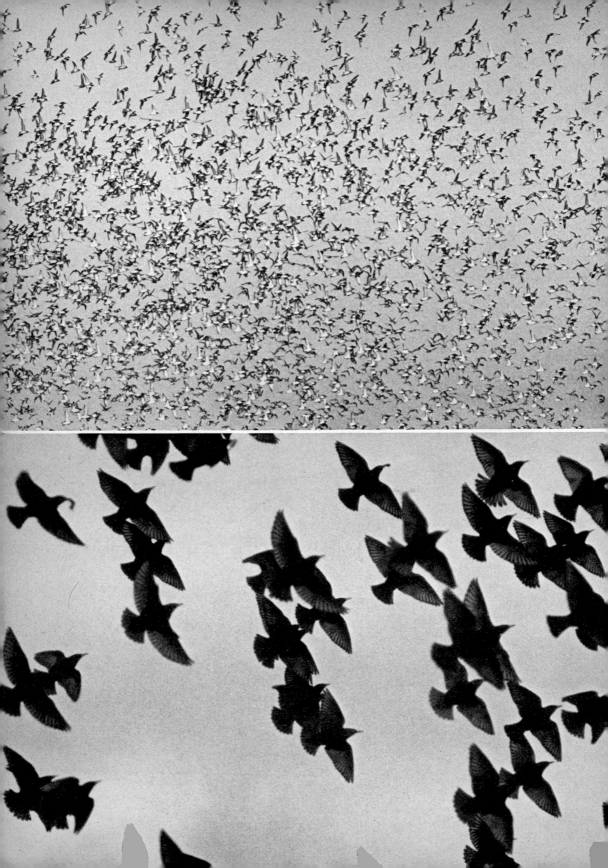

It is often more practical to take advantage of natural features as cover, for in this way the photographer can usually arrange to have a largely unrestricted field-of-view. It is often sufficient to stand next to, or even in front of, a familiar feature in the landscape. One of the keys to success is to arrange the camera position so that the approaching bird becomes gradually aware of the photographer, and is not alarmed by any sudden surprise. Using these methods with discretion, and avoiding sudden movements, photographers will often be delighted by the confidence with which they are treated by the shyest and most wary of species.

Other Factors

The physical conditions in the immediate locality may have a fundamental influence on flight behaviour; an understanding of their relationships is therefore important. For instance, soaring land birds such as vultures or buzzards, will only rise to great heights in their lazy circular paths when the conditions allow well-formed thermals to become established; sea birds such as albatrosses, petrels and shearwaters, are unable to establish their characteristic dynamic gliding in conditions of dead calm.

Wind velocity is of prime importance to the flight photographer, for it greatly modifies bird flight. Birds face into wind when alighting, and at take-off, and a strong wind can be exploited by photographers. Not only will ground-speed be reduced, but the birds may have to approach their landing site in a far more elaborate manner, constantly correcting their course and attitude; these can be very productive times for flight

Plate 29. Masses of birds in flight. (Upper) Knot. Large flocks, even at a distance, can cause depth-of-field problems. This can be tackled, as here, by exposing when the flock has little horizontal spread. A lens of moderate focal length allows the inclusion of a great many birds. Details as for Plate 28.
(Lower) Starlings. At relatively close range, the above difficulties are accentuated. It is essential that birds in key positions are crisply focused. Partial back-lighting here emphasizes the feathers' translucency. Details as before.

photography. On the other hand, many display flights may be restricted or temporarily cease during very high winds.

Disturbance

Flight photographers must exercise great care for the welfare of their subjects. If working adjacent to a nesting area the position chosen must not prevent the parent birds visiting the nest with normal frequency. Roosting and feeding places are vital to the birds, and every precaution must be taken. For instance, when working at a wader high-tide resting place, care must be taken to erect and occupy the hide well before the birds arrive in the vicinity, and the hide must not be vacated until the birds have departed with the receding tide (cf. Chapter 6).

When a hide is not used, it is obviously in the photographer's interests that an area is approached without disturbing the birds; it is also important that, work completed, the retreat is equally unobtrusive; disturbance is equally regrettable before or after photography.

Fortunately, the interests of the bird and the flight photographer usually coincide, for it is photographs of undisturbed birds, flying normally, that are required. If you set out to photograph flying birds without a proper knowledge of their needs and without regard for their welfare, you will, apart from the odd lucky shot, return empty-handed. If there is any doubt, err on the side of caution; lost shots are better than lost species.

If your ornithological knowledge is scanty, do not attempt rare, shy or difficult species. One of the joys of flight photography is that an afternoon spent with the pigeons in the square, or the gulls in the park, can produce

Plate 30. (Upper) Pink-footed geese. Birds that fly in groups can be tackled from a distance using a long-focus lens. Often something can also be shown of the habitat. Leica M.4, 400 mm Telyt; 1/1000 at f8 on Tri-X film developed in Microdol 1:3.

(Lower) Fulmar. Good modelling of the subject is achieved by photography in the early or late parts of the day, when the sun's rays are less steeply angled. Head-on views are difficult because of the rapidly-changing range. Leica MD, 135 mm Hektor: 1/1000 at f11 on Tri-X film developed in Microdol-X 1:3.

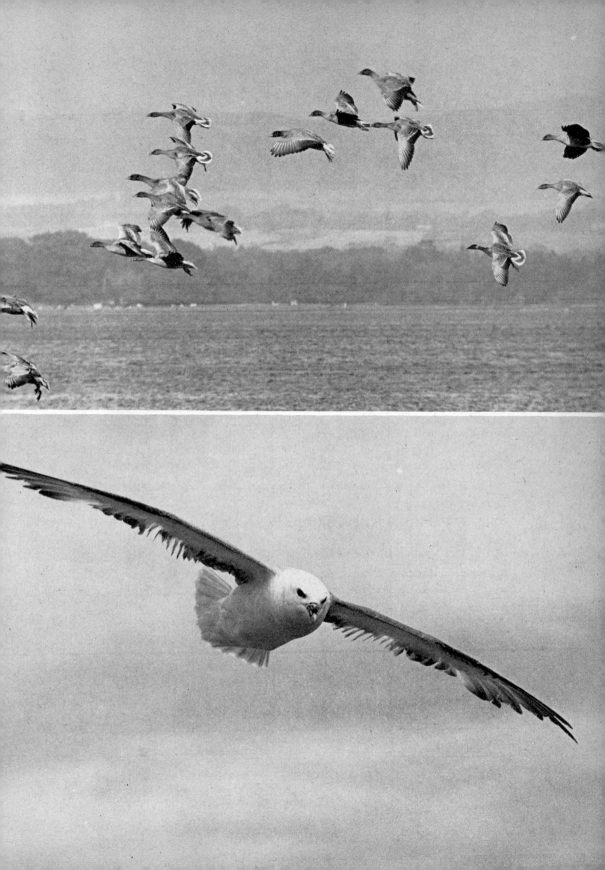

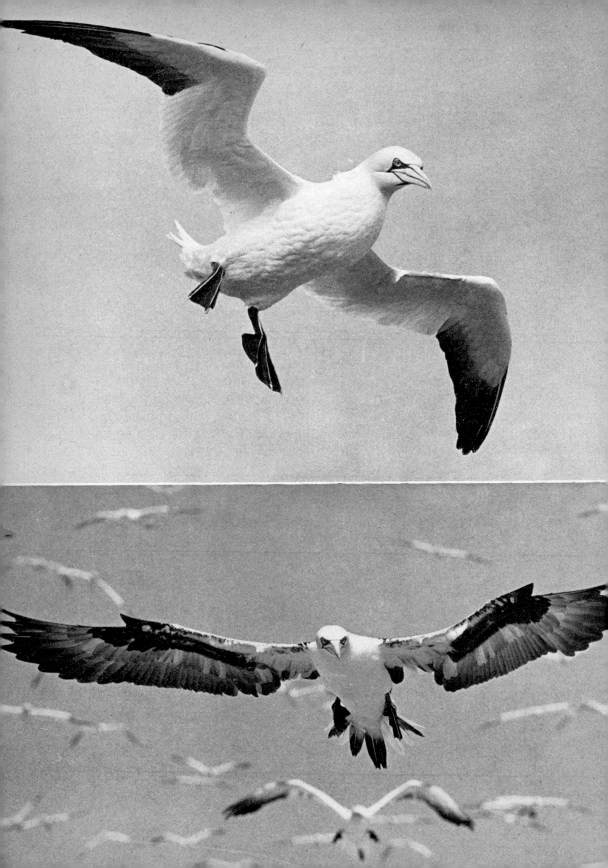

more original pictures, full of zoological and pictorial interest, than many long hours endured on a freezing marsh.

Cameras

For flight photography the camera must be used rapidly, usually in the hand, and frequently with a long focal-length lens. The requirement is, therefore, a camera that is light but nevertheless achieves a high standard of mechanical and optical performance, and for which an adequate range of interchangeable lenses is available. These conditions are admirably fulfilled by a number of high-quality 35 mm cameras.

The 35 mm format has another advantage: the speed and unpredictable nature of much bird flight can produce many exposures that are imperfect in at least some respects; the novice may well find that failures are far more frequent than successful exposures. Practice and experience will reduce the number of technically imperfect results to a small proportion, but the rapidity of much flight requires even the seasoned flight photographer to make very many exposures of each subject. The flight photographer, then, uses film in quantity; 35 mm film costs less, its light weight is warmly appreciated on long hikes to remote locations, and the ability to make 36 consecutive exposures without reloading reduces those frustrating moments when, with fingers made clumsy by haste, film has to be changed at moments of peak flying activity.

Little need be said on the choice between the coupled-rangefinder and single-lens reflex variants of the 35 mm camera. Coupled-rangefinder cameras can be converted by a reflex housing into the equivalent of a single-lens reflex; even with lenses normally capable of use with the

Plate 31. (Upper) Gannets, losing height on a windy day and moving fast. Although the wings are not being flapped, very careful panning and a brief exposure are needed. Leica MD, 280 mm Telyt; 1/1000 at f8 on Tri-X film developed in Microdol-X 1:3.
(Lower) The wings have a high angle of attack, and the fanned primaries and raised bastard-wing provide slotting to reduce stalling-speed on the approach to landing. Compare this shot with that above to appreciate the versatility of wing shape in a single species. Details as above, but at f11.

coupled-rangefinder, it is still preferable to use this reflex viewing system, for reasons discussed later.

The ideal tool for photographing bird flight therefore, in terms of practicality and economy, is the 35 mm camera, either in the form of a single-lens reflex, or a coupled-rangefinder camera converted to its equivalent.

Lenses and Image Size

Birds are small subjects for rapid action photography, and are often shy and wary, making close approach difficult. On the other hand, the small negative size of 35 mm film makes it undesirable to enlarge small portions of the negative. It is therefore necessary to fill the picture area adequately with the subject at the time of exposure, and this requires lenses of long focal length. However, the choice of focal length for any particular assignment should be made with care; increase in focal length carries with it inherent restrictions and limitations.

When concealed, the bird photographer cannot often alter the camera position, and the distance between the camera and the subject is therefore fixed. As focal length increases, the depth-of-field at this set working distance decreases, and this disadvantage may outweigh any gain in terms of image size. Furthermore, other things being equal, good definition is easier to achieve using the relatively short focal-length lenses. It is, therefore, advisable to keep the distance between the bird and the camera as short as conditions will allow.

The narrow field-of-view of the longer focal-length lenses makes it difficult to locate a fast moving bird in the viewfinder. Little trouble will

Plate 32. Fast-flying birds at close range. (Upper) Puffin. With rapidly-closing ranges it is advisable to pre-focus and expose as the bird flies into focus. Note that even 1/1000 has not prevented considerable wing-blur. Leica MD, 400 mm Telyt; 1/1000 at f11 on Tri-X film developed in Microdol-X 1:3.
(Lower) Guillemot. Side-on, the bird is in focus a little longer, but requires rapid panning. By exposing just before the downstroke, wing movement is at a minimum. Leica M.3, 280 mm Telyt; 1/1000 at f11 on Tri-X developed in Microdol-X 1:3.

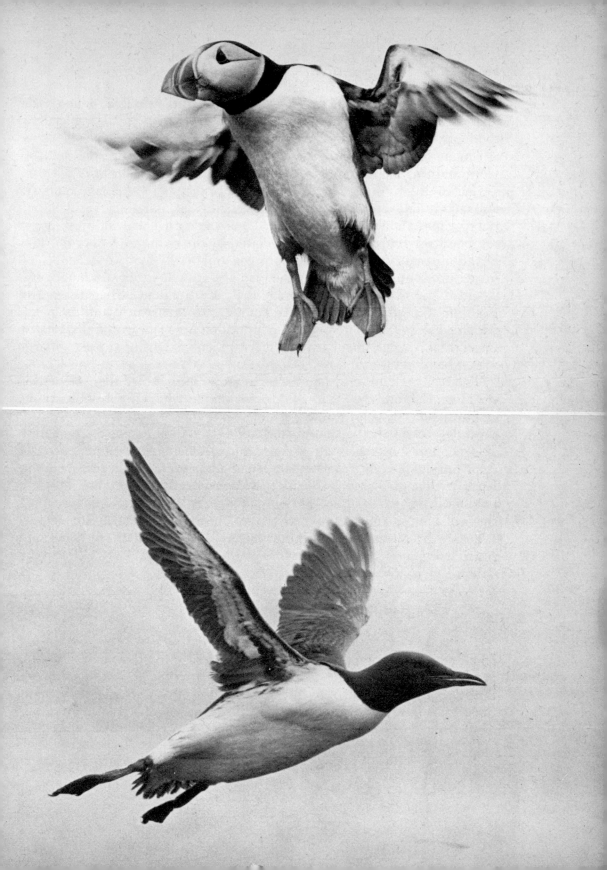

be experienced with a 135 mm lens, but some initial practice is necessary to aim a 400 mm lens accurately at a small swiftly flying bird, especially if the flight path is erratic.

Having located the bird, it is necessary to hold it within the field-of-view, and this is again more difficult with greater focal length.

Lenses of long focal length will not only magnify the image, but will also accentuate any vibration or unevenness of panning, resulting in photographs showing camera shake. In practice the choice of focal length resolves itself into a compromise dictated by the requirements of the subject. For instance, when photographing a gull boldly flying to accept food, image size is no problem, since the bird will pass at very close range; this would allow the choice of, possibly a 135 mm lens, with its ease of handling, rapidity of focusing and good depth-of-field. A wild swan will not fly so close and therefore, although much larger, it would produce an unacceptably small image using a 135 mm lens; a lens of at least 250 mm would be more appropriate.

The really useful focal lengths for photographing bird flight lie within the range 135 mm to 400 mm. The occasions on which flight photography can be achieved with focal lengths of less than 135 mm are rare indeed; the bulk, weight and balance of lenses of over 400 mm make them formidable propositions for flight photography. Recent developments in the design of lightweight and compact lenses of catadioptric design ('mirror-lenses'), have made it possible for the experienced photographer to hand-hold focal lengths of up to 1,000 mm; however, their fixed aperture make them of limited appeal to the flight photographer, whose ability to vary exposure by alterations of shutter speed is, as we shall see, unusually restricted.

Arresting Movement

In all action photography it is usually necessary to arrest or 'freeze' the movement of the subject to some extent, to avoid an unduly blurred image. Some degree of movement is not objectionable, and may sometimes even be desirable. Total lack of blur can rob an action photograph of its basic qualities, and give an immobile unnatural result, though at

other times it can be most effective, rendering a rapidly moving event as static. Usually, the flight photographer will require a sharp image of the bird. 'Panning', or swinging the camera to follow the subject will achieve this, and at the same time the movement of the camera can impart blur to the background, creating an impression of speed.

Smooth camera panning is essential for all action photography, and for bird flight it must be thoroughly mastered, since the flight of a bird is not always smooth and predictable but may alter suddenly and repeatedly. However, habitual panning is far from being a disadvantage; with a hand-held camera it is far easier, after a little practice, to execute a smooth pan than to hold it completely still. In practice this allows the flight photographer to use, hand-held, much longer focal-length lenses than would normally be advisable if camera shake is to be avoided.

When choosing apparatus, remember that most bird flight photographs will be taken with a hand-held camera. Although the 35 mm camera itself is small and light, it acquires an appreciable weight when equipped with a 400 mm lens, and the balance of the complete unit is important in avoiding strain and fatigue of the wrist muscles. Nothing is more certain to produce jerky, uneven panning than weary muscles; in long sessions of flight photography this stage must not be reached. It is normally best to restrict the time during which the weight of the camera is supported at eye-level to a brief period before, during and after exposure.

When using the larger and heavier lenses a 'shoulder-pod' can be of great help; this can be pulled well into the shoulder, and assists steady camera handling without interfering with free movement. A tripod should normally be regarded as a temptation to be resisted by the flight photographer; if the birds fly higher than the movement of the tripod allows, or even overhead, it may be necessary to face the rather ludicrous task of making the exposure with both camera and tripod hand-held! The only time that a tripod is of importance to the flight photographer is when working from a hide.

The overall movement of the bird is effectively dealt with by panning, but this does nothing to arrest the reciprocating motion of the wings. This action, at right angles to the movement of both bird and camera, can only be dealt with by a sufficiently brief exposure. The exposure time required will be determined by the speed at which the wings are flapped;

whilst an exposure of 1/250 sec or even 1/125 sec may cope adequately with the slow beating of a swan's wings in level flight, the wing tips of a landing puffin will register considerable blur even at 1/1000 sec. The vigorous wing movements at landing and take-off make it advisable to use 1/500 sec, or 1/1000 sec, for all species at these times (see Plate 32).

These high shutter speeds, as well as providing a sharper image of the wings, will also act as insurance against slight camera shake when handling the heavier lenses. From this it will be inferred that a shutter capable of an accurate 1/1000 sec, is a great asset when photographing flying birds (see also p. 367).

The ability to arrest motion successfully is vital to the flight photographer. Many beautiful and graceful photographs may be obtained at moments of minimal activity, but much of the thrill of flight photography will be lost without the ability to deal with fast action.

Depth-of-Field

It has already been stressed that to fill the frame adequately with a single flying bird, the distance between the subject and the camera must not be great, even when using lenses of long focal length. At a given working distance, although increase in image size is gained by long focal length, the depth-of-field is reduced. The situation is aggravated by the need for brief exposure times, preventing the flight photographer gaining depth-of-field by using a smaller aperture.

It has to be accepted that flight photography must often, indeed usually, be undertaken with an uncomfortably restricted depth-of-field. To illustrate the critical limitations imposed, imagine that a shot is required, side view, of a medium-sized bird with a wing span of 60 cm (2 ft). In order not to exaggerate the difficulties, let us say that the bird is bold, allowing a close approach, and therefore not requiring a lens of very long focal length. At a distance of 4·5 m (15 ft) this bird would comfortably fill the frame using a 135 mm lens. Under average conditions of sunlight, using 400 ASA film and 1/1000 sec exposure, an aperture of f11 would be required for correct exposure. At f11, and at 4·5 m (15 ft) range, the depth-of-field would be 80 cm (2 ft 7 in.); a deterioration in

the light, necessitating opening the lens of f8, would reduce the depth-of-field to 56 cm (1 ft 10 in.), less than the wing span of the bird.

However, restricted depth-of-field is not always an unmitigated annoyance when photographing flying birds. In many situations, such as at sea-bird colonies, the air can be so full of birds that it is difficult not to include some in the background. Restricted depth-of-field ensures that, even if quite close to the principal bird, these subsidiary birds are out-of-focus, and therefore less distracting.

The problems associated with depth-of-field are not eased when photographing large flocks from greater distances. Although the depth-of-field at these ranges has expanded considerably, so has the size of the subject, which may now be regarded as having the dimensions of the entire group.

Focus

Since the distance between the flying bird and the camera is constantly altering, often rapidly and erratically, precise focusing is not easy. Nevertheless, the restricted depth-of-field often allows minimal latitude for inaccuracies.

Focusing, particularly at close range, must not only be precise, but must often be rapidly executed. Reference may again be made to a 135 mm lens, focused at 4·5 m (15 ft) and set at f11, which, as we have seen, gives a depth-of-field of 80 cm (2 ft 7 in.); if the distance between the bird and camera is only altering at a rate of 16 kph (10 mph), the bird will traverse the depth-of-field in approximately 1/5 sec. Very often the photographer will want to work with longer focal-length lenses, or when the bird's approach exceeds this arbitrarily chosen speed.

Under these conditions, at very close range, any attempt at keeping the bird continually in focus is sheer folly. By pre-focusing, however, these situations are mastered with comparative ease. The range at which the exposure will be made is determined in advance, a decision influenced by the size of the bird, the required image size, the focal length of the lens, and the probable flight path. The focus then remains unaltered, and attention is concentrated on composition and smooth panning, exposing

as the bird flies into focus. Anticipation is called for, since there will be a brief but important interval between the photographer's decision to press the button and the actual moment of exposure.

Instant return of the mirror to the viewing position is also an aid to gauging this anticipation of exposure when the bird is allowed to fly into focus at close range. This enables the photographer to compare the sharpness of the image in the viewfinder immediately before and after exposure; neither viewfinder image will be absolutely in focus, for that moment will occur at exposure, but if they appear equally uncrisp it is certain that true focus has been anticipated correctly. In this way the instant-return mirror acts as a fine adjustment to the photographer's reflexes at the time of exposure.

At greater range the changes in focus required to retain a sharp image in the viewfinder at all times will be slower and more gradual. It then becomes possible to keep the bird continually in focus and therefore to choose the moment of exposure with much greater freedom. Although it is possible to maintain continuous focus in this manner using normal helical focusing mounts, the focusing travel required at medium range on very long-focus lenses can become excessive, and alternative focusing mounts are of great help. These mounts replace the helical action with a linear action, either directly or through a rack and pinion mechanism, and considerable and continuous changes in focus can be made rapidly and smoothly.

For fast action, composition and focusing must become a single integrated mental process. This unification of composition and focusing is much easier if the focusing screen is of the plain ground-glass type, uncluttered by central focusing aids.

Lenses with automatic diaphragms are undoubtedly an aid to focusing under all conditions, since the lens is then focused with the diaphragm fully open irrespective of the exposure aperture in use. The flight photographer is, however, little inconvenienced by the lack of this facility. Although there is insufficient time to execute this process manually, lenses are seldom considerably stopped down, even in bright light; the image on the focusing screen will therefore be adequately bright, even for critical work, when the lens is set to the exposure aperture.

It has been seen that depth-of-field sometimes barely exceeds or may

be less than the dimensions of the bird. In such cases it is necessary to consider how to deploy the available depth-of-field. As a general rule the head, and particularly the eye, of a flying bird should be needle-sharp; any part of the bird occurring between its head and the camera, such as the near wing, should also be fully in focus; if the depth-of-field is insufficient to encompass the entire wing span it is not too distracting if the far wing tip, which in any case may be blurred by movement, is not critically crisp.

Large flocks of birds can provide problems of focusing; this is especially true of bold birds, such as starlings, attempted at moderately close range. The restrictions of depth-of-field may make it impossible to have all the members of the flock in focus at the same time. In practice, as long as a sufficient number of birds in key positions of the composition are in focus, some out-of-focus birds will not spoil the picture. However, all too often a fine picture of hundreds or thousands of birds can be spoiled by the few that flew too close, and have registered their dominant but unsharp images on the negative. Success is achieved most consistently by concentrating on those moments when the group has little horizontal spread, but has piled up vertically; in this way the flock can be contained within the depth-of-field.

The ability to focus with precision and speed is one of the major keys to success in the photography of flying birds. Experience will subtly educate the eyes, mind and muscles to act in unison, and it becomes very much easier in practice than it sounds in theory.

Exposure Determination

Exposure determination carried out at the subject position is obviously impossible, and substitute readings of the incident light at the camera position provide the best method. When working at long range it is, of course, essential to check that the light at camera and subject positions is the same, and if it is not, to apply an estimated correction.

One common difficulty is the inability to predict exactly where the bird will fly, and therefore at what angle the camera will be pointing at the time of exposure. It is advisable to take light readings in advance for all likely angles and to retain the necessary camera settings in the head, so

that last-minute adjustments may be made as circumstances dictate. The flight path of the bird is normally predictable within limits that make these variations reasonably small.

On days of fluctuating light it is worth remembering that, unless flight activity is continuous, the birds and not the photographer will determine the actual moments of exposure. If exposure determinations, based on maximum and minimum light, are made in advance, final settings can again be estimated when the opportunity occurs to expose.

Remember that the very intense whiteness of the plumage of certain sea-birds, notably kittiwakes and gannets, will often require an estimated reduction in exposure to retain feather detail.

Incident Light and Wind Direction

The majority of flight photographs will be taken when the birds are facing into the wind. Birds will always fly upwind when landing, rising from the ground, or hovering, all periods of interest to the photographer; at other times birds flying into the wind will also be making less ground speed and are consequently easier to photograph. The relation between the direction of the incident sunlight and the quarter of the wind is therefore significant. The worst condition is that of the wind blowing directly towards the sun; all birds flying into the wind will then be faced directly away from the incident light, with their heads consequently shaded. There are certain birds which, at these times, will make pleasing *contre-jour* photographs; the delicate translucency of the wings and tail of a tern are emphasized if the light is seen streaming through the feathers. However, the texture and detailed pattern of feathers are normally required, and these will not be produced by harsh back-lighting.

The height of the sun above the horizon is also significant when photographing bird flight, particularly since the camera will normally be inclined to some degree upward. Around noon on unclouded summer days, the undersides of flying birds will be deeply shadowed, and the wings will cast hard, sharp shadows on the body. It is better to work earlier and later in the day, when the less steeply angled rays of the sun produce much better modelling.

The relatively shadowless but bright illumination on days of very thin cloud or mist produce what is undoubtedly the finest light for the photography of flying birds.

Film Material

There are several factors determining the choice of film for flight photography; all 35 mm film, with its small negative area, is grainy on enlargement. This by itself would favour the choice of slow emulsions, with relatively small grain size. However, nearly every other aspect of flight photography weighs heavily against that choice.

The long-focus lenses in use will normally have a maximum aperture of f4 or less; in any case, it has been seen that depth-of-field is severely restricted even at f8 or f11. Fast shutter speeds are usually required to arrest movement. The amount of light transmitted to the film during exposure, therefore, cannot be increased by a wider aperture or by a longer exposure. These limitations have to be accepted as inherent in the subject, and the only practicable solution is to use a fast film (250–400 ASA), allowing brief exposures and, if possible, stopping down to some extent to gain depth-of-field. The grain produced by these emulsions, if properly handled, will not be excessive; an unduly grainy picture is more likely to result from the enlargement of only a small portion of the available negative area.

Interesting flight activity often occurs in conditions of poor light, due either to weather conditions or time of day. For instance it would be a great pity to have an idle camera when the sun has just set and, over a well-sited roost, starlings in their tens-of-thousands fill the sky with bold interlacing patterns. It is well worth uprating film (monochrome or colour), extending development and gracefully accepting the consequent reduction in quality.

Most monochrome films of 400 ASA can be uprated to twice this value at least, if extended development or a special speed-increasing developer is used in compensation. If the light is so poor that even more film speed is called for, it is better to load with a faster film. Kodak 2475 Recording Film is a useful standby for these occasions; although nominally rated at

1,000 ASA this film can be uprated to 3,200 ASA with suitable development.

The need to uprate monochrome film will occur infrequently, but the slower colour films will often require this treatment. The authors, working exclusively on reversal film for colour photography and after considerable experiment, have found Ektachrome-X to satisfy their requirements. Although, at 64 ASA, this is not the fastest colour film available, it is characterized by a remarkable tolerance to extended development and is therefore capable of considerable uprating. Development by the E4 process will yield very high-quality results with Ektachrome-X rated at up to 250 ASA, and for work under adverse conditions an acceptable quality can be obtained up to 1,000 ASA.

However, uprated film will often give results inferior to film exposed and developed normally. In addition, the latitude of film tends to decrease with this treatment, and great care and precision should be exercised when exposing and developing; careless processing of uprated colour film can also cause serious alterations of colour balance. Manufacturer's recommendations for the extended development of uprated film should be taken as guidelines, the bases for the photographer's individual experiments.

Conclusion

It will by now be apparent that there is a variety of complex, and often conflicting, ornithological and photographic requirements associated with the photography of bird flight. These problems are not overwhelmingly difficult, and it can be a source of much pleasure devising solutions to meet the individual needs of each occasion. They are, however, largely technical considerations and the final result will, as always, depend upon the intentions and abilities of the photographer. This freedom of expression, and the abundant variety inherent in the subject, combine to make the photography of flying birds a most satisfying and exciting branch of photography.

Bibliography

Animal Locomotion, Gray, Sir J. (Weidenfeld and Nicolson) London, 1968.
Bird Flight, Simkiss, K. (Hutchinson) London, 1963.
Flying Birds, Urry, D. L. and Urry, K. J. (Vernon and Yates) London; (Harper and Row) New York, 1970.

via a voltage-doubling circuit, to a large paper capacitor of about 33 microfarads, which, when fully charged, was at a potential of some 2,500 volts. This voltage was discharged through a spiral xenon-filled discharge tube giving a brief but brilliant light. The unit described (see Fig. 1) would have been rated at 100 joules or watt-seconds, with a flash duration of the order of 100–200 microseconds, depending on which part of the light-output curve is chosen for the measurement (usually above $\frac{1}{3}$ peak on the output/time curve, for the output below $\frac{1}{3}$ peak is of little photographic value) (see Fig. 2).

These units were heavy, being usually in excess of 5·5 kg (12 lb), and consequently much development of electronic flash has been directed

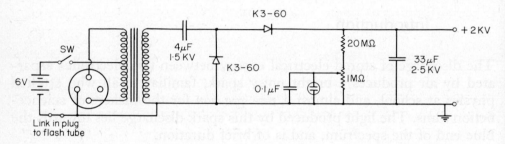

Figure 1. Basic high-voltage high-speed electronic flash circuit, employing a vibrator. (Flash head circuit as Figure 3b.)

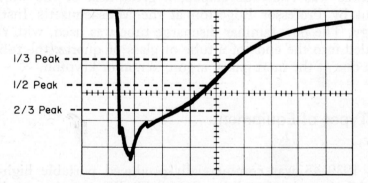

Figure 2. Light output from flash tube (LSD3/CCA7) using 33 μ farad capacitor charged to 2·2 kv. As seen by a 931A photomultiplier and displayed on a HP175 oscilloscope. (50 μsec per cm. $\frac{1}{3}$-peak = 200 μsec = $\frac{1}{5000}$ sec.)

towards weight reduction. Initially this was achieved by the development of 'low-voltage' equipment, working at some 500 volts or less, and utilizing electrolytic capacitors; later the development of miniature circuitry made it possible to produce the many tiny electronic flash units that are available today. Some of these have a special circuit included which, by draining off some of the energy from the capacitor (usually in response to a photo-electric cell in order to give automatic compensation for variation of range), give flashes as brief as 20 μs, though with a marked reduction in the amount of light produced: in effect, such circuitry uses only the tip of the output curve, e.g. above $\frac{2}{3}$ peak (see Fig. 2).

Modern small units are very efficient, and deservedly popular, but with most low-voltage equipments the flash duration of 500–1000 μs is too long for effective flight photography.

Requirements

Flight photography with electronic flash implies 'close-up flight photography'. The first consideration is the speed of the bird or insect, and the second—perhaps of even greater importance—is the speed of wing movement. A bird travelling at 48 kph (30 mph) will in one second move some 13·4 m (530 in.) and a bird moving at 32 kph (20 mph) will similarly cover 8·9 m (350 in.): in 1000 μs (1/1000 sec) the distances will be 1·34 cm (0·53 in.) and 0·89 cm (0·35 in.) respectively. The rates of wing beat vary from about 1 per sec in the larger birds to about 80 per sec in the case of the smaller humming-birds.

The actual speed of movement will vary with the activity of the bird at any point in time, but as an estimate (assuming an angular wing movement of 120 degrees, and considering three sizes of bird):

	Wing length	Wing beats/sec	Calculated wing tip travel/sec
barn owl	280 mm	2	2400 mm
storm petrel	120 mm	10	5000 mm
blue tit	60 mm	30	7500 mm

These figures only form a guide and take no account of the null period

at either end of the cycle when the direction of movement of the wing tip is reversed. Thus, even the modest requirement of photographing a blue tit in flight may need a flash duration of not more than 200 μs; at 48·3 kph (30 mph) the forward movement would be 2·68 mm and the wing tip movement would be 1·5 mm in 200 μs. For the faster wing-beats of humming-birds and most insects a much shorter flash duration would be required, of the order of 50–80 μs.

Thus, on the score of flash duration alone, the choice of equipment must be that of the high-voltage high-speed unit. It should be mentioned that it is only the small low-voltage units that have a flash duration of 500–1000 μs, and they have the disadvantage of a rather low light output for open-air work; the larger low-voltage units have an adequate light output (in many cases greater than a 100 Joule high-voltage unit) but they have an even longer flash duration (usually 800–1250 μs) and are thus even less suitable for flight work.

Construction of Equipment

One major difficulty in the decision to use high-voltage equipment is that there are very few, if any, such units now manufactured (except perhaps to special order). However, many of the old units are still available second-hand, or, as the units are not difficult to build, they can be constructed by a competent electronic engineer. It cannot be emphasized too strongly that these high-voltage units utilizing capacitors of 33 microfarads are *lethal*, and many of the low-voltage units potentially so, especially if they are used in damp or wet conditions. It is important that the construction of units or the repair of old units be carried out by competent electronic engineers. The Mullard LSD3 (and the equivalent Mazda or Siemens) discharge tubes are no longer made, but Messrs De Vere (of London) have been able to supply a discharge tube (CCA7) which is a suitable equivalent.

Plate 33. (Upper) Barn owl. Coming in to land, with all slots open, flaps down and undercarriage lowered. Field camera, 135 mm Ysar lens; HSF (*c.* 1/6000 sec) at f26, using an infra-red trip.
(Lower) In more cruising flight. Details as above.

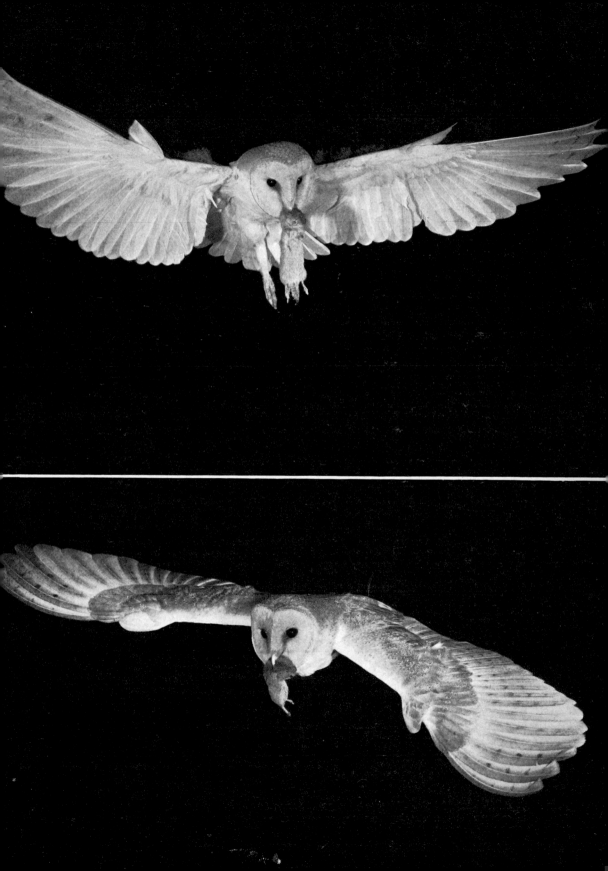

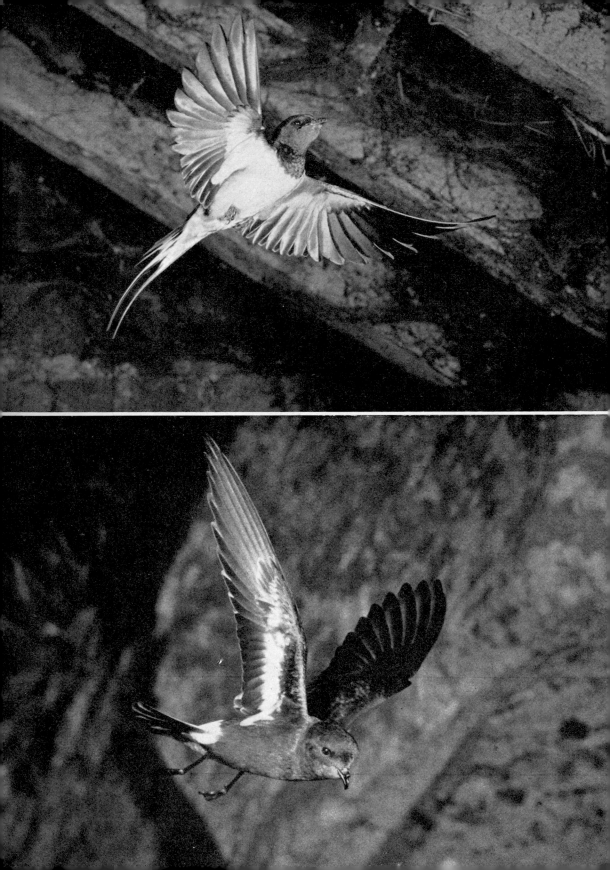

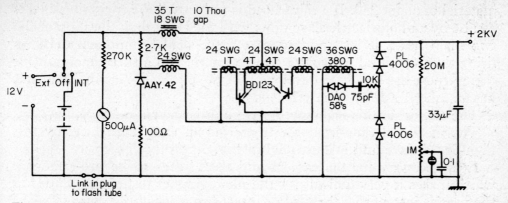

Figure 3a. High-voltage high-speed flash circuit. (Transformer core LA 2,000 Mullard: Chokes F × 2242 Mullard.)

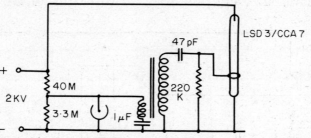

Figure 3b. Flash head circuit, using LSD3/CCA7 tube.

The vibrator used in the early sets was noisy and inefficient; a recent circuit developed for me by W. E. Austin, MIEE, M.Eng., uses new circuitry which is more efficient and to the human ear is noise-free, though it may have some ultrasonic emission. This circuit (Fig. 3a and 3b) works at 12 volts either from an external accumulator or from internal batteries (9-HP2 or equivalent), and gives a flash duration of 200 μs above $\frac{1}{3}$ peak (see Fig. 2). A second head with its own capacitor can easily be added; this will give an equal output to the first head and will be triggered simultaneously. This unit has a flash factor with 200 ASA

Plate 34. (Upper) Swallow approaching nest (note the direction the bird is looking). Details as for Plate 33, but f22.
(Lower) Storm petrel. An example of a species whose habits do not lend themselves to any other technique of close-range photography in the wild. Details as above.

material of about 250. If a third head is to be used the triggering of this can be by a photoelectric slave unit; with the short flash duration of the two main heads it is important that there shall be minimal delay in firing the third head to avoid a double image, and a suitable circuit for this purpose has also been developed for me by W. E. Austin. This unit has an inherent delay of only 1·5 μs.

The circuit for this high-speed slave unit is shown in Fig. 4.

The measured time-lapse for triggering an extra flash head by this high-speed slave unit is illustrated in Fig. 5.

It is necessary for the camera and flash heads to be pre-arranged, which makes it very difficult for the photographer to fire the shutter at the precise instant that the bird or insect has reached the point in space upon which the camera and flash heads have been focused. It is therefore almost essential to use a photoelectric trip with an infra-red beam of

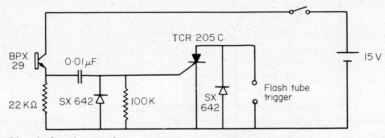

Figure 4. Circuit for slave unit.

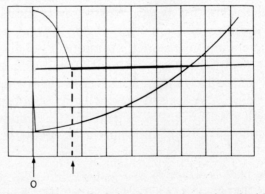

Figure 5. Trace illustrating delay in flash-head triggering using the high-speed slave unit. (Upper trace = voltage across thyristor. Lower trace = voltage across 22 kohm.) Phototransistor illuminated by flash gun at T = O. Time base = 1 μs/cm.

light. Interruption of the beam of light allows current to flow and activates a solenoid to fire the shutter, which in turn triggers the main flash heads. The slowest part of this operation is the mechanical part, that of moving the shutter release. This can be reduced to acceptable limits if a leaf-type shutter is used. With this type of shutter it is possible, by using a 'locking' type cable release, to take up most of the movement of the shutter release lever, making it into a 'hair trigger' and giving the solenoid a minimum of work to do. A suitable circuit for such a photoelectric trip is shown in Fig. 6, and the total time involved to open the shutter in the time lapse trace Fig. 7.

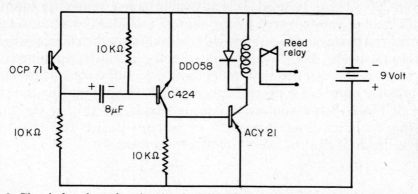

Figure 6. Circuit for photoelectric trip. Activated by interruption of infra-red light falling on OCP71.

Figure 7. Time lapse trace-beam interruption/shutter open. Illumination of OCP 71 is removed at T = 0. Time base = 5 ms/cm. Delay to shutter opening = 10 ms.

The use of an open-shutter technique would reduce this delay

considerably, but is not practicable for birds where, even at night, there will be enough ambient light to make a double image a possibility. It could be used, perhaps, for insect photography in controlled studio conditions.

In practice the author has found that at least two flash sources are necessary to give good 'modelling' to the bird, the flash heads being placed at approximately 45° to either side of the camera. One is usually at camera level and the other two or three feet higher. Using a film format of 6 × 9 cm or 9 × 12 cm and with a subject distance of 1·3–4 m, a 135 mm lens has been found to be the most valuable, but on occasions where the subject is small, or the distance unavoidably long, then a lens of about 200 mm can be used. It is advisable to so arrange the equipment that the field of view covered by the camera includes the whole length of the infra-red beam, so the subject will be caught by the camera whenever it breaks the beam. As the demonstrated delay in shutter opening (Fig. 7) is 10 ms, it is necessary to have a depth of field sufficient to allow for the bird to move some 1·2–5 cm (for speeds of 32–48 kph) outside the chosen point of focus. Some allowance may be made for this at the time of focusing, but a small aperture (f22, or perhaps less) is required to give enough depth of field to allow for this movement.

Operating in the Field

The practical problems of equipment have been discussed, but there remains the even more important aspect of introducing the equipment to the bird. It is of course necessary that the trip be placed across a known flight path, and this will entail patient observation of the behaviour pattern, and when the equipment is finally in place it is of the utmost importance that the bird be observed most carefully to ensure that the equipment has not caused any alteration to that pattern. If the bird's behaviour has been affected at all then the equipment *must* be dismantled and removed. The photographer must not let the amount of work put into erecting the apparatus influence his judgement of the need to leave the area with his equipment, if the bird is being upset.

Once the bird is seen to accept the equipment, and has not altered its previously observed pattern of behaviour, then photography can be

undertaken. The short duration of the flash is unlikely to upset the bird; it may perhaps show some reaction to its first experience of the flash, but this is invariably transient and does not cause any long-term change of behaviour pattern.

The photographer's actions will depend upon whether the camera is set up in a hide or not. When using a hide, resetting the shutter and changing film or plate present no problems; however, if the camera is in the open then resetting the shutter and changing the film will need extreme care, and the timing will have to be based on the bird's previously observed pattern of behaviour. The photographer must only approach the camera when it is a certainty that the bird (or, where both sexes are involved, both birds) have left the vicinity, otherwise there is the very real risk of serious behaviour upset; if the flight line being used is that to the nest there is the consequent risk of desertion and the loss of the young birds.

The same arrangement can be used for insect photography in the wild if there is a known flight path, e.g. bees returning to a hive, but in general the photography of insects is best undertaken in a studio, with the insect so released that it will fly through the infra-red beam. The equipment described previously, with a flash duration of 100–200 μs will in many circumstances give satisfactory results, though with insects having a very fast wing movement a specially-built unit delivering a flash in about 75 μs will be required. I have no personal experience of such equipment, but the results may be achieved by the simultaneous triggering of multiple lamps; the reader is referred to the description of the equipment used by C. Greenewalt for photographing humming birds, and described by Professor Edgerton in his book (see Bibliography).

Two points remain to be mentioned. Firstly, the light from the discharge tube lies towards the blue end of the spectrum, and with colour film this may result in an undesirable blue colour cast: a suitable filter, such as the Kodak Wratten 81EF or its equivalent, will lower the effective colour temperature and reduce or eliminate this blue cast. The second point is that of reciprocity failure; in normal photographic practice, with exposure times between 1/10 sec and 1/1000 sec, the relationship of light intensity and exposure time is constant. However, this ceases to be true with increasingly long or short exposure times, and certainly is no longer valid with exposures in the low microsecond range. This must be allowed for with monochrome material by some increase in the exposure, by

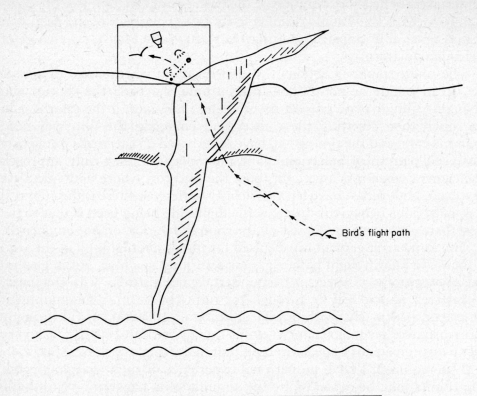

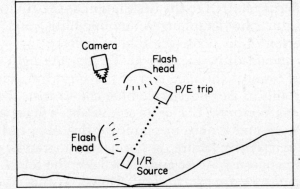

Figure 8. Sketch of the set-up to photograph storm petrel. (Inset details of equipment.)

using a wider lens aperture or a proportionate increase in the development time—usually of the order of 25–50 per cent. With colour emulsions the problem is more complex as the various layers in the colour material may not all react in the same way; there may be a shift of colour balance as well as some loss of effective speed. Increasing the effective exposure by use of a wider aperture may be necessary (even if undesirable because of reduction in the depth of field), and for correction of the colour shift the use of colour correction filters may be necessary. The Kodak CC range or equivalent will be adequate, but as the actual filtration will depend on the individual flash unit, the type of colour material used, and to some extent the subject matter, the actual filtration can only be determined by experiment.

A typical equipment set-up is shown in Fig. 8, where the arrangements to photograph the storm petrel are illustrated. It is essential that both the lamp delivering the infra-red beam and the photoelectric trip are on firm supports, for any movement of either piece of equipment will result in an interruption of the light beam to the receptor of the trip, and the camera and flash will fire. This can be caused by wind, or even (as was my experience with a barn owl) by the bird using the trip box as a perching site before finally flying in to feed the young. This resulted in a whole night with many exposures but not a single photograph of the bird!

Flight photography is perhaps the most rewarding of all branches of Natural History photography, but it requires much time and patient observation, together with a great deal of hard work, as there is inevitably a lot of equipment to set in place. The 'perfect' picture may well be only one from dozens of exposures, for many will show the subject in an unfavourable position: that one shot will however more than repay all the time and trouble expended.

Acknowledgements

I am deeply indebted to W. E. Austin, MIEE., M.Eng., for all his help in the design and construction of the equipment, the production of the circuit diagrams, and the oscilloscopic measurements of the delay times of the equipment and the duration of the flash discharge.

Bibliography

Electronic Flash, Rickman, E. J. and Abbey, S. (Pitman) London, 1958.
Electronic Flash Photography, Aspden, R. E. (Temple Press) London, 1959.
Electronic Flashlight Photography, Snow, P. (Fountain Press) London, 1961.
Electronic Flash—Strobe, Edgerton, H. E. (McGraw Hill) New York, 1970.

10

Insects and Other Invertebrates

Sam Beaufoy

General Aspects

The remarks in the Introduction concerning the two approaches to Natural History photography—that of the photographer who uses Natural History subjects as models, and that of the Naturalist who uses his camera to augment his interest in wildlife—particularly apply to the photography of insects. Until the mid-1950s few photographs of insects were seen in exhibitions, mainly because of the inadequacies of equipment and materials. Bird photographers produced excellent work, though most was done at the nest or some other point to which the birds would repeatedly return. But the chances that a butterfly, say, will visit a particular spot, such as a flower upon which a camera is pre-focused, are small, and stalking insects is difficult with a large reflex, the only type available in the early days. Modern equipment and materials make things much easier both in the field and under controlled conditions, and insect photographs are now often seen. However, many people still use insects as models without a good knowledge of their Natural History, so that their photographs—perhaps excellent from the technical and composition points of view—are ruined because they are untrue to nature. Editors of magazines and even selectors for photographic exhibitions often do not have a sufficient knowledge to distinguish between the good and the bad. Any photographer can induce, say, a dragonfly (which may be docile in dull weather) to rest on a highly coloured flower in order to obtain an attractive picture, but the Natural History would be wrong—dragonflies do not visit flowers. Some years ago a photograph was published of a dead

clouded yellow butterfly pinned to a flower, with wings widespread. Not only is it against all the ethics of Natural History photography to make dead subjects appear to be alive, but the photographer did not know (or chose to ignore, for the sake of an 'attractive' picture) that this species never rests with its wings open! Such glaring examples of spurious Natural History are perhaps most prevalent with insects, because of the difficulty of photographing them alive as well as a general ignorance of their habits.

Whatever the reason for the photography, the results must be as true to life as possible. Some subjects can be photographed 'free and wild', particularly in these days of fast emulsions and sophisticated apparatus, but there are many that cannot. For the whole of the insect to be in focus one must use as small an aperture as possible and give a comparatively long exposure, which demands perfect immobility both of the insect and the foliage it is on; there is also the risk of camera shake. Electronic flash can be used to arrest motion, but even then the insect may move in and out of focus. Another nuisance is the wind: flower photographers will confirm that even on the calmest day there always seems to be a howling gale! The setting and background can cause difficulties; insect photographs often have to be taken quickly, before the subject flies away, and it is not always possible to remove unwanted grass stems, obtrusive leaves or flowers, which spoil the result.

Clearly one can photograph 'free and wild' only those insects that happen to come within range, and this is infrequent. The photographer who is primarily a naturalist will wish to record more aspects of his subject than are available by taking his camera into the countryside and hoping that something will turn up. Life-histories (from ova to imagines), habits and the means of protection (cryptic marking and shading, mimicry, warning colouration, etc.) can all be illustrated. The observations and study necessary for these details will themselves widen his interest, and it is often useful for a beginner to work in the field in the company of a more experienced naturalist. Much can be learned by joining both a Natural History and a general Photographic Society, while the preparation of a Natural History lecture can reveal gaps in one's own knowledge that require filling!

The Camera

The photographer must choose a camera that will suit his own preferences and his pocket. Very expensive and sophisticated apparatus is not essential for good results. Photographs of insects taken by Hugh Main and J. J. Ward in the first quarter of the century were with 9×6.5 cm or quarter-plate cameras without large aperture lenses, high-speed emulsions or electronic flash, and such instruments still have their uses, particularly under controlled conditions. They should have a long extension and be capable of using lenses of different focal lengths, so as to provide a wide choice of reproduction ratio. Focusing needs to be exact and only screen-focusing cameras can be considered. These can be of the field type, but a reflex is quicker in operation. With cameras taking plates or cut-film, single exposures can be made and processed quickly—a useful point, since it may be impossible to re-take a photograph a few days later, owing to the short time between stages in an insect's life.

There is a good choice now of 35 mm and 6×6 cm single-lens reflex cameras with interchangeable lenses, automatic iris and instant-return mirrors. With most SLR cameras the automatic iris can be retained with extension tubes, though few keep it when using bellows; where it is not so, it is usual for the modern lens-head to have a pre-set iris mechanism, operated manually just before the shutter is released. To avoid camera shake, it is advisable to practise all operations until they can be carried out quickly and smoothly. With 'full-frame' through-the-lens metering systems, care must be taken when, for example, a light insect is being photographed against a dark background or vice versa. But with 'spot' metering the angle of acceptance can be very low, and well within the area of importance in the photograph.

In choosing lenses, extension tubes, bellows and supplementary lenses, provision should be made for subjects of different size and at different scales within the frame (e.g. full-frame to show anatomical details, or at a much smaller scale to show, say, how the insect fits in with the surroundings). Some camera-makers supply charts which give the degree of magnification when using certain lenses with supplementary lenses and with extension tubes or bellows. Such a chart can easily be made up by focusing on a foot-rule and noting the length of rule seen in

focus on the screen: it will allow the appropriate equipment for a particular subject to be selected quickly before the actual photography.

Photography Wild and Free

The photography of insects 'in the field' requires considerable patience and one must be prepared to accept a high proportion of failures through movement, incorrect focus, insufficient depth of field, bad background, lack of suitable light, non-co-operation of the insects themselves and even their absence!

The appropriate lens and, if required, supplementary lens or extension tube should be fitted, by reference to the chart mentioned earlier, and the camera made ready. The area selected should be watched for some time to note where the insects are alighting to feed or rest: often one particular bloom is preferred to others. The approach has to be slow and careful, without disturbing the surroundings. One needs to keep an eye on the background and on any foliage between the camera and the insect. Background is always a problem in the field: if possible, choose one that is in shade and without spotty highlights, with the subject in bright light, so that it stands out well. (This last recommendation applies where the object is to obtain a portrait of the insect itself. If, however, one wants to demonstrate how the insect is camouflaged in its natural setting, then more of the surroundings must be included. This aspect is dealt with later.) Where an insect is resting and likely to remain in position for some time, the background can be adjusted to remove unwanted highlights and blobs of colour. The effect should be judged through the view finder at the taking aperture: a background which appears satisfactory at full aperture will often be quite unsuitable when it becomes sharper on stopping down.

Focusing should be carried out by moving the camera bodily to and from the subject. Focusing on close-up subjects by using the lens or bellows focusing movement is always difficult, as the distance between subject and lens is also changed and the scale thereby altered. For subjects near the ground it is useful to have a waist-level finder or a right-angle attachment to a pentaprism. A unipod support can be a help at times.

Insects are often in awkward positions and a great deal of preliminary practice should be carried out, without a film, standing, crouching, kneeling, sitting or lying, so that no time is lost when the subject is actually being photographed.

For exposure, a compromise is necessary between a small aperture to give as great a depth of field as possible and a shutter speed which will not give rise to camera shake. This latter depends upon the photographer and upon the focal length of the lens. As recommended in Chapter 17, a satisfactory proportion of shake-free exposures will be obtained at a shutter speed which is the reciprocal of the focal length in mm: e.g. with a 50 mm lens, use a shutter speed of at least 1/50 sec. As ranges are so short, almost any movement of the insect will require an even higher shutter speed. A caterpillar, for instance, crawling quite slowly, will show movement at a speed of 1/125 sec. It is therefore necessary to wait until the insect is at rest before the exposure is made. The use of electronic flash to stop motion will be dealt with later. Because of the general uncertainty many exposures should be made for a good chance of a few successful results. Plate 35 (upper) is an example.

Controlled Conditions

If the photographer wants to make his insect photography more comprehensive and to take more and better photographs than can be obtained in the field, he must resort to some form of control. Photography of insects in a small room with artificial light will produce satisfactory results. Most butterflies are fairly docile in artificial light and can usually be induced to rest in a suitable position. The room should be small, with the minimum of fittings—the camera, tripod or camera bench, lights and means of holding foliage. The walls should be plain white. The reason for this bareness is to reduce hiding places to a minimum. A position of rest is often high up on the wall and for this reason a low ceiling is recommended.

A robust tripod with a pan-and-tilt head is required. As with 'free and wild' photography, focusing is best carried out by moving the camera bodily to and from the subject. This movement can be effected by

mounting the camera on a rack-and-pinion, the fixed part being attached to the tripod head, and the camera to the moving part. Such a mechanism can easily be made from the rack-work of an old half-plate or quarter-plate stand camera. Some manufacturers list apparatus designed for this purpose for 35 mm and 6 × 6 cm cameras.

The foliage or other resting place for the insect is easily held in a clamp such as is used in a chemical laboratory. This allows it to be easily and quickly moved.

Lighting by two photoflood lamps is recommended, and they also should be mounted on adjustable stands. It is not advisable to use high-powered lamps as they generate too much heat, often causing the insects to become very restive; No. 1 (275-watt) photofloods are very satisfactory, but as their life on full voltage is short they should be connected to the supply through two 2-way switches, so that they can be connected either in series (when half voltage is applied to each lamp) or in parallel (when each lamp receives full voltage). In series the lamps will last indefinitely and the light is enough for the preliminary arrangement of the subject matter and for focusing. They are then switched into parallel to give full light when ready to make the exposure.

The choice of foliage and background needs a knowledge of the habits of the insects in the wild. The setting must be true to nature, and it is in this respect that photographers with little Natural History knowledge may make mistakes. When an appropriate setting has been arranged, the task of inducing the insects to rest in a suitable and natural position begins. There is no guaranteed way to success; patience is essential. Moths are relatively easy to deal with, as most species rest during the day and can be made to crawl on to, say, a piece of bark, representing the side of a tree, and there they will rest for as long as necessary. Butterflies are not so co-operative. The best method is by very slow and careful movements to get the insect to crawl on to a small stick and then to induce it to crawl from this to the position required. Some butterflies, such as the clouded yellow, the brimstone and the grayling, will never rest with their wings open. Others, such as the swallow-tail, will spread their wings as soon as exposed to the bright lights. Some insects react very quickly to lights and cannot be induced to rest: they should be placed in position and focused on in as dim a light as possible, the exposure being then made by flash. Synchronization is not necessary; open flash is quite

satisfactory. It might be argued that flash should be used on all occasions, but experience shows that better lighting will usually be obtained with lamps, which can be moved around and the effect seen in the viewfinder.

The question of exposure is a purely photographic matter, depending on the film or plate used, on the aperture, on the type of lighting and on the subject matter. An exposure meter will give a general idea of exposure required, but this may need to be amended by experience when dealing with close-up subjects under artificial light conditions. As a rough guide, a butterfly with Kodachrome X (daylight type) and correction filter, with two 275-watt photofloods at one metre needs about $\frac{1}{2}$ sec at f16.

Photography of Early Stages

At a casual glance the ovum is a tiny spot on a leaf, the larva something that crawls, while the pupae are seldom seen at all. Close examination will reveal the true beauty of colour and patterning of these early stages, and the photography is easier than when dealing with the final stage.

A microscope is not necessary when photographing ova or very small larvae; quite simple apparatus will do—for example a reversed short-focus lens on the long extension provided by an old double- or treble-extension stand camera; a magnification of $\times 5$ to $\times 10$ is usually sufficient. A low-power microscope objective with a focal length of about 30 mm can also be used in such a camera: it does not usually possess a built-in means of adjusting the aperture, but there is available the so-called Davis Shutter (not a shutter in the photographic sense, but an adjustable iris diaphragm fitted behind the objective). Focusing at such close range is extremely critical; both the camera and the object should be securely held on a rigid workbench. Exposure is best made not by opening and closing the shutter in the normal way, which might cause camera shake, but by opening the shutter in the dark, removing the hand from the shutter release (so preventing any possible shake being transmitted by the release), and then switching on the lamps for the required time, which is a matter for experiment. As the ova are static, long exposures can be given with the smallest possible aperture, to obtain the maximum depth of field (Plate 36, lower).

Larvae are best photographed under controlled conditions, unless one wants to record a mass of them in their silken web, as occurs with some species. Individual larvae can be placed on suitable foliage in the work-room. A larva may crawl around and start to eat, and although it might be thought that this is another instance for the use of electronic flash, the problem is not so much one of stopping movement-blur as of the insects moving in and out of focus; it is better to wait for it to come to rest of its own accord, when the foliage and camera are adjusted so as to bring the larva into a suitable position.

Lamp arrangement when photographing larvae under controlled con-ditions is of particular importance from the Natural History point of view. For example the larva of the eyed hawk-moth normally rests horizontally on the underside of the stem of a leaf, with its ventral side uppermost. This side of the larva is a much darker shade of green than the dorsal side, and receives more light as it faces the sky. This 'counter-shading' has the effect of making the larva appear to be of one shade overall, and thus it tends to lose its roundness. If the larva is inverted it will appear in bold relief with the paler green dorsal side highlighted from above, so that the insect becomes conspicuous and more liable to preda-tion. Thus to obtain a good Natural History photograph under artificial light conditions (whether it be of an insect, a bird, a fish or a mammal), one must take care that the arrangement of the illumination is as close as possible to daylight (Plate 38).

The photography of pupae presents little difficulty. When one is enclosed in a cocoon (as with most moths), the case can usually be cut open to show not only the pupa but also the construction of the cocoon. That of the emperor moth is a good example; the silken threads forming the cocoon are spun in such a way that the emerging moth can easily push its way out, but the entry of enemies is prevented.

Rearing the Insects

The photographer who takes a real interest in the Natural History of insects will not be content with photographing only specimens that he may come across; to record the complete life history of a butterfly, for

instance, he will often have to rear them from the egg stage. Searching for ova or larvae may occasionally be successful, but it is usually better to catch a female and induce her to oviposit in captivity. Nearly all females in the wild are already impregnated, as pairing takes place very soon after emergence, but the ease with which they can be persuaded to lay varies with the species; some strongly-flying species are very difficult. The female should be enclosed in an airy cage, which contains the foliage upon which she would normally lay. Some species are particularly fussy; for instance the larvae of the brimstone butterfly will feed only upon the leaves of the common or alder buckthorn, so that these must be provided. In the enclosure should be placed a few flowers in water or a wad of cotton wool soaked in a solution of honey for the butterflies to feed on. The cage should be placed in sunlight with a little shade, and it should not be allowed to get too hot. Hatching time depends on the species, and may be lengthy.

The type of enclosure for the larvae during their growing life is not important, provided it is airy and kept clean, with frequent changes of food. In the early stages quite small containers should be used, so that the larvae can easily be found when one needs to supply fresh food. The foodplant can be kept fresh by immersing the stems in water, care being taken to plug the neck of the bottle with cotton wool to prevent the larvae from crawling down and drowning. Some larvae become dormant during the winter, though they may wake up during warm spells; for such species the foodplant should always be present. Others will not awaken at all until the spring—usually those feeding on leaves which are not available during the winter, e.g. the larvae of the white admiral, which feed on honeysuckle, and the purple emperor, which eat sallow.

Larvae change their skins several times during their lives, and the colour, shape and patterning may alter considerably from instar to instar. The different stages will provide an interesting series, as will the actual shedding of the old skins, and the final process of pupation. There is usually no immediate indication that these changes are about to take place, and, when they do occur, they may be very rapid. One must have the larva in position before the camera with everything ready before the process starts; it is then a case of continuous watching. Electronic flash is often useful to arrest the convulsive movements made by the larva during the change.

Photography of pupae presents few problems, though larvae will sometimes pupate in the corners of the cage where photography is impossible. Plenty of twigs and foliage should be provided to give suitable supports for the pupae, so that they and the emergence of the final insects can be easily photographed. The larvae of many moths burrow into the earth, so plenty of soil should be provided in the cage. When the pupae have been formed they can be dug up if the act of emergence is to be portrayed. With nearly all butterflies the pupae are formed above ground, often being attached by the tail only to a silk pad spun on their support, though others additionally secure themselves with a silk girdle. A few hours' notice of emergence is usually given, because the colours of the wings appear through the skin of the pupa. Without warning the skin splits and within seconds the butterfly, with soft crumpled wings, crawls clear of the pupal case. The wings expand to their normal size in a few minutes, and they harden for flight within an hour or so (Plate 35, lower).

Another advantage of rearing insects at home is that the final insects are in perfect condition. Many species in the wild quickly lose their emergent 'bloom' or become damaged (by flying around bramble blossom, for example—a favourite food for many species).

Dragonflies

Dragonflies are popular subjects, and here again the Naturalist will not be content with photographing only the final insect. In the wild, dragonflies are difficult; when the weather is hot and sunny many will be seen flying, but they seldom rest, and when they do they are usually in inaccessible places. They have very keen eyesight, needing a slow approach, with great care not to disturb the foliage. The photographer is seldom able to choose the best background, with the result that successful 'in-the-wild' photographs of dragonflies are scarce. In dull weather the insects will rest

Plate 35. (Upper) Meadow browns, paired; wild and free, × 1·8. Sinclair Reflex, 150 mm Tessar; 1/100 at f11 on P.1200 plate (9 × 6·5 cm) developed in ID.11.
(Lower) Monarch, emerging from pupa; controlled, ×2·2. Details as above, but 2× photoflood, 1/60 at f5·6 on HP3 plate.

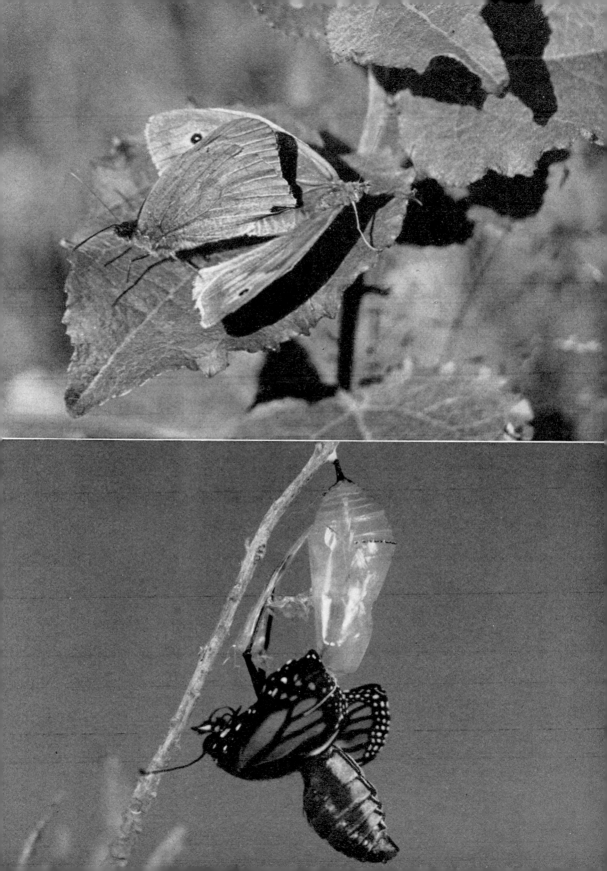

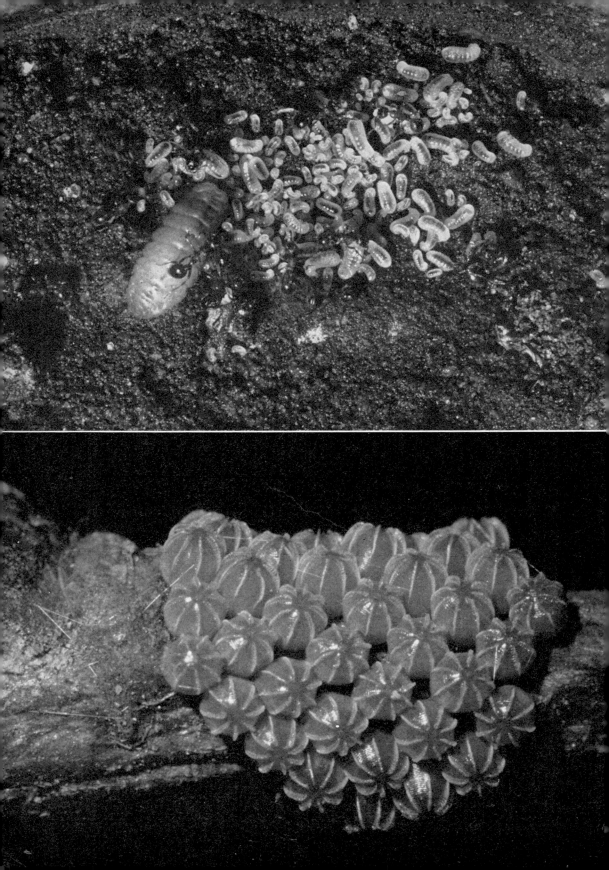

for hours at a time, but then they are extremely difficult to find. The most successful results are obtained by catching the dragonflies in a net—not always an easy task—and photographing them at home with artificial light or flash, as already described. The emergence of a dragonfly from the larval stage is a never-to-be-forgotten sight, rarely seen in the wild. The larvae can be kept in aquaria at home, and are not difficult to rear; they will feed on many sorts of pond life, the larger ones eating earthworms with relish. The changing of the skin in the water and the capture of prey by means of the 'mask' are processes well worth watching and photographing. Before emergence the larva will rest just below the surface of the water on a support, and under controlled conditions such supports must be provided. Here again a constant watch must be kept, and as soon as the larva leaves the water the support, with the larva on it, must be removed and placed in front of the camera, which, together with lamps or flash, must be already prepared, because the dragonfly will emerge in a very few minutes. The skin splits, and the head and thorax break free: then the emerging dragonfly rests for 15 or 20 minutes with the end of the abdomen still in the larval case, and with the head, thorax and front part of the abdomen hanging downwards; suddenly the larval case is grasped by the legs, and the remainder of the abdomen is withdrawn. The photography of dragonflies requires less knowledge of photography than of Natural History. Some of this can be obtained from books, but actual experience is necessary for the greatest enjoyment (Plate 40).

Other Insects and Invertebrates

The methods already described can be applied to many other insects and invertebrates. Bees, wasps, flies, grasshoppers and crickets are not often

Plate 36. (Upper) Large blue, larva in symbiosis with ants (*Myrmica laevonoides*), controlled, ×3·8. See p. 206. Voigtlander Avus, 105 mm Skopar; 1× Sashalite bulb, open flash at f45 on P.1200 plate (9 × 6·5 cm) developed in DK.20.
(Lower) Large tortoiseshell; eggs laid in a batch around an elm twig. Controlled, ×20 Sinclair Reflex, 36 mm microscope objective with 'Davis shutter' stopped down, 2× photoflood, on P.1200 plate (9 × 6·5 cm) developed in DK.20.

very co-operative under controlled conditions, so they will usually have
to be photographed in the wild. Many beetles are fairly docile in artificial
light, but smaller creatures are so lively that further forms of restraint
have to be employed. A cell made of two small pieces of glass, separated
by strips of wood, so that the distance between the two glasses is about
5 mm, will be useful; it can be used for the photography of a small insect
engaged in a particular activity or for a portrait to show anatomical details.
The photograph of the parasite *Nemeritis canescens* laying her eggs in the
larva of the flour-moth is an example (Plate 41, lower). Close control
was essential; the larva was moving little, but the parasite was flying
around and could have been lost; even if it had been closely interested in
the larva (already placed in front of the camera), the positions adopted
would have been unlikely to be at satisfactory angles to the camera.
Within this cell, however, the parasite had no room to fly; it crawled
around, found the larva, inserted its ovipositor and laid eggs. This
happened several times, allowing a number of exposures to be made by
flash. As the positions of the insects remained more or less the same, little
alteration of camera position or focus was required.

Invertebrates which live in the soil or under stones or bark, such as
millipedes, centipedes and wood-lice can be photographed by confining
them in a small area on a flat surface under a glass cover, such as a watch-
glass. The camera can be focused through the glass and everything made
ready for a quick exposure. The subjects can then be left in darkness,
when they will probably settle down. In the minimum of light the glass is
removed and the photograph taken by flash. Plate 36 (upper) shows the
larva of the large blue butterfly among a brood of the ant *Myrmica
laevonoides*. The ants had taken the larva into their nest, where it spent
the winter, feeding upon the ant brood. To obtain the photograph, larvae
were reared under controlled conditions in company with the ants raising
their brood under a large walnut shell in a tin with soil. The tin was
stood in a dish of water to prevent the ants from escaping. The photo-
graph was taken by momentarily removing the shell to reveal the larva
and ants underneath.

Plate 37. Goat moth. At rest on bark. Controlled, ×1·8 showing cryptic coloration.
Sinclair Reflex, 150 mm Tessar, 2× photoflood lamps, 1 sec f25 on P.1200 plate (9 ×
6·5 cm) developed in DK.20.

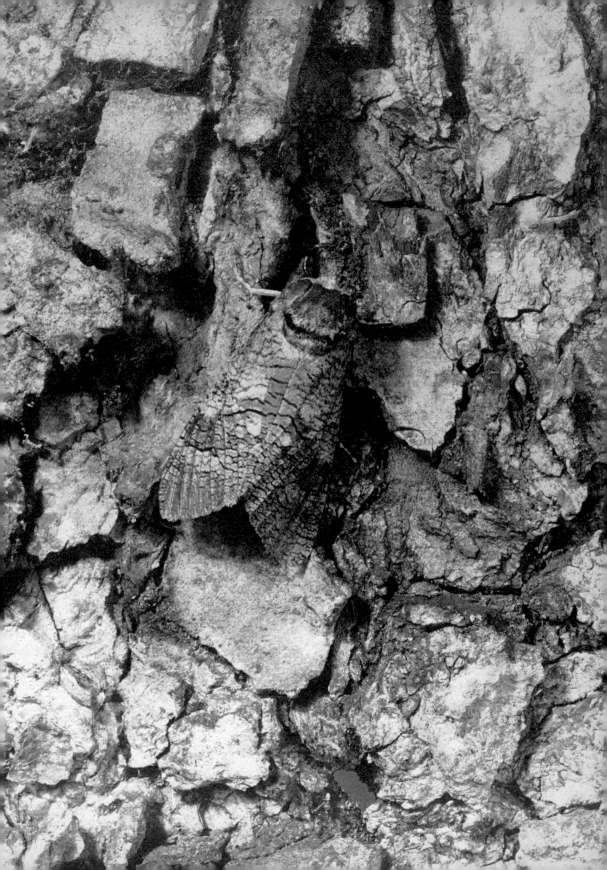

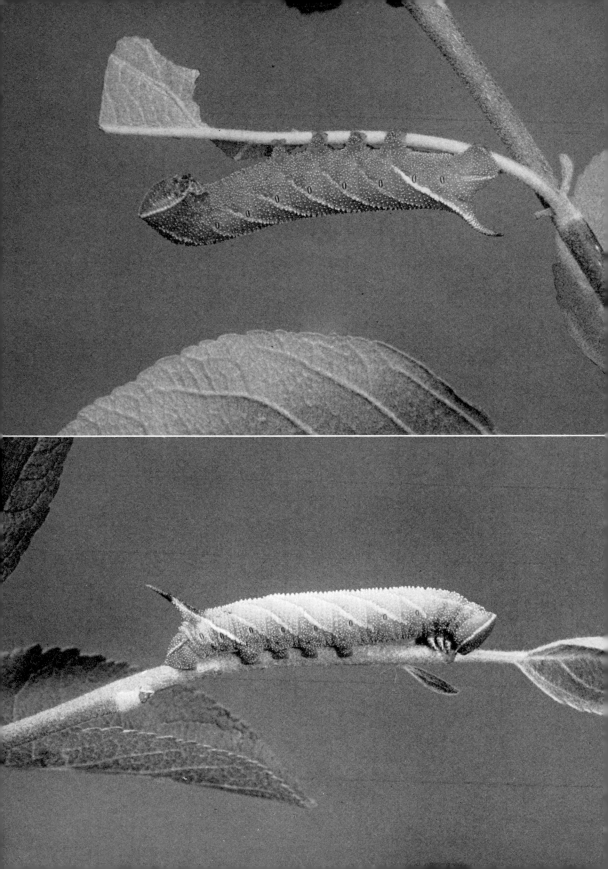

When a photograph is required of a creature whose habit is to move at great speed, or to lurk in dark corners, e.g. silverfish and some beetles, the methods of control already described may not suffice. *As a last resort*, it may be permissible to use means such as placing the subject for a short time in a container in a refrigerator, or giving it a whiff of ether or other anaesthetic, sufficient only to slow down its movements. Under no circumstances should it be 'posed' to look as though it is engaged in some activity; and on publication of the photographs the method of control ('etherized', 'temperature-controlled') should be stated.

Snails and slugs should present no difficulties. A snail's pace may appear to be slow, but when close to the camera electronic flash is necessary to arrest the movement. Any attempts to stop them will cause them immediately to retreat into their shells or to shrink. In all case the habits of the subjects should be carefully studied before photography is attempted.

Spiders have received little attention from Natural History photographers, perhaps because they do not have the remarkable metamorphoses that occur with most insects. Most species must be photographed in the wild; attempts at control will meet with little success, as the slightest unnatural disturbance will cause the spiders to run for shelter in an obscure corner where photography is impossible. The eyesight of most species is poor and is restricted to the area close at hand, though some of the jumping spiders can see about 20 cm; because of this most spiders can be approached closely, but care must be taken that moving shadows do not pass across them. Spiders are extremely sensitive to unnatural vibrations; when attempting to photograph one in its web, the situation should be carefully examined, not only from the front but also from the sides. The silk threads forming the supports for the web may extend a considerable distance, and are extremely fine and difficult to see. If there is any wind photography is not easy, as the slightest breeze causes the web to swing; electronic flash would obviate this movement, but the

Plate 38. (Upper) Eyed hawk-moth, larva, controlled, ×1·7. Correctly shown, in normal resting position (see p. 200). Sinclair Reflex, 150 mm Tessar, 2 × photoflood lamps, 2·5 sec f25 on S.G. Pan plate (9·6 × 5 cm) developed in ID.11.
(Lower) Incorrectly shown, with counter-shading destroyed by the inverted position. Details as above.

subject is so close to the camera that it will be continually moving in and
out of focus. Backgrounds are a great source of trouble; it is seldom
possible to remove highlights or spots of colour without causing vibration
of the web. It is better to search the locality for a suitably situated web
than to try photography at the first one encountered.

Many spiders do not use webs, lying in wait among foliage to pounce
upon any prey that comes within reach. Most of these remain quite still
and should not be difficult to photograph. They are often difficult to
find, however, because of their protective colouration.

Photography of Set Insects

One is sometimes asked to take photographs of specimens that have been
killed and taken from an entomologist's collection. The photography is
simple, but there are a few points which are often overlooked. When one
has to photograph a number of specimens together for one plate in a
book, for instance, it is advisable to use as large a film as possible, quarter-
plate or even half-plate, if detail is not to be lost when the block is made;
35 mm can be used for single specimens.

Distractive shadows are unavoidable with set insects pinned straight
on to a plain board. They can be avoided by pinning the specimens to
tiny pillars of plasticine which are stuck on to a sheet of glass, the pillars
being small enough to be hidden by the bodies of the insects. To get the
specimens in exactly the right positions on the glass, they may be
arranged and mounted first on a sheet of paper the same size as the sheet
of glass. The specimens are then removed, the position of each pin being
marked on the paper. The glass can then be placed over the paper, and a
pillar of plasticene fixed to the glass over each mark on the paper under-
neath; the glass must be scrupulously clean, care being taken not to touch
it with the fingers when fixing the plasticene. The pins will protrude
above the insects, and in some cases may spoil the photograph. If the

Plate 39. (Upper) Stag bettle, controlled. Imago, $\times 1 \cdot 7$, on oak leaves. Voigtlander Avus,
10·5 cm Skopar; $2 \times$ photoflood at f32 on P.1200 plate ($9 \times 6 \cdot 5$ cm) developed in DK.20.
(Lower) Larva, $\times 3$. Details as above, except f45 on HP3 plate developed in Microdol.

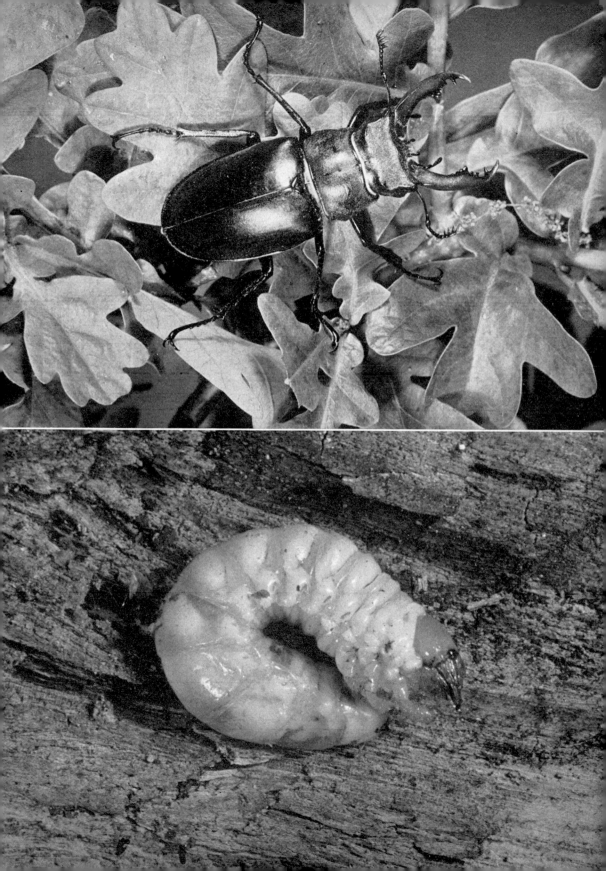

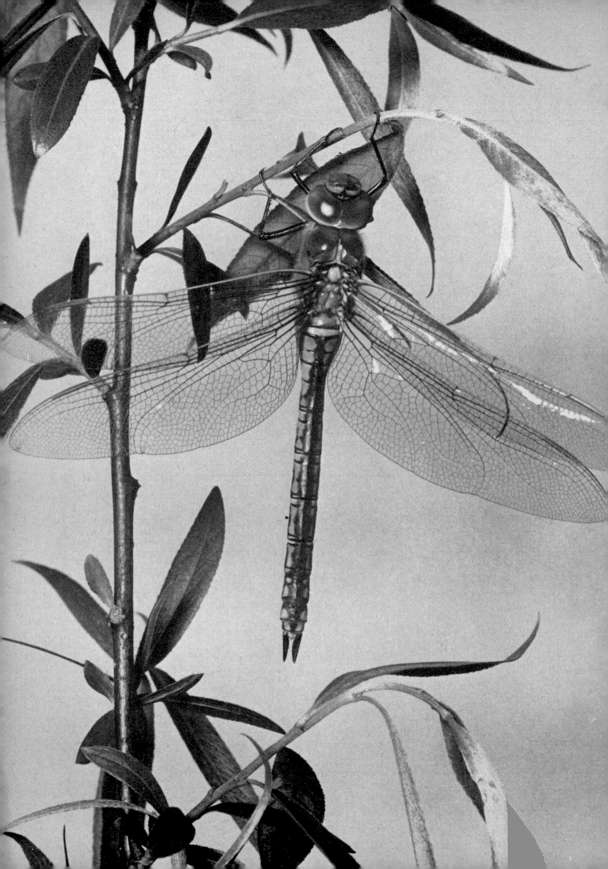

owner of the specimens agrees, the pin may be cut just above the body, leaving only sufficient to enable it to be held in a pair of forceps. The bright spot caused where the pin has been cut can be eliminated by a tiny spot of paint the same colour as the body of the specimen below. It now remains for the specimens to be mounted on the pillars of plasticine. Extreme care has to be taken when moving the specimens, as some are very brittle and the slightest touch may result in the loss of a leg or antenna. The plasticine must be firmly stuck to the glass and the pins firmly embedded in the plasticine.

The glass should be held in front of the camera in a vertical position. The front illumination can be supplied by two lamps, one on each side, ensuring that they are placed sufficiently wide for there to be no reflection from the glass into the camera. Behind the glass holding the specimens can be placed a sheet of white flashed-opal glass, sufficiently far back for no shadows of the specimens to be thrown on it. Two lamps behind and to the side of this opal glass illuminate it to give a plain white background. A sheet of black paper, fixed to the front of the camera, with a hole through which the lens protrudes, will prevent bright parts of the camera from being reflected from the glass.

To show anatomical details dead specimens can be placed flat on glass and, if necessary, kept flat by placing another piece of glass on top. Such objects, usually small, need the same treatment as was described for the photography of ova and young larvae. In the case of opaque objects, such as butterfly wings, illumination will be from the front. Transparent objects, such as the wing of a dragonfly, can be illuminated from behind by a light shining on a white background, so that the structure of the wing is clearly defined.

Flash

In pre-electronic days flash bulbs were often used. Synchronization, with a brief opening of the shutter in the middle of the flash burning period, enabled some movement to be arrested. With open flash, in which the

Plate 40. Dragonfly, *Anax imperator*, female, controlled, ×1·4. Sinclair Reflex, 150 mm Tessar, 1× Sashalite bulb, 1/100 at f25 on P.1200 plate (9 × 6·5 cm) developed in DK.20.

shutter is open for the whole burning period (approximately 1/30 sec, depending on the type of bulb), the full light value is obtained. Little movement is stopped, but this type is useful for still subjects in poor light or when they are likely to move if exposed to the glare of flood lights (see p. 198). The exposure and the distance of the bulb from the subject are largely matters of experience, depending on the type of bulb, aperture used and the reflectivity of the surroundings.

Electronic flash is now used by most Natural History photographers, and very helpful it is, but it must not be thought that all photographs require it; far from it! The total amount of light given is considerably less than that from most types of flash bulb. To counteract this an electronic unit is often brought very close to the subject; consequently, although the insect itself is correctly illuminated, the background, being relatively further away, is often badly under-exposed, giving an unnatural effect—as if the photograph had been taken at night. In controlled conditions it is therefore advisable to keep the background as close as possible. The position of the flash unit and surrounding reflecting surfaces are matters for experiment, to give the most natural effect. A single source of light at a considerable distance and with dark surroundings will give the effect of a concentrated spotlight, and helps to emphasize such small details as, say, the scales on the wings of a butterfly. However, this is not how the wings are seen in the open air, where, even in sunlight, the light comes from all parts of the sky, softening the outlines of small details. For the most natural effect with a single flash, it is better to have the unit close to the subject with plenty of good reflecting surfaces. The use of two or more units, placed as with filament lamps, is sometimes a help.

The flash duration of most small electronic units is from 1/600 to 1/2000 sec, and this is usually short enough to 'stop' any slow movement of an insect. But it must again be emphasized that it is often very difficult to keep the whole of the insect in focus when it is moving.

Plate 41. (Upper) Larva of *Coenagrion puella*, controlled, ×5. Voigtländer Avus, 105 mm Skopar, 2× photoflood lamps, open flash at f45 on P.1200 plate (9 × 6·5 cm) developed in ID.11.

(Lower) The parasite *Nemeritis canescens* inserting its ovipositor into a larva of the flour moth; controlled, ×4 (see p. 206). Speed Graphic, 15 cm Tessar; 1× Sashalite bulb synchronized at 1/200 at f16 on quarter-plate SXX cut-film developed in DK.20.

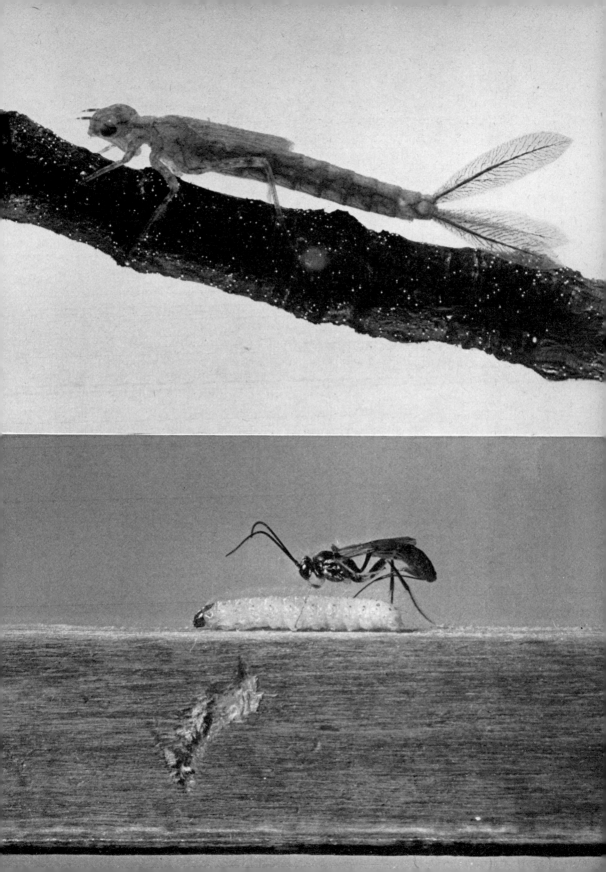

The use of electronic flash and photoelectric cells, developed for the photography of birds in flight, has recently been extended to the photography of insects in flight. Chapter 9 'Flight Photography with Electronic Flash' gives details; very fine results have been obtained by this means, some showing actions, e.g. exact wing positions, which were not known before.

Presentation

Photographs of Natural History subjects should be true records of what is seen. It is sometimes said, for example, that a moth does not stand out distinctly from its background—maybe the bark of a tree on which it is resting. Such a criticism usually comes from a non-Naturalist, not realizing that the whole idea of the photograph was to show how the moth resembles its background (Plate 37). The photographer must not be tempted to make such insects 'stand out' more prominently just for the sake of producing a more attractive 'picture'. All Natural History photographs should be judged by the question 'Is this good Natural History?'. If the answer is 'No', then the photograph fails, however technically excellent.

Very large prints of small insects should not be made for the sake of size alone, unless these will show details which would not be noticed otherwise. Some photographic exhibitions require that mounts shall be of a standard size, often 50 × 40 cm; rather than one large print on such a mount, it is often preferable to have two or more smaller ones, depicting different aspects of the one subject—a life-history, or a series of prints of related species. Such mounts may not catch the eye of an undiscerning judge as easily as a larger print would, but it could well be of more value from the Natural History point of view. In any reproduction, the scale should be stated so that the uninitiated can judge the actual size of the insect.

Conservation

Conservation of insects is just as important to the environment as the conservation of birds, flowers and mammals, but in the past it has not

received the attention that it should. Recently, however, the Joint Committee for the Conservation of British Insects has been formed, and has produced a *Code for Insect Collecting*; this is designed for Britain, of course, but the principles are applicable in all countries. It is mainly for specimen collectors, but photographers should study it too. The numbers of many insects fluctuate, a year of abundance of a particular species often being followed by a year in which only a few are seen. This is the normal way of nature, but there are some species that are always rare and to be found only in restricted localities. A member of such a species should be taken from such a spot only if it is certain that it can be returned safely to the same place after the photographs have been taken. It is no use releasing it where it is not normally found; it would not meet any others of the same species, and the distribution records could be badly upset. In a similar way, when insects have been reared in captivity, they should be released in suitable localities, the common species more or less anywhere, but the rare ones only where the original female, from which the ova were obtained, was caught.

Although collecting in moderation does no harm to the insect population, some entomologists are notorious for the manner in which large numbers of rare insects are caught, killed and mounted in rows. Collections of photographs are better for bringing back memories of days of observation spent in the field, and will be of far greater interest than cabinets full of dead specimens. One hopes, too, that the efforts of insect photographers will result in more of the general public taking notice of the Natural History around them.

Bibliography

Butterflies, Ford, E. B. (Collins: New Naturalist Series) London, 1957.

Dragonflies, Corbet, P. S., Longfield, C. and Moore, N. W. (Collins: New Naturalist Series) London, 1960.

Moths, Ford, E. B. (Collins: New Naturalist Series) London, 1972.

Insect Natural History, Imms, A. D. (Collins: New Naturalist Series) London, 1957.

The Oxford Book of Invertebrates, Nichols, D., Cooke, J. and Whiteley, D. (Oxford University Press) London, 1971.

11

Aquaria and Vivaria

Heather Angel

The Advantages

Photography under controlled conditions is a perfectly valid form of Nature photography in many circumstances. It is essential for recording the movement of small highly mobile or dangerous animals, for detailed pictures of small aquatic organisms, for photographing pest species, and for record-photographs of rarities which can normally be seen only in collections or zoos. In all these instances, controlled photography is fully justified, providing that such pictures are not palmed off as having been taken 'in the wild'.

Apart from the obvious benefit of not having to chase after an escaping subject every few seconds, the main advantage of confining the subject is that the direction and output of the lighting can be controlled, and the background selected and varied. This should result in a higher proportion of successful pictures. There is also a better chance of obtaining a sequence of pictures illustrating an aspect of behaviour. By using sophisticated techniques such as light-beam triggering units, high-speed flash and fast repetitive strobe lighting, information can be obtained about activities that are faster than the human eye can perceive, such as the way in which a flying insect takes-off, and lands, or the way a snake strikes. Some of these techniques are described in more detail in Chapter 9— 'Flight Photography with Electronic Flash'.

Controlled photography is by no means a quick and easy way of obtaining nature photographs. Very often animals will take several days to readjust to their artificial surroundings: no photography should be

attempted until they have settled down and begun to feed. For aquatic animals, control of the water temperature is important and can be critical. A sudden temperature increase causes a rapid increase in the respiration rate, and may lead to death. Even a gradual rise in temperature may result in abnormal behaviour; for instance, the suckered feet of sea urchins droop distinctly in warm sea water. The amount of oxygen that will dissolve in water decreases with a rise in temperature, resulting not only in streams of bubbles from stones or weeds, but also the respiratory distress of the subject. If the aquarium is much colder than its surroundings, condensation develops on the outside of the glass.

Small intertidal animals such as barnacles, hydroids and sea anemones feed only when immersed in water. Because the depth of field is so critical with close-up photography, these animals cannot easily be photographed *in situ* underwater. Freshwater ponds, canals and rivers are also usually unsuitable places for close-up photography. Firstly, the animals are rarely close to the surface and, secondly, tripod legs pressed down into the bottom stir up murky clouds. Larger vertebrates, such as fish, cannot often be photographed easily in the wild, although blennies are possible in rock pools and trout show up well in clear chalk streams. Such *in situ* pictures are always overhead, unless underwater cameras are used, whereas tank photography permits a much greater variety of viewing directions.

Vivaria are clearly sensible for dramatic close-up head-on photographs of poisonous snakes. They are essential for confining active small mammals and for obtaining action shots of amphibians and chameleons feeding on flies and moths.

Photographs of animals from unusual angles, to show features not normally visible, usually require tank photography. For example, the shape and mechanics of the muscular foot of a limpet or a slug, the suckers of a leech or a lamprey, or the suction pads on the digits of treefrogs and geckos, can be illustrated by photographing the subject through the sheet of glass to which it is clinging. This is most easily done either by placing the sheet in a vertical position, or by using one face of a glass aquarium.

Collecting Animals

No animal should, of course, be collected unless it is common in the wild state. Unless a captive is photographed immediately, it must be fed until it can be released back into its natural habitat. Animals such as shrews which have a high metabolic rate can starve to death during a photographic session, unless they are fed very frequently. The main disadvantage of confining subjects for photography is that unless a considerable quantity of vegetation is brought in to simulate the natural habitat, the subjects inevitably look rather stark against a plain background. When collecting either livestock itself or the vegetation for use as 'background material', care should be taken not to wreck the habitat in general. Collect only common plants and remember that even bits of bark and rotten wood provide essential micro-habitats for many species, so they should not be removed in large quantities.

Freshwater plants are essential as underwater supports for many aquatic invertebrates. Water boatmen and water beetles, which both have to surface to breathe, are positively buoyant; as soon as they stop swimming, they therefore rise to the surface, unless they can cling on to weeds. There is no point in collecting too many subjects: photography takes time, so collecting should be restricted to a few animals which can be adequately housed and fed in vivaria or aquaria.

One does not have to be a lepidopterist to know that butterflies are caught with a voluminous muslin net. However, the equipment and techniques required for collecting marine life, snakes or small mammals, may not be so familiar. Small insects and invertebrates can be collected by such methods as beating vegetation with a stick over a sheet or tray, filling a large plastic bag with leaf-litter or moss for future sorting, or sucking them up with a 'pooter'. (A pooter is a corked suction bottle with two tubes inserted through the cork. One tube, with its base covered with a piece of gauze, is connected to a piece of rubber tubing, forming the mouthpiece, which is used for sucking small insects up through the other tube into the bottle). Entomological suppliers now offer a great range of plastic boxes and perforated tins suitable for carriage and storage of these smaller animals. Damp moss or soil placed in the container will

ensure that the high humidity—so essential for the survival of many small insects—is maintained.

Many intertidal marine animals, such as molluscs, crabs and echinoderms, as well as the hydroids, worms, sponges and sea squirts which grow on seaweeds or stones, can be collected by hand. Soft sea anemones should be prised gently from rocks with a finger-nail, rather than hacked at with a sharp knife. Better still, specimens attached to weeds or small stones, can be transported back to the studio intact. A small aquarium net is ideal for catching prawns and small fish in rock pools, while a garden fork is suitable for digging worms and bivalves from sandy beaches. At the same time one should collect an adequate supply of sea water, preferably in large plastic carboys or clean glass Winchester bottles. Commercial salt mixtures, for dissolving in water to make artificial sea water, have the advantage of containing no suspended debris, but are relatively expensive and are not suitable for all marine animals.

Most freshwater invertebrates and small fish, can be collected in a water net with a robust frame and a terylene or nylon mesh bag. The size of the mesh will determine the size of the catch and the practicality of using the net in running water. Grapnels are sometimes useful for collecting weeds especially if they are out of reach of the net, and a surprising number of photogenic subjects crawl out of a good haul of weeds.

Predators such as crabs, water beetles and water boatmen, should obviously be carried in separate containers. The traditional containers are wide-necked glass jars carried as a pair in a wicker basket. A good substitute is any plastic container with a carrying handle—a bucket will do—or even a milk-bottle carrier with jam jars.

Amphibians are collected most easily when they concentrate in their spawning grounds. Newts, frogs, toads and salamanders can all be collected from water with a coarse-meshed water net. When on land, they can be caught by hand or by dropping a sweep net over them. Amphibians are best carried in jars or tins lined with damp moss. A sweep net is also useful for trapping lizards—especially those species which shed their tail as soon as any pressure is applied to it.

While non-poisonous snakes can be caught by hand, any active snake, crawling at speed, is better caught with a net. A cleft stick, often recommended for catching poisonous snakes, can cause internal injuries; a wire loop at the end of a pole, gently slid down the body of a snake, can be used

to lift it safely into a container, such as a plastic dustbin with a tight-fitting lid. Other smaller reptiles can be carried in perforated tins or cloth bags.

Small mammals are best caught in Longworth traps. Made of aluminium, each consists of a nest box which is clipped onto the tunnel. At the free end of the tunnel is a flap door, which is set in the raised position. The trap is sprung when the mammal enters the tunnel via the flap door, and knocks a treadle wire running across the end of the tunnel. Shrews are a particular problem because they have continuous short alternating periods of activity and rest and will die if they do not feed every 2–3 hours: so, if traps are to be left out all night, they should be examined at least every 2 hours.

Construction of Aquaria and Vivaria

A vivarium is an artificial enclosure in which terrestrial animals are kept alive in naturalistic surroundings: a large glass 'aquarium', with a gauze cover is suitable for photography. Indoor vivaria for amphibians should include soil, stones and mosses or other plants as well as a large container of water. Reptiles, on the other hand, will usually prefer drier surroundings and exposure to sunlight. Larger vivaria can be made out of doors by building a wall around a pond for amphibians, or constructing a snake-pit for large reptiles.

Glass-sided tanks are generally most appropriate for indoor enclosures. Perspex, being light and very adaptable, can be used for constructing small containers without any additional framework. It is so readily scratched, however, that critical photography through it is not practicable. The cheap Perspex tanks now available commercially are nonetheless useful for keeping animals. Small custom-built tanks are useful for overhead photography when pictures are taken of animals directly on the substrate or the water surface. Bottomless cylinders or boxes can be useful in corralling crawling animals on the ground or on a sand tray.

If photographs have to be taken through a transparent wall, glass is the most suitable material. This should be flawless, and often it is worth replacing the front glass of a conventional tank with a sheet of plate glass:

it should be kept scrupulously clean, free from finger marks and other smears. Cleaning should be with a soft cloth which does not leave bits on the glass; a well-washed unstarched linen handkerchief is ideal. Better still is an 'anti-static' cloth.

An aquarium set up on a sunny window sill, or with a permanent light source directed onto it, will soon develop a growth of algae on the inside walls—this can be scraped off with a razor blade or the plastic scraper often supplied with an aquarium. If a rim of precipitated salts develops, it may be both cheaper and quicker to replace the glass rather than to scratch it by cleaning. Less time, less film, and fewer precious subjects are wasted by replacing scratched glass straight away.

Tank frames can be plastic or metal. Because sea water and even soft fresh water is corrosive, stainless steel frames are well worth the extra expense in the long run. Angle-iron frames need to be well maintained and regularly painted. Plastic is resistant to corrosion but not robust enough for large containers. Some putties are toxic, so a new tank should be filled with water and allowed to stand for several days before it is refilled for photography.

Size of Aquaria and Vivaria

The size of an aquarium or vivarium will depend very much on the size of the subject, its activity, the type of picture required and the range of photographic equipment to be used. The choice will inevitably be a compromise between a container that is large enough to allow the animal to move around, behave and display normally, and the need to restrict its activities as much as possible to the field of view. Clearly the side walls of the container should be outside the field of view. Close-up portrait pictures may be possible by restricting the animals to a small space, but very often such pictures are unacceptable because the animal's posture gives away the tightness of its confinement. Pictures of hunched small mammals with erect fur and bulging eyes are typical examples.

Better results will be achieved if the animal can set up home within the container. Because each individual will have its own set of foibles, as to what sounds or movement make it react, different techniques will have to be used to lure it into the field of view.

Terrestrial Invertebrates

Many crawling insects can easily climb up a vertical glass face and out of an open vivarium. A covering of glass or gauze is particularly important when photographing household pests, such as silver-fish, cockroaches and termites, whose escape could possibly result in an accidental infestation. The escape of a scorpion or poisonous spider could be even more serious: for such creatures a moat of water is an effective barrier.

The subject can be confined for photography either by using a narrow tank or a standard-sized tank with an internal glass insert. If the subject is close to or in contact with the front glass, some frontal lighting is essential. Additional back-lighting can be used to give a rim-light effect, for instance when an animal is photographed crawling over glass. Such restriction of an animal's movement is particularly appropriate for activities such as a locust or bush-cricket ovipositing in soil, in which it is important not only to show the insect, but also the extended oviposer and the eggs being laid beneath the soil.

When the axis of the camera is perpendicular to the front glass, specular reflection of frontal lighting will appear in the field of view, unless the light source is positioned well to the side of the camera. In Fig. 1 the region where the light can be positioned in the same plane as the camera without its reflection appearing in the field of view, has been cross-hatched.

The limit of this area is derived by plotting a line running at an equal and opposite angle to the line CF—the line from the camera (C) to the edge of the field of view (F). To prevent reflection of the light appearing in the field of view, the distance between the normals of the camera (N) and the light (A) to the glass must be greater than the width of the field of view (FF[1]). The normal is a line drawn perpendicular from a given point (in this case the camera) to a plane, i.e. the glass.

Light is refracted towards the normal when it passes from air into an optically denser medium. Total reflection, however, occurs only when light passes from a dense to a less dense medium. Therefore, because there is no critical angle for light passing from air into glass, the lights can be held at a far shallower angle to the glass (or greater angle to the

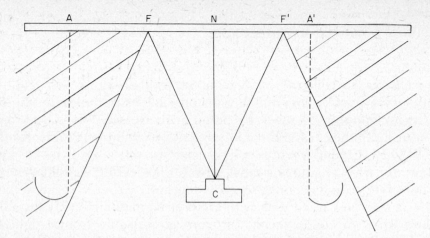

Figure 1. Correct (left) and incorrect (right) positioning of light source, in same plane as camera, for frontal lighting through glass. Point A lies further from point N than the field of view (FF') whereas point A' lies closer to N than distance FF'.

normal) than might at first be expected. For most subjects, positioning the light source at 45° to one side of the camera is most practical.

Reflections of the camera—even the photographer's hands—in the front glass spoil many tank shots. These can be eliminated quite simply by mounting a matt-black mask on the front of the camera. The central hole in the mask must be large enough to ensure there is no restriction of the field of view when the lens is used at maximum aperture. A single-lens reflex (SLR) camera is most suitable for this type of photography, since parallax is avoided and the masking is far simpler than with a non-reflex or a twin-lens reflex (TLR) camera.

The lighting used will depend on the activity of the subject. For active subjects, electronic flash is most suitable. The best position for the flash-head can be found by replacing it temporarily with a continuous light source and checking the lighting and the pattern of the shadows. With photofloods this procedure is unnecessary, but unless heat filters are also used, the heat generated can have undesirable effects on the subject, by increasing its activity or even killing it. Furthermore, primitive nocturnal animals like silver-fish and cockroaches will respond to the continuous bright light by scuttling away under whatever cover they can find.

If a water moat can be used to confine the insects, the problems of

through-glass photography are removed, and there is a greater flexibility in lighting positions.

A method of confining an active flying insect is to cover it and some vegetation, with a loose box. This open-bottomed box can be made from a wire framework covered with transparent cellophane or from a cylinder of clear plastic with a lid. Whenever the insect lands on the inside of the box, it is persuaded to move by tapping the outside. By repeating this procedure, the insect sooner or later settles on the plant. The camera is then focused through the loose box—which is gently removed before the exposure is made. It is obviously a wise precaution to close all doors and windows *before* the box is removed.

The burrowing activity of earthworms through layers of different coloured soils can be observed through any glass container—including old battery jars, but for photography the front glass must be flawless. The worms can be induced to make at least part of their burrows in contact with the glass, by wrapping the outside of the wormery with black paper. For a complete view of the entire worm in its burrow, a special narrow container will have to be made by sandwiching a layer of soil between two glass plates slotted into a wooden framework or separated by a piece of rubber tubing approximately the same thickness as the earthworms.

Aquatic Invertebrates

While many inter-tidal invertebrates can survive several hours exposure to the air, they show little activity and can be photographed satisfactorily in action only when submerged. Filter-feeding animals such as barnacles, mussels and fanworms, feed only when immersed. Out of water they close down their valves or withdraw into their tubes.

Clear, shallow waters covering tropical coral reefs are ideal for the underwater photography described in Chapter 13. But even in these conditions, small invertebrates present major problems. In order to show detail, they must be photographed in close-up at magnifications of a quarter to life size or more. The limited depth of field at these magnifications means that focusing is critical. Even if flash enables the maximum

depth of field to be used, a diver finds it almost impossible to maintain his position accurately enough to ensure a sharp close-up picture. Nearly all detailed photographs of small marine and freshwater organisms—especially from turbid waters—are consequently taken in aquaria; so are small deep- and mid-water oceanic animals.

Aquarium photography is by no means simply a question of collecting livestock, putting it in a tank and taking a photograph a few minutes later—a great deal of preliminary work must be done. A standard glass-sided aquarium measuring 30 × 20 × 20 cm is adequate for photographing most small invertebrates and fish. When a picture is taken through the

Figure 2. Trapezoidal aquarium.

entire front glass, of a standard rectangular tank, perspective effects will result in the back verticals appearing inside the front verticals. Therefore an aquarium with a trapezium-shaped base, with the back face longer than the front face, is especially useful for photography.

After the aquarium has been selected, it is filled with either sea water or fresh water—but preferably *not* tap water—unless it has been allowed to stand at least overnight. The chlorine put in to purify tap water is lethal to many freshwater animals. It may be necessary to filter sea water or river water containing pieces of weed and debris, as any particles illuminated against a dark background become immediately conspicuous. Larger particles can be removed by pouring the water through a kitchen sieve; fine silt particles in suspension can be removed only by pouring

Plate 42. European tree frog, controlled. Photographed through glass, to show the digital suction-pads. Hasselblad 500C, 80 mm Planar; Braun F700 flash on Pan-X roll-film developed in D.76 1:1.

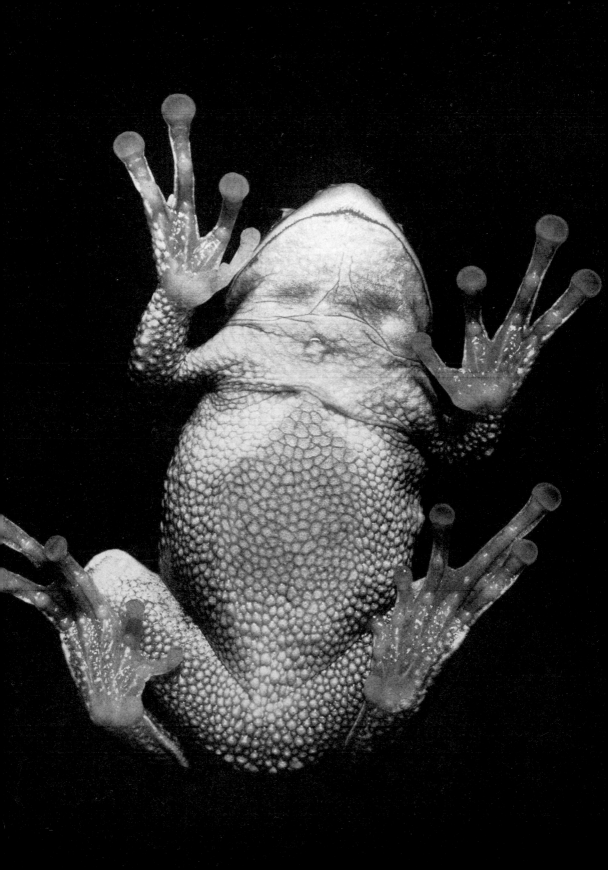

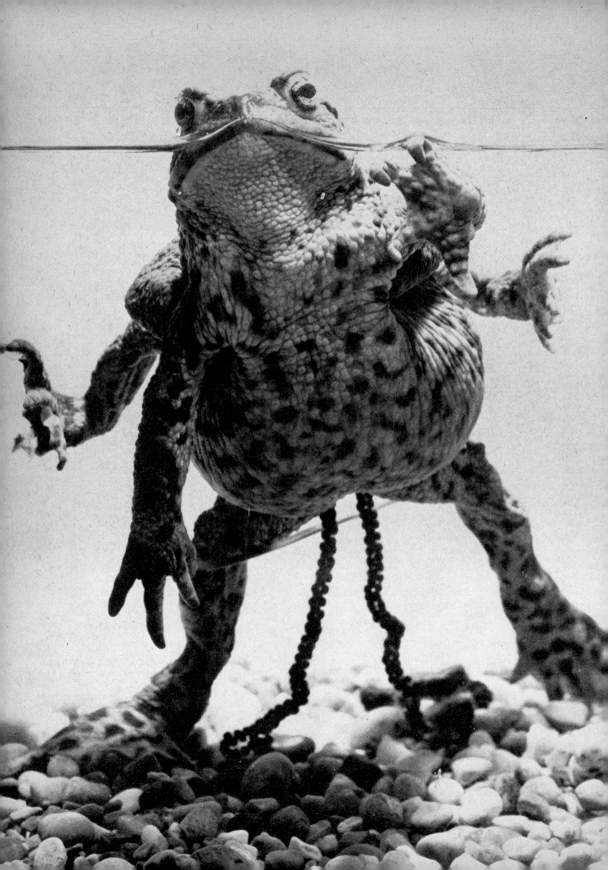

through filter paper. But filtered water does not remain clear, even if the animals are not fed at once, they soon begin to defaecate. Aquarium water can be continually filtered by bubbling it up and passing it through a filter in the corner of the aquarium. Some people argue that clear, filtered water looks unnatural, and certainly when photographing large fish, particles are not so distracting and can therefore be ignored.

If time has been spent filtering water, it is obviously sensible to wash weeds, stones, gravel or sand before they are added to the aquarium. The bottom substrate should be an authentic one—sand being provided for animals which live in soft beaches and the lower reaches of river, and rocks for the inhabitants of turbulent stretches or rocky shores.

Lugworms and bivalves can be photographed in their sandy burrows by using a glass insert to restrict their burrows so that one side becomes visible through the front wall of the aquarium, in the same way as the wormery described for earthworms. While this technique does enable the burrowing activity to be photographed, it must be regarded as unnatural, because of the restriction.

Weeds attached to stones will not need to be anchored amongst gravel or beneath stones. When dry stones and rocks are immersed in water, the air trapped in cracks, becomes released as a stream of air bubbles. This can be just as distracting as particles in the water, and so it is preferable either to use wet stones or else to set up the aquarium and leave it for a day before beginning any photography.

Unless seaweeds are kept under running sea water they soon begin to decay, and they are therefore not suitable for a permanent marine aquarium. If the entire back of the aquarium is filled with weeds so that objects outside the tank are invisible, there is no need for an artificial background. Plain backgrounds, however, are quite acceptable for studio work, and indeed have the added advantage of isolating the subject from its surroundings, so that its shape and its structure can be related to function. Pale blues, greens and browns are the most acceptable colours to use for underwater backgrounds. While black is always dramatic in both monochrome and colour work, it has the disadvantage of showing up

Plate 43. Common toads in amplexus, controlled; the female is beginning to lay egg-ropes. Details as for Plate 42 except 2× Mecablitz 181 flashes were used.

every particle in the water. Black backgrounds, however, are essential when photographing transparent subjects such as jellyfish, comb jellies or the freshwater phantom larva, which appear invisible against any other background. These subjects can be shown either with side lighting or with back lighting. Lights placed behind the aquarium will have to be directed in through the sides of the rear glass, in order to avoid the problem of flare (even with modern multi-coated lenses). The lens-hood —so essential for reducing flare when backlighting terrestrial subjects— can be replaced by a matt black mask here. When a dark background is placed outside the back face of the aquarium, reflections of pale stones and weeds will appear on the inside back wall. By placing the background *inside* the aquarium, these back reflections then become eliminated. Wettable backgrounds, such as cardboard, are obviously not suitable for immersion, whereas coloured Perspex will retain its colour and any surface scratches will disappear on wetting.

Freshwater pond skaters, floating plants and some oceanic animals like the sea slug, *Glaucus*, which move or float on the surface of water, should be photographed with the camera mounted vertically, so that the lens points down onto the water surface. The 20 cm depth of a conventional aquarium is unnecessary for these surface animals. Because the photography is not done *through* the sides, the container can be made of Perspex and could even be a simple plastic lunch box.

The camera can be mounted on either a copipod—preferably one with adjustable rack and pinion movements—or on the inverted head of a tripod. A mask, similar to the one described for photography through glass, can be used for cutting out reflections of the lens, camera and hands on the water surface.

The ambient temperature is important, for in a warm room condensation will develop on the outside of the aquarium and eventually the animals inside it may die or behave abnormally. The water temperature must therefore be taken before any animals are introduced into the aquarium. Many aquatic animals are stimulated to mate and spawn by a rise in temperature. If the aquarium water gradually rises a few degrees

Plate 44. Grass snake, with extended tongue, controlled. Details as for Plate 42 except that two Braun F.700 flashes were used.

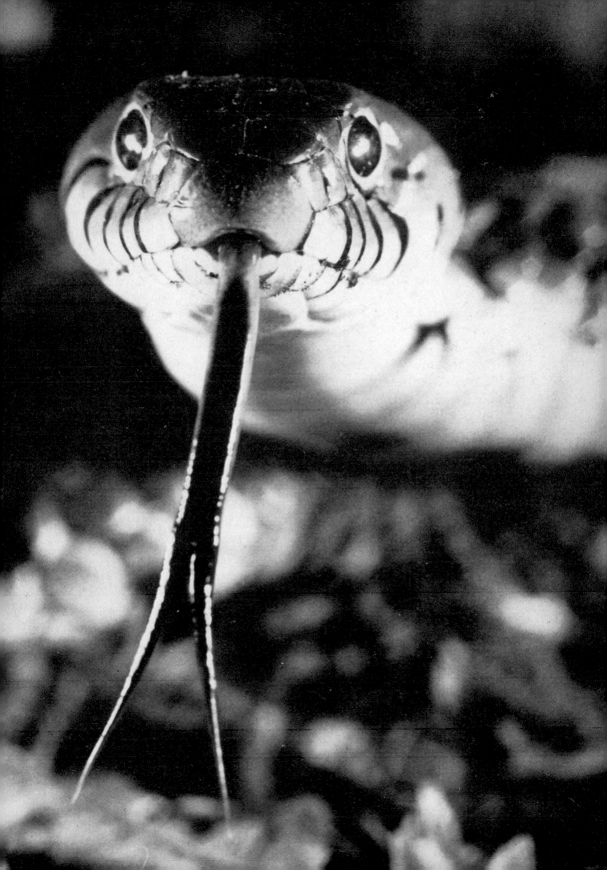

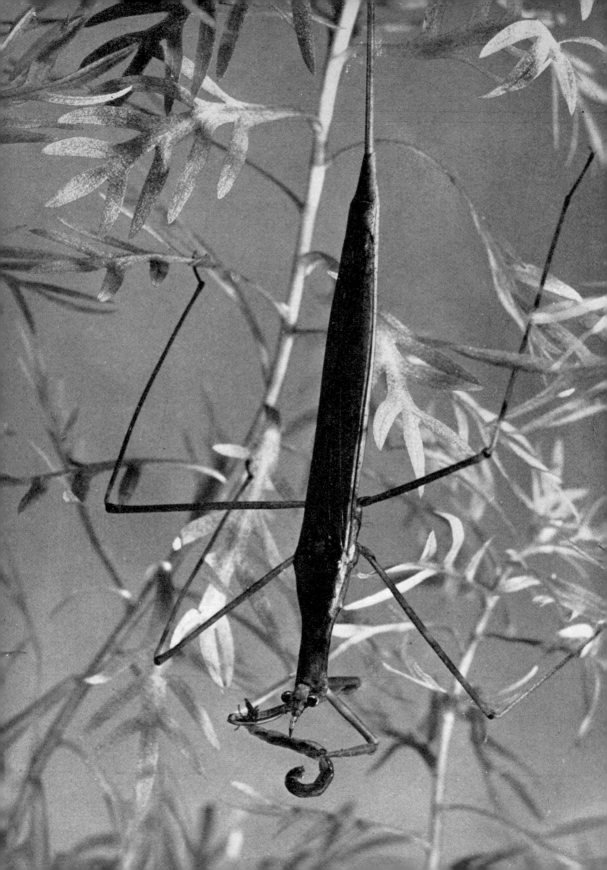

above the natural water, and the animals happen to contain ripe gametes or mature larvae, they may be stimulated to release the eggs, sperm, or larvae prematurely.

Lighting

Small aquaria offer much more scope for flexibility of lighting than large public aquaria, which often can be illuminated only by directing flash-light through the front glass.

Static subjects such as weeds, sponges and compound sea squirts, can be illuminated either by making use of available light streaming in through a window, or with photofloods. Photofloods are not particularly suitable unless they are switched on for short periods only, or if they are used in conjunction with heat filters. If daylight colour film is used with photoflood lighting, then a yellow cast results. The correct colour balance can be achieved with photoflood lighting either by using artificial light colour film or, if necessary, by using daylight colour film and a colour conversion filter. There is a considerable loss in film speed with such a filter, for example, with a Wratten 80B filter, Kodachrome II (25 ASA) becomes re-rated to 8 ASA.

The movement of active subjects can be arrested either by using a fast film and a high shutter speed, or, preferably, by using electronic flash. As with any studio work, the position of the light sources should be individually selected for each subject. The most obvious way to light an aquarium is so that it simulates natural sunlit surroundings with the lighting overhead. The main disadvantage of using a direct light source positioned close to the aquarium is that it will cast a shadow of any subject swimming over a pale bottom. If the aquarium has four accessible glass walls, the light sources can also be directed through the sides, through the front glass, or through the edges of the back glass. With top or back lighting, reflectors can be used to throw additional light back through the sides of the aquarium. The correct position for lighting through the front glass has already been illustrated in Fig. 1.

Plate. 45. Water stick insect feeding on bloodworm, controlled. Details as for Plate 42 except $2\times$ Mecablitz 181 flashes were used.

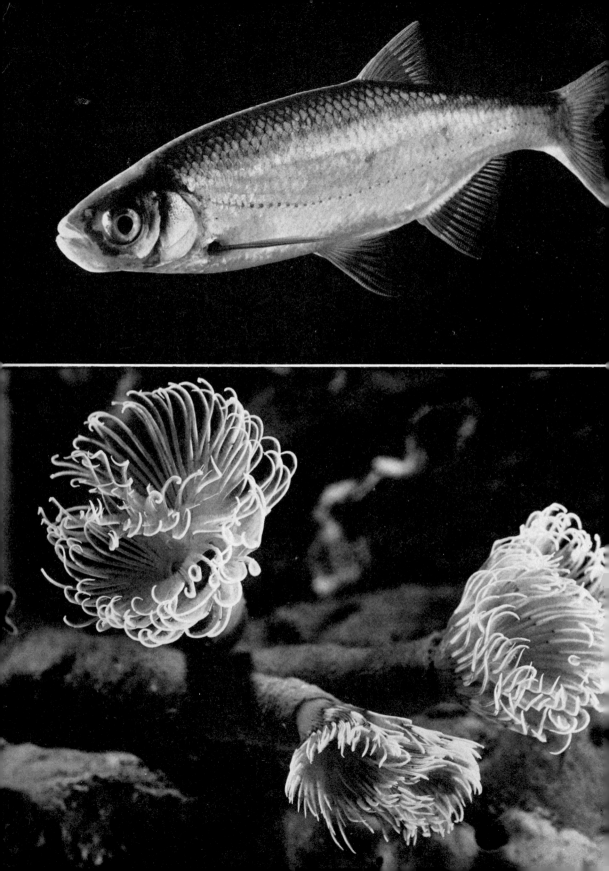

A table-top tripod with a ball-and-socket head fitted with a flash shoe, is useful for anchoring the flash, which can also be held in place by means of a clamp stand. Multiple flash units can be used with a double or triple connector on the camera, but if the flash sets are not of identical make, premature firing may occur if their triggering units have a different voltage or polarity. Slave units are sometimes the only practical way of triggering multiple flashes (see p. 186, Chapter 9).

Sea water is a well-known corrosive, so it is wise to cover exposed connections of flash extension leads, with tape. Before any exposures are made, check that connections are clean and making contact. If they are not, use a piece of wire or pin to scrape away surface corrosion.

The correct exposure when using flash for aquarium photography can be determined only by making tests and keeping careful notes. Film speed, magnification, flash-to-subject distance, the size of the aquarium, the tone of the subject and the background can all be varied and each affects the exposure.

Because of the problems associated with frontal lighting, it may be easier to photograph a mobile animal by confining it to an area several centimetres inside the front glass, by means of vertical transparent glass or Perspex partitions and lighting it from above or the side. Many photographs of fish are taken in this way. While such photographs may show a clear lateral view, they give little impression of movement, as there is no room for the body to turn within the partitions. Subjects can be confined still further by using a clear Perspex or glass V insert in the aquarium. With an adjustable back, the space inside the wedge can be varied to support any animal—regardless of breadth—in mid-water. Here, the animal has even less freedom of movement than with vertical partitions. This technique, however, is extremely useful and quite valid for recording the colours of live deep sea animals which die, and lose their natural colours, so soon after capture.

Because few can photograph living deep sea animals, some people seem unable to resist using the wedge technique to photograph very dead,

Plate 46. (Upper) Bleak, controlled but free-swimming, showing the lateral line. (2 flash.) (Lower) Fanworms (*Bispira volutacornis*) emerging from tubes underwater, controlled, ×2·8. Details as for Plate 42.

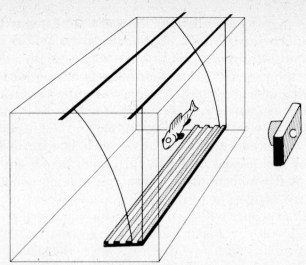

Figure 3. V-insert for confining difficult subjects such as deep sea organisms, in a fixed plane.

tatty fish with opaque eyes, to imply they are swimming in mid-water. This practice, comparable with photographing pinned insects amongst natural foliage, can never be justified.

Surface animals and floating plants, viewed from above, are best shown by directing lights down on to the surface water. Each light should be held well to one side of the camera, or its reflection on the water surface will appear in the field of view. The correct position of the light source from air to water, with the camera perpendicular to the water, follows the same ruling as given for lighting from air through glass in Fig. 1. For the maximum penetration of light through the water, the top lights should be placed as near to the normal as possible, without their reflections appearing in the frame; in practice, an angle of about 45° is quite adequate.

The backgrounds for overhead photography can be natural weeds or artificial plain coloured boards. With overhead lighting, pale backgrounds can be used only when the aquarium has a surface area larger than the field of view, so that the shadows from the surface animals, fall on the bottom outside the field of view. A black background, however, eliminates this shadow problem. A layer of clear Perspex or glass raised up from the bottom of the tank can be used to support weed or animals

above an out-of-focus background. This technique has been used for photographing dead fish laid out in rows, surrounded by a scattering of opaque, preserved plankton—a practice which fools no marine biologist.

Overhead photography is also practical for radially symmetrical animals such as sea anemones, which attach themselves to the bottom substrate, as well as crawling flatworms and polychaete worms. Lighting can then be either from above, down through the water, or through the sides of the aquarium as shown, in Fig. 4. While side lighting is suitable for flat subjects against any background colour, it will cast conspicuous shadows of bulky subjects on a pale background.

Figure 4. Correct positions for lighting aquarium subjects when photographed from overhead. Left: light placed above water for surface subjects; right: lights directed in through sides of aquarium.

Fish

Fish should be kept in aquaria with as large a surface area as possible, and the aquaria covered to prevent the fish from leaping out. Although fish such as sticklebacks collected from ponds, will survive without any aeration, all fish will be healthier and live longer if the water is aerated with an aquarium pump run directly from the mains. Because the water in rivers and ponds is so rarely clear, murky browns and greens make suitable background colours for many freshwater fish. A variety of weeds make a suitable backcloth for colourful freshwater tropical fish, while tropical marine fish will look more at home swimming amongst coral.

A single light source directed in through one side of an aquarium, so

that it lights up the head only, while the rest of the body merges with the unlit background, is suitably dramatic for a predator such as a pike. Fish living near the surface, and shoals of small fish, can be lit either from above or through the sides of the aquarium.

A fish with large silvery scales turning in mid-water is difficult to light satisfactorily from the side. Because the angle of incidence equals the angle of reflection, some of the scales act as mirrors, reflecting the light towards the camera lens and appearing over-exposed in comparison with the rest of the fish. Any fish with big silvery scales can be illuminated safely only from above.

Photographs taken with the camera mounted overhead can illustrate the way in which bottom-living fish such as bullheads (sculpins in America) and cat-fish merge with the bottom substrate.

The courtship, nest building and egg laying or (rather exceptionally in fish) the birth of live offspring, can make a worthwhile sequence of photographs. For this sort of behaviour picture the aquarium surroundings must simulate the natural habitat as closely as possible, and the fish must be left undisturbed for weeks, if not months. Nest-building species, such as sticklebacks, must be given suitable vegetation—preferably several weeks before the male is ready to begin his construction.

Sisson, an American photographer, devised a special spawning tank for photographing the act of fertilization of salmon eggs by the sperm-laden milt from the cock salmon lying alongside the hen fish. A rectangular area was cut away from the bench on which the aquarium was resting, so that photographs could be taken looking up through the glass base of the tank. The camera was mounted beneath the aquarium, with the lens viewing the undersides of the salmon. Two flash were directed down through the water, and a third up through the bottom of the glass in the same way as previously described for frontal lighting of animals in contact with the front face of an aquarium.

Photography is used as a tool for the scientific study of fish behaviour—both underwater in the field and in laboratory aquaria. Dr G. Potts, working at the Plymouth Laboratory (England) has used photographs to study the schooling behaviour, the reproductive behaviour, predation and food preference of several species of marine fish. The back of his large aquarium (2 m \times 60 cm \times 60 cm) is divided up into a 10 cm grid. This grid appears in each photograph, and providing the different

refractive indices of water, glass and air are taken into consideration, can be used to measure the distance of each fish from another. To ensure the camera always records the same aspect, a sighting line on the front of the tank is lined up with the grid. The light source is electronic flash. In addition, a closed-circuit television system is used with a video tape recorder, and has the advantage of operating at a low level of light intensity.

A modified aquarium which has water flowing continuously through it is called a fluvarium. The River Laboratory of the (British) Freshwater Biological Association has had a fluvarium built into the path of a mill stream leading off the River Frome in Dorset, England. The water level at the upstream end of the fluvarium is about 2 m above floor level and it falls to about 1 m above floor level at the downstream end. The flow in the pair of large tanks each 6·1 m long, 1·4 m wide and 0·9 m deep, can be regulated. This fluvarium has been built for culturing, rearing, and observing river organisms, and cspccially for experiments modifying one or more environmental factors. Simulation of a natural river is close, but the river water may sometimes be too turbid for photography. Filtration is impractical here, because it would cut down the rate of water flow.

In order to photograph river fish swimming head-on against the current, the (British) Oxford Scientific Films Unit have built an inverted periscope. The camera, mounted above the periscope out of the water, records pictures which would otherwise be impossible—even by diving underwater. Movements of the paired pectoral and pelvic fins, as well as breathing movements, can be photographed in this way.

Amphibians and Reptiles

Amphibians and the smaller reptiles are relatively easy to keep in a vivarium. Feeding is not too much of a problem so long as a regular supply of live food is available. Flies bred from gentles (used by anglers as bait) and meal-worms are standard food items. Frogs and toads will eat most insects and earthworms that can be found in a garden. Newts and salamanders may feed underwater on aquatic worms and crustaceans; but some species feed only on land, and therefore prefer a diet of worms

and woodlice. Lizards are active hunters, smaller species eating flies, spiders and meal-worms, larger species attacking anything which they can swallow. Some of the burrowing legless species, like slow-worms, have a very useful appetite for small slugs. Terrapins feed only in water, but although they prefer live food, they can with patience be trained to take dead food, like pieces of liver, when it is dropped into the water.

Snakes are not so easy to keep in captivity. They tend to require more space and are often much more choosey about food. Species indigenous to a country are best kept outside, in a snake pit, rather than within the confines of a vivarium. In the wild, snakes eat a variety of small vertebrates from frogs for the European grass snake to peccaries for the anaconda. In captivity, they can be trained to take dead food, but meals tend always to be large and infrequent.

The main problem of keeping many reptiles is to provide them with sufficient ultra-violet light to keep them healthy. Basking in sunlight is essential for many species to synthesize various vitamins and so maintain themselves in a healthy condition.

Photography of snakes in a snake-pit is more akin to photography in the wild. The snakes are free to crawl around and bask in the sun, and they can be photographed by available light in almost natural surroundings. Since the snake-pit provides the subjects with greater freedom, a far greater range of their activities can be photographed—from feeding and sloughing their skin to egg-laying or, in a few species, giving birth to live young. The classical stereotyped way of photographing snakes is coiled up on the ground. One way of inducing them to coil is to cover them with a bucket, which is removed just before the picture is taken.

Both in the studio and outside, electronic flash is useful in arresting rapid activity. Even so, a blurred image of the flicking tongue of a snake, taken by available light, may create a much better impression of movement, than a pin-sharp flashlit picture.

Since amphibians and reptiles are cold-blooded, their activity is directly related to the ambient temperature. By controlling the temperature the photographer can directly control the activity of his subjects. Humidity is also very important for amphibians and many tropical species. Whereas desert reptiles may bask in the heat generated by photofloods, the drying effect can be lethal for species normally living in

damp conditions. As with insects, deliberate chilling of amphibians and reptiles can be effective in slowing them down, but there is always the danger of their appearing moribund in the final picture. Also, chilled animals will fail to show the full range of behavioural patterns, such as aggressive or defensive attitudes and mating displays. It is not a practice to be recommended.

Natural 'props' are useful not only for conveying the habitat of a given species, but also for enabling it to move or sleep in its own characteristic way. Obvious examples are tree snakes which are only at home if they have branches to climb through and coil round; desert animals need sand in which to burrow; many amphibians are completely out of place without some water. However, for close-up photographs of head, eyes, claws or pads, a naturalistic background may be distracting or confusing, and a plain black or mono-toned background may prove more effective.

As for other animals, photography of amphibians and reptiles in vivaria through glass can be perfectly successful. The more active the animals are, though, the more quickly the inside of the glass becomes smeared by flicking tongues or muddy feet. A detachable front glass can be wiped clean more easily than a permanently fixed glass. Moreover, if the subject is reasonably quiescent, several shots may be possible with the front glass removed, thereby avoiding all problems of reflection and scratches.

The pattern of lighting used will vary according to the position of the subject and the desired mood of the picture. A head-on view of a toad or frog may well require as many as three separate light sources, if the underside of the head as well as the texture of the skin on both sides of the body are to be brought out. A snake taken head-on can be dramatically lit by a single light from above. But a single light source needs to be very carefully positioned when taking a profile of the head resting on a coiled body or poised above the ground, to avoid casting a distracting head shadow, and thereby losing details of the head's outline. The grass snake illustrated in Plate 44 was lit with two flashlights, so that the outline of the wet tongue stood out from the dark background.

Grazed, or strong cross lighting, is effective for showing up skin texture, such as reptilian scales. Wet amphibian skin, however, creates the problem of highlights with any kind of direct lighting. Diffuse bounced lighting or the use of a polarizing filter over the camera lens can

reduce these highlights, but their complete elimination is not necessarily desirable as they do convey the moist nature of the skin.

To catch a leaping frog in full flight is difficult, not only because where it leaps is unpredictable, but so is the timing of the leap. The action is fast enough to beat most people's reaction time. A light-tripping beam, as described in Chapter 9, will ensure a greater proportion of success; but a pair of these beams crossed and triggering the camera and flash only when the animal breaks their intersection, is better still. If the animal avoids white light, filters can be used to cut out all but either the red or even the infra-red wavelengths. Multiple images of a moving object on a single frame can be produced by using a stroboscopic flash unit which fires repeatedly at high frequencies up to a hundred or even a thousand flashes per second. Lower frequencies can be obtained in a cheaper improvised way by placing a slotted spinning disc in front of a powerful photoflood. The shape and size of the slots and the speed of rotation govern the frequency and duration of the flashes. Since the light output of photofloods is less than that of most electronic flashes, this method if suitable only for use with fast black and white film.

Underwater aquarium photographs can effectively illustrate life history stages of amphibians. In the majority of species, the prenuptial behaviour and spawning take place in water. Male frogs and toads clasp the females in 'amplexus' so that the spawn is fertilized externally as it is laid. Male newts develop a special breeding dress, often with an enlarged crest which can be seen properly only underwater when the water supports it. Fertilization in newts is internal and the eggs are attached to vegetation as they are laid singly by the female. The length of the aquatic larval stages varies considerably between species, and so does the degree of metamorphosis undergone by the tadpoles.

Many aquatic reptiles such as alligators and turtles, as well as frogs and toads, often lie half-submerged—especially when they surface to breathe. As long as they are close to the front glass and small apertures are used, giving maximum depth of field, dramatic split-level pictures can be taken showing both the submerged parts of the body and those projecting above the surface. Alternatively two pictures may need to be taken, one focusing on the projecting head, the second focusing on the submerged body. The pictures are cut along the line of the water surface, and the halves discarded which are out of focus because of differences in the

refractive indices of air and water. The completed montage is made by joining the two good halves.

Small Mammals

Pictures of small mammals in the wild are often difficult, though Chapter 3 gives good and practical advice. It also mentions controlled conditions, in which many species can be photographed more easily. If they are long-term vivarium residents, the activity cycle of these mammals can be reversed gradually by illuminating them during the night and darkening the vivarium during the daytime, so they then have their active periods during the photographer's working day. This reversal is now put into practice in the small-mammal houses at many zoos.

When mice and voles are released into a vivarium which has been carefully arranged with a naturalistic setting, they soon destroy the vegetation by eating it or by shredding it to make a nest. Photography must either be done quickly or several vivaria must be set up, so that when the inside of one has been demolished, the animals can be transferred to another. Wood mice and harvest mice both enjoy climbing and will readily climb up a branch or corn ears respectively.

Electronic flash is again the most suitable for photographing active small mammals. Once they have explored the vivarium, they will usually stop to wash themselves before starting to feed. If the cover of the vivarium is made of glass, then the lighting can be directed down from above, as well as through glass sides.

Public Aquaria and Vivaria

Zoos, dolphinaria, and oceanaria provide scope for photographing large reptiles and mammals swimming underwater, in addition to smaller aquatic invertebrates and fish, and terrestrial vertebrates. In some aquaria the use of flashlight is not permitted. All exposures will then have to be made with available light and fast films. Remember when working with

colour to use the appropriate type for the lighting (daylight or tungsten). If the ambient lighting is low, the film speed may well have to be up-rated from the normal film speed *for the whole film*, which will then have to be specially developed by a colour laboratory. If fluorescent lighting is used, colour correction filters are now available for use with daylight type colour films.

In aquaria, where the use of flash is permitted, daylight colour film stock can be used. Very often, the front face is the only accessible one and there can be no choice about how to light the tank. To avoid reflections of the flash in the front glass, either photograph at an angle to the glass, or else hold the flash well to one side of the camera which is positioned perpendicular to the glass. A pocket torch held in the flash position can be used to check that no reflections will appear in the field of view. Reflections of the camera, and more especially of white shirts or coats in the front glass, can be blotted out with an enlarged black mask.

Two flash units may be needed to illuminate a large tank satisfactorily. The refraction of light from a pair of small narrow-beamed flashlights held on either side of the camera will result in a dark cone appearing in the centre of the picture. While this can be improved by moving the lights further away from the aquarium, the depth-of-field will also be reduced as the lens diaphragm has to be opened up. The whole central area of a large aquarium can be completely illuminated at close range with a pair of wide-angled flashlights.

It is both a waste of time and film trying to photograph through dirty or scratched tanks. Messy or conflicting backgrounds in large tanks will almost certainly be thrown out of focus behind the maximum depth of field. In small tanks this will be possible only by deliberately using wider apertures to reduce the depth of field.

Similar problems arise when photographing amphibians and reptiles in zoos and collections. In addition, the background of the vivarium is often pale, and it is therefore difficult to avoid the subject's shadow appearing on the background. If there is any means of lighting the vivarium from above, this will eliminate the problem of distracting back-ground shadows. Alternatively, as most of the reptiles and amphibians spend long periods resting without movement, long exposures can be made with the camera mounted on a tripod.

Although many zoos are beginning to replace bars and netting wherever

possible with a moat or electric wiring or a steeply sloping chasm, there are still many animals which have to be housed behind bars or wires. While such barriers cannot be physically removed, they can be eliminated from photographs. Widely separated bars present the least problem, as the camera lens can be centred in the space between a pair of them. Photography through continuous fine meshed netting is more difficult, but is possible providing the camera lens (protected with a lens hood) can be held flush with the mesh. Then, using a relatively wide aperture, and focusing on a subject several feet inside the enclosure, not only will the netting be thrown out of focus, but also any unsightly concrete walls in the background. Focusing, however, then becomes even more critical. Ideally, at least the head—especially the eyes—of the animal should always be sharp.

Always look critically at backgrounds to make sure they do not conflict with the subject. As an alternative to using a wide aperture to throw distractions out of focus, move round the outside of the enclosure or alter the camera viewpoint, so as to avoid conflicting backgrounds appearing in the picture.

Bibliography

Nature Photography, its Art and Techniques, Angel, H. (Fountain Press/M.A.P. Book Division) King's Langley (England), 1972.

Marine Aquaria, Jackman, L. A. J. (David and Charles) Newton Abbot (England) 2nd Ed., 1968.

The Vivarium, Hervey, G. F. and Hems, J. (Faber and Faber) London, 1967.

Zoos, Bird Gardens and Animal Collections in Great Britain and Eire, Bergamar, K. (Shire Publications) Aylesbury (England), 1969.

12

Plant Photography

Michael Proctor

Introduction

Plant photography is, in a sense, obviously easier than the photography of birds and insects, yet many plant photographs are disappointing, and plant photography has a largely undeserved reputation for difficulty. Plants are often very attractive, and some are straightforward subjects for the camera; others have less immediate appeal, or do not fit the picture format readily, and these are less easy. The fact is that there are technical problems in photographing plants, which are often different from those that face the animal photographer, and which may not be obvious at first sight. What is important is to recognize them, and to put the necessary thought, patience and effort into solving them. If one wants a photograph of a particular plant, it is no use to complain that it is difficult or un-photogenic. The photographer's job is to *make* it photogenic.

Cameras

Under ideal conditions there is no doubt that a large-format technical camera will produce the best plant photographs. The detail and delicate textures of flowers and leaves can put to good use the definition and smooth tone-rendering of a large negative. Equally important, the 'movements' of a camera of this kind allow control of perspective, and enable the depth-of-field to be deployed to the best advantage. Reeds or tall tree

trunks can be kept parallel, and an erect stem below the level of the camera or a sprawling patch of a plant on level ground can be kept sharp throughout. And the single expensive exposures of a large-format camera can have a healthy effect in encouraging the photographer to take trouble to get everything right before the first exposure is made.

In practice, the camera and film are often not the factors limiting the quality of the final result. A 35 mm single-lens reflex with modern materials can produce plant photographs of excellent quality, and it combines ease of handling, versatility and portability in a high degree. An outfit that will tackle practically any job in colour or monochrome can be carried easily in a holdall or small rucksack. The through-the-lens metering facility of many 35 mm reflexes is particularly useful for close-up work with plants. A right-angle viewfinder attachment can make for comfort when working close to the ground; it is more useful for plant photography than a removable pentaprism and 'waist level' finder, because it can be swung round to use the camera in a vertical position. Focusing screens which are excessively cluttered or which consist largely of clear glass are best avoided. The type commonly fitted, of ground glass with a fresnel lens to brighten the outer parts of the field and a small central microprism grid, is probably the most generally useful (and is my own preference). Plain ground glass, though less good for critical focusing of normal subjects, is better for focusing close-up subjects away from the centre of the field, and some people prefer it.

The larger roll-film single-lens reflexes will produce somewhat better print quality than 35 mm, but are heavier to carry, and both equipment and materials are more expensive. Twin-lens reflexes can do good work, but their usefulness for plant photography is limited by parallax problems at close distances (see also p. 365).

Lenses

I do most of my own plant photography with a lens of about 'normal' focal length or a little longer. A 50 or 55 mm lens on a 35 mm camera, or a lens of corresponding focal length on a larger format, gives a convenient working distance and pleasant perspective. Longer lenses allow more

working distance, but the longer the focal length the greater the risk that definition will be lost through vibration. However, with a good tripod and reasonable care, no difficulty should be found in using a 135 mm (or longer) lens on a 35 mm camera, and this is often useful where water or broken ground make the plant inaccessible. Some people like to use a lens of rather more than normal focal length (say 90 or 100 mm on a 35 mm camera) as a matter of routine. This can reduce the amount of stooping and bending required of the photographer, but may limit the possible range of viewpoints with some subjects; it is a matter of personal preference.

Lenses of shorter focal length (e.g. 28 or 35 mm on 35 mm cameras) are useful for working in confined situations, and especially so if a plant is to be shown in the wider context of its habitat. Their use for this purpose will be discussed later. Such lenses, with a reversing ring, are also very useful for low-power macro work.

Most general-purpose lenses will perform well at the distances normally involved when photographing whole plants. However, many good-quality large-aperture lenses for 35 mm cameras, computed for general work, are poor performers at a 1:1 reproduction ratio, even at the small apertures usually necessary in close-up work. Only a practical test will show whether a particular lens is satisfactory for work in this range. For plant photography it is useful if the lens will stop down at least to f22. Many do not, but for much plant photography the slight loss of definition through diffraction at f22 (or even f32) is often more than outweighed by the benefit of greater depth of field.

If much close-up work on plants is to be done with a 35 mm reflex it is well worth using one of the specially-computed macro-lenses, which combine the convenience of a long focusing movement with excellent definition and contrast and a flat field throughout the close-up range. Those fitted with automatic diaphragms make very versatile general purpose lenses if a wide aperture is not needed.

A large-format technical camera, or a 35 mm reflex with a macro-lens, provides all that is necessary for most plant photography without further additions. With other cameras and lenses, some means of providing for closer focusing will probably be needed. My own preference is for extension tubes, which are convenient to carry, rigid in use, and (if 'automatic' tubes are used) maintain the operation of the automatic

diaphragm. Not all extension tubes are adequately protected against internal reflections. Fitting additional baffles in the longer tubes or lining them with black flock paper may give a worthwhile improvement in image contrast. Supplementary lenses are convenient for moderate close-up work. A 2-dioptre supplementary, plus the focusing movement of the camera lens, will deal with most photographs of whole plants.

Filters

With modern sensitive materials filters are not often essential for monochrome plant photography. A medium green or yellow-green filter is useful for reducing the contrast between foliage and white flowers, and can give some improvement in the tone rendering of foliage. Contrast filters are sometimes useful in particular instances. Deep blue flowers are often rendered in too light a tone without a filter, and a $\times 2$ yellow or yellow-green filter is likely to give a more acceptable result.

The use of filters with colour materials is discussed on p. 267.

Films and Developers

The basic problem of photographing plants is usually that the need for depth-of-field requires a small aperture, while the risk of subject movement demands a short exposure. With a large-format camera the natural choice will therefore be a moderately fast film (say 400 ASA). At smaller negative sizes, and especially 35 mm, the smoother tone rendering and freedom from grain of a slower film is worth some sacrifice of emulsion speed, and the choice will probably fall within the range 50–125 ASA. Even the slow fine-grain 35 mm films have a more-than-adequate tonal range for any contingency ever likely to be encountered in photographing plants, provided they are appropriately exposed and developed.

Any good standard developer can be used, but excessive contrast must be avoided, and there is little point in using fine-grain formulae which substantially reduce the effective emulsion speed. I ordinarily use an

MQ-borax developer diluted 1:3 for 'one-shot' use, but I have had equally good results with undiluted MQ-borax and (using slow fine-grain films) with high-definition developers. In practice, the difference in the end-product—the print—is slight. The aim should be clean and consistent working, to produce negatives with a full tonal range and of the right printing contrast, whatever film and developer are used.

Printing, and the choice of printing papers, is a highly personal matter. Excessively hard printing should certainly be avoided; much of the beauty of plants lies in the delicate gradation of tones they display. However, I think there is a rather general tendency to print plant photographs too soft. The tonal range of a print should generally extend from a crisp clear white to intense black, though without large areas of either. I invariably use glossy bromide paper, glazing small prints, but leaving unglazed large prints that are to be mounted.

Colour Materials

In the larger sizes, colour material can be chosen purely on grounds of speed and colour rendering, but in 35 mm differences in graininess and resolution are becoming noticeable. As in monochrome work, the detail and textures of plants put a premium on high acutance and smooth tone rendering. In these respects the reversal films of the Kodachrome type using non-substantive dyes have a definite advantage, and their performance compares well with that of fine-grain monochrome materials. This is not to say that good 35 mm colour work cannot be done with other materials if their characteristics and limitations are borne in mind, but one cannot expect results fully competitive in quality with those from the same materials in larger sizes.

Plant Portraits

I use this phrase to cover what I suppose most people would regard as 'ordinary' plant photographs—a picture of the whole plant (or a

substantial part of it), in flower, or possibly in fruit, taken in its natural surroundings.

Some general requirements can be stated at the outset. The aim will normally be to photograph a reasonably typical specimen in reasonably typical surroundings—unless some unusual feature is of special interest. The photograph should show the characteristic features of the plant: is it woody or herbaceous, is it much branched or not, do the leaves vary in shape up the stem, how are the flowers borne in relation to the shoots and leaves? If a particular character is important in distinguishing the plant from a related species, the photograph should show it. Obviously, the photographer will try to display any points of particular biological interest. All this means that the photographer who knows his plants well is likely to take the most useful and interesting photographs.

It is easy to concentrate on the plant and forget the habitat. The surroundings of the plant are important and often very characteristic; in a photograph the habitat provides the ambience that can make or mar the final result. It enters into the photograph in several ways. It provides ingredients of tone mass and line which can play a great part in the composition of the picture. It does much to set the atmosphere of the picture. A photograph of a woodland plant and of a plant on a chalk down should instantly convey a feeling of the difference of the habitats; intellectual effort on the part of the viewer of the print or slide should be a rewarding addition to an accurate and vivid first impression, not a laborious substitute for it. This last comment will also make the point that careful choice of the site and individual plant to be photographed can make a great deal of difference to the interest and enjoyment the viewer will derive from exploring the picture at his leisure.

All this is not to say that every plant photograph must include a lot of habitat. Different circumstances and different species may call for different treatments. When photographing species that grow in dense patches it will sometimes be appropriate to show no 'habitat' as such at all. A series of any one species will benefit from some variety of treatment.

Beware of the temptation to improve on nature. Some tidying up of the habitat—'gardening'—may be needed, and if properly done there is no objection to it: this subject is considered in more detail later. But substantial alteration to the habitat or, worse still, moving the plant to a 'better' habitat, cannot be too forcefully condemned. Like all dishonest

practices, it may appear to serve the needs of the moment, but quickly becomes a burden and an embarrassment and largely destroys the value of the photograph.

Finally, good technique is essential. Plants are often intricate, and much of their character lies in form and consistency, texture and fine detail. To render this well, definition must be crisp, and the tone-rendering must be of a quality that will convey the modelling of stems and leaves, subtle differences of surface texture, and the solidity or translucency of flowers.

The plant photographer has to face two major problems, of which the first is to produce a technically satisfactory image of the plant. For many small herbaceous species the immediate difficulty is to get enough depth-of-field to cover all the important features of the plant. This will inevitably call for a small aperture—f16 or f22 with a miniature, f22 or f32 with a larger camera. As a consequence a relatively long exposure will be needed, especially since direct sunlight is often too harsh for satisfactory monochrome work with plants, even if it is available. It goes without saying that under these conditions a rigid tripod is essential, but camera movement is more easily dealt with than movement of the plant. If one was unaware of it before, one quickly discovers that plants are seldom still. On a really windy day it is hardly worth attempting plant photography at all. In most ordinary weather there will be at least occasional moments when the plant is still for a second or two, and one simply has to be patient and wait for them. Wind shields may help, but the wind tends to eddy behind them, and I think their value is mainly psychological. The temptation to open the aperture and give an exposure of, say, 1/25 or 1/50 sec, is usually one to be resisted. If the plant is moving when the exposure is made, it will probably be enough to take the edge off the sharpness. If it is not, a longer exposure—perhaps 1/8 or 1/4 sec—could be given at a smaller aperture. In fact, in making use of the brief moments when a plant is still (up to a second or so) the limiting factor is usually one's own reaction and decision time rather than the length of time the shutter is open. Also to be resisted is the temptation to 'clip' time exposures. A little movement at the end of a long exposure is often scarcely noticeable in the result, but an underexposed negative or transparency is useless.

There is nothing absolute about depth-of-field. However small the aperture there is always a narrow band in which focus is sharpest. As far

as possible the parts of the plant that the eye will examine most intently must be placed close to this plane of sharpest focus. This will be an important factor both in the choice of the individual plant to photograph, and in the choice of a viewpoint. As a rule, flowers should be rendered as sharply as possible. If there must be some loss of sharpness it is more easily tolerated elsewhere.

There are occasions when it is necessary or desirable to work at a much wider aperture and a higher shutter speed. Erect-growing plants in open situations often respond well to this kind of treatment. Differential focus helps to convey the spaciousness of the habitat, and the shutter speed can often be fast enough to freeze a certain amount of movement. Choice of viewpoint is again important to keep the subject within the very limited depth-of-field, and to place it to best advantage in relation to the tone masses of the background.

In these situations a large-format camera with a swing back can give the photographer very useful additional freedom of action. The viewpoint can be chosen to display the characteristics of the plant to the best advantage and to get the best composition. The swing back can then be used to deploy the depth-of-field in the best possible way. The user of a miniature or a roll-film camera must accept the constraint that the two sets of requirements are interlinked; he may have to sacrifice the best disposition of depth-of-field for the sake of composition, or vice versa.

A plant photograph may be technically competent, and yet fail utterly as a piece of communication. This is where the plant photographer's second problem—or set of problems—begins. What the eye sees in the three-dimensional real world is conditioned by our purpose and preconceptions and the clues provided by the other senses, and leans heavily on the sense of depth given by movement and binocular vision. In a photograph these clues are lacking, and the viewer cannot know *a priori* what was in the photographer's mind. The photograph must compensate for these deficiencies.

Some compact plants stand out from their background naturally

Plate 47. Marsh St John's wort (England). A straightforward photograph from a tripod of a small plant which forms extensive low carpets in shallow water or on wet peat. Pentax, 50 mm Super-Macro-Takumar; dull daylight, $\frac{1}{2}$ sec. at f22 on Pan-F film.

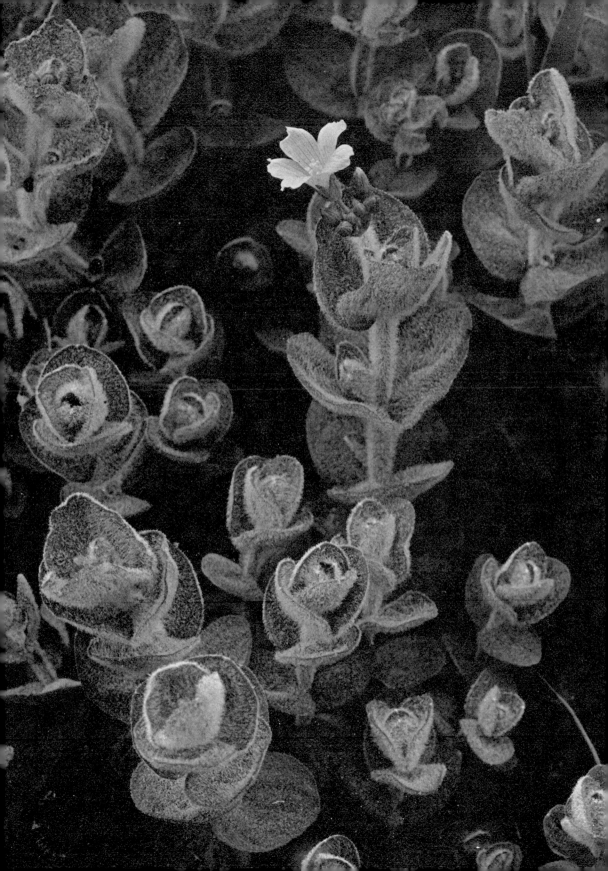

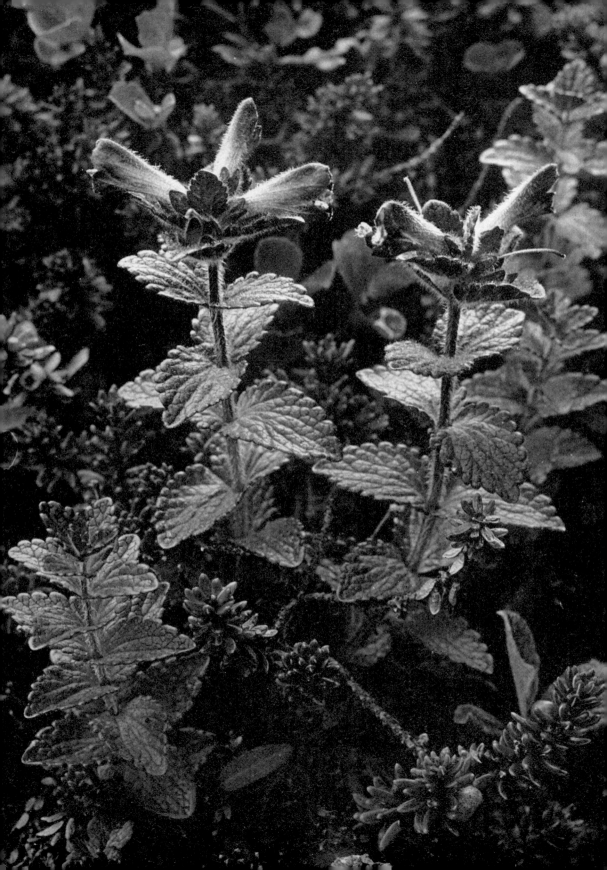

without any effort on the part of the photographer. All he has to do is to choose an individual which, with its surroundings, composes into a pleasing picture, and make a technically competent job of recording it on film. Indeed, the choice of the right individual to photograph is one of the most important factors in all plant photography, but with many species there are real difficulties in making the plant stand out adequately from its background in a monochrome print. If a plant is tall or straggling, the natural 'portrait' may be of a part of the plant rather than the whole. But in a case of this kind it is important to try to convey some impression of how much is included and how much left out, and if possible to illustrate any considerable variation in, say, leaf shape from one part of the plant to another. A picture showing only the upper parts of a plant which has distinctive lower leaves may be valuable in itself or as part of a series, but quite misleading where a 'full-length portrait' is called for. It is worth looking for opportunities to combine foliage and flowers, or upper and lower leaves, by including parts of neighbouring stems in the same photograph.

Choice of viewpoint and background can greatly affect the impact of a photograph. Often, quite a small change of viewpoint will make the difference between a plant standing out boldly and being completely lost against a distracting mass of spotty foliage. This is still important if a wide aperture is used. No amount of differential focus will show up a plant well against a background of the same tone.

Personally, I very much dislike the use of artificial backgrounds in the field. Perhaps this is irrational prejudice on my part, but the result almost always looks contrived, and the means seems a confession of failure. What can sometimes be done is to shade the ground behind the plant to produce a graduated background which still contains detail, but shows the plant up well by contrast. If this is done discreetly the result can look entirely natural; even if it is obviously contrived it may be less offensive than more drastic expedients.

The kind of lighting is also important. Bright sunshine poses difficult

Plate 48. Alpine bartsia (Iceland). A plant with good form and texture; very little 'gardening' was needed. Pentax, 55 mm Auto-Takumar; light overcast, $\frac{1}{4}$ sec at f22 on Pan-F film. Reproduced by courtesy of the British Schools Exploring Society.

problems for monochrome plant photography. Stems and leaves cast intricate shadows whose pattern tends to break up the outline of the plant. It also results in high negative contrast, difficult to handle in printing without excessively flattening the contrast of sunlit parts of the subject, or producing unacceptably large areas of detailless shadow. Very hazy sunshine or diffused lighting which is sufficiently directional to give some modelling and sparkle is the best. However, natural lighting is seldom too flat to give a pleasing result, and in my experience it is usually better to photograph a plant in your own shadow than in full sun. An exception must of course be made for some cases of plants growing in open sunny situations, and for wide-angle photographs including extensive views of the habitat.

If there is any considerable separation between the plant and its background, their relative scales will depend greatly on the focal length of the camera lens (see also p. 377). If what is wanted in the background is merely a contrasting tone with little or no detail, this will most easily be achieved with a long-focus lens. If the aim is to show the plant in its wider setting, and the background is an important contribution to the picture, then a wide-angle lens is needed. In taking photographs of this kind it is important to get the plant which forms the main subject critically sharp. If it is far from the centre of the picture beware of turning the camera to focus critically with a centre microprism grid. As a moment's consideration of the geometry of the situation will show, this can result in the plane of sharpest focus being placed too far from the camera. Wide-angle 'plant-in-habitat' photographs of this kind can be very rewarding indeed, either alone or as part of a series. For obvious reasons, this kind of plant photography has flourished much more conspicuously in the Alpine countries than in Britain, and it is obviously an exception to the generalizations about lighting made in the last paragraph.

At least a little judicious tidying-up of the habitat will almost always be needed. Such 'gardening' will have to be done carefully if it is to be

Plate 49. Monkshood (Austria). Bright sun almost directly behind the subject—a type of photograph which can be very rewarding, especially in colour. Pentax, 35 mm Yashinon: *c*. 1/60 at f8 on Kodachrome II—a transparency from which a print was made later.

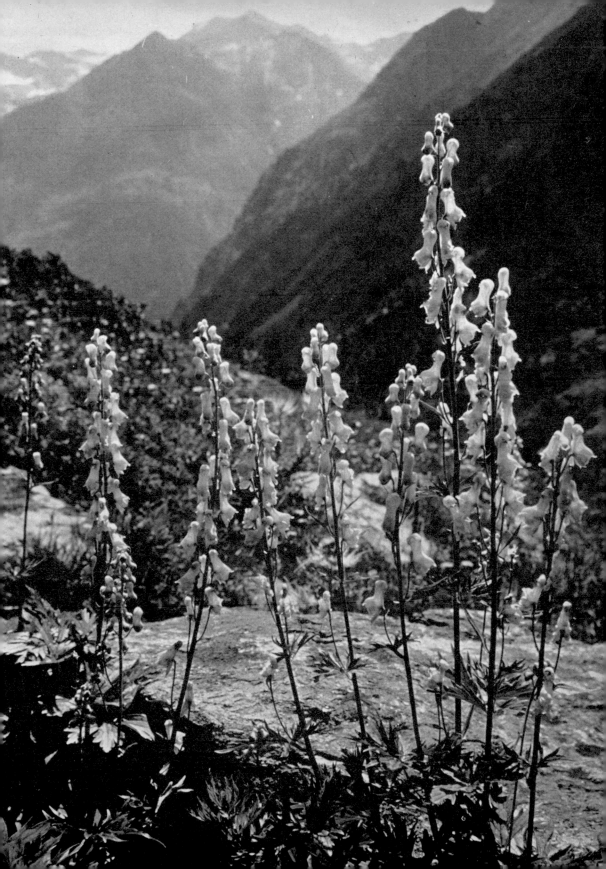

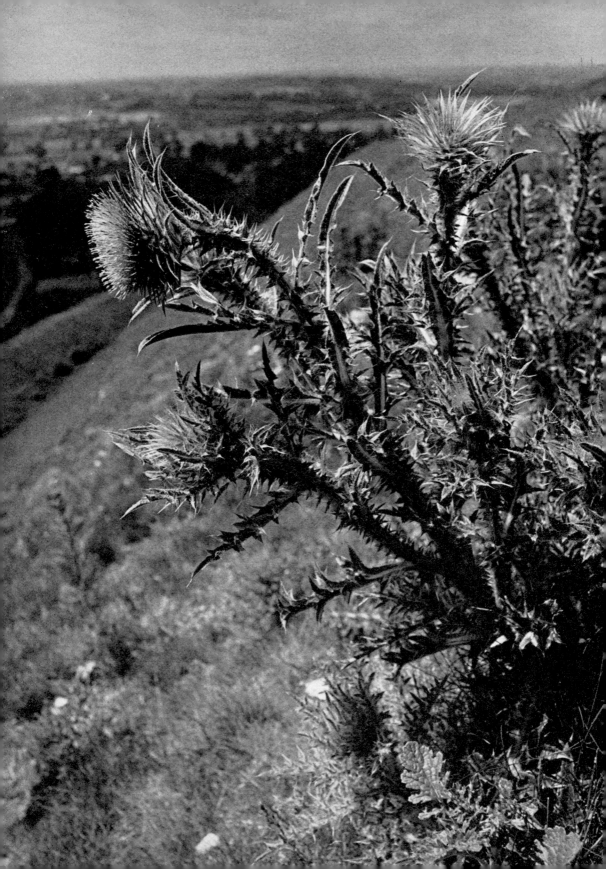

invisible (as it should be) in the final picture. The eye has an uncanny knack of ignoring, in the field, distractions which become obtrusive in a photograph. The aim of 'gardening' is to compensate for this, so that the photograph gives an entirely natural impression of the plant as it is seen under good conditions in nature.

First, it is a fair general rule that the foreground should be sharp throughout. This will usually mean that out-of-focus grass stems and leaves between the camera and the subject must either be removed, or held back out of the way. If a stem or leaf has to be removed it should be pulled right out from the base, or cut off so that the cut end is hidden from the camera. In dense or tangled vegetation, a short-focus lens may have to be used to avoid drastic gardening of this sort. White bleached grass stems and other distractions around the subject may have to be removed. It is important not to overdo this. What matters is whether the object in question works against the composition or can be assimilated within it, perhaps toned down in printing. Some habitats are characteristically full of dead grass, and look unnatural if too much is removed. It is also fatally easy to remove all the 'distractions', only to find that much of the sparkle and life of the picture has been lost. Finally, there may be obtrusive out-of-focus blobs and streaks in the background, due to flowers, grass stems, flint pebbles, reflections from leaves and other things. These should be looked for carefully in the focusing screen, and concealed or removed.

At best 'gardening' is a necessary evil, and if much is needed it is generally best to look for another plant to photograph in a better situation. Uncommon species should *never* be removed in the course of 'gardening', nor should the process be so drastic as to draw attention to the plant that has been photographed. Plant photography has a bad reputation in some circles, due to the heavy-footed and ham-fisted efforts of casual plant photographers who are ignorant or unscrupulous—or simply thoughtless. It is possible to work in such a way that signs of one's visit are almost undetectable, and this should always be the aim.

Plate 50. Musk thistle (England). A wide-angle photograph showing the plant in a characteristic downland habitat. Very little 'gardening' needed. Pentax, 28 mm Super-Takumar; good light, 1/125 at f8 on FP4 film.

Plants in Colour

Colour adds problems of its own, but it also removes some of the problems of monochrome work. The eye is accustomed to working in colour, so it is usually much easier to judge whether a particular plant and site will make a good photograph in colour than in monochrome. Also, in spite of limited exposure latitude and the problems of the colour quality of light sources, colour reversal films respond well to a wider range of lighting conditions than monochrome. This is a consequence partly of the greater realism of colour, and partly of the longer tone scale of a transparency compared with a print. Hazy sun, or clear sun relieved by reflection from plenty of white clouds, provides excellent lighting for plant photography in colour. It is generally best to avoid having the sun directly behind the camera; the result with the sun shining from one side is almost always preferable. Even contrejour lighting, which would be utterly unsuitable for illustrative work in monochrome, can be acceptable and very attractive in colour, provided a reasonable amount of fill-in light reaches the shadows. Diffuse daylight on overcast days is also good, especially for intricate plants which would suffer, in colour as in monochrome, from a fussy pattern of shadows, and for white-flowered plants where the contrast needs to be kept within bounds to avoid burning out the petals. Lack of contrast is rarely a difficulty, because colour contrast makes up for what may be lacking in tonal range.

There are few serious problems of colour rendering with modern materials, but it must be accepted that it is seldom possible to reproduce all the colours of the subject accurately. Also, appreciation of colour is greatly influenced by the quality of the light and other external circumstances, and by the other colours in the picture. What matters is not so much objective accuracy of colour reproduction, as whether the picture looks right and gives a true impression. This is well illustrated by photo-

Plate 51. (Upper) Moss, *Fissidens serrulatus*, ×5 (England), a rarity. Leica, Summar lens: open flash during a ½ sec exposure on Pan-F.
(Lower) Capsules of bog-moss, *Sphagnum tenellum* (England). A straightforward flash shot using a small HSF unit mounted on a bar on the camera. Prakticamat, 55 mm Auto-Takumar; original transparency on Kodachrome II, later a print was made from it.

graphs taken in overcast daylight, which has a colour temperature considerably higher than that for which daylight reversal films are balanced. Objectively, the results are too blue; subjectively, they are usually acceptable. In principle, correcting filters can be used to match the colour rendering to that given in bright sunlight. In practice, the result appears too 'warm', because the lack of clear shadows shows that the sun was not shining, and leads the eye to expect a 'colder' effect. Partial correction, to give a colour rendering somewhere between the two extremes, may provide the most satisfying result, but the choice is essentially personal.

Because of his frequent need for long exposures, the plant photographer is particularly prone to problems of reciprocity failure. Outside the range of exposure times for which a film was designed, the effective emulsion speed falls off. The three sensitive layers of a colour film commonly respond differently in this respect. The consequence is not only a loss of speed, but also a shift in colour balance at long exposures. Some film manufacturers publish information on the characteristics of their films at exposures outside the normal range. In such cases it is important to make sure that the manufacturer's *current* recommendations are followed, because the characteristics of colour films change from time to time and reciprocity failure characteristics are largely incidental to a manufacturer's continuous efforts to optimize the performance of a particular film under more normal conditions. If no information is available from the manufacturer and colour rendering is unsatisfactory at long exposures it may be worth photographing a grey scale at a range of different exposures to estimate what correction is needed.

Much more intractable problems are presented by blue sky light in the shade on a clear day, and by the light under a canopy of green leaves. Correction filters can do something to help in both situations. In practice, the selection of the value of the filter to give the most acceptable correction is likely to be something of a gamble, or at best a matter of trial and error; a 50 mired (reddish) colour temperature filter might provide a suitable starting point for experiment in the first case, and a CC10M or

Plate 52. Serrated wrack (Irish Republic) see p. 274). Pentax, 50 mm Super-Macro-Takumar; overcast sky, Pan-F film.

CC20M magenta colour correction filter in the second. The alternative is to avoid the problem altogether by using flash, or to reduce it to acceptable proportions by mixing flash with the ambient light (see p. 271).

Another problem which belongs particularly to the plant photographer is the colour rendering of blue and purple flowers. The difficulty arises because the colour sensitivities of the three emulsions of a colour film are rather more widely spaced in the spectrum than those of the three kinds of colour receptor in the human eye. The anthocyanin pigments of flowers transmit light in the blue region of the spectrum, and also light in the red and far-red. The eye is not very sensitive to light at the extreme red end of the spectrum, but this light registers strongly on colour film, noticeably reddening flower blues and purples. There is no complete answer to this problem. It is possible in principle to use a filter pack which cuts strongly in the far-red, with compensating general absorption in the blue and green regions of the spectrum, but in practice this reduces the effective film speed far too much to be generally useful. However, modern colour films render flower blues better than most tripack materials of 20 years ago, and the results they give may be felt to be acceptable most of the time. There is some variation between films of different makes in the rendering of flower blues, and if relative fidelity in this respect is felt to be paramount it is worth experimenting with the materials currently available to see which gives the most acceptable result. In any event, it may well be worth deliberately photographing blue-flowered plants in overcast daylight, and accepting a rather cold rendering of greens and browns for the sake of more faithful blues. Sunshine which is at all 'warm' in colour will make a very noticeable difference to the hue of purple flowers even to the eye, and should be avoided.

Flash for Plant Photography

Flash solves at one stroke the problems of movement and colour balance, freeing the photographer completely from the vagaries of daylight. The difficulties arise in getting pleasant and natural-looking lighting and in avoiding monotony. For 'portraits' of plants, my own preference is strongly for using daylight wherever possible; I find very sad a long

series of plant photographs in which the atmosphere and variety of natural lighting has been sacrificed regardless of conditions to the mechanical efficiency of flash. However, there are occasions when the hard-won (or unexpected) opportunity to photograph a rare plant occurs in failing light in a dense wood, or on a remote mountain-side in half a gale, and then the limitations of flash may be felt to be more than tolerable. It is a fair generalization that the smaller the subject, the more acceptable is flash likely to be.

The simplest approach is to use a small transistorized flash unit at the camera position. If the flash is mounted on a ball-and-socket head on a flash bar it can be angled on to the subject, and the flash–subject distance can be adjusted (within limits) independently of the camera position. A simple set-up of this kind is excellent for photographing small plants, or parts of plants, where the flash can illuminate the whole of the picture area. The chief pitfalls to be avoided are areas of dense black shadow, burnt-out reflections from leaves or other shining surfaces, and faults in the lighting of the background. Avoiding excessive or disturbing areas of shadow is a matter for thought and careful observation before the photograph is taken; inevitable shadows can be softened to some extent by using a white reflector on the side of the subject opposite the flash—a newspaper or map will serve. Specular reflections can only be avoided by care before the photograph is taken, and sometimes they cannot be avoided altogether. For this reason flash is of little use for photographing seaweeds or other wet subjects; the minute points of light reflected by wet surfaces in sunshine are acceptable where the much larger reflections of the flash tube are not. Some care is needed to make sure the flash illuminates both subject and background. As most flash units are designed for use with fairly wide-angle lenses this seldom presents any great problem. What does often cause difficulty is the fact that, with the flash mounted on the camera, illumination falls off rapidly behind the plant. Sometimes this can be turned to advantage to provide a black background, but it often gives a very disturbing nocturnal effect. This can be made even worse if the background includes patches of sky. If the plant is fairly small, it will probably be possible to avoid noticeable fall-off in illumination by careful choice of background and viewpoint.

The relation between exposure and flash-to-subject distance will have to be determined in the first instance by trial and error. A flash unit with

a guide number of 9–12 m (30–40 ft) for 25 ASA film has about the right power to work conveniently at f16 or f22 within the range of reproduction ratios required for plant photography. Contrary to the assertion sometimes made, the inverse-square law still holds normally at close-up distances, with two important provisos. The first is that guide numbers determined for 'normal' use (generally with much light reflected from surrounding walls and ceilings) are not appropriate to the very different conditions of close-up work. A figure of about 60 per cent of the maker's guide number will probably prove a fair starting point for experiment. The second proviso is that allowance will of course have to be made for lens extension. For close-up work, the usual formula for calculating the relation between subject–distance and aperture becomes:

Guide no. = flash-subject distance × f-no. × relative extension.

Guide number and flash–subject distance must be measured in the same units (e.g. cm, m, in., ft); relative extension is the ratio between the actual lens–film distance and focal length (it is numerically equal to the reproduction ratio plus 1, so that at a reproduction ratio of 1:2 (0·5) relative extension is 1·5, and so on). Thus, once the correct exposure has been obtained in one set of conditions, it is easy to calculate the appropriate flash–subject distance for any other set of conditions. If extension tubes are used, it is convenient to work out the flash–subject distances corresponding to all the available combinations of tubes, and to keep these noted on a card (or labels on the tubes) for reference. For bellows or a macro-lens it will probably be more convenient to plot a graph of flash–subject distances against reproduction ratio, or the graduations of the bellows unit or lens mount. The flash unit is, of course, not a point source of light, but this will not affect the calculations if the flash–subject distance is measured from the effective source, usually about 1–1·5 cm behind the front face of the unit.

Using the flash on the camera is unquestionably quick and convenient, but it is a limited technique, and other flash positions offer more varied possibilities. If the camera (and/or flash) is set up on a tripod it is easy to use the flash to give side or back lighting. Rather shorter flash–subject distances will be needed than for frontal lighting, but, freed from the restraint of proximity to the camera, a more powerful flash can be used to light evenly a much larger area. The possibilities of control are

considerable, and the results can be very pleasing and look very natural.

It is often useful to mix flash and diffuse daylight. On the one hand, flash helps to solve problems with colour balance due to reciprocity failure or the colour quality of the available daylight, and it adds sparkle. On the other hand, a daylight fill-in exposure softens the tell-tale dense fuzzy-edged shadows of flash. The easiest procedure is to calculate a daylight exposure and a flash distance for an aperture 1 stop larger than it is intended to use, and then to combine these at the chosen aperture to give an even balance between flash and daylight. Thus if the exposure meter indicated an exposure of 1/8 sec at f16, and the calculated flash distance at f16 is 20 cm, a flash from this distance during an exposure of 1/8 sec at f22 should give a correctly exposed transparency. The relative proportions of flash and daylight can be varied to meet the particular needs of the case.

If more than a single flash head is used, the second flash must be placed circumspectly to avoid obviously unnatural double shadows. A useful arrangement is a directional flash from one side and above, plus a fill-in of lower power close to the camera position. More elaborate lighting arrangements are of course possible, but they bring their own problems and are likely to be limited by what one is prepared to carry into the field. Under studio conditions matters are different. Indeed, working indoors sheltered from draughts, photographing isolated shoots or flowers, one can put the room into near-darkness and build up quite complicated and varied lighting effects by successive open flashes from a single unit during a long exposure. It is worth devoting much thought and experiment to the lighting that will best display particular features and structures of flowers.

So far, we have been considering orthodox flash units in which the flash head, even if it is mounted on the camera, is separated from the lens. In a ring-flash unit the flash tube is circular, and completely surrounds the lens to which it is fixed. It might be thought that ring-flash would solve many of the problems of close-up plant photography. It is certainly useful, and virtually indispensible for some purposes, but it has serious limitations and is far from a universal panacea. Although it is often said to give shadowless lighting, this is true only in a limited sense. It is all too easy to produce a picture of a flatly-lit subject with diffuse but ugly and distracting shadows on a plain background. Since the flash tube is

fixed to the front of the lens, it is useful if the unit provides the means to vary the power of the flash, as otherwise the exposure can be controlled only by varying the aperture, or by using neutral density filters.

Ring-flash is at its best for photographs around life size, when the light is reaching the subject obliquely enough to give a certain unusual but quite pleasing modelling. It is both convenient and effective for photographing single flowers of wild orchids and comparable small plant parts. It has two particular fields of application in plant photography. First, it can effectively light cavities. This, the basis of its use for intra-oral photography, is invaluable to the plant photographer faced with, say, the hollow lip of a lady's slipper orchid, or a dissection of the interior of a flower. Second, as the flash tube is symmetrical about the lens one does not have to worry about the position of the lighting relative to the subject. This is particularly useful in recording the behaviour of flower-visiting insects, because one can concentrate on what the insect is doing and its relation to the flower, confident that anything that can be seen in the viewfinder will be recorded adequately on the film.

Finally, it is worth pointing out that a ring-flash is useful as a fill-in light when working in bright sun, and that ring-flash and an orthdox flash unit can be used together to combine some of the advantages of both.

Particular Groups of Plants

Trees

It is very easy to take adequate, dull, run-of-the-mill photographs of trees, but surprisingly difficult to photograph them really well. Many otherwise fine trees bear evidence of past mutilation—lopping or pollard-ing—which may be interesting, or may disqualify them from further consideration. Neighbouring trees, buildings or power lines can obscure or distract; the branching of a tree may be obscured by ivy, or its base hidden by a bank or hedge. Finally, weather and sky have a great influence on the character of the picture. Luck in being at the right place at the right time plays a big part, and opportunities to take good tree photo-graphs should not be allowed to slip by. It is always worth photographing

the same tree in summer and winter; spring and autumn provide opportunities to photograph trees with enough leaves to give some solidity to the crown without completely losing the pattern of the branching. Trees in woods are different in growth from isolated specimens, and are also worth photographing. There are no great technical difficulties. A fairly fast shutter speed should be used to freeze any movement of the twigs and leaves, and a yellow or yellow-green filter may help in providing a pleasing rendering of the sky. The background need not be sky, of course, especially if a lens of fairly long focal length is used. Some very pleasing tree photographs can be taken with backgrounds of fields, moorland or sea.

Mosses, Liverworts and Lichens

The larger members of all these groups can be treated in the same way as ordinary vascular plants; there is no difference in principle between photographing a big *Polytrichum* or *Peltigera* and photographing a clover or small fern. For the smaller species there is little to be lost and much to be gained by using flash. Many of these plants require a reproduction ratio between 1:2 and 2:1; at the corresponding flash distances an ordinary small flash unit subtends quite a large angle and gives a pleasantly directional but not excessively harsh lighting. Compared to the general run of subjects among flowering plants, bryophytes tend to require $\frac{1}{2}$–1 stop more exposure, and lichens on flat rock or bark surfaces $\frac{1}{2}$–1 stop less. At reproduction ratios around 1:1 or larger, focus is extremely critical, and it is worth going to some pains to choose individual patches of the species concerned that will make the best use of the very small depth-of-field. Lichens on flat rock surfaces may prove a critical test of the flatness of field of the camera lens under close-up conditions.

Fungi

The larger fungi are attractive subjects for photography, and in some ways are easier to deal with than flowering plants. Much that has been said earlier in this chapter applies equally to fungi. However, the woodland species especially raise certain difficulties for colour photography,

because they are at their best while light conditions on the ground in woods are at their worst. The light is already failing in late summer and autumn, but the leaves are still thick on the trees. Long exposures are the rule, with consequent reciprocity failure troubles. Pure flash is not a very satisfactory substitute for daylight, because fungi, being large solid objects, cast large heavy shadows. However, mixed flash and daylight can be very successful.

Apart from difficulties with lighting, the main problem in photographing fungi is to show adequately the various characters of the fruiting bodies. Characters of the stipe and gills are often more important for identification than those of the cap. I often use the time-honoured device of tipping over one specimen of a group, or picking a nearby individual and placing it upside down or on its side next to one or two growing individuals *in situ*. To some people this is contrived, and a cliché to be avoided. Against this it may be argued that it is so obviously contrived that it is at least honest, and thus justified as a means of putting over more information! Although it is not always possible, it is obviously a happy solution if one can find a viewpoint which makes this device superfluous.

Seaweeds

Here again, the larger species exposed on the shore present few technical problems of their own—but their habitat may try the corrosion-resistance of a tripod! Bright overcast weather generally gives the most satisfactory photographs. It may be found worth using a pink or straw-coloured haze filter deliberately to give a somewhat over-warm rendering, and counteract any tendency to a blue cast. Wind can be very troublesome on the shore. Strong sun produces high contrast, and rapidly dries out exposed seaweeds; the virtual impossibility of satisfactory colour photography by the blue sky light in the shade of north faces and overhangs makes one very conscious of the relative richness of their seaweed flora.

Seaweeds in rock pools can be photographed through the water surface provided reflections from the surface can be avoided, and provided the water surface is reasonably still. Flash can be used successfully as long as the seaweed does not break the surface film; obviously care must be taken to keep the reflection of the flash tube out of the field of view. Good

photographs can be taken in bright sun, if the viewpoint is chosen carefully. A dark cliff, or even the body of the photographer may eliminate reflections from a particular angle. Blue sky light is polarized at right angles to the sun's rays, so on really clear cloudless days there are viewpoints from which reflected skylight is practically eliminated. A polarizing filter produces the same effect in any weather at the cost of increased exposure.

Conclusion

Much of this chapter has been about technical matters, but enough will have been said to show that technique is only a part of the story. Composition is vital, but the rules and guidelines that will be found in many general photographic books, though useful, are no substitute for the photographer's more-or-less instinctive sense of pictorial structure and balance, sharpened and developed by observation and experience and appreciation of other pictures of all kinds. The most utilitarian record will do its job better if it is pleasing to look at, and leads the eye naturally to the significant features. There is never any reason to accept either dullness or monotony in plant photography. Sometimes the challenge is to find strong and relevant form in apparently unpromising material. But many plants of all kinds are attractive and rewarding subjects, which offer the imaginative photographer opportunities for very varied pictures which may have high pictorial merit.

Bibliography

Die Farnpflanzen Mitteleuropas, Rasbach, K. and H. (text by O. Williams) (Quelle and Meyer) Heidelberg, 1968.
Fleurs Alpines, Danesch, E. and O. (Editions Silva) Zurich, 1969.
Living Plants of the World, Milne, L. and M. (Random House) New York and (Nelson) London, 1967.
The Pollination of Flowers, Proctor, M. and Yeo, P. (Collins, *New Naturalist*) London, 1973.

13

Underwater Photography

John and Gillian Lythgoe

Introduction

The underwater photographer has to cope with two major problems not
met by his counterpart on land. In the first place, he must be able to dive
and, in the second, his camera must function when submerged. The
efficient working of a camera under water is not simply a question of
water-proofing, but involves more difficult and subtle problems arising
from the different optical properties of air and water. For the underwater
photographer the hard fact is that his requirements comprise but a tiny
fraction of the photographic manufacturers' market and, with few excep-
tions, all the optical equipment he can buy has been designed from the
outset with the terrestrial photographer in mind.

Diving

The ability to dive is the first requirement of the underwater photographer.
He must become so familiar with the underwater environment and his
equipment that survival becomes second nature to him.

The present-day aqualung is a tool that allows almost anyone to work
down to a depth of some 60 m. It is rare for the Natural History photo-
grapher to go deeper since it is in relatively shallow water that most marine
life is seen, and it is generally only at these depths that the available day-
light is sufficient for reasonable exposure times or, indeed, for vision.

A particular problem associated with diving to depths in excess of about 40 m is the narcosis brought about by the high partial pressure of nitrogen contained in air breathed at these depths. Some of the extreme symptoms, such as offering one's mouthpiece to the fish, are bizarre and perhaps apocryphal. But there is no doubt that the diver becomes incapable of logical thought and might not, for instance, be able to work out the way to increase his exposure by two stops by reducing the shutter speed and increasing the aperture.

The most satisfactory method of learning to dive and of gaining the necessary experience is to join one of the many diving clubs, such as the British Sub-Aqua Club and the American YMCA, that exist throughout the world. However, once the necessary skills have been mastered and serious photography begun, the normal diving activities of a club can prove unsuitable for the Natural History photographer. Most experienced photographers prefer to dive alone or with an experienced and sympathetic 'buddy'. Diving alone is not necessarily dangerous if the proper precautions are taken and if there is adequate surface cover. The conditions where lone diving is safe have been recently outlined in the Underwater Association's *Code of Practice for Scientific Diving*:

> 'When diving alone, there must always be adequate surface support. The use of a life-line preferably including a telephone provides maximum safety. Alternatively, a bob-line passing to a conspicuous float may be used. This must be attended by surface cover. Diving alone without a safety line to the surface is strongly discouraged.'

In very clear deep water such as is found in the tropics and Mediterranean, it is probably always best to dive with a companion since the superb conditions entice one into depths where nitrogen narcosis clouds the judgment; the temptation is very strong to ignore the physiological safe limits and to continue photography. There is always the feeling that the particular animal being photographed will appear within the next few seconds and what difference can a minute or two make? These few minutes can, in fact, mean the difference between life and death. A buddy diver can be an infuriating but very necessary person to have around in these conditions.

The major diving skill of the underwater photographer is buoyancy control, which involves the ability to settle gently and quietly on the sea

bed without disturbing the substrate or the animals living on it, the skill to move over the bottom without disturbing anything, and the ability to remain stationary in mid-water with only gentle fin movements. Disruptive motion is much easier to control with an adjustable-buoyancy life jacket; indeed, this is probably the greatest single aid to the underwater photographer yet devised. These jackets are inflated with compressed air, either from the main aqualung cylinder or from a small cylinder on the jacket. The air can be emptied from the jacket by means of a purge valve. The diver can thus carry a weight-belt sufficient to hold himself firmly on the bottom when photographing bottom-living animals, but by inflating the jacket he can increase his buoyancy enough to float in mid-water. A word of warning here—these jackets need training and practice for their safe operation. It is all too easy to begin an uncontrollable upward ascent which can result in a fatal pulmonary embolism.

For shallow work, say down to 7 m, it is possible for a swimmer using snorkel alone to take very acceptable photographs. The major problem here is not as one would think, the short duration of the dive, but rather one of excessive buoyancy. Like the shark, the unaided swimmer relies on his forward motion to keep level in the water and if he stops to focus on some animal he will float slowly and inexorably upwards. One dangerous solution is to empty the lungs before submerging. A much safer solution is to wear an easily detachable weight belt, perhaps teamed with a life jacket.

The snorkel diver should be aware of the dangers of hyperventilation and anoxia. A succession of very deep breaths and exhalations will flush out most of the carbon dioxide in the lungs. It is the build-up of carbon dioxide in the blood, not the decrease in oxygen, that tells the body that oxygen is short and panting should begin in order to make up the oxygen debt. If much of the carbon dioxide has been flushed from the system, this warning does not operate and the swimmer quietly loses consciousness.

Underwater Cameras

Having learnt the basic techniques of diving, the next problem is the choice of camera and its waterproof case. There are readily available on the market a number of underwater cases which will accommodate a

range of cameras of widely different price. There are also a number of complete photographic systems.

The choice of camera depends on many factors, but perhaps the most important is the type of subject. It is unlikely that one can satisfactorily photograph a small encrusting organism in murky British waters with the same system that will do well for a shark in the tropics. It is possible that there is no commercially available camera and housing that is suitable for the particular needs of the photographer. In this case, it is necessary to consider putting a camera into a custom-built case. Detailed instructions for building camera housings are described in Harwood's pamphlet (see Bibliography). Techniques are now fairly well-known and can be summarized as follows.

In choosing a camera to be put in a case, it is important to have well-separated controls that stand proud of the body and can easily be linked to separate controls outside the case. The aperture and exposure settings must be easy to read (this is always more difficult underwater) and the reflex viewing system must give a large, bright image.

Single-lens reflex cameras with fixed pentaprisms are perhaps the most suitable for building into an underwater case. A reflex viewing system is helpful because the apparent distance of an underwater object appears to be only three-quarters of its true distance and a diver finds it difficult to make the judgment. Paradoxically, this is a problem that besets the experienced diver more than the novice because the experienced diver unconsciously discounts the magnifying effects of the air-water interface and thinks in terms of true, not optical, distance. Twin-lens reflex cameras have one particular disadvantage underwater, namely, that they cannot easily be positioned behind a hemispherical port and severe aberrations result in the viewing system. This problem is discussed in more detail below.

Mertens, in his already classic book *In-Water Photography* (see Bibliography), has reviewed most of the currently available underwater

Plate 53. (Upper) Grouper (*Epinephelus* sp.). North Island, Aldabra (Indian Ocean), depth 20 m. Rolleimarin, 75 mm lens, 1/60 at f5·6 on H. S. Ektachrome, from which the monochrome print was subsequently derived.
(Lower) Salp (*Boops salpa*), Wied iz Zurrieq, Malta, depth 3 m. Calypsophot, 35 mm lens, 1/125 at f5·6 on Tri. X 35 mm film.

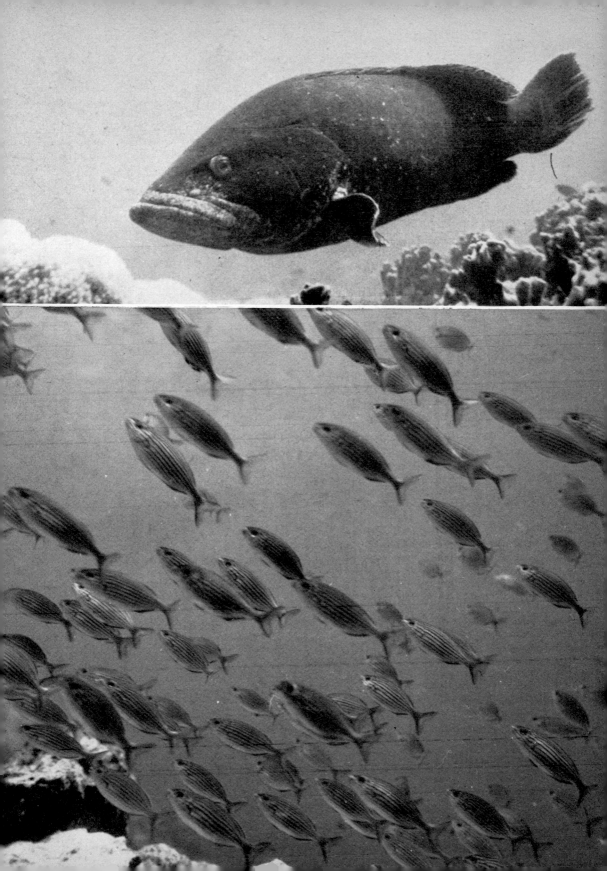

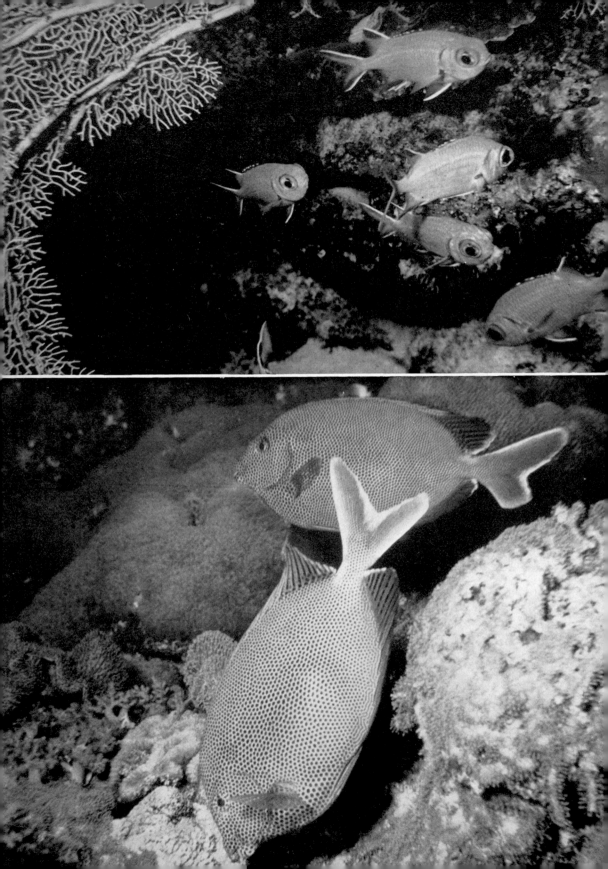

camera systems. Over the years the Hans Haas Rolleimarin, which contains a Rolleiflex camera in a specially built underwater case, has proved itself exceptionally reliable in the rough-and-tumble of diving use. The package is exceptionally well balanced when submerged, having just the correct amount of weight underwater. The controls are large and well placed. A bulb flash unit has a battery-capacitor circuit inside the housing whilst the flash leads, and bulb socket, are free-flooding. The 'wet' parts of this system require meticulous cleaning if the flash is to fire regularly. Auxiliary lenses for close-up work can be fitted whilst submerged by a system made somewhat complicated by the need to fit a similar, but parallax corrected, lens to the reflex lens. When using a Rolleimarin for the first time, attempts to find and follow a moving target in the focusing screen can be highly frustrating. This is partly because the angle of the viewing screen is about 45° to the direction of view of the camera; and, secondly, because the image displayed is right-way-up but reversed from left to right. However, with practice, these difficulties recede and the Rolleimarin becomes exceptionally easy to use. There is one incidental advantage to the highly placed focusing screen—in shallow rock pools the camera lenses can be submerged whilst the focusing screen remains above water and the photographer does not need to get wet!

The Rolleimarin is a conventional camera within an underwater case, whilst the Nikonos/Calypsophot 35 mm camera was designed from the outset as an underwater camera. The camera itself is watertight and is the same size as a conventional 35 mm camera. It is thus exceptionally portable and, being compact and strong, can be taken on any dive 'in case something should turn up'. The controls have been designed with the diver in mind and have the feature that the camera can be cocked, aimed and fired with one hand. The results taken by such a method are rarely of exhibition quality (camera shake is the problem) but when the diver is holding on in a strong current or a rough sea, it is frequently the only way to get a picture. A limitation of the Nikonos/Calypsophot is that

Plate 54. (Upper) Squirrel fish (*Myripristis*, sp.) with *gorgonia*. Aldabra, depth 30 m. Rolleimarin, 75 mm lens, 1/250 at f11.
(Lower) Rabbit fish (*Siganus stellatus*). Aldabra, depth 10 m. Rolleimarin, 75 mm lens, 1/250 at f11 on H. S. Ektachrome (from which the monochrome print was subsequently derived) using bulb-flash.

there is no reflex viewing and focus must be estimated. However, for close-up work, a rectangular frame at the end of a ranging stick attached to the camera has proved very satisfactory. The manufacturers make a series of free-flooding auxiliary close-up lenses that can be clipped to the camera lens underwater and these work well in conjunction with a ranging stick. The Nikonos/Calypsophot bulb flash system, unlike the Rolleimarin, is housed in a separate flash unit.

Light in the Sea

Once the photographer has succeeded in getting himself and his camera underwater, his next problem is the quantity and quality of the light that reaches him. The water surface acts as an inter-face both reflecting and refracting light. Daylight reflected back at the water surface is obviously lost to the diver.

Refraction of light at the water surface affects its angular distribution, particularly in shallow water. At low solar elevations, direct sunlight hardly penetrates into the water and though it may be bright enough for photography on land it is too dark underwater. On looking upwards the diver can only see out of the water within a solid angle of 97°. This bright disc is known as Snell's Window and may be 100 times or more brighter than the background light from other directions.

Light that penetrates through the surface is selectively absorbed by the water. Thus in the exceptionally clear waters of the Mediterranean and tropical oceans, the long wavelength red and orange light is much more rapidly absorbed than the shorter wavelength blue and green light. The ambient light in deep ocean water is a fairly monochromatic blue or blue-green. In inshore waters which contain a considerable amount of 'yellow substance' produced by decayed plant material and have also a large phyto-plankton population, blue light is absorbed by the chlorophyll and yellow decay-products, and red light is again absorbed by the water, leaving green light to penetrate the deepest. This has a much more than theoretical interest to the underwater photographer, for pictures taken by natural light in temperate coastal waters generally have a strong green cast, whereas those taken in clear tropical waters have a blue cast.

An even greater problem encountered by the underwater photographer

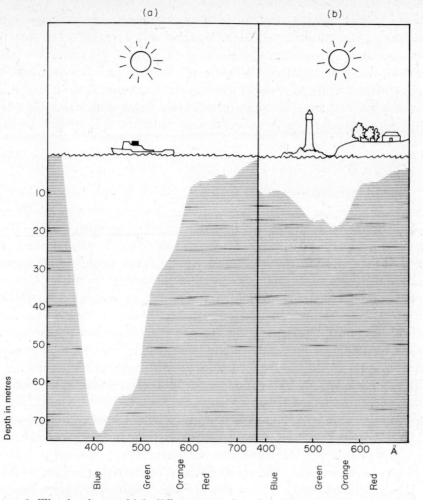

Figure 1. The depths at which different wavelengths of light reach one tenth of their surface intensity: a) oceanic gulf stream water; b) coastal water. Data from Tyler and Smith, 1970.

is the loss of contrast due to suspended particles in the water. All the image-forming light from the subject does not reach the camera lens, for some is absorbed and some is deflected from its path by the water and by the particles it contains. At the same time, light from other directions is scattered into the lens. It is this scattered light that comprises the background light underwater. As the subject gets further from the camera the

proportion of light coming from the object decreases, whilst at the same time the proportion of scattered light increases. Eventually the scattered light swamps the image-forming light and the object becomes invisible.

A horizontal through-water visibility of 60 m would be excellent for very clear water and 20 m would be excellent for clear British water. In muddy estuaries a diver would be lucky to see 1·5 m. The range that acceptable photographs can be taken is very much less than this and the nearer that the camera can get to the subject the better.

The Camera Port

Light rays passing from the water, through the camera case port into the air within, are strongly refracted due to the different velocities of light in the two media. Light rays passing at normal incidence through a flat port are not refracted, but as the angle of incidence becomes more oblique aberrations due to refraction become progressively more severe. Rays striking the port at angles greater than 48·5° to the normal are totally reflected. The field of view can thus never exceed 97° and in practice acceptable quality is only achieved within an angle of about 50°. The plane camera port acts as a positive lens; underwater objects are reduced in range to three-quarters of their true distance, and their image size is correspondingly increased. Since the magnification effect increases as the ray becomes more oblique, the image shows pincushion distortion.

At the time of writing, the most common method of overcoming these aberrations is to replace the plane port with an hemispherical one with the camera lens placed at the centre of the sphere. With this system there is no reduction in field of view, and since all rays passing through the centre of the sphere where the lens is located pass through the port at normal incidence, aberrations due to refraction do not, in theory, exist. Nevertheless, barrel distortion can be introduced if the lens aperture is large in relation to the diameter of the port, since rays entering near the edge of the lens will not pass through at normal incidence and will undergo some refraction. Pin-cushion distortion can be corrected by a supplementary concave lens and barrel distortion by a supplementary convex one.

There is nothing inherently difficult about designing correct lenses for in-water use; the problem is simply that the demand is not sufficient to enable the manufacturers to make enough to sell at competitive prices. There are correcting lenses available which will overcome most of these optical problems, of which the best known is the Ivanoff–Rebikoff lens. The only lens system specifically designed for underwater use in large-scale commercial production is the 28 mm f3·5 Nikkor lens for use in the 35 mm Nikonos camera.

Choice of Lens

The over-riding consideration in choosing a lens for underwater use is the need to get as near the subject as possible. This either means a wide-angle lens for large subjects, such as a fellow-diver or sharks, or a close-up lens for small animals. There is little point in using a lens of greater field of view than about 50° if a plane camera port is used. With hemispherical ports a true fish-eye lens gives apparently good results and they enjoy a certain vogue at this time. However, image distortion is very marked in these pictures, and the results can look peculiar.

Light Meters

An underwater light meter is well-nigh essential, since it is difficult to gauge the intensity of underwater light and variations in water transparency make rule-of-thumb methods most unreliable.

Of the two common types, the selenium cell is to be preferred to the cadmium sulphide (CdS) cell. This is because CdS meters are particularly sensitive to red light which is rapidly filtered out by the water. Exposures near the surface should be correct, but in deeper water the film will be over-exposed perhaps by as much as 2 stops at 140 ft in clear blue water, unless a correcting filter is incorporated in the design.

Fortunately it is not expensive to put an exposure meter in a case. Indeed, an ordinary Kilner jar will do well. Do not forget, however, that

the exposure calculators will not be accessible underwater and it is necessary to tabulate the expected combinations of exposure time and f-number on a piece of card slipped into the meter case.

Film

There is often much disappointment when early attempts at colour photography are returned from processing. The transparency is suffused by strong blue or green cast and the remembered range of colours is simply not there. This is because the film is balanced to record surface colours more or less accurately, but underwater the eye adapts to the reduction of red light by becoming much more sensitive to it whilst the film does not. To our knowledge, there is no film specifically balanced for underwater use and missing colours have to be restored by the use of supplementary lighting.

The choice of black-and-white film presents no special problems that are not encountered in dim light on land. Where supplementary lighting is used sensitivity is not normally an important consideration.

Supplementary Lighting

Artificial light is usually necessary underwater to restore the full range of colours lost by the selective filtering action of the water, as well as the more usual function of providing sufficient light for short exposures and small lens apertures.

Probably the most important consideration when assembling a flash unit is the position of the light in relation to the lens and subject. The problem is that large suspended particles between the camera and the subject are seen as bright spots on the film whilst smaller ones cause a milky wash over the picture. It is essential, therefore, to illuminate as little of the intervening water as possible. This normally means mounting the light source as far away from the camera as is feasible, and well away from the direct line between the camera and the object.

The light underwater tends to be very diffuse, giving a flattened effect

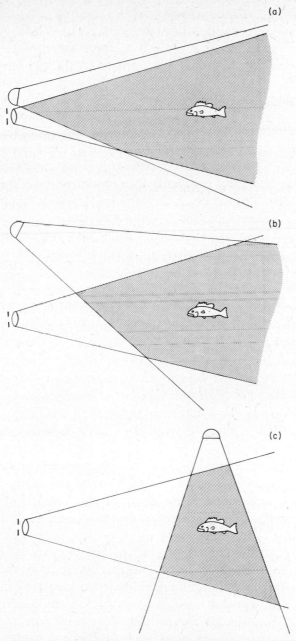

Figure 2. The amount of unwanted scattered light produced by camera lights in different positions. The greater the stippled area between the fish and the camera the worse will be the contrast degradation due to diffuse veiling light.

to the photograph. A second light can be used to give depth and interest to a subject which would otherwise look rather dull. A useful way of achieving this in still photography is to have a completely separate flash unit fired by a 'slave' activated by light from the primary flash (see also Chapter 9).

Another problem is that there are usually few large reflecting surfaces and the light is anyway quickly absorbed by the water itself. In consequence, the manufacturers' flash guide numbers must be divided by two for the first metre. For each successive metre a further stop must be added. This works surprisingly well, except in two particular situations. Sandy bottoms are very reflective and, furthermore, the animals living on them are very pale—for camouflage. Here it is necessary to stop down by at least 2 stops. Silvery fish present a problem (also commented on by Heather Angel on p. 240) since their flanks act as specular reflectors and the flash reflected from them will cause a burnt-out image, and even halation around the fish. Here again it is necessary to stop down by two or more stops.

For the reasons outlined above, one often obtains a perfectly exposed picture of a fish against a black background. Opinions differ about the aesthetic quality of such a picture, but what is certain is that it loses most of its ecological interest and much of its colour. A solution is to photograph the fish against a bright background and this normally means taking the photograph obliquely upwards. Background detail can also be increased by waiting for a fish to swim near to a rock or seaweed. Photographs taken inside a cave, or from the inside looking out, are often very effective.

Both bulb and electronic flash can readily be used underwater, although most photographers use electronic. The pros and cons of each type are very much the same underwater as on land, except that underwater the difficulty of carrying extra equipment makes bulb flash relatively less convenient.

Underwater flashes frequently fail to fire because of corrosion of the free-flooding contacts and these should be cleaned thoroughly before each dive. An insidious fault can develop in the electric cables: they appear sound when the exposed wire is inspected, but on stripping away the insulation it is found that the hidden length of wire in the middle has corroded away. It is always worth carrying spare leads.

Bulb flash has the advantage of simplicity since the capacitor and battery can be mounted within the camera housing and everything else, including the bulb and holder, is free-flooding. Exploding flash bulbs are not a real hazard underwater although it is still possible to burn one's fingers on a recently fired one!

Electronic flash is more convenient to use underwater. It is now usual to fire the flash by means of a circuit housed with the flash gun but triggered by an impulse from a battery/capacitor circuit like that used to fire bulb flash. This trigger circuit can be 'potted' in resin and is thus immune to flooding.

The use of electronic flash with an automatic cut-off when the correct exposure has been reached ('computer' type) has had some limited support for underwater use. The problem at the moment is that the sensing photocell is housed very near the flash tube and thus receives a large amount of backscattered light and the flash is shut off prematurely. The system should work well, however, were the photocell mounted near to the camera lens.

Filters

Red and orange-pass filters are sometimes used to restore these hues to the underwater scene. In general these have not been very successful since they give an unnatural appearance to the transparency. It is possible that better results could be obtained for particular situations if the filter was carefully chosen to complement the spectral distribution of the ambient light. However, the colour of the sea changes from day to day and even from hour to hour. Furthermore, the depth would have to be taken into account since the band of the spectrum penetrating into the water becomes progressively narrower as the depth increases.

Underwater Wildlife

It is essential for any Natural History photographer to know as much as possible about the habits and ecology of his subjects. The underwater

photographer can be at a distinct disadvantage here, as underwater ecology is a relatively new field and information gained from the older methods can be misleading. For example, the leopard-spotted goby was, until recently, unknown in British waters and when first caught by a diver was thought to be new to science. It subsequently proved to be a Mediterranean species, but one which we now know to be common as far north as Scotland. It had escaped notice because it habitually lurks in rocky crevices substantially below low-tide level and until the aqualung came into common use was never seen by Naturalists.

Vertebrates—Offshore

Many of the largest and most interesting fish and mammals live far offshore and have to be found by a surface boat first. Even then contact is not certain, for a school of fish and their following sharks may take fright on the diver's entry and they can swim many times faster than he can. Some very large plankton-eating animals such as basking sharks and Manta rays are slightly less difficult and can be approached quite closely. The most spectacular cine film of sharks yet taken was obtained when a dead whale was left overnight to be eaten by them. These facilities, however, are not always easy to arrange!

For some unexplained reason, fish often gather in company with large floating objects such as driftwood, rafts, floating weed and jellyfish. Pilot fish and the true dolphin fish are well-known and photogenic examples. Some species, notably garfish and grey mullet, often swim very close to the surface and are worth looking for.

Offshore species often gather where there are rock formations in association with deep underwater cliffs. In tropical seas, the outer edge of deep fringing reefs are productive, especially those that crown a slope which falls away steeply to many hundreds of metres, as at many coral atolls. Pelagic fish often follow channels into comparatively shallow water and, indeed, the deeper reef channels are almost always worth looking at. The best time to enter the water is at high slack tide when the channels are filled with clear ocean water and the tidal current has temporarily subsided.

Vertebrates—Inshore

These are generally found where there is plenty of cover such as kelp forest, rocky areas with plenty of holes, and coral reef. Isolated outcrops of coral and rock always seem to support fish in abundance. Caves are also popular and several of the more nocturnal species can be found in them and around the entrance. Large mammals such as walruses, seals and sealions frequent particular areas. In the antarctic seals are frequent visitors to breathing holes in the ice. Very little is yet known about the reactions of these animals to man in water, and extreme caution is still advised—particularly near breathing holes and in the mating season.

Some animals are very inquisitive and it is the dolphin that finds the diver and not vice-versa. Localities are recognized where dolphins will visit a diver, sometimes becoming a playful nuisance. At most other times, attempts to locate dolphin schools in open water are failures.

Bottom-living Fish

These are mainly found on soft sand or shingle bottoms and many, such as rays, weevers, flatfish and stargazers are usually half buried in the sand. They can only be distinguished by the two protruding eyes and perhaps a vague outline. The dorsal fins of the guitar fish and the tails of rays are often left above the surface and are a give-away to the experienced eye. These fish rely on camouflage and it is possible to get very close indeed to them. Care must be taken because sand dwellers have more than their share of weaponry. The dorsal fin of weevers and stone fish contain a dangerously painful venom, as do the tail barbs of sting-rays. The electric ray can deliver a shock of considerable intensity if the unwary photographer pokes one to make it swim.

Apart from the half-buried fish, the sandy bottom often swarms with beautifully camouflaged gobies which will begin to move if the diver remains very still for a minute or so. These will come right up to the diver, feeding on the disturbed sand, but as photographic subjects they

are difficult because their near-perfect camouflage against the bottom gives virtually no contrast unless carefully positioned flashes are used.

Diver and Fish

Most fish will accept a diver as a more or less neutral object, albeit large and noisy. Some fish like the whimple fish or the batfish are quite inquisitive and will come so near that the camera will not focus close enough. Others, such as the whiting and haddock, never seem to approach closely and, indeed, are rarely seen by divers. Unfortunately, the photographer must often share a stretch of water with a spearfisherman and most photographers will testify that fish rapidly associate a diver with peril and naturally enough do not distinguish between speargun and camera! Most of the Mediterranean has been spoilt for large-fish photography within the last two decades, though with rigorous conservation techniques the situation could be improved.

An experienced fish photographer can become almost as integrated with the environment as a fish. He is able to sense from the behaviour of small fish schools if a marauding group of predators is approaching and he will soon learn how to control his breathing and smooth out his movements to cause little or no alarm to his subjects.

Chasing after a fish never works for they can swim much faster. Barracuda can circle a diver faster than he can rotate on his own axis. A gentle fin after a fish sometimes works, for many will turn to survey a diver. A grouper, for instance, will do so as a kind of threat display and as he turns away will present a full flank view to the camera. Split-second timing is vital here. A full head-on view is seldom satisfactory and even worse is one where the fish has his tail towards the camera.

Underwater hides have often been suggested as a possible way in which natural underwater photographs of fish may be obtained. It is only recently that the idea has been put into practice with the American underwater habitat 'Tektite'. There are, however, a number of disadvantages. Most fish and other marine organisms of interest to photographers tend to live in shallow water and in association with rocks or

coral. This zone is subject to greater disturbance by surge and wave action and there are severe problems of anchorage.

In water deeper than 10 m where most experiments of this kind are conducted, the physiological problems of remaining at length at depth are often too great for any but the dedicated scientist with very large back-up facilities. The best photographs taken on any of the underwater living experiments have come from diving excursions outside the houses.

Conclusion

Good underwater photographs are rarely taken by accident. There are so many things that can go wrong outside the control of the photographer that nothing within it can be left to chance. Perseverance usually pays handsomely. It allows a certain 'rapport' to be built up with the subject so that the shutter is released at just the right moment. Once the right subject has been found, do not try to save film, but take the whole succession of shots. The diver, cold and fuddled as he usually is, cannot discern the finer points of composition of, say, a shoal of fish. He must leave that much to chance and make his selection in the comfortable warmth of his studio.

Bibliography

Camera under Water, Dobbs, H. E. (Focal Press) London, 2nd Ed. 1972.
Design and Construction of Your Own Underwater Housing, Harwood, G. (British Society of Underwater Photographers; data sheet no. 2). Available from the Secretary, B.S.U.P., 47 Dudley Gardens, Harrow, Middlesex, England.
In-water Photography, Mertens, L. E. (Wiley Interscience), New York, 1970.
Optical Oceanography, Jerlov, N. G. (Elsevier) Amsterdam, London and New York, 1968.
The British Sub-Aqua Club Diving Manual (Riverside Press), London and Whitstable (England), 1972.
Underwater Photography, Kodak Data Sheet (Kodak) London.

14

Photography in Caves

John Woolley

Introduction

This chapter starts with a warning. Caves are fascinating places full of
photographic possibilities but they are also *dangerous* for the inexperi-
enced. Accidents may happen and it is then that knowledge of caving is
vital, not that of photography! So, before aspiring to cave-photography,
it is wise to join a good caving club to learn the necessary skills—and
incidentally be shown the best caves and places to photograph (see
Bibliography). This warning applies particularly to old mine-workings,
which can be death-traps for the inexperienced explorer.

The apparatus and techniques of cave photography must satisfy two
sets of requisites; one arising from the characteristics of the cave environ-
ment and the other from the wide range of photographic subjects.

The salient feature of the interior of a cave is the absolute darkness.
Artificial light is the Aladdin's lamp which reveals the wealth of beauty
in the underground scene—as his headlamp is the most important piece
of equipment to the cave explorer, so to the underground photographer
are his photographic light-sources.

The cave owes its origin, form and decor to water. A dry cave is a
dead cave—its life, lustre and beauty gone. But water sets problems for
the photographer, as do associated mud, humidity and the numbing cold-
ness which results from the inevitable long periods of standing about in
wet clothes at low temperatures.

Every item of equipment must be man-handled through the cave;
down ladder-pitches which may be hundreds of feet deep, dragged

through water, mud and tight crawls, carried suspended from the waist in vertical clefts where all hands and feet are required for traversing, and so on—and back again! Every single gramme of weight must be considered and this means careful planning to include only necessary items. Everything must be suitably packed so that delicate photographic apparatus survives such harsh conditions.

The subjects include large halls with massive formations which require vast amounts of light for photography, small grottoes with delicate incrustations of great beauty, underground rivers, waterfalls and lakes, the strange sculpturing of water-worn rocks and long cave passages with their lighting and depth-of-field problems. Human aspects of adventure and exploration are there to record, also scientific aspects of the geology and hydrology of cave systems; and the fauna and flora, often highly adapted to a cave environment, offer a wide and relatively new field for on-site work.

Choice of Camera

There is no universal camera which will satisfy all requirements. It must be robust but not heavy, compact, constructed to withstand the harsh conditions and remain reliable, easy to manipulate with cold wet hands, and have well-defined calibrations for focusing and aperture setting, because eyes which are dark-adapted lose their acuity of vision.

A good lens is required, as much as the appeal of a cave photograph depends upon delineation of fine detail. Preferably it should stop down to f22 to cover a large depth-of-field. X and M synchronizations are necessary; for other light-sources a range of slow speeds is useful. A time setting has the advantage of not requiring a locking cable-release, as most caves seem to possess a Gremlin whose sole amusement is stealing these, or concealing them on the muddy floor or in the depths of the camera-carrying box. Delayed-action has its uses, and the longer the delay the better. A direct-vision view-finder is a useful accessory; although not as accurate as others there are times when this is the only type which can be used. In general, the two classes of cameras which have proved their worth in caves are the 35 mm and the 6-cm square formats.

Providing that it meets the above specification, a simple fixed-lens 35

mm camera, with a 40 mm or less focal-length lens (to cover the required wider-than-normal angle of view) is all that is needed for general work. A good second-hand model can be recommended both for the novice and to keep as a spare for the more strenuous caving trips. A wider range of work is covered by the coupled range-finder (CRF) and the single-lens reflex (SLR) cameras with their interchangeable lens facilities.

Snap-action and detail shots at wide apertures suit the CRF as it is the easier to focus. The earlier Leicas with collapsible lenses are sturdy, reliable and compact cameras. On one of my early caving trips to the Bull Pot of the Witches, a sack containing three Leicas detached itself at the top of the entrance pitch and crashed eighty feet to the bottom. Admittedly it fell on a dead sheep, which cushioned the impact to some extent, but everyone was surprised and relieved when the cameras were found to be still mechanically and optically perfect.

An SLR is the most versatile caving camera, its main faults being a tendency for the viewing optics to mist up and difficulty in focusing, especially with wide-angle lenses. Providing the basic requirements are met, the cheaper models are satisfactory; coupled through-the-lens light metering is of little use in the dark. Auto-iris is an advantage.

Six-cm square cameras produce the highest quality results and for general work the twin-lens reflex (TLR) has much to recommend it. The standard 75 mm lens covers a wide angle and the square format suits the cave scene. Although bulky, construction is robust; it will survive rough handling and even the occasional total immersion in water. The direct-vision view-finder often fitted is a frequently used utility. For close-up work, the TLR is not as versatile as the SLR. Condensation is the usual nuisance.

There is much to be said for a good second-hand folding twelve-on-120 camera. These give large negatives but are more compact than the modern 35 mm SLR, being truly pocketable, smooth in outline and well protected when folded. Double enclosure in self-seal polythene bags gives a water-proof package which can be tucked away inside a wet-suit next to the skin, where it will remain warm and dry even on a 'hard' caving trip involving much immersion in water.

Six-cm format SLR and TLR cameras with interchangeable lenses are excellent instruments but tend to be too expensive, heavy and vulnerable for most cave photography.

Lenses

The most useful 35 mm camera lens is, without doubt, of 35 mm focal length. Space is often restricted; a wide-angle lens not only includes more of the scene but it also appears to give a picture corresponding more closely with visual memory. Surprisingly, this effect is even more pronounced when photographing large passages or chambers; the steep perspective gives depth and spaciousness which add much to the visual impact on viewing. Another advantage is depth-of-field. Six-cm cameras with 75 mm lenses give across the diagonal almost as wide an angle, but require aperture settings two stops down for an equal depth-of-field (hence the value of small stops on these cameras).

Lenses of 30 mm focal length or less can give even more spectacular results, but their use is restricted by distortion effects. A characteristic feature of macaroni-straw stalactites is the way they hang down vertically in clusters from the roof, all in neat parallel lines. A photograph showing these diverging, like rays emanating from a hidden sun, is unnatural and objectionable. For perfect shots with very short focal-length lenses, the use of a spirit level is almost essential; alternatively, a length of thin string attached to the top of the camera and hanging down with a weight attached, serves as a plumb-bob to square up the camera with the scene.

Long focal-length lenses have a limited use, mainly for detailed work.

Light Sources

The low weight and high light output of flash-bulbs fulfil the requirements of portability; flash-cubes provide a convenient, compact and rugged four-shot light package which for simple lighting situations is as good as any. However, they are less effective for the more complex lighting set-ups. The very effective single-flash technique of firing the flash in front of the camera, using the body as a shield, requires back-lighting for the best effect. This can be obtained by using flash-guns with a fold-away reflector of the fan type; a further advantage of these is that

with the reflector in place, a wide angle of illumination is obtained. Unprotected bulbs should be used with care because of explosion possibility. The ejected hot bulb is another hazard in the dark, and care should be taken that this is directed to a safe place and not down the neck of a fellow Caver, or into the flash-bulb container where it may ignite the lot! Please do not litter the cave with spent flash-bulbs—bury them out of sight.

Electronic flash has many advantages. Miniaturization has given compact, highly efficient units powered by a set of penlite batteries, pocketable and weighing less than 300 g complete. Very good lighting set-ups can be devised using a number of these small units. The speed of the flash, 1/500 sec or less, freezes movement and avoids camera shake. The short flash duration does not trouble the dark-adapted eye, whereas flash-bulbs, with their 1/50 sec burn time, are painfully dazzling. The light output of the small units is about one third that of a small flash-bulb, but repeated flashes with open shutter may be used on static subjects. Larger units, 100 watt-sec or more, give a light output about equal to that of a small flash-bulb; they are expensive but the cost of each flash is negligible and, if much work is done, the overall cost is less than that of an equivalent number of flash-bulbs. The battery provides enough flashes for most caving trips, but for expedition use, recharging facilities must be available. In many ways dry batteries are preferable to rechargeable ones, especially for the smaller units; they are light, they do not lose their charge on standing and a good reserve can be taken on long expeditions. Carefully used, a set of penlites will give up to 40 flashes (150 with the alkaline variety). A good and economic practice is to draw up and always follow a list of battery conservation rules—to switch on only when required and a switch off check all round on completion of the work in hand. As David Cooke has stated (on p. 182), electronic units are potentially lethal, the 'low voltage' only slightly less so than the 'high voltage' ones. Insulation is perfectly adequate when the gun is dry but the wet environment of a cave presents a hazard; extra precautions must be taken at all times to keep the gun dry. A water-proof container must be used for transport through the cave; when taken out for use the gun must be handled with dry hands only. I have used a wide variety of electronic units in caves during a period of twenty years and have experienced one shock, fortunately not severe, from one of the first portable units made (which

operated on a voltage of 2,700), and one short-circuit caused by water entering an extension flash socket. This was very impressive, with a bang which echoed through the cave like a thunderbolt, and the socket was completely melted. Since taking precautions, no trouble has occurred, as modern guns are reasonably safe—but any do-it-yourself repairer or improver should certainly take extreme care.

Some very spectacular monochrome pictures were taken during the 1964 British Expedition to the Gouffre Berger using the cine-photography lights. These were 24V QI floodlights and spots, powered by lead-acid accumulators, which in all gave a total of two kilowatts of illumination. The power supplies for this modest level of lighting weighed over 250 kg and presented a major transport problem, both to and down the cave. However, the great advantage of this form of lighting is that it is visible and can be studied and arranged before the photograph is taken; also, in very large chambers, time exposures can be used to integrate the available light. During the expedition, still photographs were taken in the vast Bourgin Hall and in the Hall of Thirteen with a light throw of nearly a 100 m, with time exposures of up to 1 sec at f8 with medium-speed mono-chrome film. The beauty and magnificence of these superb caves were certainly revealed and there was a tendency for the photographic team to use up valuable ampere-hours just standing and staring, lost in admira-tion of the sights, instead of getting on with the job of photographing them. Disadvantages are the weight of the power-packs, the means of recharging them and the man-power requirements for transport through the chaotic terrain of a cave.

For vast amounts of light, capable of lighting up the largest caverns, there is nothing to beat the old-fashioned flash powder. Judged solely as a light source it is excellent, giving a soft plastic lighting with a colour temperature of about 4000°K. Its disadvantages are many. Explosion, fire and burn risks are high; exposure is uncertain; the amount of smoke produced in an unventilated cave is unbelievable and quite out of propor-tion to the amount of powder used. Even a small quantity will reduce visibility to zero; it is necessary to work in a direction against any air currents to take more than one photograph.

Magnesium ribbon is a very portable reserve for lighting static subjects when other methods are impracticable. On fast monochrome film, the burning of 15 cm will illuminate targets up to 3 m away; by moving the

burning ribbon around, soft shadows are obtained. A spring clothes-peg or paper-clip, used as a holder, prevents burnt fingers. A disadvantage is the smoke produced.

Pictorial colour slides can be taken using candles as the sole source of illumination. The candle-flames, if included in the picture, do not give objectionable halation, in fact they add visual impact to the final result. By placing a number along a passageway, fine perspective effects are obtained; in shallow water the reflections make very attractive patterns. The low colour temperature gives a warm rendering on both daylight and artificial light colour films. Exposure times of up to five minutes are required; different colour renderings are obtained on different manu-facturer's film of the same colour balance, possibly due to reciprocity law failure. The warm reddish colours which result with Ektachrome X daylight film, exposed for 2 min at f5·6, are attractive and give an exotic but surprisingly natural-looking appearance to cave scenery. Overall illumination is sometimes improved by a small fill-in flash, which must be small to avoid swamping the candle-light effect; with a 30 watt-sec flash, bouncing the light into the picture by reflection from the palm of the hand is sufficient.

Lighting Accessories

Manual synchronization of flash with the camera on open shutter is simple, but with more than one flash a tripod is necessary and any included human figures must stay motionless to avoid double images. Auto-synch of all flashes with the camera shutter is preferable. The use of inter-connecting flash leads is one method. Initially, when the leads are neatly coiled and packed, these are manageable, but with use they become an intolerable nuisance. Mud and water ruin the insulation of the connecting plugs; after being trodden on, tripped over and generally man-handled, the leads become tangled up and tend to finish as an untidy bird's-nest stowed away in the bottom of the carrying box, manual synch being used for the rest of the trip.

Slave-control (see Chapter 9, p. 186) is more reliable and versatile, adaptable to all varieties of situations. The more sensitive slaves will trip if the light-sensor is caught in the beam of a caver's headlamp, firing off

all the other flashes. This is of no consequence with electronic flash, the guns soon charge again, but it is both annoying and potentially hazardous with flash-bulbs, which may be fired in the face or during insertion of the bulb. All cavers should switch their headlamps from beam to diffuse lighting as a precaution, and the flash operator should take care to keep the slave out of the direct light of his headlamp.

Film

Monochrome photography has merits for depicting the cave scene, perhaps because vision tends to lose colour differentiation in dim light—all cats look grey in the dark—and the caver is accustomed to viewing in the inadequate light of his headlamp. Spacious caves, large passages and chambers require a high-speed film, but for fine detail a lower-speed film and a large negative format are preferable. Development is usually normal though some high-contrast subjects on slow film give better negatives if a high-acutance, compensating-type developer is used.

Colour transparencies certainly add glamour to the cave picture, often revealing colour and detail which were not suspected. The high definition of 25 ASA film is desirable for detail in animal and mineral characteristics, but is too slow for most situations. In very big systems it is best to standardize on a high-speed film, specially processed if necessary to 400 ASA, and to keep in reserve a spare camera loaded with slower film.

Commercial colour prints by the neg-positive process are disappointing. The negatives should really be printed by someone familiar with the scene, and who better than the caver himself? Certainly very attractive caving colour prints can be made (see Bibliography).

Exposure

Determining correct exposure in a cave environment is a considerable problem. Because of the inverse square law of illumination, photography

Plate 55. Gaping Gill, Yorkshire. Britain's largest underground chamber, showing flood conditions. Ikoflex, 75 mm Tessar; three flash positions (powder and electronic) at f8 on FP3 roll-film.

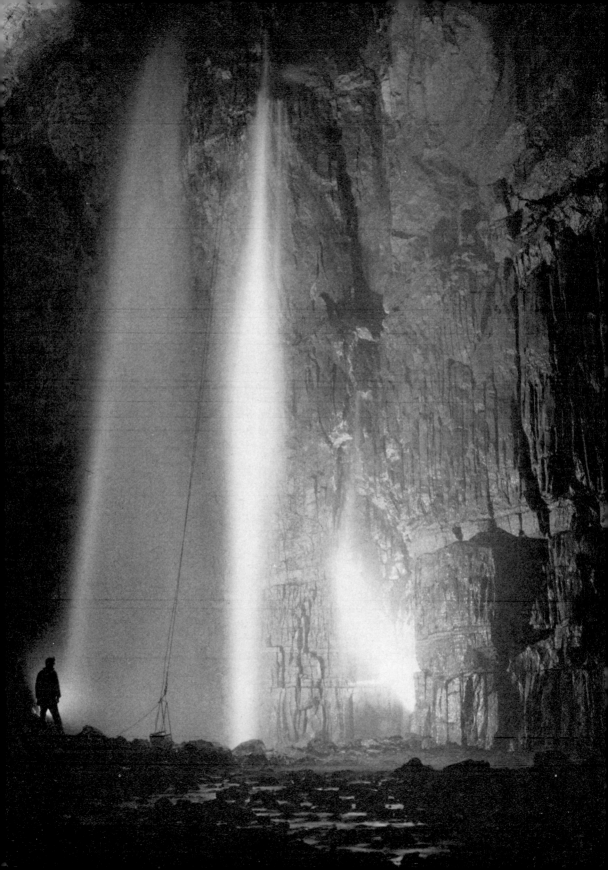

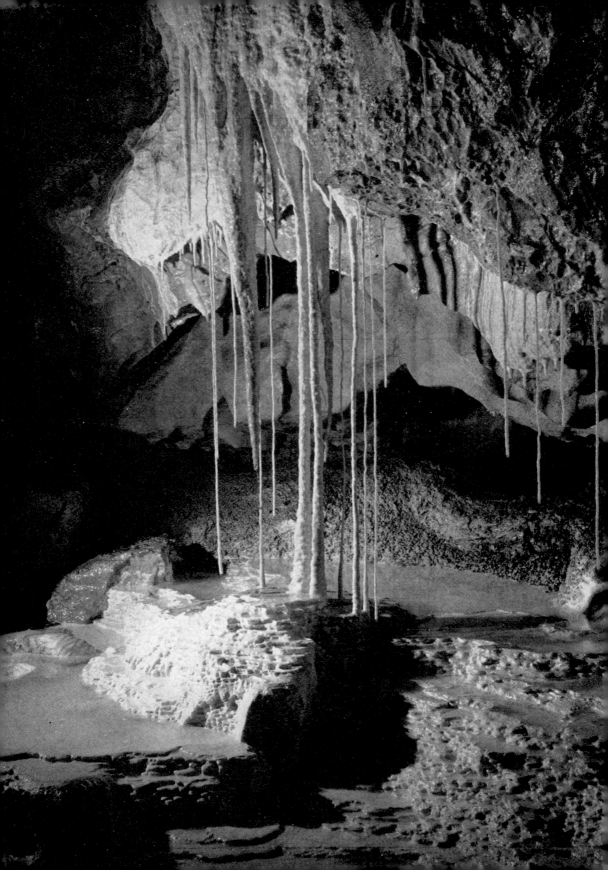

in a cave passage often shows the nearby walls and rocks out-of-focus and burnt out, with distant objects vanishing in the gloom. This characteristic upsets the 'computer' in automatic flash-guns; the light sensor reads the light reflected back from near objects, computes for this, cuts the flash output to match and the result is worse under-exposure of distance. These guns do, however, give good results with near shots of flat fields. Exposure is normally based on the guide number of the flash. Exposures so calculated must be adjusted to suit the particular conditions; in a large chamber, or one with non-reflective walls, the aperture is opened up one or more stops to compensate for the absence of reflected light, whereas in a small grotto with highly reflective surrounds the aperture is closed one or more stops. Some cave-formations, especially those which are actively growing, are fluorescent. This can be observed by extinguishing all lights, closing the eyes tightly while firing the flash and on immediately re-opening the eyes, the formation will be seen to be glowing in the dark with a light of its own which soon fades. This super-reflectivity plays havoc with exposure calculations!

In the midst of all these variables, one thing that is constant is the light of the flash. The 'average' guide number relates this and the square law and it is the only basis from which to work. Experience will indicate any exposure correction, but the wise photographer, as an added insurance in an important shot, will take two further shots at apertures one up and one down from the estimated value.

Lighting Techniques

Standard frontal lighting, with a single flash on or near the camera, is the form of lighting popular with novices and sometimes is imposed by the situation. It is the safest and least interesting form of lighting, giving low-contrast results with no apparent depth or dimension, especially in

Plate 56. Peak Dale Cave. A fully-developed cave formation with roof, wall and floor detail (since destroyed by commercial quarrying). This demonstrates the use of side lighting to bring out texture and detail. Folding Zeiss camera, 75 mm Novar; Metz 502 HSF at f32 on FP3 roll-film Beutler developer.

monochrome. It is better to position the flash well to the side of the camera. A popular and effective technique is to fire the flash forward of the camera position, using the body as a shield to prevent direct light from entering the lens. Greatly enhanced results are obtained with added back-lighting, by using a flash-gun with the reflector folded away or removed, or by using two flash-guns held at arm's length with one flash pointing forward and the other backward. Synchronization is preferably by slave from a small-powered flash on the camera, the fill-in light from which usually improves the results. Another flash may be used along a passage or around a corner to give more depth to the picture. A similar distribution of lighting is required for vertical ladder pitches; it is impossible to illuminate a deep pot-hole with a single flash. A slave-controlled gun is attached to the helmet of the man climbing the ladder, this leaves his hands free for climbing and there are no trailing sync-leads. On long pitches, slave guns may be attached to the ladder or the walls to distribute the light more evenly. With electronic flash, any number of shots can then be taken during the climb, but climbing up and down a long wire ladder to insert flash-bulbs is not popular with the non-photographically in-clined members of the caving team.

Side, top and bottom lighting will bring out wall and formation texture and detail. In general, cave walls are non-reflective or will introduce colour casts; a square of metallized film (survival sheet) or white fabric, used as a reflector, will reduce contrasts and improve the results. Alternatively, a small flash is used on the camera, serving both as a fill-in and to trigger the main flash. Bounced light gives soft, shadow-free lighting which is safe and attractive for colour shots of formations, wall or floor detail.

Pictorial shots in both monochrome and colour are obtained by back-lighting alone; the flash is fired behind formations and pointing at the camera, taking care that no direct light shines on the lens. The translu-cent beauty of calcite curtains and draperies, with the coloured banding which streaks them is well shown by this technique.

Plate 57. Dead cave fly, *Scoliocentra villosa*, being used as a sporulation site by a cave fungus × 3·6. A live fly can be seen at top left. Threads from the fungus hang down from the dead fly's body and coalesce, terminating with an enclosed drop of water. Exa I, 50 mm Domiplan; Metz 502 HSF at f22 on FP3 film, Beutler developer.

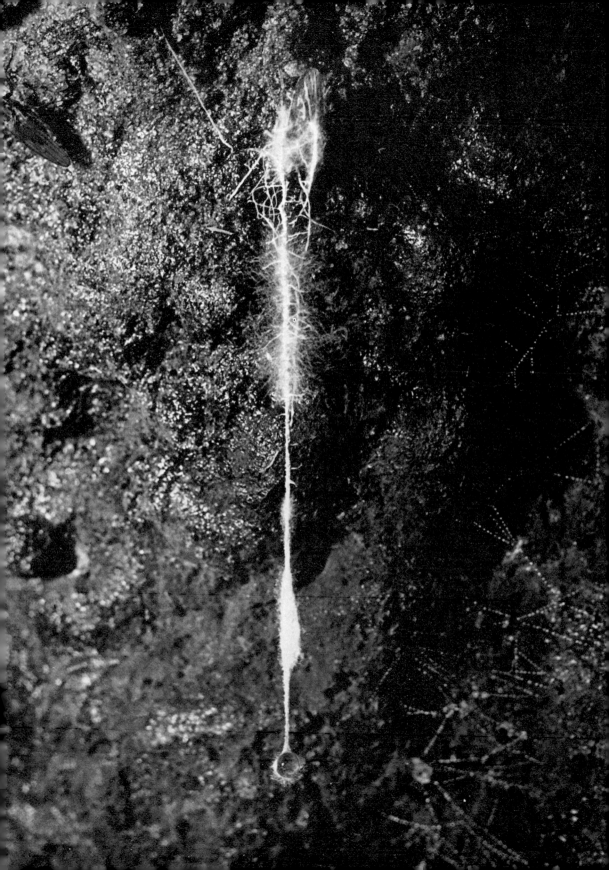

Still water is difficult to portray attractively, usually appearing as a black area devoid of interest. Where possible, reflections of rocks or formations, or cavers with their headlamps, should be included to add interest to the scene. Electronic flash is not really suitable for waterfalls as it gives a frozen effect; side-lighting with low-voltage lamps and exposures of 1/10 to 1/2 sec gives a more natural effect.

The use of an object to give an idea of the scale is desirable. The human figure is excellent and its inclusion in shots of large passages, halls or formations adds impact and interest to the picture. Other scale objects used should relate to caving (a candle, match-box or match according to the field size) but yet should be familiar to the non-caver.

Close-up Photography

Close-up photography offers a wide and interesting field, ranging from the infinite variety of detail in the crystallizations to life within the caves.

Cave fauna comprises three classes: troglobites, troglophiles and trogloxenes.

The troglobites, the authentic cave-dwellers, live only in the dark zone and never leave it. They are usually adapted to the dark, wet environment, being unpigmented and eyeless but with other sense organs well-developed. The cave shrimp, and the cave salamander, are examples. Where organic material is scarce, the troglobites are small and not easily seen, but there are plenty to be found if diligently sought for; most caves have flourishing colonies of *Collembola*. Bat guano is an excellent life support for many creatures. There are interesting symbiotic relationships, such as that of the *Mycetophilid* flies and fungi; the fly larvae feed on the mycelial fungal threads and the dead adults serve as sporulation sites for the fungus—possibly a fixed-nitrogen conservation cycle.

The troglophiles are the dwellers in the threshold zone, indigenous to a cave environment but found only as far as light penetrates. The spider *Meta menardi*, and the beetle *Quedius mesomelinus*, are examples.

The trogloxenes are the cave guests which use it for shelter, rest and hibernation. Bats are the best-known trogloxenes, but there are many less familiar creatures, such as the tissue moth, common in the threshold zone everywhere. Some conventional birds use the zone for nesting sites.

The flora of the dark zone is restricted to saprophitic species, fungi and bacteria. The mycelia of fungi are present on most cave walls: another interesting symbiosis is that of an alga and a fungus which grow together under the artificial lighting of show caves. This was responsible for the attack on the cave paintings at Lascaux.

The threshold zone has an interesting gradation of plant and animal life from the bright light of the entrance to the endogean realm of absolute darkness.

A simple outfit for medium close-up work comprises a folding 120 camera with a set of supplementary lenses, a flash gun and a retractable metal rule. This will cover a reproduction range of 1:15 to 1:5 for formations, surface detail, mineral deposits and the larger cave fauna (for bats, see Chapter 4). Besides being very portable, other advantages are that these cameras often stop down to f32 giving good depth of field, no stop correction is required for exposure determination and a tripod is not necessary.

The SLR camera with auto-iris is the most versatile instrument for greater magnifications but it is not easy to use. Positioning and focusing on the uneven terrain is awkward, condensation is its usual nuisance and, because the eye loses acuity of vision when dark-adapted, eye-strain soon develops. Electronic flash is the preferred light source; a powerful unit (at least 100 watt-secs) is required for high-definition colour film (25 ASA) at small stops. Smaller units need fast film; alternatively two can be paralleled together for more light. A small torch attached to the flash-head is a useful aid for focusing and composing the picture.

Depth-of-field, rather than the highest definition, appears to be the more important contributor to the visual appeal of a caving shot; a good rule is to always use the smallest stop and decide exposure by the distance of the flash. For reproduction up to 1:5, dividing the guide number by the f-number gives this distance, but when the higher magnifications are used, the marked f-number must be corrected to the Effective Aperture according to the formula:

$$\text{Distance of flash to object} = \frac{\text{Guide number}}{\text{Marked f-no. } (1{\cdot}0 + \dfrac{D}{F})}$$

where: D is the distance the lens is moved forward from the infinity setting.
 F is the focal length of the lens used.

With extension tubes (whose rugged simplicity suits cave use), the length used is equal to D; a table of flash distances for various combinations of tube lengths and lenses, used for required magnifications, can be prepared and taken on site for ready reference.

A good caving tripod has not yet been invented. It would be compact when folded, light in weight, easy to set up a sometimes very uneven base, with a positive lock on all legs to ensure stability, with accurate control and positioning of the camera in all dimensions, and it must withstand mud and water. The nearest approach to this ideal is the human body, hence the need for flashes of short enough duration to freeze camera or other movements.

Condensation

One of the bugbears of cave photography is condensation of moisture on the equipment; this can ruin all prospects, and positive action must be taken to prevent it.

The air of a cave is in contact with the wet roof, walls and floor and so is saturated with water-vapour. The measure of the water-vapour content of air is expressed as the percentage Relative Humidity (RH%); when saturated, RH is 100%. The higher the temperature of the air, the more water-vapour is required to maintain RH100%, and vice versa. In winter, the air outside is colder than the cave air; during transport to the cave, gear will have cooled to the outside temperature and when the colder camera is taken out of its container into the cave air it will cool this in its immediate vicinity. To maintain RH at 100%, some of the dissolved water-vapour must condense as liquid, which appears on glass surfaces as a film of water-droplets ruining the optical performance. Once formed, the water-films will not dry out in the RH100% surrounding air, since this cannot dissolve any more water.

A second source of condensation is the human body. Steaming bodies, warm with exercise, soon give a misty atmosphere, especially in confined places; this may not be visually apparent but will result in flat contrast and degradation in a photograph. Ladder pitches in deep shafts are prone to this effect; shots should be taken as soon after arrival as possible in such places.

On breathing out in a cave, the warm moisture-laden air from the lungs condenses to a thick mist like steam from a boiling kettle; with flash on the camera this often appears on the photograph as a dense white cloud. An incautious breath on the lens or viewing screen will render these useless. A method of prevention is to breathe deeply a few times and then hold the breath during focusing and taking the scene. The eye is a notorious offender for misting up the viewing optics and moist hands will quickly mist up the lens if held anywhere near it. If the lens is protected with a filter or optical flat, a supply of paper-tissues can keep it wiped free from condensed or splashed-on water, but this cannot be done when condensation is on the interior glass surfaces. Skilful use of a carbide-lamp, candle or matches (taking great care not to replace the water-film with a film of soot) can be used in emergencies to warm and dry out the glass surfaces; for important expeditions a less brutal and more certain method is required.

When a camera is misted up, the water-films must be dried out and its temperature raised to, or preferably higher than, that of the cave atmosphere to prevent re-occurrence. One satisfactory method is as follows. A layer of silica-gel granules, 1–2 cm deep, is spread over the bottom of a metal box which has a water-tight lid. The box, with lid open, is heated over a cooking-stove, fuel-tablet or a number of candles, until the gel is uniformly heated just about too hot to touch. A piece of foam-rubber, cut to a size slightly larger than the box-bottom, is pressed down over the granules to give a tight fit. Any equipment which requires demisting is placed on the foam bed, the lid is closed and soon any condensation, even on the interior surfaces, will have dried out. As long as the box maintains a higher temperature than that of the cave, any equipment taken from it will not mist up, except perhaps from the breath and even this will soon dry out.

Transport

Transport is a problem which the cave-photographer must solve. Containers must be provided for carrying the numerous and delicate items of photographic equipment; they should be light but water-tight, and strongly constructed to withstand the man-handling and rough treatment

they will receive. The average caver, kindly acting as porter, will not be too concerned about the container's valuable contents but more with the task of moving it to and fro as easily as possible—and using it as a seat when weariness gets the better of good intentions. In British caving circles, the standard Jack-of-all-trades container is the ubiquitous government-surplus ammunition box; these are unbeatable and one wonders what could take their place when the supply dries up.

Careful packing is essential to withstand bouncing from wall to wall and off rock ledges when the container is lowered and raised in shafts at the end of a rope. The camera and other items of equipment are individually wrapped in squares of absorbent cloth, such as towelling; all are packed into the box and overlaid with a square of towelling so that when the box lid is closed the contents are compressed into a shake and shockproof assembly. The overlay serves to wipe the hands free from mud and water before handling any of the packed equipment.

A good idea is to attach to the inside of the box-lid a printed list of the contents, to serve as a check-list for initial packing and after each location spell of work; it is most frustrating to struggle down a hard cave only to find that some small but necessary item has been forgotten. Other details such as guide-numbers, supplementary-lens focusing distances or any other useful information can similarly be displayed.

On return home, a first task should be to remove mud from all gear, clean thoroughly with a damp cloth and dry out. Cave-water has a high content of dissolved solids and is corrosive to metals, causing rapid deterioration of electrical contacts; if allowed to dry, the residual white deposit is difficult to remove and mars the smart appearance which well-cared-for apparatus should present.

Concluding Comments

Caving is an arduous sport, and photography is not at its easiest in the dark, wet, hostile cave-environment; it requires much in technique and mental discipline, but this is part of the challenge. Good results are not only personally rewarding, but may also be valuable records of some aspect of speleological science.

The cave-photographer should set an example; always follow the

Caving Code (see Bibliography); leave no litter in or out of the cave, and never interfere with the various formations or scientific features merely for the purpose of taking a photograph (unless this is to advance our knowledge).

Caves are often important archaeological sites. Should any signs of past occupation be observed, these should be photographed but not disturbed and contact made with a local museum or archaeological society for advice.

Finally, always ask permission to visit and enter a cave and treat the farmer's land and property with respect.

Bibliography

British Caving, Cullingford, C. H. D. (Routledge and Kegan Paul) London, 1962. (A standard text book on caves and caving techniques with references.)

Photographic Aspects of Caves and Caving, Woolley, J. M. (Vol. 3, No. 2. Ilford Journal on Photography and the Graphic Arts) London, 1965. Reprinted, Vol. 11, No. 10, 11, 'The Speleologist' 1967. (With particular reference to the British 1964 Expedition to the Gouffre Berger.)

Radiant Darkness, Bögli, A. and Franke, H. W. (Kummerly and Frey) Berne, 1965. English Translation (George G. Harrop) London, 1967. (A general account of caves and caving, with excellent illustrations in monochrome and colour.)

Symposium on Cave Photography, Vol. 11, No. 4, pp. 15–273. Transactions of the Cave Research Group of Great Britain, 1969. (This is a standard reference work on Cave Photography with specialist contributions by several authors.)

The Caves of Derbyshire, Ford, T. D. (Dalesman Publishing Co.) Clapham via Lancaster (England), 1964. (One of a number of books which provide graded lists of the known caves in the various limestone regions of the British Isles. The *Caving Code* is therein, also a list of British Caving clubs.)

15

Stereo Photography

Pat Whitehouse

Introduction

The term stereo, as applied to three-dimensional photography, is derived from the Greek word *stereos*, meaning solid. Stereo photography is therefore the representation of solid subjects in a way which shows not only their height and width, as in conventional flat photography, but also their depth. Every Nature photographer knows that some subjects photograph less well than others. This is usually because they are less easily distinguished from their background and surroundings, either on account of their protective colouring or because, in a monochrome print, they are rendered in similar tones of grey. All subjects, however are distinguished from their background by position, and hence a satisfactory stereoscopic record is almost always possible (Plates 58, upper and middle) and frequently may also be both striking and beautiful.

The fact that we see things around us as solid objects is due to having two eyes on the front of our heads, separated by an average distance of 63 mm, so that we get a slightly different view with each eye. These two independent views are then integrated by the brain to give an impression of depth (stereopsis), so that the front of an object is recognized as being closer than the back. This may sound obvious, but it is basic to an understanding of stereo photography. Here the aim is to record the two views separately in such a way that when presented simultaneously, one to each eye, they will be integrated into an acceptable solid reconstruction of the original subject.

There are other ways of assessing solidity and recession, by means of

perspective, relative size and recessive colour changes, which we all use to augment stereopsis and which are well known, particularly to the artist and photographer, as dodges for emphasizing recession in a flat picture. For true stereoscopic vision however, we depend on the angular

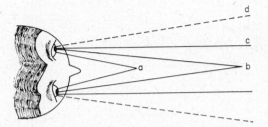

Figure 1. Convergence of eyes for objects at different distances: a, at reading distance, maximum convergence; b, at mid-range; c, at infinity, no convergence; d, abnormal *divergence* caused by excessive separation of far images in a stereo pair, giving rise to viewing discomfort.

difference (parallax) between near and far objects, recorded by our two eyes. From Fig. 1 it will be seen that the eyes subtend a greater angle for closer subjects. This angle diminishes as the subject recedes, until at around 150 m (known as 'stereo-infinity') there is no perceptible angular difference, and the light-rays being parallel, each eye then sees an identical view. Thus a landscape beyond stereo-infinity is seen flat—a fact often employed in the theatre by the use of a flat painted backcloth.

Conversely, as we approach closer to an object we become more and more aware of its solidity, until at average reading distance with maximum eye-convergence, we have full appreciation of its three-dimensional qualities. In stereo photography the greatest impact of the three-dimensional approach is also experienced at close range. This is why stereo is ideal for Natural History photography, where so much of the subject matter demands close-up treatment. To look through a stereoscope at, say, a bird feeding its young (Plate 58, lower), or a bee visiting a flower (Plates 58, upper and 59, upper and middle), is to see the subject substantially as it was, in colour and depth, at one particular moment of time, even when the subject is closer than the normal limit of focus of the unaided eyes (20 cm). Furthermore it is often possible to discern details of structure and functional morphology in a stereo close-up, which could

never be deduced from a conventional flat photograph (Plates 59, upper and middle).

The Standard Stereo Camera

The most popular type of stereo camera readily available (Fig. 2a) has an inter-lens separation roughly equal to the average human eye-separation. The film format is nearly square, 23 mm wide by 24 mm high (22 × 23

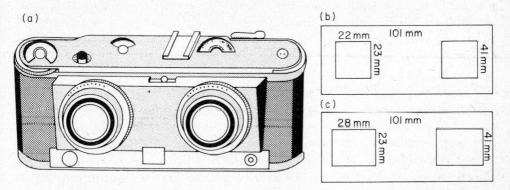

Figure 2. (a) Standard stereo camera for 35 mm film. Lens separation is approximately equal to average human eye separation. (b) American format (22 × 23 mm) for transparencies 23 × 24 mm. (c) French format (28 × 23 mm) for transparencies 30 × 24 mm.

mm on the slide), giving 29 stereo pairs on a 36-exposure cassette of 35 mm film (Figs 2b and 5a). It is known as the 5-sprocket or American format, and has been used by the majority of makers of stereo cameras including Edixa, Iloca, Realist, Revere and Wray. (A horizontal (French) slide-format also exists, giving 20 pairs, 28 × 23 mm (Figs 2c and 5b), but such cameras—Verascope, Belplasca—are less common and will not be discussed here.)

A stereo camera is easy to use, having all the usual controls that would be expected on a normal 35 mm camera. In shape it is obviously wider than a single-lens camera, but it is often lighter in weight and less bulky than most 35 mm reflex cameras, and being of simple design is relatively inexpensive. Sophisticated apparatus is just not available for stereo, and the slight increase in the film used per photograph (29:36) is amply

justified by the addition of the third dimension. The system is cleverly designed so that when the resulting pair of transparencies is viewed in a *standard* stereoscope, that is with viewing lenses of focal length approximating that of the standard (35 mm) taking-lenses, the subject is faithfully reconstructed through a 'window', apparently at 2 m from the viewer, and with the same magnification and perspective as seen originally by the camera.

Focusing is possible in most standard stereo cameras down to about 1 m, but for reasons which will be discussed later (p. 329) it is not usually advisable to approach closer than 2 m, to avoid depth-distortion and viewing problems. For Natural History photography however, there is a snag; the standard stereo camera has lenses of relatively short focal length, usually 35 mm, and they are not interchangeable. For normal use this short focus is reasonable in relation to the small format it covers (22 × 23 mm), and although there are some Natural History subjects suited to this average range approach, as for example in ecology or forestry, the standard stereo camera is of only limited use at extreme ranges, either close-up or very distant. For most of our subjects, a stereo camera with lenses of longer focal length is required, and this is something the photographic trade does not supply. However, stereo photographers are not easily deterred, and do-it-yourself methods flourish where the manufacturers fail.

To describe all the various techniques employed and the ingenious apparatus devised by different workers—ranging from the outright Heath Robinson to superb precision-made instruments—would fill a book and is quite beyond the scope of this chapter. Only general principles will be discussed, and those methods which may be of interest to the Natural History photographer using apparatus which is readily available, or can easily be constructed.

General Considerations

There are two requirements for successful three-dimensional photography at all ranges. First, it is necessary to produce stereo photographs which are comfortable to view, either in a hand-held stereoscope or by projection. Secondly, they must appear to be three-dimensionally true, or at

least—since this is a personal judgment—not to show unacceptable dis-
tortion. Inherent viewing-discomfort and depth distortion frequently go
hand-in-hand, so attention to one often prevents the other. Of the two,
avoidance of eyestrain is undoubtedly the more important, for difficulty
in viewing may invite rejection of stereo outright. People easily lose
patience—and hence interest—in a medium if it plays havoc with their
visual comfort, and although depth distortion may sometimes be sur-
prising and occasionally grotesque, discomfort is obviously intolerable.

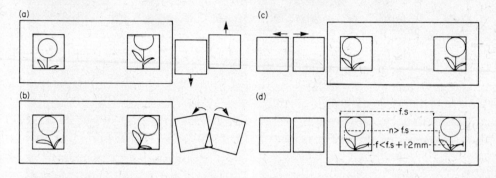

Figure 3. Errors in mounting stereo pairs. (a) Vertical misalignment. (b) Twist—causes
bad eye strain. (c) Excessive horizontal separation of far images, causing divergence of eye
axes (see Fig. 1d)—sometimes due to excessive separation of transparencies on the slide
mount, but also caused by excessive parallax between near and far images (greater than
1·2 mm) which cannot be corrected by remounting. (d) Correct—no vertical misalignment
or twist—separation of nearest images (n) not less than frame separation (f.s.), and
separation of farthest images (f.) not exceeding 1·2 mm more than that of near images.

The most common cause of discomfort arises from errors in mounting
the pairs of transparencies for viewing (Fig. 3). These faults can usually
be corrected by accurate re-mounting, and are therefore only temporary.
More serious are the inherent faults, often due to excessive parallax
between the two views (too much depth), which cannot be corrected
subsequently, and must therefore be avoided in the taking. In judging
depth, we normally depend on the degree of convergence of our eyes to
indicate differences in parallax between near and far objects. In the same
way a stereo camera records differences in parallax between the two
views—images of far point (or far homologues) at infinity being further
apart on the mounted transparencies than images of near points (at 2 m).

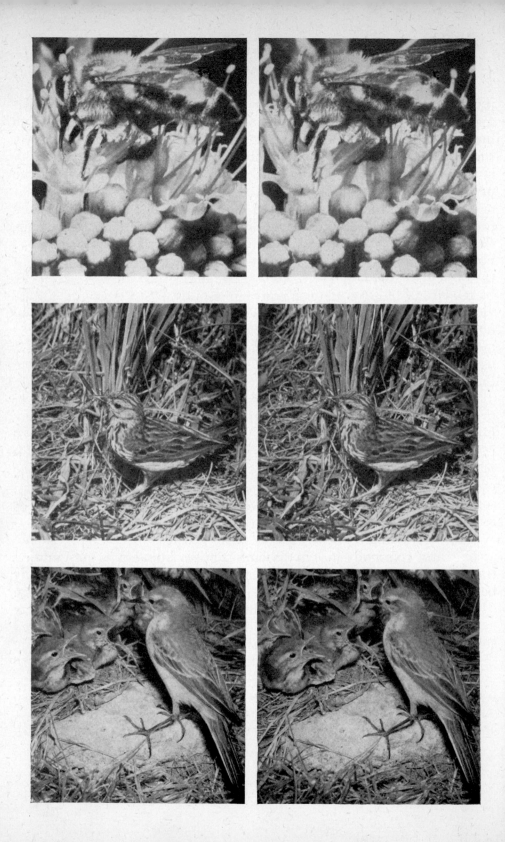

This is known as *deviation* and is a measure of the depth in the scene. For comfortable viewing in a standard slide-mount this difference should not exceed 1·2 mm of linear measurement or 2° of angle. When it does, the axes of our eyes are forced to diverge, and this is neither natural— since we never normally look beyond infinity—nor comfortable, and gives rise to eye-strain (Fig. 1d).

To avoid discomfort of this nature, one must restrict the total deviation (depth) in a slide, and it can be checked in two ways. Before mounting, the two separate transparencies can be superimposed and viewed with a magnifying lens against a bright light. When the nearest points coincide, the most distant points should not be separated on the two transparencies by more than 1·2 mm. Similarly, after mounting, when the right and left views are correctly placed on the mount, the distance between the far homologues in the three-dimensional view should not exceed 1·2 mm more than the distance between the near homologues. The latter is usually taken to be the separation of corresponding sides of each frame of the mount itself, which act as the frame of the stereo window (Fig. 3d). The same limit of deviation applies at all ranges of the subject, right down to the closest close-up. Here the most distant point, equivalent to infinity in an average-range stereo, is known as *false infinity*, and the separation of its homologues should again not exceed 1·2 mm more than the separation of those of the nearest point. (Absolute measurements for the separation of homologues on a slide would be misleading here, because frame-separation can vary fractionally between different commercial brands of mount.)

How can such excessive parallax between near and far homologues arise? First it should be emphasized that it does not occur when a standard stereo camera is used in the standard manner for subjects between 2 m and infinity, and this is why a 35 mm stereo camera is so

Plate 58. (Upper pair) Honey-bee on *Caryopteris*, showing how the third dimension isolates the subject from otherwise confused surroundings. Range 15 cm. Whitehouse 'Baby Bertha' camera, Dallmeyer 7·5 cm lens; HSF at f32 on Ektachrome-X, subsequently transposed to a black-and-white print.
(Middle pair). Tree pipit, near nest, range 75 cm. Details as above, except f16.
(Lower pair). Yellow wagtail, female at nest. Details as above.
Note: instructions for stereoscopic viewing are on p. 340.

simple to use. It is only when special techniques are employed, as in long-range or close-up stereo, where the possible depth in the subject is infinite, that excessive deviation can occur—and these are the very techniques that are of particular interest to the Natural History photographer. The inclusion of more depth than the eye can accept at one glance produces features, beyond 'false infinity', which are difficult to fuse. So limitation of the total depth in the view is always desirable.

That then is the problem, and to appreciate and understand it is a significant step towards a successful solution. In practice, however, there is considerably more latitude than might at first appear. The figure of 1·2 mm corresponds to a deviation from 2 m to infinity for *average* eye separation. Although taken as 63 mm average, the human interocular distance varies from 54–72 mm, and hence there is considerable variation in deviation tolerance. 1·2 mm is a safe average and works well in practice, but it can sometimes be extended to an absolute limit of 1·5 mm. It should also be realized that tolerance is greater in a stereoscope than with projection, and some stereos which do not project satisfactorily, may be completely acceptable for hand-viewing.

A useful means of calculating the depth-of-field (in cm) which will give a deviation of 1·2 mm between the nearest and farthest object, is given by the formula

$$\frac{120\,d^2}{sf - 12d}$$

where d is the distance of the nearest object from the camera lens (in cm), s the interlens separation (in mm) and f the focal length (in mm). This formula can be used for any camera having f and s fixed, to draw up a table showing the permissible depth-of-field for various distances of the nearest object.

Plate 59. (Upper pair) Leaf-cutting bee, showing the characteristic angulation between thorax and abdomen, not readily appreciated in a 'flat' photograph. Details as for Plate 58 (Upper pair).

(Middle pair). Bumble-bee visiting Himalayan balsam, showing the relationship of floral and insect morphology. Note how the bee's legs fit into grooves in the petals and how its wings are flattened by the stigma. Details as before.

(Lower pair). Orange-tip butterfly, male, range 20 cm. Details as before.

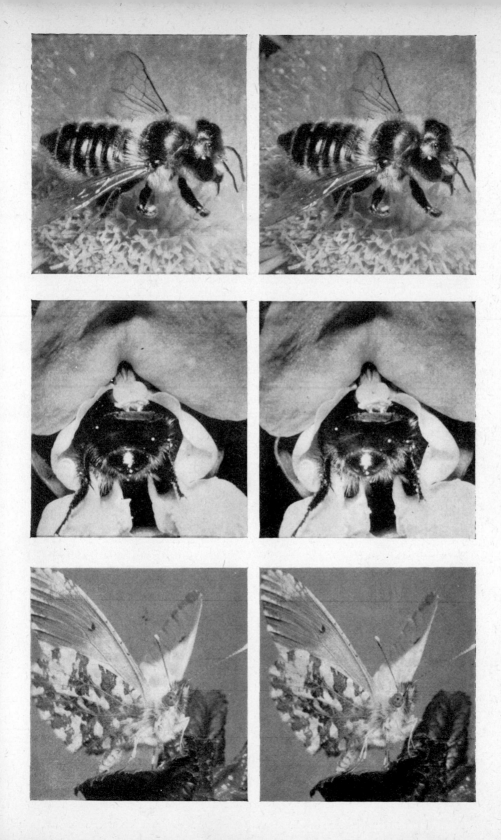

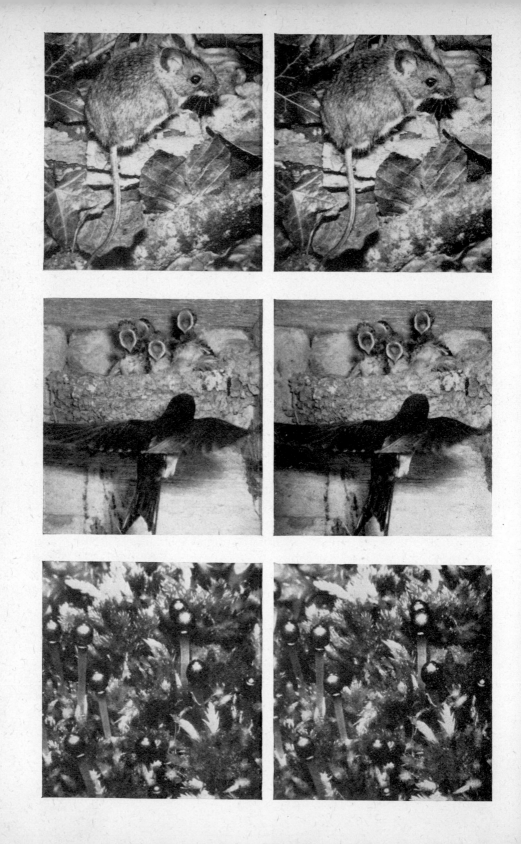

Long-range Subjects

It is assumed that the stereo photographer is already acquainted with the fundamental approach to long-range subjects necessary for conventional 'one-eyed' photography, as discussed in earlier chapters. To obtain a three-dimensional picture, two simultaneous views must be taken instead of one. This simply means doubling up the equipment, employing two lenses of suitable focal length separated by an appropriate distance and with shutters synchronized to fire at exactly the same moment.

Early attempts to combine these requirements into one camera were known affectionately by their makers as 'Big Bertha' stereo cameras, after the German long-range cannon used in 1917 to shell Paris. Besides requiring longer than normal focal length, Big Bertha techniques usually, but not necessarily, imply the use of wider than normal inter-lens separation (hyper-stereo). This was often unavoidable owing to the sheer size of the longer-focus lenses, which could often not be mounted side-by-side with normal separation. However, Big Bertha cameras justified their nickname in more respects than the size of the lenses and lens panel. The whole structure was necessarily bulky and heavy, and often unwieldy to use—though to keen workers the reward at long range obviously out-weighed this inconvenience.

Nowadays, with compact 35 mm and smaller format cameras available, Big Bertha stereo can be a very different matter. It is as sophisticated as the two independent camera bodies which, linked together, give the two independent views (Fig. 4), and as long-range as available matched long-focus lenses permit. Simultaneous shutter control is obtained with a twin cable-release. In aligning the two cameras, it is important that they are set with parallel lens-axes—not toed in or out—and that they are mounted on the same horizontal baseline.

To give greater solidity to subjects at longer range, the inter-lens separation can be greater than normal—always providing it is realized

Plate 60. (Upper pair). Wood mouse, range 37·5 cm. Details as for Plate 58, f16.
(Middle pair). Swallow approaching nest, range 75 cm. Details as above.
(Lower pair). Sphagnum moss, with capsules, range 15 cm. Details as above, but f32.

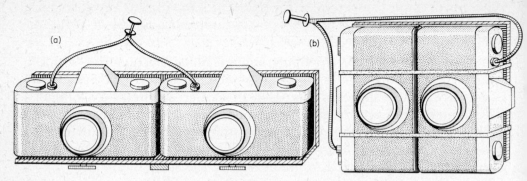

Figure 4. Use of two matched single-lens cameras. (a) Linked side-by-side on a right-angle support to give a lens separation around 65–70 mm (for average range). (b) Closer lens separation is sometimes possible by linking base-to-base, with thick rubber bands to hold the cameras firmly on a supporting splint.

that the increased depth, built in by parallax to the resulting stereo, will introduce greater risk of excessive deviation between near and far homologues. Distortions introduced by varying the inter-lens separation will be discussed later (p. 340), but deviation itself can often be controlled by choice of background. For example, a featureless blue or out-of-focus hazy sky forms an ideal background for a bird, either perching or in flight, whereas a powerfully patterned sky should be avoided because the eye-catching distant homologues may be difficult to fuse. For animals in open surroundings, a high viewpoint is preferable, so that the extent of the background is limited by looking down upon it. A vertical background, such as a bank or tree trunk, is another useful arrangement for limiting total depth, and different local features can usually be found in special situations. Another dodge, when a troublesome background cannot be avoided, is to render prominent distant features so out-of-focus that no attempt is made to fuse them.

For faithful three-dimensional reproduction of solid subjects, viewing conditions should be similar to the taking conditions, that is, the viewing lenses should be of similar focal length to those of the camera (see p. 335). This is not always possible, and when Big Bertha stereos are viewed by standard methods in a stereoscope of relatively shorter focal length, a perspective distortion is introduced in which the more distant parts of a subject are seen to be relatively larger than those nearer the camera. A

cube, for example, is seen to be the shape of a pyramid without an apex, and the birds in a flock of waders photographed at long-range along the sea shore appear to increase in size as they recede from the camera. While this perspective distortion is always present to greater or lesser extent in Big Bertha stereo, it is rarely noticed unless geometric shapes are present in the picture. Fortunately, most Natural History subjects and their surroundings are variable, and not showing this particular distortion too obviously they are some of the most suitable subjects for Big Bertha stereo.

Close-range Subjects—Standard Stereo Camera

Close-ups form one of the most rewarding aspects of stereo photography, for only at close range can the fullest impact of solidity be appreciated. As with long-range subjects, the standard stereo camera is of limited use —not this time so much on account of the focal length, but of the separation of the lenses. Special techniques are again necessary, and are aimed at reducing the inter-lens separation (hypo-stereo).

An obvious reason is that when a close range subject is centred on one of the lenses of the standard camera, it may lie completely outside the field of view of the other lens. Even when it does appear on the edge of both views, the resulting stereo image will show unpleasant exaggeration of depth, and also distracting monoscopic edge-strips, which do not correspond in the two views. Everything photographed closer than 2 m with standard inter-lens separation will show this distortion to some degree, and it becomes more noticeable as the close-limit of focus of the standard camera (1 m) is approached. At this range, control of the background is essential for comfortable viewing, and the subject itself should be of only very limited depth. Special mounting in 'close-up' mounts is necessary to eliminate the non-stereoscopic edges and to hold the subject behind the stereo-window. For even closer approach to the subject, supplementary attachments are available known as angle-lenses (close-up lenses combined with prisms), which prevent monoscopic areas by keeping the images centrally placed on the film-frames. However, their use on the standard camera at full inter-lens separation, gives results that are often grossly distorted and may also be difficult to view.

So the standard stereo camera, with its 35 mm focal-length lenses and its range restricted to subjects not closer than 1 m, holds little appeal for most Nature photographers. The photographic industry has again been slow to realize this fact, and at the time of writing there are only two stereo cameras on the market which offer any concession to close-range approach by adopting a less-than-normal lens separation.

Cameras with Reduced Lens Separation

The Italian Super-Duplex is no newcomer to the market and is offered as a multi-purpose stereo camera for use at average as well as close range. The frame size approximates to the familiar American standard format (23 × 24 mm), but the pairs lie side-by-side across the width of 120 roll-film. To accommodate this economy in film, the lenses are also set closer than normal, at an inter-lens separation of 30 mm—less than half the usual lens separation. The consequence, because one cannot have the best of both worlds, is that for average-range shots the depth of the three-dimensional image is only half that recorded by a standard stereo camera with full inter-lens separation. However, this frequently passes unnoticed at distances not exceeding 4 m, and is a reasonable compromise. The f3·5 lenses in 5-speed shutters are of standard focal length (35 mm), and focus from 90 cm to infinity. Twenty-four stereo-pairs are obtained along the length of the 120 film (Fig. 5e), and single exposures are also possible—48 to the roll. Its appeal for Nature photography is that three sets of close-up lenses (angle-lenses) are available, for use at 50, 30 and 20 cm from the subject, covering at closest range a field of approximately 8 × 9 cm. Range/view-finding frames are provided, which greatly simplify close-up manipulation by eliminating parallax and focusing difficulties. It seems a very versatile camera, but there are problems at these closer distances, and to appreciate them it is necessary at this point to consider some concepts of close-range stereo.

The standard stereo system, as we have seen (p. 323), imposes a limit of deviation of 1·2 mm between far and near homologues for comfortable viewing, and this is given in the standard camera by a near point at 2 m and an inter-lens separation averaging 66 mm. (In practice the inter-lens

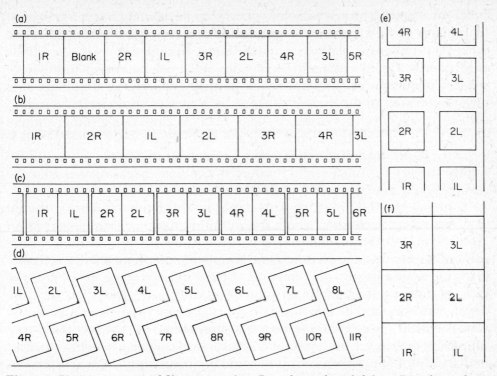

Figure 5. Various systems of film progression. L = frame from left lens, R = frame from right lens. (a) Standard 5-sprocket American format (actual frame size 23×24 mm). The film is advanced 10 sprocket holes between each exposure leaving 2 frames between the R and L frames of each pair. (b) French format (30 × 24 mm)—involving irregular film progression. (c) Half-frame format (18 × 24 mm) giving one pair on standard frame (36 × 24 mm) of normal 35 mm camera. (d) Diagonal progression—used to convert obsolete plate cameras for film, giving 25 pairs, American format, on 120 roll-film. (e) Super-Duplex—24 pairs, American format, on 120 roll-film. (f) Baby Bertha—whole film area used, giving frames 31 × 31 mm and allowing selection of subject area in mounting.

separation varies slightly in different cameras from 62 to 70 mm.) Thus the ratio of inter-lens separation to subject distance is 66:2,000 = 1:30, and we arrive at a simple formula known as the 'one-in-thirty' principle, namely

$$\frac{\text{Inter-lens separation}}{\text{Distance from subject}} = \frac{1}{30}.$$

Not only does this principle ensure comfortable viewing, but it has proved in practice to be a satisfactory guide for preserving correct perspective when the inter-lens separation is different from normal. It should be regarded as a guide rather than a rule, and may be varied judiciously where circumstances and experience permit. Indeed, for simplicity it is often expressed in mnemonic form as 'one mm of inter-lens separation for every inch of subject distance'—i.e. 1:25. At close range some workers prefer the more generous depth afforded by 1:18 or even 1:12, and this is a matter of personal preference, since assessment of perspective is always highly subjective. What really matters in the final assessment is that the result should not be uncomfortable to view.

Applying the 'one-in-thirty' principle to the Duplex camera, the 30 mm inter-lens separation gives a minimum distance for close-ups of 30×30 mm $= 90$ cm. This corresponds to the near limit of focus of the camera, so any closer approach using supplementary lenses will inevitably introduce some degree of distortion. At the closest range of 18 cm, the ratio of inter-lens separation to subject distance is 30:180—1:6, and the depth distortion will be five times greater than with the generally accepted ratio of 1:30—a gross distortion by any standard! Nevertheless the Duplex is employed successfully in close-range specialist fields, such as oral and ophthalmic surgery and in some biological studies, where a technique can be standardized to give results which, although distorted, are useful on a comparative basis. The acceptable range for this camera is from around 50 to 400 cm, and within this limitation it certainly qualifies as a valuable working tool for the naturalist.

The other stereo camera available commercially for close-range approach is the American Macro Realist. Based on the normal Stereo Realist camera-body, the standard 35 mm focal-length lenses cover the usual 5-sprocket format (23×24 mm) with a field approximately 44×46 mm, that is nearly 1:2 magnification. The apertures are set permanently at f25 for use with electronic flash, and focus is fixed so that the effective depth-of-field covers a range from 100 to 137 mm. A wide range of shutter speeds is provided for use with other light sources. A probe-type range-finding attachment allows the camera to be used hand-held. The separation of the lenses is 15·8 mm, so the ratio 'inter-lens separation : subject distance' is approximately 1:6 (15·8:100) at closest range, and approximately 1:9 (15·8:137) at farthest range—both indi-

cating considerable distortion. However, the camera is neat and easy to handle, and is no doubt useful for special applications where distortion (and the price!) does not matter.

There being no 'ideal' camera on the market for stereo at close range, it is therefore necessary to adapt, design and construct special equipment for the purpose.

Home-made Close-up Cameras

The simplest approach is to adapt an existing obsolete plate-camera for use with film in the standard stereo format. An advantage of this method is that many of the older large-format cameras have lenses of relatively long focal length, allowing a less close approach to the subject, and hence reducing the distortion of the full inter-lens separation. I have adapted an old Voigtlander Stereoflektoscop, by fixing to it the back of a 120 roll-film camera, in diagonal fashion, so that the pairs of views lie diagonally across the film (Fig. 5d). This peculiar alignment looks odd, but it can be made to accommodate the required separation of the frames, according to the degree of tilt.

Depending on one's skill and ingenuity, a close-up stereo camera can be built either from entirely new materials, or from bits and pieces of other cameras. The possibilities are endless, but one or two practical points are worth mentioning. It is worth looking out for an old roller-blind shutter of the Thornton-Pickard type. The slow speeds are usually fairly accurate, and the gap in the blind moves vertically to expose both lenses at the same time. For flash synchronization, all that is required is an electrical contact which completes a circuit when the gap is fully open. Inside the camera, a central vertical septum is essential to prevent light-spill from one side to the other. To allow for focusing, this can be made from two overlapping leaves, attached one at the front just behind the lenses, and the other at the film plane, and sliding over each other as the lens panel is racked in or out. Another method is to use a tensioned roller blind.

The lenses themselves should be reasonably matched in focal length and of small diameter, and set as close as possible to give minimum inter-lens separation. Although long-focus lenses are preferable, the choice of

focal length is limited because photographic lenses of small diameter tend also to be of relatively short focus—though telescope eyepieces can provide the exception. A reasonable compromise which I have used for many years is 75 mm focal length and 25 mm diameter. Set side-by-side these lenses give a separation of 25 mm, and by grinding away a quarter of each lens lengthwise (with a file and emery paper), it has proved possible to approximate the lens centres to 12 mm (Fig. 6). The pairs of transparencies lie side-by-side across the width of 120 roll-film, 25 pairs per roll, and each frame 31 mm square (Fig. 5f). The separation is

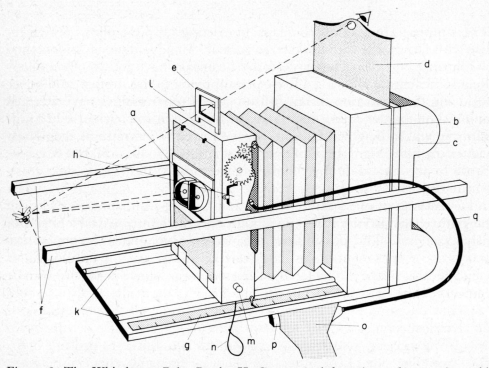

Figure 6. The Whitehouse Baby Bertha II. Constructed from items from various old cameras: a, 75 mm Dallmeyer anastigmat lenses, filed away to give minimum centre-separation of 12 mm, and sliding apart to 30 mm; b, camera body with plate holder; c, holder for 120 roll-film; d, dark slide with hole for viewfinding; e, frame view finder; f, sliding rods for range/view-finding at close range; g, focusing scale; h, flash contact; k, focusing rack; l, Thornton-Pickard roller-blind shutter; m, knob for adjusting shutter speed; n, string for setting roller-blind shutter; o, pistol grip; p, shutter release button; q, cable of shutter release.

variable (12–31 mm), the lenses being mounted to move apart and together so that every range of close-up subject, from 100 down to 11 cm can be photographed with appropriate inter-lens separation. This nearest range of 11 cm is considerably less than the average close limit of human vision (20 cm), within which our eyes cannot easily focus or converge. So with such a camera, subjects can be viewed in three-dimensions which cannot normally be seen stereoscopically at extreme close range (Plates 58, upper; 59, upper and middle; 60, lower). The linear magnification at closest range is $\times 1\frac{1}{2}$, and the impact of this macro third-dimension can be very exciting—and often astonishing.

Such a camera has become known as a 'Baby Bertha', because it has longer than normal focal length like Big Bertha (p. 327), whilst the inter-lens separation is actually less than normal. It is this longer focal length (75 mm) which distinguishes Baby Bertha from the Macro Stereo Realist (35 mm). When a stereo pair is viewed with lenses of shorter focal length than the taking lenses, the three-dimensional effect is diminished in proportion to the ratio of these focal lengths (see also p. 328). So when Baby Bertha close-ups taken with 75 mm focal length are viewed in a standard stereoscope (focal length 35–40 mm), the effective depth of the view is approximately halved. This does not happen with Macro Realist close-ups taken with 35 mm focal length and the ratio inter-lens separation: subject–distance of 1:6 causes distortion. At close range for Baby Bertha this ratio is 1:9, and the effective depth becomes halved when viewed in the standard stereoscope, giving the equivalent of a ratio of 1:18—not only less distorted, but also less troublesome to view. So the choice of longer than normal focal length for Baby Bertha cameras carries a welcome bonus.

Close-range Stereo with a Single-lens Camera

Slide-bar

When the subject is completely static, very successful stereo photographs can be obtained with a single-lens camera, by moving the camera in relation to the subject between the two exposures. Many botanical subjects are especially suitable for this method. A simple, easily constructed slide-bar (Fig. 7a) is required to support the camera firmly on a tripod, whilst

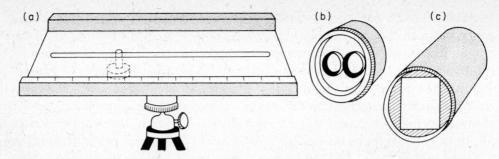

Figure 7. (a) A simple slide-bar from wood and hardboard for supporting a single-lens camera for sequential shots. A convertor bush sunk into the lower surface, allows it to be used on a tripod. The scale in mm allows simple calculation of the required camera movement between exposures—i.e. 1 mm per inch of camera-subject distance. (b) Twin-lens adaptor for use on single-lens camera—mounted in extension ring. (c) Lens hood with vertical side-masking, used in reflex cameras where the mirror prevents a central internal septum, to give sharp cut-off between R and L images at the film plane.

allowing it to be moved sideways along a common baseline. It is important to avoid vertical or angular displacement, especially toe-in of the lenses between the two exposures, but with such precautions excellent stereos can be obtained by applying the 1:30 principle, i.e. 1 unit of camera displacement per 30 units of subject distance.

A great advantage of the slide-bar method is that the appropriate inter-lens separation can be applied for every range of the subject, including extreme close-up where it is not even possible to approximate two small separate lenses, owing to their sheer size. Another advantage is that it can be employed by any photographer who can handle an ordinary 'one-eyed' 35 mm camera at close range. Serious workers usually make several extra exposures of each subject anyway as insurance shots, so for the slight extra trouble of using a slide-bar on a tripod, the reward is a stereo record.

Stereoscopes are available for viewing the 5 × 5 cm slides side-by-side (e.g. the Gitzo Viewer from France, imported into the United Kingdom by Malhams), or a home-made stereoscope can be constructed from two cheap eye-level viewers for 5 × 5 cm slides. If hinged together at the front, the interocular distance can be varied to suit different eye-separations. Projection is also possible, using two separate projectors provided with crossed polarizing filters. The two views are superimposed on a silver screen, which reflects the light back—still polarized—to the viewer, who wears similar polarizing spectacles. Each view is then seen

by the eye for which it was intended. Alternatively, the pairs of trans-parencies can be mounted in regular stereo-mounts (101 × 41 mm overall) for normal hand-viewing or stereo projection. Of the available frame-formats, the French Verascope (28 × 23 mm) (Fig. 2c) is prefer-able to the smaller American format (22 × 23 mm), since it involves less wastage of the original full-size frame (36 × 24 mm).

Devices Using Half-frame Format

These include beam-splitters and twin-lens devices. Used on a 35 mm single-lens camera, they give two views (18 × 24 mm) side-by-side within the normal (36 × 24 mm) format (Fig. 5c). Beam-splitters collect the light rays at full separation and bend them inwards to make use of either the existing camera-lens, or a twin-lens device replacing it. One of the best (currently available, together with a viewer) is made for the Pentax SLR 55 mm standard lens which confers a higher magnification at 2 m than the standard stereo camera. However, the effective full separa-tion precludes the use of beam-splitters for close-range subjects, so they will not be considered further here.

Twin-lens devices without the beam-splitter are suitable for close-up work, however, on account of the small separation of the lenses. They are available commercially (Stereostar C by Zeiss, Kindar by Rochwite, USA, etc.), but can easily be constructed by mounting a matched pair of small lenses within an extension ring. When used on a non-reflex camera, a vertical septum separating the two lenses can be extended right back to the focal plane, but in a reflex camera this is not feasible, owing to the internal mirror. A sharp junction between the two views can be obtained on the film however, by using a lens hood with vertical sides, adjusted so as to mask off the views precisely down the middle of the frame (Fig. 7c). My own adaptor (Fig. 7b) uses small lenses of 31 mm focal length— longer would have been better—mounted in an extension ring, with a separation of 15 mm, and with fixed focus for use at 22·5 cm. This obligatory fixed focus is a disadvantage in twin-lens adaptors, and so is the rather unpleasant tall and narrow half-frame format—more often 16 × 23 mm than 18 × 23 mm, when suitably masked. A great advan-tage however is that the stereos can be interspersed with full-frame shots on the same 35 mm camera. The stereo pair can be separated and mounted in regular stereo masks of 16 × 23 mm format, but a further advantage

of this sytem is that, in fact, they need not be specially mounted. Unfortunately devices produced commercially for viewing the untransposed 5 × 5 cm slides as returned from processing, either hand-held or by projection, are now difficult to obtain, but they are not difficult to construct. By eliminating the need for mounting—undoubtedly one of the greatest chores of stereo—one may perhaps glimpse a possibility of future trends.

General Considerations at Close Range

In close-ups, as with long-range subjects (p. 323), limitation of total depth, by avoiding excessive deviation between near and far homologues, is absolutely essential for comfortable viewing. This is not too difficult for close-ups, where it is often possible to arrange a viewpoint looking down on to the subject from above, rather than from the side. Use can be made of flat objects—stones, tree trunks, large leaves, etc.—to provide a natural backdrop, and in controlled situations the scene can be limited by using a featureless artificial backdrop, to represent for instance a blue sky or mottled greeny-brown vegetation. It must look natural however, and be rendered completely out of focus, for stereo unmercifully reveals everything. If flash is used, it can often be arranged to light the subject without too much of the background, and thus limit the total depth. This fall-off with flash seems not to be as disturbing in stereo as it is in flat photography, probably because it can be seen to relate to the actual recession of the scene. Flat lighting is generally suitable, because one does not depend on shadows for modelling. Whenever possible, small apertures should be used, in order to cover the greatest depth-of-field.

Exaggeration of depth, due to excessive lens separation at close range, can be avoided as we have seen, either by increasing the focal length so that the camera is further from the subject, or by reducing the inter-lens separation. Both methods produce their own peculiar type of distortion, so by attempting to cure one distortion, we introduce others. Perspective distortion and depth compression (p. 328) resulting from longer focal length are not serious in natural history subjects, but another form of distortion, due to decreasing the lens separation, can often be misleading. It appears as a false three-dimensional magnification and is known as *giantism*. When a small subject is photographed at close range with

reduced inter-lens separation, each lens of the camera does not 'see' so far round it as our own eyes would normally do. We get what is sometimes called a 'mouse-eye view' and we judge, from experience based on full human eye-separation that it must be large. The degree of giantism varies with the reduction of inter-lens separation. Scale is therefore sometimes difficult to assess in stereo close-ups, and when a subject—a migrant bird for instance, is familiar in its absence from stereo photographs, it is astonishing to re-discover when the bird returns, how small it actually is. Incidentally, the opposite of the 'mouse-eye view' occurs in extreme wide-base or hyper-stereo, where the effective 'giant's eye-view' produces miniaturization, or Lilliputism.

Objection to stereo photographs of mobile subjects, such as birds, is sometimes made on the grounds that they look stuffed. This is because in other respects they appear so completely real that their lack of movement is worrying. The remedy, ciné stereo at close range, is rewarding, but beyond the scope of this book. In many ways however, stereo still-photography has the edge over stereo ciné. A moment in time, frozen in three dimensions and then viewed at leisure, may reveal fascinating and hitherto unrecognized spacial design—the twist and curve of feathers in flight, or the structural engineering of insect wings (Plate 60, middle pair).

Conclusion

Stereo is ideal for Natural History photography because it is a medium which holds greatest potential at close range. There is however, an astonishing lack of equipment suitable for a specialist approach, and what little there is must be used within its limitations. Purpose-built cameras, with variable lens separation to suit different ranges of the subject, and with lenses of longer than normal focal length, have proved very satisfactory.

Distortions of one sort or another are difficult to avoid, but the ratio 'inter-lens separation: subject distance' of 1:30, gives results reasonably free from depth distortion. Particular care is necessary to avoid viewing discomfort, by limiting the total depth to give tolerable deviation between near and far homologues (not greater than 1·2 mm).

Finally, and probably of greatest interest to the Natural History photographer, is the fact that excellent stereo photographs of static

subjects can be taken with an ordinary 35 mm camera, by moving it 1/30 of the subject distance along a slide-bar between exposures. On return from processing, the two 5 × 5 cm mounted slides can be inserted into a 'Gitzo' viewer and enjoyed immediately as an accurate three-dimensional representation. Anyone taking up stereo and needing help would be well advised to become a member of one of the amateur organizations—now worldwide—which specialize in this branch of photography.

Instructions for Viewing Plates by Unaided Vision

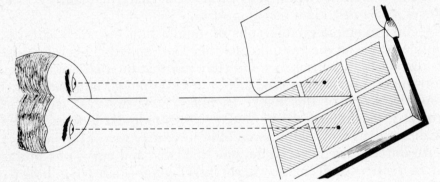

Figure 8. *Method A.*
1. Arrange to have a good, even light on *both* views, with no glare.
2. Hold book at reading distance, with page flat.
3. Line up a strip of card of same length, with one end along the vertical line between the two pictures, and the other touching the bridge of the nose.
4. Focus one eye on each picture, let the mind wander—and suddenly the view appears in depth. If unsuccessful, try again at greater distance.

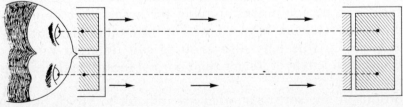

Method B.
1. Hold book near eyes, so that the nose almost touches the centre of stereo pair, forcing the out-of-focus images to fuse.
2. Fixing the gaze on a prominent feature, slowly draw the book away, maintaining fusion of the out-of-focus images, until at reading distance they leap into focus in three-dimensions.

Acknowledgements

I thank the many members of the Stereoscopic Society and the Third Dimension Society who have shared with me their experience and enthusiasm, and in particular J. R. Bibby, K. C. M. Symons and D. S. Ward who read this chapter in manuscript and made many helpful suggestions.

Bibliography

Build your own Stereo Equipment, Thomson, C. L. (Fountain Press) London, 1954.
Stereo Photography, Symons, K. C. M. (Focal Press) London and New York, 1957.
Stereoscopy, Valyus, N. A. (Transl. from the Russian by H. Asher; Focal Press) London, 1966.
Three-dimensional Projection, Krause, E. E. (Greenberg) New York, 1954.

16

Tropical Conditions

John Reynolds

The Tropics

The Tropics are easily defined as the region lying between latitudes 23° 27′ north and south, but probably only two valid generalizations can be made about conditions there. Firstly, the tropical day is twelve hours long at the equator, throughout the year, and, even at the southern and northern limits, the difference between 'summer' and 'winter' daylength is only of the order of thirty minutes. Secondly, as a result of altitudinal differences, variations in temperature and vegetation can be extreme, the latter spatially and the former spatially and temporally.

To illustrate this we may make an imaginary ascent of Africa's highest mountain, Kilimanjaro. Starting in arid semi-desert at about 610 m (2,000 ft) above sea level we ascend through increasingly lush vegetation into Rain Forest, which gradually merges into Cedar-dominated Mist Forest. At about 3,660 m (12,000 ft) this gives way to a remarkable Upland Moor Grassland containing monstrous groundsels over two metres in height. Climbing higher, we pass over a boulder-strewn scree, devoid of anything except a few lichens, to finally enter a zone of permanent snow and ice that continues until the Uhuru (Kibo) peak is reached at 5,899 m (19,340 ft). These zones reflect the diurnal temperature regime characterizing high altitudes in the equatorial Tropics; for every 305 m (1,000 ft) ascended there is not only a temperature drop of about 1·8°C, but an increase in the difference between day and night temperatures, so that in the moorland zone the day temperature of about 15°C drops to about 0°C during the night. Thus, in a distance of about 48 km (30

miles), one passes through climatic and vegetational zones that would span several thousand kilometres of latitude at sea level.

Having emphasized the extreme variability of natural conditions in the Tropics, we can, nevertheless, group the relevant aspects of tropical conditions into three categories: those associated with the general economic conditions, those associated with climate (particularly heat and humidity), and those associated with the 'quality' of the light as compared with that of higher latitudes.

Economic Conditions

For reasons that need not be discussed here, most tropical countries are, to use current jargon, 'under-developed, or developing, nations of the Third World'. Partly because until very recently most of them were (and, in a few cases, still are) under colonial domination, they have not passed through the agricultural and industrial revolutions that changed the pattern of life in the now technologically-advanced nations over the last two hundred years. Populations may be dense (much of Asia and Latin America), or sparse (much of Africa), but all are increasing rapidly and are, characteristically, mainly rural, being largely composed of peasant farmers and their dependants who, if the seasons are kind, eke out a meagre existence from subsistence agriculture. Since few of the crops are available for sale, *per-capita* income is low and many items in everyday use in western Europe and North America are unknown luxuries for most of the people. These underlying economic considerations have a number of consequences relevant to this chapter.

Towns are relatively small, few in number, and separated by great distances. Such industries as there are produce unsophisticated goods sold to the rural population by general stores; these stock a wide range of such essentials as salt, sugar, clothing, etc., but few 'luxury' goods— including photographic items for which there is no demand by the local population. Most manufactured goods have to be imported, but, to conserve foreign exchange, there are often severe restrictions on the importation of goods regarded as 'essential' by nationals of developed countries working in the tropical nation concerned, but as 'luxuries' by most of the

local people. Unless there is a thriving tourist industry, photographic imports are among those particularly liable to import restrictions.

Road and rail communications may be non-existent or, at best, poor. Roads are seldom macadamized and many become impassable during the rains. Maintenance, especially on 'secondary' roads, is sporadic and often consists of 'grading'—a process that tends to convert a previously reasonable surface into a soft sandy one liberally sprinkled with large jagged stones capable of ripping open one's sump. Potholes, corrugations, and dense clouds of suffocating dust add to the discomforts and hazards of dry season driving. Even on main roads filling stations can be 200 km apart.

Equipment and Materials

These are considered in connection with the needs of a Nature photographer, visiting or resident in a tropical country, who already has cameras, lenses, tripods, and so on, and will take these with him to the Tropics.

The visitor's main requirement will be film and, possibly, such small spare parts as lens and body caps, filters, cable releases and retaining screws which are, in fact, just the sort of items likely to be difficult to replace. The resident will also be concerned with the supply of processing materials for his films and his needs for enlarging. Except in countries catering for tourists the availability of photographic equipment is limited; even in these the range of items stocked may be very restricted. Moreover it is liable to be altered at short notice, either through a change in government policy or at the whim of importers who may suddenly decide that the profit from certain slow-moving goods does not justify the bother of importing them. It is wise to assume that where a good range of photographic products is imported these will only be available in either the capital or in centres for the tourist industry: these do not necessarily coincide.

The following notes on the present availability of photographic requirements in an African city supporting a thriving tourist industry (mainly based on game-viewing) should indicate to the reader the sort of shortages to be expected in places which do *not* cater for the needs of tourists.

Apart from obscure makes, there is no difficulty in buying black-and-white and/or colour film in both 35 mm and 120 sizes; other sizes are unlikely to be found. Although including some well-tested 'brews', the choice of developers is limited, so that anyone who has standardized on a particular developer/emulsion combination may well have to modify his technique in accordance with what is locally available. Paper is usually in good supply but there are sporadic shortages of the more popular grades, surfaces and sizes. Developing tanks, measuring flasks, thermometers and negative files are difficult to obtain and are completely off the market in some African countries.

The writer's advice is that, before leaving for a particular tropical country, one should find out who are the importers and distributors of the films, developers, papers, etc. that one uses, and ascertain from them just what lines they regularly import. With this information one can estimate what needs to be taken in to last out one's stay. It is also advisable to discover whether there are Customs' regulations restricting the personal importation of photographic goods.

Transportation

Possible transport for the photographic naturalist in the Tropics may run the whole gamut, from walking with a string of pack-animals and/or human porters, carrying his equipment slung from their backs or balanced on their heads, to chartered light aircraft that take him to specially constructed landing strips deep in 'the bush'. Each type of transport presents special hazards for photographic equipment, but the risks are greatest when travelling by water in flimsy canoes, and when pack-animals or porters are negotiating slippery mountain slopes or dangerous fords. To generalize, apart from theft (only common in towns), the chief risks are mechanical shock, entry of dust, immersion in mud and water, and the effects of heat and humidity on lenses and films, both exposed and unexposed. In other words, the problems are essentially ones of packing.

Most of one's travels will probably be by very rough roads. The jolting makes it necessary for all gear to be so firmly wedged and strapped in

position that it stays where placed, in the face of bumps that put the occupants' heads in painful contact with the roof.

The camera(s), lenses and other accessories should each be individually packed with a bag of silica gel in at least two stout, tightly sealed polythene bags (to keep out dust, and guard against accidental immersion in water or mud). The individual packages should then be carried in one of the hard plastic or metal carrying-cases, filled with foam plastic, from which compartments are cut to tightly fit one's particular equipment. Careful packing in this way, and careful placing of the case in car or boat, or on a pack-animal, will give excellent protection in all but the most disastrous circumstances. The price one has to pay is the inaccessibility of the camera for recording interesting scenes on the journey. If the camera has to be kept constantly ready for use, the risk of damage is correspondingly greater, but, on the other hand, this is largely offset by the camera being in the direct care of its owner.

Heat and Humidity

Heat has directly adverse effects on film while humidity combined with heat favours the growth of fungi on films (and lenses). Colour film is particularly sensitive to overheating, which may cause unpleasant colour casts. Even in England, this can occur when, for example, a camera is left on a car seat exposed to the sun. Since shade temperatures can reach 50°C (well above the optimum for the well-being of film) in some parts of the Tropics as, for example, in Sind (Pakistan), the Arabian Gulf, and Mexico, keeping film in good condition on a tropical safari can be a major problem.

Film carried on safari is best kept inside a well-insulated container such as a picnic 'cool-box' with packets of silica gel for absorbing moisture. A cool-box, filled with hard-frozen tins of fruit-juice, butter and cheese, will keep cold for several days, but it is probably better not to chill films to this extent as they then have to be allowed to 'thaw out' for some hours before being loaded into a camera. In any case, on a long safari, things cannot be chilled but only prevented from becoming too warm. The cool-box should, of course, always be kept out of the sun if this is at all possible.

Unexposed black-and-white film is sealed in air-tight waxed paper or tin foil, but nowadays is seldom supplied with a metal or plastic container. Colour films whose price includes processing are supplied with cans, but ones that can be user-processed are often not. Before setting out for the Tropics, the photographer should stock up with enough film containers for all the material he hopes to expose on any one safari. It is easy to obtain containers for 35 mm film, but not for 120 film. Some manufacturers, for example, Agfa-Gevaert (England) will supply them on request.

Processing

The visitor to a tropical region will probably decide to leave his black-and-white processing until his return home, but the resident will be doing his processing either in the field or at his home. The latter is likely to have a piped water-supply and a refrigerator.

The only real argument in favour of field processing is that one can find out whether anything terrible has happened to the functioning of one's equipment. Unless one's camp is by a river, stream, or lake, water may be too precious to use for anything other than drinking and a minimal amount of washing, while at any camp site clean water is almost certain to be difficult to obtain. Even though one may modify one's processing technique so as to do without temperature regulation (see below), preventing dust and insects from landing on the drying film is far more difficult than in a house. Furthermore, carrying developer, fixer, tank, thermometer, and measuring flask means more 'clutter', much of it relatively fragile, to be fitted into packing space already filled to capacity by all the impedimenta that have to be taken on safari.

The only significant difference between processing in the Tropics and

Plate 61. Tropical bird-photography. (Upper) Secretary birds in pre-copulatory display. Stalked from a car. Mamiyaflex, 180 mm Sekors; 1/500 at f11 on Tri-X roll-film developed in Microdol 1:3.

(Lower) Steppe eagle, juvenile at water-hole. This shows the problem posed by overhead lighting at mid-day. Pentax SV, 300 mm Takumar; 1/250 at f8 on FP4 film developed in Perceptol 1:3.

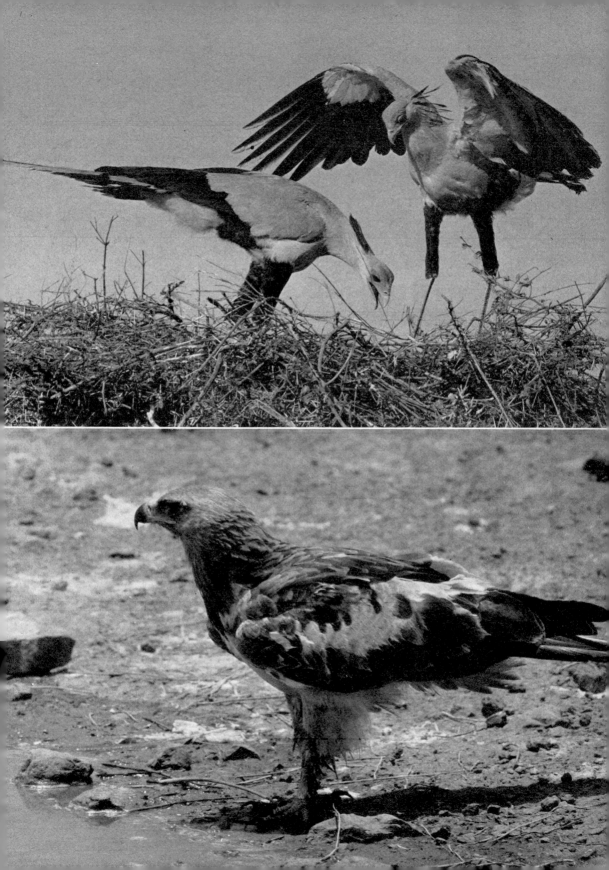

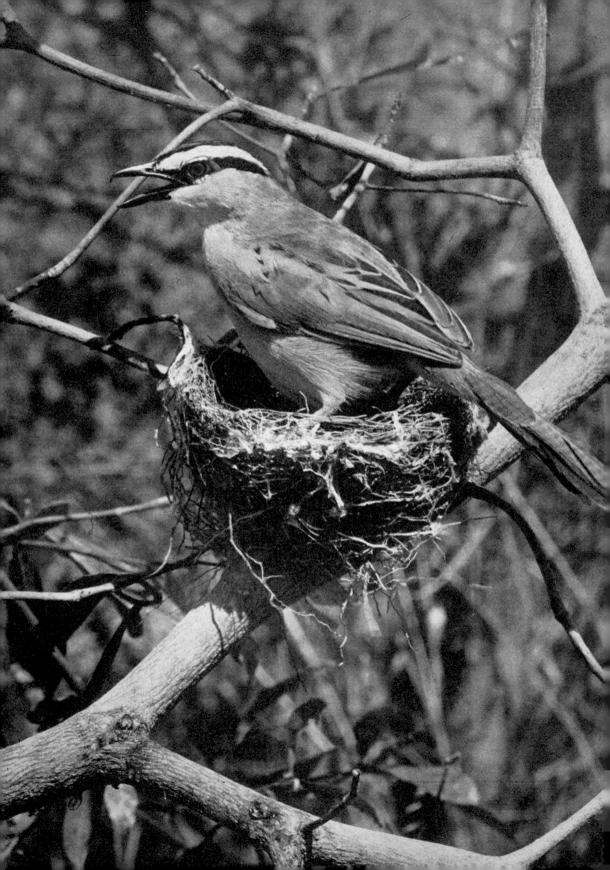

in the temperate zone is that, except at high altitudes, ambient temperatures are such that tap water is seldom at less than 20°C, often between 25°C and 28°C, and sometimes over 30°C. The actual temperature will depend on the altitude and on whether the pipes or storage tank are exposed to the sun; water from artesian wells often has a temperature considerably below the ambient air temperature.

Provided ice is available, there is no difficulty in developing and fixing at 20°C, but, if there is too big a difference between the processing and washing temperatures, films may reticulate and/or 'frill'. In practice, these calamities do not occur when an efficient hardening fixer is used before washing in temperatures not above 26°C.

When the tap water temperature is higher than this, it becomes advisable to develop and fix at, or near, the tap water temperature, while the use of a stopbath becomes essential. When standard-strength developers are used at high temperatures, the developing times are often inconveniently short, but can be increased by 'sulphating' the developer (which also protects the film from frilling). For a developer normally made up to 600 ml, dissolve the developer in the usual way, make up to 50 ml, and add (with constant stirring) 60 g of anhydrous sodium sulphate or 135 g of the hydrated salt ('Glauber's Salts'); when completely dissolved, add water to make up 600 ml of standard sulphated developer. At 27°C this has a development time equal to that of non-sulphated developer at 20°C. Times at other temperatures can be calculated from data supplied from photographic reference books or by the developer manufacturer. Nowadays, the one-shot dilution technique of development is increasingly favoured by photographers, especially those working with 35 mm film. Using this method at high temperatures reduces what are otherwise rather lengthy development times, and no sulphate needs to be added for increasing the time of development, though it may be necessary for preventing frilling.

Even where the water supply is stated by the Public Health Authorities to be safe for drinking without being boiled, it is seldom free from

Plate 62. Black-headed bush-shrike at nest. A typical tropical passerine, panting while shading small young in a cup-shaped nest unsheltered by the foliage. (No 'gardening' was done here.) Parke field camera, 25 cm Aldis lens; *c.* 1/30 (Luc shutter) at f22 on HP3 plate, developed in Unitol.

particulate suspended matter. Filtering is therefore necessary for producing reasonably clean negatives. Various filters for fitting to taps have been patented, and in larger tropical cities there is often a wider choice than in towns of the temperate zone where it tends to be assumed, probably wrongly, that the water supply is not only 'safe' but clean.

Drying presents no difficulties peculiar to the Tropics, though in some stations, particularly during the dry season, the air may be excessively dusty.

Storage

In the dry Tropics, storage of negatives and transparencies presents no problems, but in the humid Tropics there is constant risk of one's precious negatives and transparencies being ruined by mould. When electricity is available on a 24 hr basis (many 'bush' stations have generators providing electricity only between sunset and about 2300 hr), it is possible to keep the store-place dry by keeping a 60W bulb constantly burning. Where this cannot be done, there is no simple answer except the use of silica gel, regularly desiccated, and constant vigilance. Experimentation on the effects of a rinse of dilute formalin before drying is worth doing. Recently anti-fungus kits, based upon 'Panacide', have become commercially available in Europe, but are not widely stocked in the Tropics. Incidentally, lenses are as much at risk as processed film, and it is wise to make sure that one's 'All Risks' insurance policy does not exclude damage caused by mould, as this can be very expensive to put right.

Lighting in The Tropics

A photographer contemplating a foggy November landscape in England tends to think of the Tropics as having continuous conditions of perfect lighting, whereas this is, in fact, far from being the case. Although many high-altitude habitats are almost perpetually clothed in mist or cloud, with only occasional glimpses of the sun, it is more characteristic for tropical regions to be extremely sunny and hot. Twilight is very short, with sunrise at approximately 0645 hr and sunset 12 hr later. At midday

the sun is, of course, almost directly overhead: subjects photographed at this time show poor modelling, with brightly lit upperparts and under-parts in dense shadow. Nature photography under these conditions should be avoided if the same subject or activity can be photographed during the periods of optimum lighting, roughly from 0730 hr until 0930 hr and 1600 hr until 1800 hr. Thus, contrary to popular belief, there are only four, or at most five, hours of the tropical day during which really pleasing results can be obtained.

Except for species with specialized hot-weather brooding behaviour (see below) there is no real reason for photographing (as contrasted with studying) nesting birds during the unfavourable middle part of the day. Fill-in flash can partly solve the lighting problem, but there are many nature photographers who feel that the resulting picture always looks 'unnatural'. The wait-and-see or opportunist photographer has less choice and must take his photographs when his subjects come to him. Many species visit waterholes during the hottest part of the day, and vultures are more likely to be found at a carcass then as their searching cannot start until it is hot enough for the development of thermals, on which they depend for soaring. In practice, most nature photographers will take pictures of interesting subjects under sub-optimal conditions, but live in hopes of repeating their exposures under better conditions.

Bird photographers, especially nest photographers, working in the Tropics may find their opportunities far less than they had hoped or expected. Some of their special problems and difficulties will now be briefly discussed in what is, essentially, a supplement to Chapter 5.

Tropical Birds at The Nest

Planning an expedition to photograph a particular tropical bird at its nest is much more difficult than similar planning for a trip in higher latitudes. Published data is often in little-known journals, and may be non-existent for the area or species in which one is interested. Local ornithologists are few and often surprisingly ignorant of breeding dates or localities.

The most striking difference between the breeding of temperate and tropical birds is that, in many parts of the Tropics, some birds may be found breeding in every month of the year, although it is probable that

most individual species have definite seasons that are correlated, directly or indirectly, with rainfall, often the most important environmental variable in the Tropics. Some species are dry-season nesters (e.g., coursers, many plovers) while others are wet-season nesters (most passerines); accurate correlations are difficult to establish, as there is so much variation in the actual pattern of rainfall in different parts of the Tropics, and over different parts of the range of a widespread species.

Generally speaking, the Tropics support a much higher diversity of species per unit area than do higher latitudes but, associated with this greater niche specialization, the actual numbers of many species are low and a high proportion can only be described as rare. Nest-finding is usually difficult, with 'cold searching' often being more effective than watching the birds. A discouragingly high proportion of sites are, to say the least, photographically awkward; many hours, or more often days, of hard field work may be necessary to find a single photogenic nest of even a reasonably common bird. Predation by snakes, mongooses, ants, and other natural enemies is high, so that one's preliminary field work is often nullified in a few moments.

On the whole, tropical birds accept hides more readily than their temperate counterparts, but, even after fourteen years' experience in East Africa, I still find it difficult to decide the best hide position for taking full advantage of either optimal lighting period. I vividly remember the chagrin experienced when, a week after arriving in Tanzania, I went to photograph my first African bird, only to discover that I had completely miscalculated the direction of the light at the time I would be working. While the magnitude of that error was a result of forgetting that I had moved south of the equator, it remains easy to site a hide so that its shadow appears in the picture area during the time of optimal lighting. The best way of avoiding this is to make the final move at the time when one expects to eventually occupy the hide, so that one can see precisely where the shadow falls at that time.

As in other parts of the world, nest photography is best attempted in places free from human disturbance. In the Tropics, human populations are often sparse, but it is rare to be working in completely uninhabited country. In the African 'bush', children materialize from nowhere and, by settling down on the ground about 20 m from the hide (by which they are completely mystified), effectively bring photography to a halt. Even

if one can speak their language, explanation of what one is doing is of little help as they will return when you have departed to eat the nestlings on the spot (a propensity also shown by Eskimo children in Greenland). Poor peasants could undoubtedly find a use for all parts of a hide: it says much for the honesty of the rural African that I have never had a hide stolen nor such 'luxuries' as camp beds, saucepans, etc. from my untended camp. Once I came back to find a hide wildly flapping because all the large safety-pins had been removed, but even this could hardly be regarded as theft as several hens' eggs had been put inside the hide: several months later and some 40 km away I saw what were probably my safety-pins adorning the ears of a tribal elder.

The photographer who, having overcome all the above difficulties, finally settles himself in his hide, anticipating a visit every three or four minutes, soon has his expectations of having plenty of exposure possibilities during his two hours of good lighting rudely shattered when he discovers that visits are more often twenty or thirty minutes apart. Whether the longer intervals between feeds are because the typical tropical brood of two requires less food than the temperate brood of five, or whether the lower brood number has evolved because the parents cannot find food for more young, or whether the female is unable to find enough food to produce more eggs, remain unresolved problems about which ornithologists tend to speculate with insufficient data.

The effects of heat pose problems both for oneself and one's subjects. Many tropical plovers, pratincoles, coursers, thicknees and terns only brood their eggs in the night and during the hottest time of the day (when, in fact, the eggs are shaded rather than brooded). This behaviour makes it very difficult to assess their reaction to a hide unless it is introduced at this time of day, when the bird is reluctant to leave the eggs exposed for more than a few minutes. For such subjects, special precautions must be observed: the eggs must be shaded from the sun while the hide is being erected and this must be taken away if not accepted immediately, as otherwise the embryos will be killed by the sun's heat. In practice, this means that, if the bird has not returned by the time one has moved out of its flight distance, the hide has not been, and probably will not be, accepted at that distance—in other words the hide must be taken down if not accepted within five minutes.

When the hide has finally been accepted at working distance, the

photographer must reconcile himself to photographing, under very uncomfortable conditions, a subject that is unpleasantly lit, and is panting in an apparently distressed condition (though, in fact, these 'distress reactions' are adaptations for thermo-regulation while exposed to extreme heat and occur at times even in temperate climates). If some unexpected clouds should roll up, producing the 'cloudy bright' conditions so beloved by nest-photographers, the photographer need not expect a 'scoop' of pictures taken in ideal light, since, in all probability, the bird will leave the eggs to start feeding, not returning until after nightfall if the clouds persist. Unless the photographer has thoughtlessly exposed a naturally *concealed* nest to the force of the sun, he need have no qualms in portraying passerine birds at the nest with panting beaks and drooping wings, since this is normal behaviour in species that build open cup nests in sites offering no protection from the sun.

There is little the photographer working under such conditions can do to improve his own comfort. Apart from wearing little or no clothing, he will need a cloth for wiping his hands (to minimize the amount of sweat transferred to the camera), a large thermos of water, and sometimes a can of insecticide spray. Since the hide offers some shade he must expect to find snakes, lizards, toads, scorpions and other animals taking up residence. I have several times had snakes entering hides while in occupation, though none were recognized as being poisonous. Hide work in the Tropics can be very enervating, so that, after a long session, one may lack the drive to do the field work necessary for finding fresh subjects.

The tropical worker has, however, one tremendous incentive, and that is that many tropical birds have never been observed at the nest, let alone photographed; of those that have been photographed only a very few have been portrayed at the standard customary in the British Natural History Photographic Societies.

Bibliography

Camera in the Tropics, Dodwell, G. C. (Focal Press) London, 1960.
The Tropics, E. Aubert De la Rue, E. A., Bourliere, F. and Harroy, J. P. (Harrap) London, 1957.

17

Some Technical Points

Derek Turner Ettlinger

Purpose and Scope of this Chapter

Some wag once commented that the formula $\frac{1}{v} + \frac{1}{u} = \frac{1}{f}$ summed up almost the whole of photography—what was left was up to the man behind the camera. An over-simplification perhaps, but I do not think it necessary to go far beyond plain English and common-sense in this chapter, despite its 'Technical' title.

I am concerned here with selected points of general value in Natural History photography: some have been touched on by the other authors, some have not. I have left out descriptions of elementary matters covered by the basic familiarities (optics, the photographic process, and features of modern cameras) which the Introduction assumed readers to have. The use of normal flash units at close range is so well covered by Michael Proctor in Chapter 12 that no more needs to be said—except perhaps to recommend the use of a flash meter (of which relatively cheap models are now beginning to appear on the market); this takes much uncertainty out of flash calculations, especially when one is using multiple-unit set-ups.

This chapter, then, is a rather arbitrarily chosen *tour d'horizon* of the technical scene: it is not intended to be comprehensive. It is a personal set of views too; even my co-authors may not agree with everything written here.

Choice of Camera

From the other chapters it is abundantly clear that, in photography as in pugilism, 'a good big 'un will always beat a good littl'un'. The highest quality, other things being equal, will always come from the material which needs least enlargement in printing or projection. Of course, other things are not always equal: versatility, ease of use, portability, and all the other considerations of one's choice of subject may dictate a smaller format. Furthermore, the highest quality may not always be necessary: the person whose only aim is to produce colour transparencies for non-professional use, or black-and-white prints of 25×20 cm (10×8 in.) maximum, is a fool if he thinks 35 mm cannot do the job well, whatever his subject.

Financial resources have an always large and often crucial bearing, too. Many subsequent remarks in this chapter are aimed towards the cheapest solutions of problems.

Large-format Cameras

Large-format cameras (6×7 cm material or larger) are only necessary in Natural History photography for three reasons. The first is for subjects whose exact position at the moment of exposure is uncertain (e.g. a bird at the nest may alight on one edge or the other, or on a twig nearby; extra negative space reduces the number of exasperating occasions when its tail is 'cut off').

The second is the possession of 'movements'. This applies only to the 'field', 'view', 'stand' or 'technical' type of camera, of course, and they are discussed in general by Stroebel, see Bibliography; 'swing-back' is covered in a later section in this chapter, and few other movements are of much use in Natural History—though Michael Proctor makes a reference to 'rising-front' in Chapter 12.

The third is simply that (provided they do not come into the recent category of 'collectors' item') they are often cheap; not the Linhofs, Pentax 67s and Mamiya RB67s, of course, but elderly Thornton Pick-

ards, Sandersons, Watsons, etc. Field cameras have changed little since the 1880s, except for greater use of metal and higher precision (and sometimes a monorail focusing bed), and a 50-year-old example may be perfectly serviceable today when adapted to take 6 × 9 cm roll-film (cf. Arthur Gilpin's remarks in Chapter 5). Of course, if such an instrument has not been used for some years, a full overhaul is necessary; rack-work may need packing with shims to remove play; bellows may well need replacing, and loose or stripped fixing screws will need repair. The design being simple and the construction easy to follow, any reasonably competent handyman can do this work: real precision is not required and squaring-up can be safely done by eye, since view-finding and focusing are invariably done on a focusing-screen. Incidentally, modern epoxy-resin adhesives can make even a crude joint as strong as proper machine or cabinet work.

Elderly large-format reflexes are still to be found—and it is worth remembering that some of the best Penguin photographs taken to this day were by H. G. Ponting in 1910–11 using a half-plate (21 × 17 cm) reflex. Their focal-plane shutters are wildly inaccurate (though they can be consistent—a more important point, since a table of correct speeds can be provided by any camera repairer). They lack movements, except rising-front on some, but they are robust and often very light for their size. They are easily adaptable to having an extra front shutter for use with long-focus lenses. Most middle-aged Nature photographers served an apprenticeship with one or more of these cameras, and remember them with affection. A beginner could do worse than seek one out today and adapt it for 6 × 9 cm roll-film.

Swing-back

At one time, this would have been well within the basic knowledge assumed in readers. But few modern amateur photographers are familiar with it; even though it is described in Stroebel's book already quoted, an explanation is necessary here.

As the man said, $\frac{1}{u} + \frac{1}{v} = \frac{1}{f}$. If v (distance of the focused object from the lens) is to be decreased, then u (distance of the lens from the film)

must necessarily be increased. This, of course, is the basis of focusing; by varying u, we arrange that v coincides with the target.

Consider what happens if we tilt the film-plane relative to the lens-board. If we tilt it backwards, u at the *top* of the film will be increased and v at the *bottom* of the subject area will consequently be decreased. The plane of focus will be tilted in the opposite sense to the tilt of the film plane (see Fig. 1).

Considering the camera with lens-board and film-plane parallel, the plane of focus may not coincide with the required plane of the subject, and the depth-of-field may well be insufficient to cover it all.

By tilting the back, the focus can be adjusted so that the depth-of-field, while not itself increased, is now deployed in a plane which will cover the whole of the target.

6×6 cm Cameras

Cameras designed for 12 exposures on 120 (or 24 exposures on 220) roll-film are probably the most popular instruments now among Nature photographers aiming at the highest quality. Results can be virtually indistinguishable, with modern film and lenses, from those taken with larger format cameras even at high degrees of magnification.

The single-lens reflex (SLR) is the commonest type and many examples have the same features as 35 mm SLRs—interchangeable lens, instant-return mirror, auto-iris mechanism, and pentaprism viewing (at least as an alternative to waist-level). Few as yet have through-the-lens (TTL) metering to the same degree of sophistication as in 35 mm, but this will undoubtedly come. Some take film in interchangeable magazines, enabling two or more film types to be used with one camera body.

A major problem for the 6 × 6 cm SLR is that the mirror necessarily has more inertia than that of a 35 mm SLR, and the energy absorbed on mirror-raising is very prone to lead to shake. With many models one can only be sure of sharp results at the low speeds required for much Nature photography if the mirror is locked up in advance, and not all designs have this capability, apart from the loss in operating versatility which it incurs. Focal-plane shutters (FPS) are fitted in most designs and these can also cause shake at low shutter speeds because of the energy absorbed

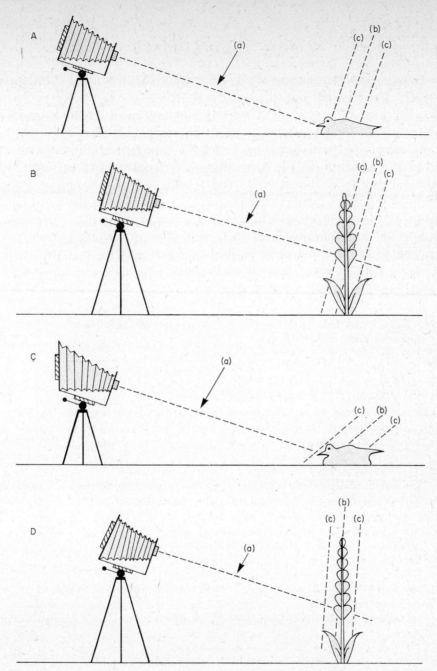

Figure 1. The use of swing back. (a) Lens axis. (b) Plane of focus. (c) Limits of depth-of-field.

A. Camera, with film plane and lens-board parallel, looking down at a horizontal target.

B. Camera, with film plane and lens-board parallel, looking down at a vertical target.

C. Camera, with optimum swing, looking down at a horizontal target.

D. Camera, with optimum swing, looking down at a vertical target.

by the body from the leading blind; they are also noisy to an extent which many shy animals will not tolerate nearby.

However, an FPS-type SLR (of any format) can be transformed into a pseudo-field camera (without the movements, of course) by fitting a good-quality long-focus lens, backed by a separate sector-type shutter, on a bellows attachment. Such arrangement usually requires some rather elementary home modification to the female bellows flange and to the shutter flanges. The camera in this mode is focused with the front shutter open; this is then closed and set for exposure; the camera-body shutter is set to 'B' and locked open, and the equipment is then ready. Operation is blind, of course, as with a field camera, but for static or predictable subjects this is a very satisfactory way of ensuring shake-free and quiet results at low shutter speeds.

Plate 63. Home-made field camera outfit. Arrowed items are as follows:
 (a) Focusing rack, ex Leitz Bellows, c. 1950.
 (b) Intermediate bellows between rack and back.
 (c) Wing-nut controlling the swing-back friction-pads (which are on lugs araldited to the rack and the revolving back).
 (d) Revolving back, ex Thornton Pickard Reflex, c. 1930.
 (e) Roll-film holder, Rada, 1946, taking 120 film; maximum negative size 6 × 9 cm.
 (f) Luc-type shutter, Thomas Day, 1955. Pentax-type flanges have been araldited on.
 (g) 210 mm f6·3 Dallmeyer Perfac lens; a Tessar type, designed in the 1930s and still in production. A home-made pre-set iris device can be seen at the bottom. The lens-flange has been modified to Pentax-type screw.
 (h) Lenshood, screwing into a 49 mm filter-holder araldited to the front of the lens. The flange in front is to prevent hide material sliding across it.
 (i) Pneumatic bulb, operating the shutter.
 (j) Scale for post-focusing adjustment (see p. 374).
 (k) Screw adapter from Leitz bellows to Pentax-type fitting.
 (l) Extended version of the same, for longer lenses.
 (m) Prontor shutter, 1970, fittable as an alternative to the Luc.
 (n) 300 mm f5·6 Novoflex lens-head, c. 1960. Flange adapted to Pentax screw.
 (o) Focusing screen.
 (p) 500 mm f7 Komura lens-head, 1965. A telephoto type. Flange adapted to Pentax screw.
 (q) 180 mm f5·6 Wray H. R. Lustrar lens-head, 1965; this is an Aviar-type lens retaining good definition down to 1:1 reproduction, useful for small animals and plants. Flange adapted to Pentax screw.
 (r) Various masks, giving different formats with the roll-film holder.
 (s) Magnifier × 10 (Cooke and Perkins 1955).

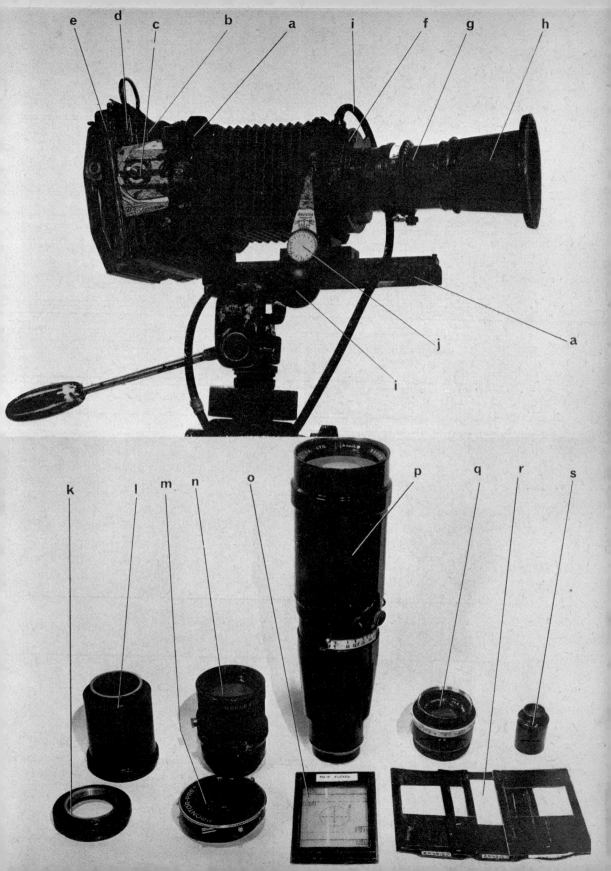

Most 6×6 cm twin-lens reflexes (TLR) have fixed lenses of short focus and a very limited focusing range, unsuitable for most Natural History work (though see Chapter 14 for their usefulness in caves). However, one design (Mamiyaflex) has an interchangeable lens facility up to 250 mm FL and a long focusing movement: this has become a deservedly popular instrument. The TLR naturally has no mirror-bounce problem, and the sector-type shutters are quiet and cause little shake. Its unique problem is parallax, *viz*. the fact that the scene shown by the viewing lens is not quite the same as that seen by the taking-lens: at moderate ranges, e.g. birds at the nest, this can be ignored, or corrected by slightly tilting the camera upwards after focusing. But for close work, e.g. small plants and insects, it must be compensated for; correcting prisms, as used on fixed-lens TLRs, are inadequate and the only satisfactory correction is to raise the whole camera after focusing by the distance between viewing and taking lenses. Mamiya make a special device for this, but it is clumsy; it is easier to pre-scribe the appropriate distance on the tripod centre-column and just use that (of course the centre-column must be normal to the lens axis, or focusing error will be introduced).

35 mm Cameras

There are many good 35 mm rangefinder cameras available, but their close-focusing capability is insufficient for most Nature work; not all have

Plate 64. Register and focus-shift tests (see p. 372). The lenses used for this illustration were for Mamiyaflex 6×6 cm TLR. Ranges were $12\times$ focal length.
(Top right). 80 mm Sekor, at f2·8. Optimum focus is well forward of the aiming point (the pin) indicating a register error.
(Top left). The same at f5·6. Focus is now 'on', indicating firstly that there is focus-shift on stopping-down, and secondly that the register error in (top left) was deliberate in order to get correct focus at f5·6.
(Lower left). 180 mm Super-Sekor, at f4·5. Focus is 'on'. Note the squarer shape of the test board than in (top left and right), showing the different perspectives.
(Lower right). The same at f11. Focus is still 'on', showing that this lens has no shift on stopping-down.
 Note: that the depths-of-field in this series are in the order 80 mm f2·8, 180 mm f4·5, 80 mm f5·6, 180 mm f11—supporting the assertion on pp. 376–7 that at a constant reproduction ratio depth-of-field depends on aperture only, not on focal length.

interchangeable lenses, and those that do are limited effectively to 135 mm FL for rangefinder coupling. Some can take special reflex-housings and in this mode can be considered as SLRs, though of relatively simple design.

For most Natural History work, only the SLR need be seriously considered and it has an annually-increasing sophistication of design. In portability and ease and speed of use it is unsurpassed in all-round suitability. For subjects which require short reaction-times there is often little choice of camera—a 35 mm SLR it must be, despite the higher quality theoretically available from larger cameras.

Nevertheless, one does sometimes wonder whether all the 'advances' over the Kine-Exakta and Praktiflex of the 1930s are really worth the extra expense and the opportunities for unreliability which they incur. Pentaprism viewing is usually a gain, though a waist-level finder is still sometimes better—particularly if it incorporates a high-power magnifier; few designs offer both. Spring-operated instant-return mirrors have value (note particularly the Urrys' comments in Chapter 8), but there are occasions—e.g. low-speed work on relatively static subjects—where the obsolete but shake-free manual raise would still be better. Fully automatic diaphragm (FAD), or auto-iris, operation is a great help in working speed but can contribute to shake. TTL metering may occasionally save seconds that would be vital, but an intelligently used separate meter of good quality is in most cases more consistently accurate.

My advice is to obtain a camera with only those features actually needed. If one is only using long-focus lenses with manual pre-set diaphragms—or mirror types with no diaphragm—a simple camera without auto-iris facility (e.g. the Russian 'Zenith') may well be adequate and will certainly be cheap. If one habitually does close-range work with flash, there is no gain whatever in buying a camera with TTL metering. If TTL metering is useful in principle, but one does not need to save the last second in operating time, it is a sheer (and considerable) waste of money to buy the latest designs which actually set the iris or shutter-speed on the camera.

There is one further point about 35 mm cameras—which should perhaps have been mentioned before, since it has set a number of Natural History photographers against them. This is the high incidence of minor mechanical damage to the film—stress-marks, tramlines,

scratches and dust—all so much more noticeable with the small format. They can occur even when the greatest care is taken over film-drying, film-handling, re-winding technique, cleaning camera bodies and smoothing-down possible excrescences: there are few things more infuriating than to have unrepeatable shots ruined inexplicably.

Shutters

Unless one is using an electronically-controlled FPS or a FPS (however controlled) of Copal-Square or VEB Pentacon steel venetian-blind design, it is a fair generalization that few top speeds will be more than two-thirds accurate if the camera is more than a month or two old. Photographers who genuinely need 1/1000 sec, please note!

The double 'click' of Compur, Prontor and Seikosha-type shutters has been mentioned by Arthur Gilpin (Chapter 5). This is the reason for the popularity of the usually-pneumatic 'Luc'-type sector shutter ('Luc' was the trade name of a pre-1939 German version). They were in production till quite recently by Thos. Day of Twickenham, and simpler cable-operated versions were made by Agilux of Croydon in the 1950s. Speeds are governed by the energy with which the release is pressed, and are of indeterminate accuracy. But it is surprising how often even colour can be correctly exposed, with experience.

One further point connected with shutters. Camera-shake is one of the most persistent bugbears in Nature photography because so many exposures have to be hand-held. An excellent rule of thumb—it is probably not original, but I have no idea to whom to make the proper acknowledgement—is that a good proportion of shake-free exposures can only be assured at a shutter speed of $1/n$ sec, where $n =$ FL (in mm) of the lens in use. Using a 'gun-pod' this can perhaps be twice as long and with a firm tripod four times.

Lenses

One of the commonest misconceptions of beginners in photography is that the lens with widest maximum aperture is the best. In fact, an f1·8

standard FL lens of good design and manufacturing quality may well be slightly better at f4 than a similar lens of f4 maximum, but at f5·6 there will be little difference and at f11–22 (the apertures most often used in Nature photography) the f4 lens may well be superior. Similarly, an f8 lens of long focus is at least equally likely to give good results in practice as an f4·5 lens of the same quality. Focusing is easier, of course, with the wider lens but this is a minor consideration when compared with the cost difference.

Most of what follows on lenses is concerned with 35 mm SLR cameras. Innovations and refinements occur first in this class and 6 × 6 cm SLR lenses follow fairly soon, though they will be bulkier and considerably more expensive. Large-format lenses will be later still, if indeed they ever follow the trend.

Close-focusing

As a generalization, lenses of symmetrical design (Speed-Panchro, Gauss or Aviar types) are better close-up than asymmetrics (Tessars or telephotos) but there is a great deal of individual-design variation.

I would join Michael Proctor in pointing out the advantages of the so-called macro-lenses, of which several 35 mm-camera and independent manufacturers list examples. They perform well down to reproduction ratios of $c.1:2$ (1:1 occasionally, but these usually lack auto-iris facility) and remove the tedious and chance-missing business of fitting extension tubes or supplementary lenses. They also perform well at normal photographic ranges. Provided one can accept a relatively modest maximum aperture (and reasons for doing so have been given) it can mean that a 'standard' lens is unnecessary. Macros are more expensive than standards, but the extra versatility is well worth the difference. Furthermore, provided one can modify the enlarger flange, they perform very well as enlarging lenses and can save money on that account.

Without a macro-lens, focusing at close ranges must be by using extension tubes or bellows, or by adding supplementary lenses. Tubes are often assumed to be the only sensible choice; their fixed length means that calculations of extra exposure are relatively simple and (at least for lenses of appropriate design—see above) definition is fairly well main-

tained. Supplementary lenses are customarily of single-meniscus design and usually do affect definition adversely unless well stopped down. However, supplementaries of cemented-achromat construction are available or can easily be constructed from telescope or binocular objectives, fixed with epoxy resin into standard filter holders—and they can give good definition. They are quicker and easier to use than tubes, and they do not need exposure increases. Bellows have the disadvantages of tubes, plus the extra ones that even minimum extensions give too great a magnification for many purposes when using a standard lens, and only a few (e.g. Novoflex) retain the auto-iris; on the other hand, the range of magnification is greater and is continuous. One useful ploy is to use enlarging-type lenses of longer FL on the bellows: iris operation is manual, of course, but focusing is continuous with good definition from infinity down to $c.1:1$. (Enlarging lenses are usually computed for reproduction ratios of 1:10, sometimes 1:4, but in practice they work well down to 1:1.)

Whatever the system chosen, focusing by moving the lens when at nearly 1:1 is extremely difficult because of the 'conjugate foci' (see Cox, in the Bibliography). Either the lens/camera combination must be moved complete—manually or by way of a separate rack under the bellows, or the second of a 'double-track' bellows—or a variation of the old 'back-focusing' must be employed. With this, the lens is in a fixed position relative to the target and focusing is effected by moving the camera back relative to it; few manufacturers allow for this, the cheapest being BPM, of Portslade, England.

As stated in the Introduction, reproduction ratios of over 1:1 are generally outside the scope of this book. If one is going to try them occasionally, then the lens should be reversed on its mount, to give a closer relationship to the reproduction ratio for which it was designed (a quick sketch of the light paths in this regime will show why). 'Reversing-ring' adaptors are available for most 35 mm SLRs. Another technique is to use a (reversed) standard lens as, in effect, a supplementary to a long-focus lens on the camera: again, adaptors are available and this has the advantage that normal auto-iris is retained without needing a special double cable release.

Longer-focus Lenses

Few present medium-focus lenses (90–300 mm FL) will focus without auxiliary aids sufficiently close for, say, a stalked bird, lizard or dragonfly: this is largely responsible for the impracticability of much wild and free photography of small animals—as commented on by Sam Beaufoy in Chapter 10. They can be used with extension tubes or bellows but it is a clumsy arrangement and means a long delay if a target within the normal focusing range is found meanwhile. Lenses with a greatly increased integral close-focusing facility are beginning to come on to the market. An extremely compact 200 mm example (by Sigma, of Japan) focuses down to a reproduction ratio of 1:3, with auto-iris, of course; in this lens the focusing, which would require a virtually impossible purely mechanical movement, is helped at the closer ranges by a variation of the old 'front-cell' movement; computer design has kept close-range definition good. Another close-focusing range (the American-designed 'Vivitar Series I') uses a 'floating' rear element in conjunction with a simultaneous mechanical focusing movement. Such lenses are bound to become commoner, and will considerably improve Nature photographers' opportunities for 'snatch' shots of small animals in the wild.

Long-focus lenses (400 mm upwards) have equal need of integral close focusing for much stalked work, as the Bottomleys point out in Chapter 6. With one major exception this is only available in the 'follow-focus' types of mount by Novoflex and Leitz, and these do not have an auto-iris. The exception is the catadioptic or mirror-lens, which achieves close focusing by another variation of separating the elements rather than by moving the whole lens assembly bodily forwards.

Mirror-lens characteristics need mention. Because of the complex folding of the light path the lenses are extremely light and compact. The Russian MTO 500A, for example, has a FL of 550 mm but is only 175 mm long and weighs 1·1 kg; the Japanese Nikon and Yashica equivalents are slightly smaller still. The light-receiving part of these lenses is an annulus—the centre being occupied by the back of one of the mirrors. Out-of-focus highlights are therefore not rendered as the customary discs of light but as annuli themselves: similarly, out-of-focus lines are rendered as double lines rather than the usual bands. This gives an

easily recognized—and not always pleasant—effect to mirror-lens shots of detailed subjects. They are best suited to targets with plain and undetailed foregrounds and backgrounds. And, of course, their fixed aperture does bring depth-of-field and exposure-control problems.

Other long-focus lenses are either of simple cemented-achromat construction—e.g. the Leitz 400 and 560 mm Telyts and the Asahi 500 and 1000 mm Takumars—or they are true telephotos, i.e. they have multiple elements and a physical length less than the equivalent focal length. Generally speaking, the telephotos are handier but they rarely give definition as good as the straight long-focus lenses. Both, of course, give a normal rendering of out-of-focus images.

Quite good long-focus photographic lenses can be made up from achromatic telescope objectives, despite the different light wavelengths and field areas for which telescopes are designed. Home-made mounts are required, of course, and an iris diaphragm must be fitted—e.g. from a microscope sub-stage assembly: rack focusing movements are easily adapted. I have had very passable results from a 1200 mm (48 in.) lens of this sort, in conjunction with an elderly Agiflex 6 × 6 cm SLR. Maximum apertures are always small (f16 in the example quoted), but the cost is only about a twentieth of that of a commercial equivalent, so the enterprise can be worthwhile for those who could not otherwise afford a lens of this length.

Tele-converters

Tele-converters, also known as tele-adaptors or tele-extenders, are widely advertised as 'ideal for wildlife photography'. Fitted between lens and camera body (SLR only) they double, treble or vary between ×2 and ×3, the effective FL of the lens. In effect, they do this by simply magnifying the prime image; at the same time they introduce their own optical aberrations, the amount varying with design, and it is rare that some degradation is not obvious at the corners of the picture.

For definition, therefore, it is better to give extra enlargement to a prime image than to use a converter. There is, too, the operational difficulty that, when doubling the effective focal length, the aperture is reduced by two stops: focusing may be difficult and a compensating

increase in prime-lens taking aperture may further reduce the definition.

For colour transparencies, however, converters can be of value; they do save space and money, and incidentally they double the reproduction ratio available for close-ups without extension tubes or supplementary lenses. But it would be unwise to expect really first-class results from them.

Zoom Lenses

A zoom with a wide range of focal lengths, good definition, and a macro facility is the Nature photographer's dream. Alas, it is a dream of the future! At the time of writing there are some excellent lenses to this specification for small-gauge cine cameras, but none for even 35 mm still cameras. Invariably, definition at any FL is worse than that from a good prime lens; and the focusing range is very inadequate in most models.

A promising line of development is the simplified concept of the 'variable-focus' rather than true zoom lens: this has to be refocused with each change of FL, but the greater freedom given to the designer may enable him to devote more attention to definition.

Testing Lenses

Few people would be so silly as to use a newly-acquired camera or lens on a possibly unrepeatable subject without some preliminary testing. But testing by a few shots on normal subjects is inadequate; if one's 'normal' subjects are usually taken at, say, f22, a wide range of errors can be masked by the great depth-of-field and the reduced effect of aberrations and assembly errors at this aperture. When the lens is wanted for some unusual circumstance—which is more likely to be the unrepeatable one— it can let its owner down badly.

Incidentally, conditions of sale of new lenses often preclude any form of 'approval'—for quite understandable and valid reasons: there is something to be said, even apart from the lesser cost, for buying a second-hand lens which can be tested fully in advance.

The first test recommended is one which, curiously, gets little reference in the photographic press: this is for inaccurate register and, at the same

time, change of focus on stopping down. Both are far from uncommon defects even with modern equipment. The first is due to error in the focusing-screen seating or the mirror-angle. The second is due to inadequate correction for spherical aberration in the lens design, or introduced spherical aberration through incorrect element-separation in assembly.

Testing procedure is simple. The camera is erected on a tripod at a convenient distance from and at a very acute angle to the target: for comparison between lenses it is useful to have a standard range in terms of reproduction ratio—12 × FL is convenient. The target consists of a length of any detailed material (small print does well) marked at the focus point and at suitable intervals from it—say, 2·5 cm. A series of photographs is taken at all apertures, and the negatives examined through a × 10 (or stronger) magnifier (see Plate 64).

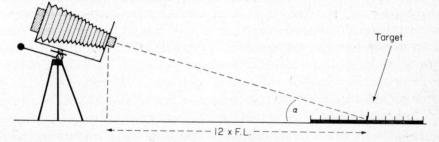

Figure 2. Set-up for testing register and focus-shift.

Note: The angle α should be as small as practicable. The distance '12 × FL' ought strictly to be along the lens axis, but at small values of α the error is negligible.

Register error will show up best at full aperture, because of the small depth-of-field: even if the depth-of-field covers the error at one's normally-used apertures, it is not being deployed about the target in the required way, and the error is still worth correcting. In field cameras, most 6 × 6 cm SLRs and a few 35 mm SLRs, correction (by putting or removing paper shims under the screen or the mirror) is within a deft owner's capability—otherwise it is a repairer's job: the thickness of the shims can be calculated accurately enough from our old friend $\frac{1}{v} + \frac{1}{u} = \frac{1}{f}$.

If focus shift is present, the photographs taken at smaller apertures will show best focus at slightly different ranges from open aperture. The shift may be within the depth-of-field at those apertures, but in extreme cases it may not and, generally, the lens should then be rejected. However, particularly on field cameras, it may be possible to devise a post-focusing allowance for the error by calibration of the focusing movement: alternatively, if one is using that lens only, a deliberate register error can be introduced to the focusing screen, cancelling the focus-shift at commonly used apertures (see Plate 64). I remember vividly a 600 mm (24 in.) Ross Homocentric of *c*. 1925 vintage which had the extreme error of 10 cm (4 in.) shift at $12 \times$ FL at f16 but gave very good definition when this was allowed for: in fact, it provided five of my eighteen Fellowship-set pictures!

The other test recommended is for definition. Generalized tests on distant twigs and suchlike are all very well, but tend to vary in assessment with the state of one's liver and the amount one has paid or is about to pay for the lens. It is better to quantify such things. Lines-per-millimetre (L/mm) testing charts are currently out of favour in technical circles, whose value-judgments are based on a computerized 'modulation transfer function'—taking micro-contrast into account as well as plain resolution. It is theoretically possible for a lens with good micro-contrast to give sharper pictures than another with higher actual resolution, but from a purely practical point of view this has not yet occurred in my experience. L/mm charts are made by a number of accessory-manufacturers, notably Paterson in the UK: they are a practical and effective way of testing lens performance, with two provisos. Firstly, film exposure and development must be standardized for valid comparison between tests on different occasions; secondly, given one's own standardizations, results are *not* comparable with anybody else's—and are certainly not absolute. There are retailers who advertise L/mm-tested lenses; they use very slow high-resolution film and develop to gamma infinity—with definition results far better than the ordinary mortal will achieve using a normal fine-grain film and standard development.

One of the incidental results of such tests is the recognition that the resolution of a good lens invariably starts to fall off by f16, often significantly at f22. This is because of diffraction, but—as several of our authors have pointed out—there are many practical occasions when the

extra depth-of-field outweighs the definition loss. Curiously, the loss seems less obvious in close-up photography, when it ought—because of the reduction in effective aperture—to be more obtrusive.

Focusing

In the camera types we are considering, focus is by way of a screen—whether the light travels directly to it (field cameras) or via a mirror in the camera body (reflexes). The simplest screen is plain ground-glass, and few large-format cameras will have anything else. Even here there is a choice between an etched or lightly-ground, bright, type and a heavily-ground relatively dark one—the latter being more exact when viewed under the $\times 6$ to $\times 10$ magnifier required for precise work.

Among 35 mm and, to a lesser extent, 6×6 cm reflexes, there is often a choice of focusing screen, and some makers arrange for easy inter-changeability: for other makes a camera repairer will be able to fit (as a permanency) a screen to the user's choice. Excluding the 'clear-screen-with-crosshair', which is only suitable for photomicrography, there are three types in common use.

The first is plain ground-glass, currently only fitted as a standard to the Russian 'Zenith' cameras. The split- or crossed-prism, or 'rangefinder' screen is now less common as a standard fitting than the microprism type; both these have two major disadvantages. The first is that they 'black out' at small apertures (f5·6–8 in the former case, depending on the angle of set of the prisms, and f4 in the latter), which means that modest-aperture lenses cannot be used—other than by focusing on the too-narrow ground-glass ring which usually surrounds the prism centre. Incidentally, mirror-lenses, because the diameter of the glass is wider than the nominal f-number implies, can be used with these screens at apertures about half a stop smaller than other lenses. The other disadvantage is that one has to focus in the screen centre, since outer areas are normally occupied by image-brightening Fresnel rings, on which focusing is inaccurate. If the object to be in focus needs to be positioned other than in the centre of the frame, the camera must be moved after focusing—a time-wasting procedure, and likely to lead to the introduction of focusing error when taking extreme close-ups hand-held.

Personally, I prefer split-prisms to microprisms for targets at moderate ranges with relatively short FL lenses, because they give a feeling—justified or not—of greater certainty. But for long lenses of small aperture, or for very close-up work with short lenses, plain ground-glass is superior to either. The ideal would be a split-prism centre, with plain ground-glass for the rest of the screen, but few manufacturers offer such a combination.

In modern pentaprism viewing systems, the compound magnifier in the eyepiece is designed to give a view of the scene approximating to 1:1 reproduction when using a standard lens. But the *apparent* range at which the scene is viewed may follow one of two conventions—infinity or 1 metre. The latter case can give rise to difficulty for the presbyopic—i.e. middle-aged people, whose eyes' accommodation is reduced. Any such person who finds he 'cannot get on' with a particular camera should, even if he does not normally need spectacles, consider whether a permanently fitted correction lens might not cure his difficulties. It is a curious fact that integral adjustment of the eye-piece optics—fitted as standard to most cine cameras and to quite inexpensive Russian rangefinder cameras —is not as yet fitted to even the most sophisticated SLR.

Depth-of-Field and Selection of Focal Length

One of the half-truths of photography is that longer FL lenses yield a smaller depth-of-field, which is often interpreted as meaning that the shortest practicable FL should be used, even when there is a choice of camera position; this interpretation is incorrect.

At a constant range, the depth-of-field does indeed decrease with longer FL. But in Natural History work, where we can, we habitually choose an optimum image size and adjust either the range or the FL of the lens to obtain it. In other words, we normally work to a particular reproduction ratio: in this regime, at the same aperture, the depth of field is the same regardless of FL. There are some negligible exceptions: mirror-lenses have slightly less depth-of-field because the image-gathering diameter is greater than that of a conventional lens, and there are some special 'deep-field' designs, of short FL, which do—by optical juggling— give slightly better performance. But in general, at f11, a 1000 mm lens at a range of 100 m gives the same image size and depth-of-field as a

200 mm lens at 20 m, or a 50 mm lens at 5 m. (Note the results in Plate 64).

Of course, circumstances may dictate the FL to be used. Stalking shy animals may require the longest available lens in order to get an acceptable scale of image; one may prefer a particular FL because that lens gives better definition than others in one's armoury, or its focusing range is more comprehensive. Or one may, perhaps, prefer a certain FL because of the perspective it gives (and perspective is one thing which genuinely does vary with FL at a constant image scale—again see Plate 64).

The factor which I suspect has contributed most to this depth-of-field myth is a plain practical point; the longer the FL used for most subjects—on the ground—the flatter the trajectory, and this unquestionably gives an *impression* of less depth-of-field.

Most published depth-of-field tables, incidentally, are useless because of an obsolete assumption that the allowed circle of confusion should vary with focal length—a hangover from the days long ago when each FL was 'standard' for a different format and negatives from longer lenses needed less enlarging.

Exposure Levels

Exposure for colour reversal material, processed under standard conditions, requires an accuracy of $\pm\frac{1}{3}$ stop.

Negative materials are less demanding. It used to be generally believed that one always had to give minimum exposure for good quality, but it has recently been shown—by Dr G. L. Wakefield in one of his admirable technical articles in the British periodical 'Amateur Photographer'—that this is another myth. With modern black-and-white negative materials and processing, up to 2 stops over-exposure (sometimes 4 stops) can be given with negligible loss of quality in normal practice. This has important consequences. A minimum-exposure technique is bound occasionally to give spoiled negatives through underexposure because of metering errors. An increase in the proportion of successful negatives can therefore be assured by under-rating the film slightly. Furthermore, in general, Natural History subjects are relatively contrasty, and development times are best cut by 10–20 per cent as a standard practice—giving even more

tolerance to over-exposure. Overall, and allowing for the extra exposure required for this slight underdevelopment, there is much to be said for rating all negative materials at 25–50 per cent less than the published speeds. Of course, people vary in their methods of timing the development, in degree of agitation, in the accuracy of their metering, and in the contrast they like in their prints, so this is very much a suggested basis for personal experiment.

Exposure Measurement

If the sun is shining, the film manufacturer's leaflet is as accurate as any other method of exposure judgment. As a generalization, for subjects of average contrast and tone, the exposure required is $1/n$ seconds at f12·5, where n = Film Speed by ASA rating. This rule-of-thumb can save vital seconds at times and is well worth memorizing.

For other situations there are two basic systems—measurement by reflected light and by incident light. Both produce a 'grey' density, so placed on the characteristic of the film/developer combination as to give reasonable exposure to items in the scene which are moderately better- or worse-lit than the average measured.

The reflected-light system derives its 'grey' from the actual scene viewed, whereas the incident light system views an artificial scene—the translucent dome over the light receptor (usually of a standard 18 per cent transmission).

Thus, reflected light measurement will give the same overall density whether the scene is itself dark or light; restoration to the correct tone will be achieved in printing, and detail will be retained in highlights and shadows. For reversal processes, correction in printing is not possible and adjustment is necessary at the exposure-assessment stage for scenes which are lighter or darker than the average.

With incident-light measurement, however, lighter-than-average scenes will be shown on reversal material as lighter than average, and vice-versa—just what is required.

My recommendation, therefore, is to use reflected-light metering for negative materials, and incident-light metering for reversal—whether black-and-white or colour. As to type of construction, Cadium Sulphide meters have by far the greater sensitivity, but most Natural History

lighting is fairly good and Selenium meters are adequate. For the greatest accuracy in incident-light measurement, a cardioid light receptor—as fitted to the Weston Master meter—is essential.

I am consequently a little dubious about the use of TTL metering for colour reversal material, since this is a reflected-light method. It cannot be denied that it works well in a high proportion of cases, but intelligent use of a separate incident-light meter would not only be cheaper but usually more accurate, albeit at some cost in operating time. On the other hand, incident-light metering at the camera position may be inaccurate for a distant target viewed through a long-focus lens: TTL metering is better in that case.

A further problem is the type of TTL metering. 'Spot' measurement is fitted in several of the latest 35 mm SLRs, sometimes as a switched alternative to 'full-screen' measurement. It is certainly the more accurate, but the great problem is to select the tone in the target area which should be given the required density; this is surprisingly difficult and can lead to exposures much more varied than expected. 'Full-screen' systems need allowances for particular targets lighter or darker, or more contrasty, than the average (as with off-camera reflected-light meters). The 'centre-weighted' system, a compromise between the two, is perhaps the most generally successful.

'Open-aperture' metering systems are easier to use, since indicating needles may be difficult to see in the 'stopped-down' mode, and they save a little time because focusing can be carried out simultaneously. But they are liable to inaccuracy, since they assume a linear relationship between viewing and taking apertures which may not be justified—because of flare at open aperture or linkage errors in the iris mechanism.

Incidentally, all TTL systems assume accurate shutter speeds, or at least a linear relationship between them, which is not often exactly the case—another point in favour of a separate meter, since actual shutter speeds can easily be checked by a camera repairer and suitable corrections then be made.

Materials

Other authors have quoted their preferences, which can be summarized as follows. For large-format black-and-white negatives there is never any

real need to use anything slower than 400 ASA. For 6 × 6 cm cameras, 400 ASA is usually good enough but there are occasions (small image size, extreme complexity of detail, or a superabundance of available light) when a film of 100 or 125 ASA is preferable. For 35 mm, such a choice *ought* to be more frequent, but in practice it rarely can be; however, even with 400 ASA material, good 37·5 × 30 cm (15 × 12 in.) prints can be made, provided most of the negative area is used: beyond that enlargement grain starts to become obtrusive.

Slow black-and-white films (25–50 ASA) are used by some Nature photographers, but the gain over the 100–125 ASA class is small in grain and less in final resolution. They tend, too, to be 'bad-tempered'—i.e. to react badly to very contrasty subjects or to exposure error.

Choice of colour material is more difficult because of the high subjectivity of assessing 'correctness' of colour. Obviously, the faster the film the fewer the operational problems, but whether the result is pleasing can only be judged by the individual: I would draw attention to Michael Proctor's comments (Chapter 12) and Arthur Gilpin's (Chapter 5). There are now several colour-reversal films which can be exposed at effective film-speeds higher than nominal—with correction by subsequent adjustment in the processing. (Note the Urrys' remarks in Chapter 8.)

All colour materials, being tri-pack, have resolving powers considerably less than single-layer black-and-white films of the same speed. With transparencies this matters little, because of the relatively undemanding way in which they are viewed; even a giant blow-up on a screen is seen from a range of several metres, but a print, even 50 × 40 cm (20 × 16 in.), is invariably 'sniffed' at minimum eye-accommodation range and poor definition, etc., are only too obvious. Few Natural History colour prints from present 35 mm reversal materials can be considered satisfactory bigger than 25 × 20 cm (10 × 8 in.); for 37·5 × 30 cm (15 × 12 in.) prints, 6 × 6 cm is the minimum negative size for high-quality results.

Processing

I advised, on p. 377, slightly under-rating black-and-white film speeds and recommended that developing times should be reduced by 10–20 per

cent. This technique, incidentally, will ease the grain problem with fast materials.

Otherwise one cannot go far wrong by following the maker's recommendations: developers are much more nearly the same than advertisements would have one think. There are many independent developer manufacturers whose products are obviously not mentioned by film manufacturers and sometimes offer significant advantages. But one should not allow oneself to be swayed by succeeding advertisements for one miracle brew after another. 'Get to know one film/developer combination and stick to it' is a good rule—at least for things which matter. For other things, experiment by all means till you find a better combination.

Presentation

Black-and-white prints for reproduction should normally be 21 × 17 cm (1/1 Plate) or 25 × 20 cm (10 × 8 in.), on glossy paper (which gives the longest tone range), preferably (but not necessarily) double-weight and glazed. They should have a normal range of tones—definitely not deliberately contrasty. They should be accurately captioned, and be clearly attributed with copyright symbol, name, and date—by a stuck-on sheet on the back: whether the Editor asks for it or not, captions should state whether the subject was wild and free or controlled.

Colour material for reproduction is nowadays almost always submitted in transparency form, the size ranging from 12·5 × 10 cm (5 × 4 in.) to 35 mm, according, chiefly, to the whim of the Picture Editor; a short look at (the late and lamented) 'Life' or the 'National Geographic Magazine' will show what can be done by expert printers with good 35 mm material. Transparencies should not be submitted in glass, which is altogether too fragile to withstand postal and editorial-office practices, but a transparent plastic jacket is an essential protection in the photographer's own interest.

All material for Editors should be sent by Registered Post or Recorded Delivery in the UK (or their equivalent in other countries). If 'on spec.' they should be accompanied by return postage, preferably in the form of a self-addressed envelope.

Black-and-white Natural History prints for exhibition must be sharp

to a degree beyond that required for most pictorial work; sharpness is an aspect of accuracy—one of our prime requirements. Presentation has long been governed by a tradition which, as hinted on p. 6, is becoming slightly tedious to the rest of the photographic world. This required that the mount should be 50 × 40 cm (20 × 16 in.), invariably white, with the print inset slightly, and the main subject occupying about one third the length of the print diagonal in order to show a sufficiency of habitat: slightly warm tone and a semi-matt finish were also conventional. There are signs of change. Flush-mounted prints, glazed glossy surfaces, varied image scales, and non-standard mount dimensions and colours are increasingly acceptable. Colour prints are usually smaller (for the reasons given on p. 380, as well as expense) and do often genuinely look better inset slightly on a neutral-tinted mount, since it is important to insulate the colour from the walls or exhibition mount-board. The essential, whatever the type of print, is to enhance its appeal by suitable choice of surface, mount and format.

Multiple prints on a single mount, as recommended by Sam Beaufoy (Chapter 10) for life-histories, have long been acceptable and it is surprising that this technique is not varied and used more often, e.g. for series in space or related activity as well as in time.

Colour transparencies, other than for reproduction are usually shown in lectures or home shows as individual slides, linked by a live spoken commentary in a sequence of varying logicality. When such shows are good, it is usually because the quality of either the slides or the commentary is good—rarely are the two integrated fully. Nature Photographers should turn their attention to Slide-Sound Sequences or Diaporama—a concept pioneered in France, increasingly popular with pictorialists elsewhere.

Basically, it consists of projecting the slides alternately in two machines, with a device for fading smoothly from one to the other, accompanied by a synchronized tape-recorded commentary mixed with appropriate music. The result is sometimes thought of as a sort of poor man's cine-photography, but this is misguided. It is a series of *still* photographs—round each of which the eye can wander—linked into a coherent whole by choice of sequence and recorded sound, and with the additional aesthetic effect of the 'third image'—the state when both one and the next picture are on the screen simultaneously. Editing is critical—selection

and order of the slides, choice and delivery of commentary, and music; and one needs an acquired expertise in dubbing audio-effects via a stereo tape-recorder (reel-to-reel or cassette) which is outside most Nature photographers' present experience. There is, too, a music copyright problem—as outlined by Frank Blackburn (Chapter 7)—but the results can be quite astonishingly beautiful and naturalistic.

Bibliography

Camera Composition, Mante, H. (Focal Press) London, 1971.

Creative Tape Recording for Amateur Photographers, Mypes, G. and C. (published by the Authors) Greeley, Colorado, 1971.

Developing, Jacobson, C. I. (16th Ed. Focal Press) London, 1966. (A basic textbook.)

The Complete Art of Printing and Enlarging, Croy, O. R. (Focal Press) London, 1950. (A basic text-book.)

The Technique of Photomicrography, Lawson, D. F. (Newnes) London, 1960.

Photographic Optics, Cox, A. (14th Ed. Focal Press) London 1971. (A basic text-book.)

Photography for the Scientist, Engel, C. E. (Academic Press) London, 1968. (A detailed treatise on technicalities.)

Principles of Composition in Photography, Feininger, A. (Thames and Hudson) London, 1973.

View Camera Techniques, Stroebel, L. (Focal Press) London, 1965. (This covers all the uses of a Field-type Camera.)

General Index

Italic numbers indicate pages where plates appear

Index of Principal Species mentioned in the Text

Italic numbers indicate pages where plates appear